Photographing Crime Scenes in 20th-Century London

Photographing Crime Scenes in 20th-Century London

Microhistories of Domestic Murder

Alexa Neale

BLOOMSBURY ACADEMIC
LONDON • NEW YORK • OXFORD • NEW DELHI • SYDNEY

Bloomsbury Academic
Bloomsbury Publishing Plc
50 Bedford Square, London, WC1B 3DP, UK
1385 Broadway, New York, NY 10018, USA
29 Earlsfort Terrace, Dublin 2, Ireland

BLOOMSBURY, BLOOMSBURY ACADEMIC and the Diana logo are trademarks of Bloomsbury Publishing Plc

First published in Great Britain 2020
This paperback edition published in 2022

Copyright © Alexa Neale, 2020

Alexa Neale has asserted her right under the Copyright, Designs and Patents Act, 1988, to be identified as author of this work.

For legal purposes the Acknowledgements on p. xii constitute an extension of this copyright page.

Cover design: Terry Woodley
Cover image: 1953, Police officers guarding the entrance to 10 Rillington Place, scene of several murders, in Notting Hill, London, pose for a photograph. © Charles Ley/BIPs/Getty Images.

All rights reserved. No part of this publication may be reproduced or transmitted in any form or by any means, electronic or mechanical, including photocopying, recording, or any information storage or retrieval system, without prior permission in writing from the publishers.

Bloomsbury Publishing Plc does not have any control over, or responsibility for, any third-party websites referred to or in this book. All internet addresses given in this book were correct at the time of going to press. The author and publisher regret any inconvenience caused if addresses have changed or sites have ceased to exist, but can accept no responsibility for any such changes.

A catalogue record for this book is available from the British Library.

Library of Congress Cataloging-in-Publication Data
Names: Neale, Alexa, author.
Title: Photographing crime scenes in twentieth-century London : microhistories of domestic murder / Alexa Neale.
Description: New York : Bloomsbury Academic, 2020. | Series: History of crime, deviance and punishment | Includes bibliographical references and index. | Identifiers: LCCN 2020019744 (print) | LCCN 2020019745 (ebook) | ISBN 9781350089419 (hardback) | ISBN 9781350089426 (ePDF) | ISBN 9781350089433 (eBook)
Subjects: LCSH: Legal photography–Great Britain–History–20th century. | Crime scenes–Great Britain–History–20th century. | Evidence, Criminal–Great Britain–History–20th century.
Classification: LCC HV6071 .N43 2020 (print) | LCC HV6071 (ebook) | DDC 363.25/9523094210904–dc23
LC record available at https://lccn.loc.gov/2020019744
LC ebook record available at https://lccn.loc.gov/2020019745

ISBN:	HB:	978-1-3500-8941-9
	PB:	978-1-3502-0253-5
	ePDF:	978-1-3500-8942-6
	eBook:	978-1-3500-8943-3

Series: History of Crime, Deviance and Punishment

Typeset by Integra Software Services Pvt. Ltd.

To find out more about our authors and books visit www.bloomsbury.com and sign up for our newsletters.

*Bryan Edward Neale, 22 March 1936–17 June 2015.
Here's to his mother's youngest son.*

Contents

List of Figures		viii
Acknowledgements		xii
List of Abbreviations		xiv
1	Introduction: Encountering Crime Scenes	1
2	'Isn't Dinner Ready?': Spatializing Working-Class Home and Marriage in Camden	31
3	'She Wore No Ring': Picturing Sexual Jealousy and Provocation in Bloomsbury	49
4	'The Love Hut': Perverting Public/Private Boundaries in Knightsbridge	79
5	'Murder Story': Telling 'Ripper' Tales in Limehouse and Beyond	103
6	'Joseph Aaku's Cat': Imagining Home and Race in St Pancras	127
7	'We've Really Hit the Jackpot Now, Doll': Changing Lives in North Kensington	145
8	Conclusion: A Place through Crime	167
Notes		174
Bibliography		198
Index		211

Figures

2.1 First floor back kitchen [photograph 1 of 2] taken by Detective Inspector James O'Brien, New Scotland Yard Photographic Section, at 12 Prebend Street, Camden Town, 23 September 1934. Source: The National Archives (TNA): CRIM 1/742: Anderson, John: Murder: Exhibit 2 (1). © Crown copyright. Metropolitan Police Service. Used with permission 39

2.2 First floor back kitchen [photograph 2 of 2] taken by Detective Inspector James O'Brien, New Scotland Yard Photographic Section, at 12 Prebend Street, Camden Town, 23 September 1934. Source: TNA: CRIM 1/742: Anderson, John: Murder: Exhibit 2 (2). © Crown copyright. Metropolitan Police Service. Used with permission 39

2.3 Plan of first floor back room of No. 12 Prebend Street, Camden Town by PC Sidney Bostock, 1934. Source: TNA: CRIM 1/742: Anderson, John: Murder: Exhibit 1. © Crown copyright. Metropolitan Police Service. Used with permission 46

3.1 Ground floor hallway [crime scene photograph 1 of 3] taken by Detective Inspector James O'Brien, New Scotland Yard Photographic Section, at 39 Torrington Square, Bloomsbury, 18 September 1934. Source: TNA: CRIM 1/743: Georgiou, Georgios Kalli: Murder: Exhibit 9 (1). © Crown copyright. Metropolitan Police Service. Used with permission 68

3.2 Dining room [crime scene photograph 2 of 3] taken by Detective Inspector James O'Brien, New Scotland Yard Photographic Section, at 39 Torrington Square, Bloomsbury, 18 September 1934. Source: TNA: CRIM 1/743: Georgiou, Georgios Kalli: Murder: Exhibit 9 (2). © Crown copyright. Metropolitan Police Service. Used with permission 69

3.3 Dining room [crime scene photograph 3 of 3] taken by Detective Inspector James O'Brien, New Scotland Yard Photographic Section, at 39 Torrington Square, Bloomsbury, 20 September 1934.

	Source: TNA: CRIM 1/743: Georgiou, Georgios Kalli: Murder: Exhibit 9 (3). © Crown copyright. Metropolitan Police Service. Used with permission	70
3.4	Book cover: Lancing, Maureen, *Girls' Friend Library 434: She Wore No Ring* (London: Amalgamated Press, 3 May 1934). Source: TNA: CRIM 1/743: Georgiou, Georgios Kalli: Murder: Exhibit 12: Copy of book. Copyright © Rebellion Publishing IP Ltd. Used with permission	72
4.1	Detail from photograph of landing [photograph 1 of 5], taken by Sergeant Alfred Madden, New Scotland Yard, at 21 Williams [*sic*] Mews, Knightsbridge, 31 May 1932. Source: TNA: CRIM 1/610: Barney, Elvira Dolores: Murder: Exhibit 3: (1). © Crown copyright. Metropolitan Police Service. Used with permission	83
4.2	Portrait of Elvira Mullens on the announcement of her engagement to John Sterling Barney. Source: *The Tatler*, 15 August 1928. © Illustrated London News Ltd., Mary Evans Picture Library. Used with permission	86
4.3	Mrs Barney's bedroom [photograph 2 of 5], taken by Sergeant Alfred Madden, New Scotland Yard, at 21 Williams [*sic*] Mews, Knightsbridge, 31 May 1932. Source: TNA: CRIM 1/610: Barney, Elvira Dolores: Murder: Exhibit 3: (2). © Crown copyright. Metropolitan Police Service. Used with permission	89
4.4	Mrs Barney's bedroom, opposite view [photograph 3 of 5], taken by Sergeant Alfred Madden, New Scotland Yard, at 21 Williams [*sic*] Mews, Knightsbridge, 31 May 1932. Source: TNA: CRIM 1/610: Barney, Elvira Dolores: Murder: Exhibit 3: (3). © Crown copyright. Metropolitan Police Service. Used with permission	91
4.5	21 William Mews, exterior [photograph 4 of 5], taken by Sergeant Alfred Madden, New Scotland Yard, 8 June 1932. Source: TNA: CRIM 1/610: Barney, Elvira Dolores: Murder: Exhibit 3: (4). © Crown copyright. Metropolitan Police Service. Used with permission	93
4.6	William Mews looking north [photograph 5 of 5], taken by Sergeant Alfred Madden, New Scotland Yard, 8 June 1932.	

	Source: TNA: CRIM 1/610: Barney, Elvira Dolores: Murder: Exhibit 3: (5). © Crown copyright. Metropolitan Police Service. Used with permission	93
4.7	'SENSATIONAL SHOOTING DRAMA IN WEST END FLAT', *The Illustrated Police News*, 9 June 1932, p. 5. Newspaper image © Successor rightsholder unknown. With thanks to *The British Newspaper Archive* (www.britishnewspaperarchive.co.uk)	98
5.1	'The Miller-Court Murder, Whitechapel: Site of Mary Kelly's Lodgings', *The Penny Illustrated Paper*, 9 November 1888, p. 1. © Interfoto / Sammlung Rauch / Mary Evans Picture Library. Used with permission	113
5.2	Rich Street, Limehouse, photograph 3 of 3 taken 6 August 1945 by Detective Sergeant George Salter, New Scotland Yard. Source: TNA: CRIM 1/1754: Hartney, Patrick: Murder: Exhibit 10: (3). © Crown copyright. Metropolitan Police Service. Used with permission	115
5.3	Yard, Limehouse, photograph 2 of 9 taken 8 August 1945 by Detective Sergeant George Salter, New Scotland Yard. Source: TNA: DPP 2/1452: Hartney: Murder. © Crown copyright. Metropolitan Police Service. Used with permission	119
5.4	Yard, opposite view, photograph 3 of 9 taken 8 August 1945 by Detective Sergeant George Salter, New Scotland Yard. Source: TNA: DPP 2/1452: Hartney: Murder. © Crown copyright. Metropolitan Police Service. Used with permission	120
5.5	From back gate looking left, photograph 4 of 9 taken 8 August 1945 by Detective Sergeant George Salter, New Scotland Yard. Source: TNA: DPP 2/1452: Hartney: Murder. © Crown copyright. Metropolitan Police Service. Used with permission	121
5.6	Showing back gate looking north, photograph 5 of 9 taken 8 August 1945 by Detective Sergeant George Salter, New Scotland Yard. Source: TNA: DPP 2/1452: Hartney: Murder. © Crown copyright. Metropolitan Police Service. Used with permission	122
5.7	From rear of Limehouse Police Station looking north, photograph 6 of 9 taken 8 August 1945 by Detective Sergeant George Salter, New Scotland Yard. Source: TNA: DPP 2/1452: Hartney: Murder. © Crown copyright. Metropolitan Police Service. Used with permission	124

6.1	Joe Aaku's flat, first floor front room, 10 Oakley Square, taken 5 January 1952 by Sergeant John Merry, New Scotland Yard. Source: TNA: CRIM 1/2206: Manneh, Backary: Murder: Exhibit 2 (1). © Crown copyright. Metropolitan Police Service. Used with permission	141
7.1	Roger Mayne (1961) 'A corner of Southam Street, North Kensington, London, with children playing in front of a blackened wall', Roger Mayne, 1961. © Roger Mayne Archive/ Mary Evans Picture Library. Used with permission	152
7.2	First floor kitchen at 28 Appleford Road, North Kensington, taken by Detective Sergeant John Merry, Photographic Department, New Scotland Yard, 8 December 1956. Source: TNA: CRIM 1/2783: Burdett, Brian Edward: Murder: Exhibit 4 (1). © Crown copyright. Metropolitan Police Service. Used with permission	155
7.3	First floor kitchen (reverse view), 28 Appleford Road, North Kensington, taken by Detective Sergeant John Merry, Photographic Department, New Scotland Yard, 8 December 1956. Source: TNA: CRIM 1/2783: Burdett, Brian Edward: Murder: Exhibit 4 (2). © Crown copyright. Metropolitan Police Service. Used with permission	156

Acknowledgements

I am endlessly fascinated by people, places and things of the past. This curiosity was nurtured by my Mum, Jayne, who took me to museums and historic houses as a child, motivated my genealogical research as a teenager and encouraged my pursuit of university education as an adult. We both were shaped by the people, places, spaces and opportunities we encountered growing up on a 1950s council estate, most especially my amazing Nan, Sheila, and my loving Grandad, Bryan. Now home is where Whisper and Phil are. Phil, thank you for making a home (and a team) with me, where we can truly be ourselves and feel safe and loved, whether times are good or bad.

I first encountered the cases in this book through research for my master's dissertation and doctoral thesis, following a bachelor's degree at the University of Leicester. As a mature student there I benefitted from (relied on) the support of Maintenance Grants, Student Loans, Disabled Students' Allowance, Student Welfare, Student Counselling and temporary work, all thanks to patient and understanding university staff. I also want to acknowledge the inspiring scholars who taught and mentored me there, including Caroline Dodds Pennock, Caroline Sharples, Simon Gunn, Tom Hulme, Pete King and Keith Snell. An Arts and Humanities Research Council Research Preparation Masters Scholarship and AHRC Doctoral Studentship allowed me to pursue my research ideas under the excellent supervision of Claire Langhamer and Ben Rogaly at the University of Sussex, where my thesis was examined by Lucy Robinson and Matt Cook. Each of these uniquely inspiring academics helped shape that early iteration of this project, but I am particularly grateful for the ways they supported me as student, researcher, Associate Tutor and job applicant during huge personal challenges. In my first post-doctoral research position, I was fortunate enough to work under Principal Investigator Lizzie Seal whose work had influenced my PhD. Collaborating with her on her project 'Race, Racialisation and the Death Penalty in Twentieth-Century England and Wales, 1900–1965' allowed me to return to the seaside place I had made home, enjoy her excellent mentorship and test my thesis against new cases. I hope one day to be able to share the kind of intellectual generosity she has shown me and help another early career researcher to flourish despite precarity in academia in the same way. Since Spring 2019, I

have been the grateful recipient of a Leverhulme Trust Early Career Research Fellowship at the University of Sussex (ECF-2018-448), working with sources which have allowed me to contextualize the cases in this book still further. Earning a doctorate in History was unlike anything anyone who knew me when I left school twenty years ago would have imagined for me. For this reason and many others, I am immensely proud of my PhD thesis. Nevertheless, I am happy that this book represents a significant reworking of that research and I am grateful to staff at Bloomsbury and anonymous reviewers for giving me the opportunity and feedback to create something new.

The images in this book are used with permission of the Metropolitan Police, Mary Evans Picture Library and Rebellion Publishing IP Ltd, with the support of the University of Sussex School of Law, Politics and Sociology, including Bente Bjornholdt, Karen Lowton and Liz McDonnell. I am also grateful to all the archive, museum and library staff I have had the pleasure of working with directly and indirectly, on this project and others over the years, including Bart's Pathology Museum, The British Library, BL Newspapers at Colindale and online via The British Newspaper Archive, The Cage (Parson Drove), East Sussex Record Office at The Keep, Leicester and Leicestershire Record Office, London Metropolitan Archives, Mass Observation Archive and University of Sussex Special Collections, Metropolitan Police Archives, Museum of Domestic Design and Architecture, Museum of Liverpool, Museum of London, The National Archives, National Fairground and Circus Archive, Old Police Cells Museum (Brighton), Peterborough Museum and Libraries, Railway Museum (York), Regency Town House (Hove) and Science Museum (London). Special thanks are due to the Histories of Home Subject Specialist Network for holding a postgraduate study day at the Geffrye Museum of the Home in 2012 where I was first introduced to the idea of using historical crime scene photographs to study domestic interiors.

While writing this book, I have been influenced and inspired by some incredible women in a variety of ways. I am especially grateful to Alison Adam, Amy Bell, Katherine Biber, Glynis Blackburn, Jess Boydon, Louise Carr, Audrey Coe, Waralak 'Mod' Coe, Ashley Dee, Flora Dennis, Carol Dyhouse, Ann Emerson, Jessica Gagnon, Gemma Gompertz, Liyana Kayali, Anne-Marie Kilday, Claire Langhamer, Anne Logan, Hannah Mason-Bish, Eloise Moss, Jayne Neale, Tracy Oak, Sophie Pearson, Alana Piper, Rosie Reavey, Lucy Robinson, Sheila Sakalouski, Annabelle Saker Neale, Lizzie Seal, Deborah Sugg Ryan, June Tate, Kathryn Telling, Hannah Vincent, Kate West, Lucy Welsh, Susann Wiedlitzka, Charlotte Wildman and Sarah and Emma Wright. Finally, much love to Adam Gifford Brown, Greg Hyde and Math Hill for decades of unfaltering friendship.

Abbreviations

C3	Fingerprint and Photographic Bureau, Scotland Yard
CCA	Court of Criminal Appeal
CO	Central Office (of Metropolitan Police)
CRIM	National Archives prefix for Central Criminal Court records
CSI	*Crime Scene Investigation* (TV series)
DI	Detective Inspector
DDI	Divisional Detective Inspector
DPP	Director of Public Prosecutions
DS	Detective Superintendent
GLC	Greater London Council
HO	Home Office
IPN	*Illustrated Police News*
KC	Kings Counsel
LCC	London County Council
LMA	London Metropolitan Archives
MEPO	National Archives prefix for Metropolitan Police records
MP	Member of Parliament
PC	Police Constable
QC	Queen's Counsel
TNA	The National Archives

1

Introduction: Encountering Crime Scenes

Imagining a crime scene

Picture a crime scene photograph. When we imagine still images of sites of murder, we think of chalk outlines, blood spatter or hidden keys in close-up. We might conjure a lonely glove surrounded by fallen leaves or the faint imprint of a lower lip on the rim of a drinking glass. We may imagine Scenes-of-Crime Officers (SOCOs) or Crime Scene Investigators (CSIs) in paper suits behind yellow or blue tape, pointing their cameras with quick clicks and flashes, countless images captured as they document entire rooms in infinite detail, touching nothing but seeing everything.[1] Later, in a caffeinated conference room, or crowded around a computer screen, detectives and scientists review and examine the photographs, select and filter, zoom and enhance, finding clues hidden in everyday objects. In the courtroom, experts explain enlarged images to the jury, pointing to the position of the body and blood-spatter patterns, interpreting their significance for the identity of the accused. The photographs *show*, they say, the defendant's presence at the scene, inviting the jury to view for themselves the fingerprint on the fallen key-fob, common sense dictating that the alibi is disproved by locating the discarded glove or drinking glass DNA. Photography has been furnishing evidence for more than a hundred years, the camera called upon as a regular witness in courtrooms since the beginning of the twentieth century. But has it always been objective and infallible? Were crime scene photographs as instrumental in convincing juries of a killer's identity in the early twentieth century as the early twenty-first? This book explores how crime scenes were read and recorded in the past, challenging what we think we know about forensic photographs: from how and why they were made, to the meanings and evidentiary powers ascribed to them.

Holmes, Poirot, Jessica Fletcher, *CSI*, *Silent Witness* and many hours of Netflix have all contributed to public perception that forensics and forensic

imaging, past and present, are concerned primarily with examining self-evident truths, capturing small things and representing them at large scale. This book argues that twentieth-century crime scene photographs were rarely called upon to represent such detail; cameras at the crime scene were not required to communicate clues or record investigations. Police the world over took different approaches to capturing crime scenes, but until well into the second half of the twentieth century, English police photographers were united in their lack of concern for facsimile, unburdened by demands for 'proof' or the location of facts through their images. Rather, the place of the police photograph was the courtroom, where monochrome prints made wide views of rooms and streetscapes portable in space and time. The authority of the photograph did not rely on its ability to enlarge, highlight or accurately copy but on its visual endorsement of an imagined crime narrative.

This book centres each of the six thematic chapters on a case of murder and its photographs, supported by references to additional examples. It reveals twentieth-century police photography as selective rather than complete, widely surveying scenes rather than documenting them in detail. Readers will quickly comprehend the extent to which tropes in TV, film and fiction have leaked into their own understandings of how crime scenes were recorded and represented in the past, corrupting views of historic cases and inflating forensic meaning. Photographing crime scenes in twentieth-century London, I argue, was more about visualizing a narrative in the courtroom than investigating and establishing that narrative in police detection. I confront assumptions about crime scene photographs in the twentieth century as infallible facsimile evidence by describing how they were commissioned, made and viewed in murder cases with a variety of outcomes, from not guilty verdicts to conviction and capital punishment.

Through careful reconstruction of crime scene practice in each twentieth-century case, I argue that forensic images represented, and were shaped by, space, place and narrative. By depicting crimes spatially, they acted as surrogates for the actual scene, allowing rooms and their look and layout, the relationships of objects to one another, to be captured. They transported the place of the crime to the place of the courtroom, collapsing time and distance. In so doing they communicated information about the places depicted, without the jury having to actually go there, including inferences about geographical place and social groups outside of the photographic frame. Most significantly, however, they were used to endorse crime narratives: ideas of how events played out, notions of assumed timelines with all their implications. Calling on familiar visual

referents, crime scene photographs could be used to tell a very particular version of what happened, inferring behaviour, culpability and criminal intent in order to support legal definitions and determine trial outcomes. These effects relied heavily on imagination, I argue. Just as our own perceptions of what images show are contingent upon the present cultural moment, so too were readings of crime scene photographs in the past. Courtrooms viewed crime scene photographs through a lens shaped by the historical, cultural, social and legal moment in which the case was tried, including contemporary ideas about race, class and gender that determined how people's identities, homes, relationships and crimes were interpreted.

The crime scene in the archive

Many historians and criminologists have highlighted how problematic straightforward readings of archived crime sources, including case files and press reporting, can be. However, there still exists a temptation to review evidence from past cases in the assumption that 'forensic' or 'scientific' exhibits possess a greater evidentiary value than other documents, or that more recent knowledge regimes have the power to reach superior understanding of old evidence.[2] Yet cultural representations of more contemporary crimes demonstrate popular knowledge of the fallibility of evidence. Defendants can lie, confessions can be extracted under pressure and witnesses can get things wrong. People are only human after all.[3] The camera, in contrast, we imagine can be trusted to tell the truth; a photograph (pre-Photoshop at least) is self-evident, possessing a retrospective realism, or at least a power of authentication; it can uniquely testify to what was really there.[4] Through characterization and narrative, this book describes the ways people have encountered crime scenes, and how those encounters have shaped representations of those crime scenes. Crime scene photography in the past is revealed to be the product of human encounters. Each chapter sets the scene with a descriptive vignette, highlighting practices that led to the creation and interpretation of crime scene photographs, drawing out the perspectives and experiences individuals brought with them. I also reflexively observe my own encounters with crime scenes (in the archives) and how they have shaped my own interpretations and hence the research and writing of this book.

When the majority of murders, past and present, occurred in people's homes, one might imagine crime scene photographs could be an excellent source for studying domestic interiors. Indeed, archived crime sources have much to offer

historians and criminologists. Crime scene photographs and their case files are a rare example of a source in which images of everyday spaces accompany descriptions of people, activities, emotions and experiences in the same places.[5] The crimes could even be incidental, couldn't they? This was what I imagined before my first encounter with a crime scene, which occurred on 8 May 2012 at the UK National Archives, Kew.

Encountering Appleford Road, Part I

A soft grey folder scattered with coloured stickers and handwritten labels appeared, by invisible hands, behind the orange Perspex of locker number 43D. I snatched it up greedily, side-stepping impatiently through the not-so-automatic doors, racing to the old leather and wood octagon where I had been waiting for thirty minutes that felt like a hundred. The bright yellow production slip was whipped out of the pages, either by my haste or by the over-powerful air conditioning. I caught it before it reached the government-issued carpet tiles. As I did so, I attempted to decipher its many codes, recognizing only my name and seat number besides the file reference 'CRIM 1/2783'. My serious-faced neighbours were hunched over their crumbling boxes and leather-bound books as I placed my bounty on the table and took my seat. With my pre-approved pencil (no eraser) and supermarket-Moleskine, I diligently copied the text of the stamps and stickers fixed to the cover including 'Warning: Images may cause distress'. I opened it cautiously, wondering how high or low my distress threshold might be. Inside was a motley collection of ephemera, held together with punched holes and treasury tags. Dozens of lightly foxed tracing-paper thin pages covered in regular lines of mechanical type, each annotated with lines of pencil and loops of ink. Buried beneath them, a creased and dirty envelope, several sheets of handwriting in biro, two torn scraps of patterned paper and nine glossy black-and-white photographs. The first two showed a room in monochrome. No white chalk outlines or bloodied weapons. Flat and grey, these chilly prints were lacking intimately framed details but bearing the unmistakable markers of lives lived between the papered walls. Colour and meaning were promised by page after page in the plentiful file, and this was only the first of dozens I could order until 43D was overflowing. I looked around for someone with whom I might share my archival joy, for here was everything I had hoped for and more besides. But with all eyes in the room silently and obediently glued to their papers, mine fell back to the file

in front of me and settled on a single sentence swimming in a page filled with handwritten cursive, and I allowed myself to whisper it: 'We've really hit the jackpot now doll.'[6]

I was far from the first to hit the archival jackpot with murder files like that representing Appleford Road in The National Archives. Refracted through the extraordinary events accompanying a murder investigation and trial, these documents used at the Old Bailey (more accurately known as the Central Criminal Court) represent detailed accounts of ordinary everyday encounters between people and places in London. Cultural historians have used them, and other collections of court and crime sources, to tell about social mores and contemporary concerns in their cultural and historical contexts from the sixteenth to twentieth centuries. Crime historians and historical criminologists have applied a Microhistory method to individuals and their crimes, through which 'macro' themes have been illuminated such as the socio-cultural implications of crime, connected contemporary political priorities and moral campaigns by the media.[7] Microhistorical writing has turned to increasingly creative narratives in recent years, drawing on techniques of characterization and description usually found in fiction, highlighting close relationships between crime and narrative storytelling. In so doing, cultural and social historians have demonstrated the rich detail crime archives contain regarding everyday lives and spaces in the past which would otherwise be obscured from view.[8] Narrative criminology, meanwhile, analyses the stories people tell about identities to make sense of crime in the present, including storytelling about the self through visual culture and portraiture.[9] Visual criminology in turn is deeply critical of representations of criminal and social 'others' through art and photography and accompanying captions and narratives.[10] Recent reflexive turns have seen scholars reflect on their own positions in relation to their sources and the individuals they study, and at the time of writing publications are in the works which promise to explore historical writing as creative practice, bringing new insights by imagining subjects beyond the limits of more traditional 'academic' styles of writing and research.[11] This book shares many of these same aims but takes murder crime scene photographs and their forensic deployment as narratives in the past as its jumping off point, whereas other historians have used visual and material exhibits as part of a range of evidence.[12] Few scholars have applied a microhistorical or creative histories approach to visual representations of crime scenes, though some have used international examples to furnish fiction.[13]

This book contributes to a field taking shape which approaches visual and material sources from Cultural-Historical-Criminological perspectives, interrogating the narratives told with and about those sources, and telling further stories with them.[14] Still and moving images, art, photography, film, cartoons, graphic novels and computer games, for examples, can all contribute to histories and sociologies of crime, punishment and violence and their means of cultural communication.[15] So too the artefacts of jurisprudence; objects and materials used as exhibits of evidence and letters narrating personal and public feelings about punishment and mercy, for examples.[16] Emerging areas which marry methodologies offer unique opportunities for bridging disciplinary boundaries, including historical criminology, visual criminology, socio-legal studies and imaginative criminology. Each takes social sciences as their subjects (Crime, the Law) but closely identify with the humanities by exploring them through, or analysing their impact on, the social, cultural, spatial and experiential.[17] Each has influenced this book, but multi-disciplinarity also presents multiple difficulties. Readers will realize that the sources on which this book draws are so richly detailed and varied in the subjects they allow us to explore that they open doors to endlessly labyrinthine libraries of literatures. Focusing on any one of the many theoretical approaches one could apply to historical crime scene photography necessarily detracts from others, or overwhelms a book like this with secondary citations. I have deliberately prioritized the primary sources and invite further research and future discussion about the frameworks which might be applied to enhance their analysis and comprehension. Historians have been notoriously light-touch in their approaches to visual sources until very recently, yet present students of histories and sociologies exist in a world where images, and perhaps mainly photographs, are a privileged means of communication.[18] New conversations are to be had, and so many uniquely creative and collaborative approaches are currently emerging that the timing seems ideal to suggest new ways of thinking about representations of crime.

It can be tempting to consider the crime in crime scene photographs incidental, as some practitioners have attempted to do, so remarkably detailed and fascinating are these exhibits as windows on everyday spaces and ordinary lives in the past.[19] However, to do so is to overlook the historically contingent contexts within which and for which they were designed. Narratives negotiated in the courtroom and debated in the press are essential to comprehending the empirical meaning and value of exhibits of evidence to contemporaries. It is the life-or-death [sentence] consequences of capital trials that make murder files particularly descriptive and comprehensive and such fertile grounds for

microhistorical analyses.[20] With the most voluminous archival traces, capital cases have tended to be those from which recent television programme-makers have selected. The moralizing of the past continues unchallenged when eagerness to entertain – couched in the language of reinvestigation to uncover possible miscarriages of justice from cases charged, convicted and capitally punished – obscures opportunities to reflect upon the contemporary conditions, damaging stereotypes and biases that produced archives of crime.[21] Attempting something like a reinvestigation of a crime based only on the limited selection of evidence that has survived many decades, even centuries, without an understanding of the empirical, theoretical and legal limits that shaped their creation and deployment, assumes a straightforward and linear process of forensic development that brings us to an accurate and factually superior present. Popular culture and 'CSI Effects' further complicate these issues.[22] For example, a work of scholarship that analyses historical images of crime and interprets English scenes based on methods of policing depicted in fictional US television programmes decades distant imagines that crime scene photographs were framed to include items and locations of direct evidentiary significance.[23] More critical examinations of such cases and how they were constructed and communicated by contemporaries have the potential to reveal something of the background to enduring legacies of sexism and racism in criminal justice.[24] The extent to which the uses of visual evidence at the Old Bailey differed from modern conceptions will be illustrated in the next section by an exploration of the traditions upon which crime scene photography drew.

Picturing a crime scene

Picturing crime scenes, or representing scenes of crime visually, predates the photograph by a considerable margin. The oldest, and certainly the most common visual representation of the crime scene in use in the twentieth century, was the scale plan. These documents demonstrate that it was police who designated the boundaries of the crime scene space and selected areas, objects and viewpoints relevant to a case. They also show something of a common-sense approach to the investigation of crime; when a body was found, or murder was suspected, the most prominent and straightforward narrative was the most likely, and this line was pursued to its logical conclusion. First, the victim probably, though not invariably, died where their body was discovered (see Chapter 5). If furniture was upturned, there was likely a fight (see Chapters 2 and 6). If a

window was broken, the crime was likely perpetrated by an intruder rather than a member of the household. The scales of a plan could represent micro- or macro-geographies, depending on the demands of the case. In the form of a line drawing, it might show a single room or several, a whole house floor by floor, an entire street or a much wider area. Copies of Ordnance Survey maps might be sourced, edited and annotated to show, for example, distances and journey times between locations (Chapters 5 and 6). *Old Bailey Proceedings* show that it was skilled surveyors and architects trained to measure and draw accurately who were employed to make plans in the nineteenth century. However, they did not always understand the specific requirements of the courtroom in murder trials, and from the late nineteenth century and into the early twentieth, divisional PCs were increasingly taking on the role of producing visual representations of crime scenes.[25] The empirical meaning and strength of these documents drew on inferred references to scientific authority and mathematical accuracy – precise measurements were indicated and commented upon by plan-makers when they introduced their drawings in court. Far from being purely functional, however, plans often included design flourishes, decorative borders, curlicues and fancy lettering, none of which were strictly necessary for the requirements of the document (see Figure 2.3). In this way, they also referenced architectural drawings and the earlier creators (architects and surveyors) who were employed to make plans of crime scenes in the nineteenth century. The empirical limits of the crime scene plan are demonstrated by what was omitted and the ways they were used in court. Bodies were mapped very rarely, blood marks or the position in which a weapon was found only slightly more frequently. Rather, plans were used in court as a reference point – for police and other witnesses to point to the spot on the plan or map where they had seen blood, discovered a body or witnessed a significant event for the benefit of the jury. They show how important the physical reference point was, with plan-makers invariably the first witness called in a murder trial at the Old Bailey.

It was not merely a two-dimensional reference point for witness observations that was required, however. Other examples of visual representations of crime scenes dating back to at least the eighteenth century show that juries needed to imagine events described, narratives related, to picture them playing out in three-dimensional space. Crime scene photographs performed a similar function for most of the twentieth century in England and Wales, but they did so following a centuries-long but little-known tradition of representing the crime scene through miniatures. Crime scene scale models share a similar history to plans, constructed using the same measuring and mathematical

skills, but they also drew on creative skills associated with hobbies and handicrafts to create an object resembling a dolls' house that had a practical, demonstrative function and central role in court proceedings. Just as plans did not map blood or bodies, neither did models. Court transcripts and surviving photographs of models show that they most commonly depicted rooms before a crime occurred. Witnesses, police and defendant were called upon to point to tiny settees and handmade matchbox furniture to say where they had found an object, or where someone had been sitting when they spoke, for examples. Even as late as the 1930s crime scene scale models were being prioritized over other visual representations, including photographs. Police officers were the makers of models, who constructed, decorated and displayed them to demonstrate the playing out of the prosecution's police-determined narrative, to stand in for the actual space of the crime scene: a sort of tiny three-dimensional stage.[26] (These functions can be usefully contrasted with those of the 'Nutshell Studies' by Frances Glessner Lee and the *CSI* TV show storyline 'The Miniature Killer.')[27]

Visual representations of crime scenes in different media shown in courtrooms in twentieth-century England and Wales were united by their functions as demonstrative surrogates for a space, making it portable in space and time but limited to the legal sphere. This was also the function of more widely consumed visual representations of crime and crime locations, which demonstrate a long history of fascination, preservation and consumption. Objects and materials from the crime scene itself were variously stolen or sold as souvenirs and treasures, displayed in private homes, museums and waxwork exhibitions as independent curios, parts of collections or elements of entire tableaux. For those who could not possess or view an authentic piece of the crime scene, replica souvenirs were available. One could purchase a tiny ceramic Red Barn or Stanfield Hall, for examples, models of the scenes of these famous nineteenth-century murders as popular as the matching figurines made in the images of the killers and victims. Rosalind Crone describes the imaginative functions of these objects which depicted people and places as they were before the crimes that made them famous rather than in the act or afterwards, alluding to elements of the murder narrative but not reconstructing it.[28] These visual and tactile objects were decorative in their own right – after all, not all ceramic figurines were about murder – but what made these particularly powerful and collectable were the stories with which they were associated, making the murder and its location portable in space and time with imagination central to experiencing and consuming them.

Newspapers also represented a visual media for consuming places and spaces of crime, and they too required a degree of imagination work. US press photographers such as Arthur Fellig, better known as 'Weegee', who took pictures at murder crime scenes while bodies were still warm and sold them to newspapers,[29] had no equivalent in England and Wales. English press did not publish police-produced crime scene photographs; rather, they relied instead on illustrations to communicate crime narratives visually. *The Illustrated Police News* demonstrates the centrality of the visual to the consumption of crime, the most popular in many illustrated newspapers originating in the nineteenth century, themselves drawing on a long tradition of illustrated media about crime. Devoted almost entirely to crime and court reporting until it ceased publication in 1938, the *IPN* continued to print woodcut interpretations of crime decades after photographs were first introduced in British newspaper publishing in 1904.[30] By sampling editions of *The Illustrated Police News* at regular intervals, Alice Smalley has shown standard features and repeated devices in woodcut depictions of crimes and crime scenes, including people, places, homes and dwellings that informed readers about the cultures of crime and social identities of the people involved. Each image in itself communicated a narrative of the crime, trial or punishment, independent of the accompanying text or the next image in the sequence in the following edition(s). The main ways these narratives were communicated, Smalley argues, were through the arrangement of the people depicted in the image, their gestures, expressions and movements.[31] Comparisons between crime scene photographs and newspaper illustrations of the same interior locations (see, for example, Chapter 4) show that the latter were not based on direct observation by the artist, nor was their popular appeal reliant upon this kind of accuracy. Artists were representing an idea of the place the crime occurred and the narrative of events. Readers did not expect *IPN* crime scenes to be sketched from life, unlike courtroom portraits.[32] Instead, illustrators drew on stock interpretations of crimes and crime scenes that invariably represented either the moment of murder or, more frequently, the moment of discovery.[33]

Photographing crime scenes in early twentieth-century London similarly meant associative, imaginative and implied meanings more than visual transcription or facsimile. However, it is important to recognize the different institutions and power structures that created and consumed crime scene photographs compared to publicly consumed images about crime and photographs more generally. Though courtroom visuals of crime scenes carry additional meanings in the twenty-first century, the scene's meaning for imagination

and demonstration continues to be important. As recently as 2018, a jury was transported fifty miles from the Old Bailey in London to a park in Brighton where the bodies of Karen Hadaway and Nicola Fellows were found in bushes. The visit was not, could not, have been to directly view physical evidence of the crime itself because thirty-two years had passed since the children's bodies were removed. The jury was invited to see routes taken by the girls, plot the alleged movements of their killer before and after the crime, and imagine the moment the crime scene was discovered. Applying spatial logic and geographical imagination, the jury was asked to map the prosecution's narrative of the crime upon the contours of the landscape they observed, collapsing three decades.[34] In other more historical examples, visits to the crime scene were suggested but not practicable. In one instance, the entire contents of a hotel room, despite possessing no forensic value as we might understand it today, were transported to the Old Bailey and set up in an anteroom for the jury to view.[35] Plans, models and photographs were made for the same case, but the reconstruction enabled the jury to imagine the spatialized narrative presented to them. Echoing the common practice of Coroner's Inquests being held at or very near the place a body was found (which faded out of practice following the 1926 Coroner's Amendment Act which transferred the relevant powers to juries at criminal courts), this and other cases show the significance of imagining narratives playing out in space for the benefit of the jury. In short, various iterations of visual representations of the crime scene have emerged over centuries from the need to collapse temporal and geographical distances and to imagine narratives of a crime playing out in space. Simply put: if you can't take the jury to the crime scene, bring the crime scene to the jury.

Images and narratives of crime are all around us in the present. Our centuries-old obsessions with crime stories, 'true' or otherwise, in spoken word, printed literature, press, television, online fora, film and podcast show no signs of abating. Appetites are only fully satiated when 'whodunnit', 'why' and 'how' are revealed, the crime itself forming the beginning of the narrative structure, revealed to brave protagonists by intelligent investigation, identification, apprehension and arrest in the meaty middle, the tension of the trial and satisfying delivery of justice at the end. The tantalizing quest for 'truth' or 'facts' and their high stakes offer particular narrative benefits, with evidence and the crime scene offering images we are invited to interrogate ourselves. Crime scene photographs are widely and popularly available for discussion and analysis on the internet,[36] Dark Tourism guides suggest crime sites to visit,[37] and reconstructions are staged, both as a method of solving a crime and as a means to entertain television audiences.[38] However, as the history of visual representations of crime scenes illustrates,

to look at past crime scene photographs through the lens of the present poses significant problems. I argue that the study of crimes past demonstrates that we will never know 'what really happened' in a murder case because of the high stakes associated with telling and archiving narratives of a crime. As this book will show, a variety of legally contingent narratives were told in each case, deployed with a purpose, recited because they could be accepted, were familiar, evocative or believable.[39] At a criminal trial, narratives are employed to prosecute and defend, to frame and explain the evidence in a way favourable to a preferred story of events, to tell juries what they are looking at and what it means, how to read an exhibit, account for findings. Juries are asked to consider vivid descriptions, blood-stained weapons, torn clothing, crime scene photographs, and post-mortem reports as artefacts of events they did not witness directly. Each side of the adversarial trial pieces exhibits together through their narrative, attempts to explicitly or implicitly demolish the opposing interpretation and asks the jury to decide which, if any, was proved. Rather than looking for the truth of what really happened in crime scene photographs, this book explores the critical significance of the visual to the construction and reception of such narratives at the Old Bailey in the twentieth century.

Visualizing a narrative

Despite our familiarity with crime narratives and images in the present, they are historically contingent. Constructions and representations of 'normative' domesticity, femininity and sexuality, for examples, dependent on contemporary codes of behaviour, were (indeed are) portrayed by the criminal justice system in the form of stock stories or familiar tropes which varied according to time and place.[40] It is a central argument of this book that these tropes were reinforced or undermined by visible referents and imagined narratives. Besides providing an observable setting or stage upon which jurors could imagine the narratives presented to them playing out, twentieth-century crime scene photographs and the traditions they drew upon constituted a visual language that spoke to the class, gender and race of people who used the spaces depicted. In this way, they spoke directly to the culpability of victims and the guilt of accused persons. These purposes and effects stand in contrast to what we now assume to be the evidentiary purpose of crime scene photographs in the twenty-first century. Surrounded as we are by images, including recent crimes and crime scenes, we think we know what they looked like and what functions they performed in the

past. By telling 'a little of the story' of how a crime was encountered, the narrative developed and the scene photographed, then presented to the courtroom in each microhistory case explored, this book will suspend myths about the nature of historical crime scene photographs. By demonstrating how evidence was deployed to support narratives, to illustrate 'bigger pictures', it will show that these images had a wider meaning than situating micro exhibits of scientific or trace evidence within a scene, or recording an investigation, which have become their primary functions in the early twenty-first century.[41]

Examining the particularities of crime scene photographs and their impact on narratives of crime exposes complex relationships between evidence and meaning, interpretation and understanding, policing and justice. Archived depositions, photographs and evidence are all revealed to be parts of a case rather than merely records of it. Fully contextualizing these documents requires situating them in their historical moment, courtroom setting, contemporary legal framework and archive context, appreciating the possibilities and limitations they pose(d), then and now.[42] As Amy Bell and Lela Graybill have noted, exploring something of the formation and interpretation of crime scene photographs as products of their specific legal system demonstrates how contemporary social mores and concerns had visual referents and legal consequences.[43] Furthermore, exploring the ways evidence was actively contested in the courtroom illuminates the standards applied to, and demands made of evidence, including photographs, as well as meanings explicit and implied. As this book will show, such analyses challenge an interpretation of crime scene photographs as objective, neutral, scientifically accurate or mechanical copies of that which is seen through the human eye. Rather than viewing these documents as records or communicants of visual 'facts', *Photographing Crime Scenes in Twentieth-Century London* explores each scene as it was represented by the police photographer who captured it.

Katherine Biber has similarly identified contestable meanings communicated by forensic photographs, identifying cultural values and psycho-social assumptions about race and gender embedded in images used in Australian courts.[44] She further argues that the law has, in the early twenty-first century, ignored 'over a century of scholarship on photography' to look at photographs 'as if they were natural or neutral, as if there were nothing impeding law's capacity to see what "is" in a photograph'.[45] Of photographs used in US courts, Jennifer Mnookin argues that their facsimile powers were established in the late nineteenth century but according to judges were contingent upon verification of their accuracy by a witness.[46] This is significant because it reveals present perceptions of crime scene photographs in the past as representing 'proof' or 'fact' – the idea that they were

used as something like direct evidence of what they showed – to be inaccurate. Such a view contributes to a notion of a smooth and upward trajectory of development in forensic science and technology, a 'civilizing' narrative of science's triumphs over crime that exist in popular perceptions but not in historical evidence. That is not to say that crime scene photography was not considered accurate or 'scientific'. As this book will show, photography was called upon to communicate different types of knowledge and meaning than that which we in the present day understand as 'forensics'. Alison Adam argues against uncritical acceptance of forensic techniques or retrospective application of standards of scientific knowledge, urging instead that 'we should consider what was accepted as a reliable, effective technique at the time, without judging it in terms of present-day views on scientific credibility'.[47] Following Adam, Bell, Biber and Graybill, I argue that forensic photography, if the medium can be so named in the twentieth century, drew more of its authority by inference from the institution that made it than by trust in the scientific accuracy of the technology. To be sure, this is not a unique perspective, John Tagg and other photographic theorists have similarly argued that the representational powers of crime photography derive from their institutional origins.[48] However, *Photographing Crime Scenes in Twentieth-Century London* focuses on the narratives that dictated how photographs were made, their purposes as documents of the courtroom and their role in telling about crime.

The crime scene in the courtroom

In the twentieth-century English courtroom, evidence presented 'for the Crown' in support of a criminal prosecution was collected and fashioned by police and represented their very particular interpretation of a crime. This primary factor is essential in understanding the character and content of crime sources extant in the archival record.[49] Though defence counsel 'for the prisoner' (also referred to as the defendant or the accused) were able to submit their own evidence, they did not conduct their own investigations at the crime scene, and so relied on whatever items and interviews police had gathered there. Evidence used by both sides of adversarial trials was therefore biased towards prosecuting the defendant. Though the capital's force, the Metropolitan Police, was split into dozens of divisions with regional staff, stations and magistrates' courts, consistency was, at least in theory, ensured by training and regular communications from central offices at Metropolitan Police's headquarters, Scotland Yard. Manuals and rules were intended to guide regular Police Constables (PCs) in how to preserve

evidence at a crime scene, how to make notes, take statements, write reports and preserve weapons or objects for analysis by specialized detectives and analysts. However, with a successful conviction being the ultimate measure of efficiency, rules reflected the standards and interests of the courtroom more than they dictated the actual practices of the police. Claims to accuracy and reliability were arguably less about unwavering conviction in the empirical value of the evidence and the method, science or technology that produced it, and more about shoring up exhibits against the techniques defence advocates used to undermine them. Even minor procedural failings, omissions or shades of doubt could be highlighted by defence counsel to render an exhibit less meaningful or altogether inadmissible. Beyond visualizing the geographical elements of the crime narrative, representations of crime scenes communicated more subtle but potentially equally damning messages to juries. Visual cues readable in the homes of defendants and victims, in the distant and more recent pasts, suggested conformity or deviation from social or moral codes to contemporaries, influencing ideas about identities, values and behaviours, and thus degrees of honesty, culpability, guilt and sympathy.[50] Though such notions were communicated in a variety of ways in criminal investigations and trials, it is a central argument of this book that visual evidence particularly reinforced narratives in this way.

The narrative of a crime could mean life or death for a defendant at a murder trial in twentieth-century England and Wales. Opening speeches for the crown commonly reminded juries of their grave responsibility for determining whether or not the evidence presented proved the prosecution's version of events. These speeches frequently described exhibits of evidence, including witness testimony, as being fragmentary, or by comparing them to a jigsaw puzzle, requiring the telling of a story to link them together. The story often began with a potted biography of the defendant, a history of their relationship to the victim, gradually moving from the years preceding the alleged crime to the weeks, days, hours and moments that ended in the victim's death, signposting exhibits at each stage. It is in this spirit, of telling 'a little of the story, so that you may follow the evidence when it is called before you',[51] that this book is laid out, following a microhistory tradition that deploys case studies to make specific points, gradually building layer upon layer to make a book of such studies more than the sum of its parts. This book also deploys a technique recently established in crime history and historical criminology that is also informing broader historical writing. The 'narrative turn' is moving towards a 'creative turn', biographical or life-writing techniques employed to describe characters, evoke a sense of place, represent 'structures of feeling' and emotional

resonances associated with places and objects.[52] It is particularly appropriate to use such a technique – to tell descriptive vignettes to illustrate how narratives and images about murder were composed and deployed – given the parallel aims that drove storytelling in and about criminal trials; to set the scene, describe relationships between people and places over time in order to evoke sympathy or describe motivations. However, it is essential to note that the ultimate aim of narrative in the courtroom was invariably securing a conviction or defending it. *Photographing Crime Scenes in Twentieth-Century London* argues that exhibits of evidence, including photographs, were used to illustrate specific narratives with dependent legal outcomes.

Murder has a narrative structure: a beginning, a story leading to a death, followed by an intelligent investigation, swift identification and apprehension, arrest, charge and delivery of justice. Press reporting on crime, 'True Crime' literature and associated genres require an understanding of what happened, whodunnit and how, before a satisfactory conclusion can be reached.[53] Crime historians have long recognized that the value of sources about crime extends far beyond the 'facts' and that even self-interested lies, told to keep secrets or evade the law, form meaningful narratives. As Matt Houlbrook demonstrated, these stories tell us more than the motivations of the teller and can be useful to historians in a variety of ways. A narrative is told with purpose, intention or function; it is based on a familiar pattern or widely understood trope and has a common outcome, implication or impact. Narratives are also telling of the cultural, social, political, economic and *legal* conditions in which they existed, the historical context that made it possible to tell them.[54] In murder trials at the Old Bailey, narratives were deployed to prosecute, defend, explain the evidence, provide alibi or motive, mitigate guilt, transfer culpability, evoke sympathy, justify verdict, describe sentence and appeal for mercy.[55] This book explores familiar narratives related to murder that drew on visual referents, bringing out the historical and socio-legal contexts on which their telling relied.

More than that, *Photographing Crime Scenes in Twentieth-Century London* explores the relationship between the crime story and the crime setting. It argues that these narratives required a stage, a place that jurors could imagine crime stories playing out. An established visual language of the crime scene was referenced in photographs, historically specific, to reinforce the narratives and tropes deployed. Visual referents signposted other exhibits of evidence and events in the timeline in the images, but less explicit visual devices also contributed meaning regarding class, gender, race and sexuality of inhabitants. As this book will show, a crime scene photograph could speak to the guilt of a defendant and

even the culpability of a victim in their own murder. The conception of 'visual narrative' that shapes analysis of crime scene photographs in this book is based on the idea of narrative as movement between events, moments and places. To be clear, twentieth-century crime scene photographs rarely represented a sequence of events in themselves, a passage of time *between* images, like a comic strip or series of freeze-frames. (Something like this was represented in the Hartney case explored in Chapter 5, but the photographs were not used as evidence at the trial.) It was not until later in the second half of the twentieth century that crime scene photography in England and Wales reflected a timeline of the investigation, movement through the crime scene or accurately depicted material exhibits in situ. Instead, the case studies in this book show that crime scene photographs represented significant moments which included:

1. The minutes preceding the crime, for example, showing a room as it might have looked before the crime was committed.
2. The moment of discovery or immediately following the murder. (In such an image narrative might be implied by, for example, a pool of blood and a knife signifying a violent act occurred.)
3. The trial, where the photograph would be exhibited.

When a twentieth-century crime scene photographer captured an image, he did so in order to collapse time and geographical distance between that location and the courtroom, enabling the prosecution and, to a lesser extent, the defence, to use the picture to tell a story. The case studies examined in this book will show that visual references and clues could communicate messages about people's homes, social lives and circumstances which had implications for readings of their identities, propensity to sex or violence, culpability and the likelihood of provoking a defendant to murder, for examples. As we will see, each photograph can imply a narrative by depicting familiar domestic references. For example, disorganized bed clothing suggested a couple were in bed before one killed the other, a half-eaten meal that it happened over dinner. These micro-narratives then formed part of a more extended narrative of an unhappy marriage or adulterous partner, for examples. Each crime scene photograph is a micro-narrative in itself, a component of a story ending in a death with a specific legal framing such as Manslaughter or Capital Murder. It is a central argument of this book that the final moment in the narrative represented by a crime scene photograph – the courtroom – is essential to understanding how contemporaries read the image and why it was taken. The courtroom context is, therefore, the climax of the book, and sources that describe the action in the Old Bailey courtroom are prioritized wherever possible.

Prioritizing courtroom narratives sees *Photographing Crime Scenes in Twentieth-Century London* departing from preceding literature. The eminent historian of crime scene photography in England and Wales, Amy Bell, described their forensic aesthetic, visual vocabulary and references to film noir, documentary and amateur photography traditions.[56] Bell's book *Murder Capital* is the only work of scholarship to date that has used crime scene photographs to describe the social and cultural textures of twentieth-century London in cases recorded by the Metropolitan Police's Register of Deaths by Violence. Bell argues that the register reflects police preoccupation with the wrapping up of crimes, case outcomes being of primary significance to their *modus operandi*.[57] I agree, following this thread to its conclusion to show how photographs were deployed to support specific narratives in order to fit legal definitions of types of crime. Building on Bell's book, which takes Metropolitan Police bureaucracy, definition and investigation of crimes as a jumping off point, the present work completes the picture by considering the courtroom as the context which defined photographs, files and historical records. Like Bell, I identify the implicit messages in the photographs (after all, every picture tells a story, or so the saying goes). However, I take this notion further down a different corridor, describing not only how the pictures were made but which familiar, legally bounded narratives they spoke to and how, linking their implied and explicit meanings. In so doing, I show that not only were crime scene photographs not a direct transcription from life but that the courtroom did not expect them to be. This stance sees a significant departure from histories of crime scene investigation that consider photography part of an increasingly systematic, controlled, objective and 'scientific' approach to crime scenes over the twentieth century, a move from proof by words to proof by (increasingly smaller) things, including blood spatter and DNA, for examples.[58]

That is not to say that crime scene photographs were not compelling, only that their primary empirical value was not associated with the direct visual proof of presence or position of objects or other evidence with which they are associated in the twenty-first century.[59] Police photographers who produced them did not tell juries how to read a crime scene photograph. Instead, I argue that, if a transformation to professionalization and scientifically objective images occurred during the twentieth century, it was not completed by 1957 when the Homicide Act altered definitions of murder and manslaughter and in so doing changed the narratives that could and would be told to prosecute, defend and mitigate those crimes. Even after this date, which coincided with the training of civilian photographers at Scotland Yard who introduced a new working dynamic and brought skills to prove,[60] the 'transfer of facts' was not so straightforward as

it seems. My conclusions in this regard come from a similar spirit but a different focus than foregoing experts on crime photography. Bell, for example, rightly points out that the CRIM and ASSI files in which most crime scene photographs (plus depositions and other documentary evidence) for England and Wales reside are silent on their courtroom use. Bell suggests that the absence of trial transcripts means 'we can only extrapolate from the pre-trial depositions how they [photographs] were referred to and used during trials'.[61] However, I have observed and will argue in this book that though trial transcripts do not exist for all cases, prioritizing those that find them preserved in additional files or sources reveals photographs and other exhibits of evidence to be artefacts of the English trial process. Transcripts demonstrate considerable negotiation, argument and debate over the meaning of exhibits of evidence, highlighting the ways photographs and other visual evidence were used to position depositions and material exhibits associated with the crime. The narrative they were being used to tell is illuminated only in the transcript, I argue. Everything else is extrapolation. Even, I would argue, newspaper reports of the courtroom action. Again, as this book will show, newspaper reports focused on textual exhibits rather than material ones. They reflected the action and emotion of the courtroom and were constrained by rules of admissibility, the stage of the trial at which the report was published and risk of contempt of court charges. They, therefore, reflect only a very partial view of events in the courtroom, including the exhibits discussed there.

The courtroom context further highlights the significance of viewing crime scene photographs as a specific medium, particularly with different aims, meanings and readings than other uses of photography in crime contexts such as identification and surveillance represented by criminal portraits. That the two have been conflated by some theorists, leading to a misreading of crime scene photographs, has been astutely articulated by Lela Graybill. She argues that Alphonse Bertillon, pioneer of criminal photography in late nineteenth-century France, foresaw a different application for his crime scene photographs than his criminal portraits. Rather than archiving and identifying individuals to assist identification and arrest, Bertillon's 'metric' crime scene photograph 'was destined for the courtroom, and for the eyes of the jury' where 'it would not be a vehicle of objective proof but rather an emotional catalyst for conviction'.[62] She also sees them as 'vehicles of witness, attempting to move viewers from the space of investigation and uncertainty to the space of conviction'.[63] It is my contention that, like metric photography in nineteenth-century France, English crime scene photography for most of the twentieth century was a 'technology of the imagination'[64] rather than a technology of

forensic 'proof' as it might be understood today. The Metropolitan Police's use of photography to preserve evidence, to produce accurate facsimiles from life, was limited, in fact, to images it made within the walls of the Fingerprint Bureau ('C3'), of which the Photographic Department was a part. Here, fixed-position cameras were used to reproduce documents, to capture special lighting and other forensic techniques applied to objects and documents that detected fraud, to reproduce and enlarge tiny indentations on bullets and the whorls of fingerprints on objects, for examples. The resulting photographic prints of these endeavours possessed a preferred reading of empirical scientific 'proof' and factual evidence of what they showed, but juries were not asked to read crime scene photographs in the same way. This is significant because, just as Graybill argues that, in the case of French crime photography, the criminal trial system complicates a 'story of a neat shift from the testimonial to the circumstantial, or from the subjective to the objective',[65] the same can be said of the English courtroom. By comparing how crime scene photographs were made and the knowledge that informed them with the narratives to which they contributed in court over three decades, this book unsettles the idea of a similar neat shift in England and Wales, a process of rising forensic and scientific objective proofs often associated with modernizing law and society more widely in the same period.[66]

Advancements in the application of photography by police and criminal justice system in England and Wales over the twentieth century certainly contributed to the development of what has been referred to as more 'scientific' methods of policing.[67] However, the conflation of crime scene photography with other uses of the medium and techniques in crime and crime detection has over-emphasized its role in investigation. For example, crime scene photographs taken at 10 Rilllington Place and presented in the case against John Christie have been described as constituting a 'sequential regime of forensic photographic recording' they 'captured pristine details for future analysis at a distance'.[68] As this book will argue, crime scene photography was not accorded the high status this description implies, at least not until many decades after Christie. By tempering such analyses of crime scene photography and unsettling the notion that contemporaries accorded the medium such a high status, this book contributes to literature on criminologies and histories of forensics by highlighting the ways that over-privileging archived documents of crime also over-privileges narratives based not on scientific 'facts' as they are defined today but on assumptions and inequalities about social groups woven into the stories such 'evidence' was used to tell.

The earliest uses of photography by criminal justice in England and Wales were to capture images of prisoners for identification, and recent research has critically examined the limits of the contemporary empirical aims and theoretical issues related to this project.[69] Kate West highlights the needs and empirical status from which prisoner portraiture emerged, as well as the interpretative lenses applied to it by contemporaries, issues which show the medium to be distinctly different from crime scene photography. Taken together, these emerging scholarships represent a departure from preceding literature on crime photography that has conflated the two media and responds to calls from visual criminologists to combine art history and sociology methods and theories to analyse images about crime.[70] West particularly highlights the pioneering work of Nicole Rafter in identifying criminologists' tendency to deny materialities of images and underestimate the significance of the visual in criminology's past more generally. Crime scene photographs, according to this perspective, like other images of crime and criminals, 'deny that they are representations and hence constructions'.[71] Just as contemporaries viewed criminal portraits and constructed a visual anthropology of 'born criminal' people, so might a crime scene photograph be interpreted as depicting a 'murder house' or in some way calling on contemporary ideas of what a criminal home might look like. Unfortunately, these classed, raced and gendered pathologies have been perpetuated by popular literature that has missed opportunities to reflect critically on the particularities of the visual, social and scientific constructions embedded in these images and associated sources. Such interpretations are particularly damaging when authors claim that these images were seen by contemporaries, including police, courts and juries, as factual, empirical and objective 'evidence' of those pathologies.[72]

That is not to suggest that photography was not deployed as a forensic investigation tool in the early days of the camera at Scotland Yard. Rather, photography was prioritized as a tool for facsimile and comparison. Special photographic techniques such as infrared and X-ray were used in forgery and fraud cases in the very early twentieth century, images of stolen property were made, enlargements of fingerprints were produced for comparison and later presentation in court. These applications of the medium were prioritized over crime scene photography (which required the camera to be portable) in initial requests to the Home Office to fund the equipment and chemicals required to carry out in-house photography, developing and printing. A letter from the Commissioner of Police of the Metropolis to the Home Secretary in 1901, for example, described 'the need for copies of photographs of fugitives from justice,

of articles of jewellery, documents, scenes of supposed crimes, &c., has long been felt in the Criminal Investigation Department'. Home Office civil servants noted the request, drawing brackets around sections of the letter they particularly wished to highlight to the Secretary of State and occasionally adding notes in the margins. In this document, they bracketed all examples except 'scenes of supposed crimes'.[73] The following year, describing successful results, the Commissioner described '162 negatives of persons, documents and property have been taken', notably, he made no mention of crime scenes.[74] Later requests to fund specific items of equipment and lighting, including cameras, were linked to increases in numbers of portraits or the demands of wartime intelligence, rather than off-site crime scene photography.[75]

Critical flashpoints in the expanding application of photography at the crime scene in London included the availability of flash for interiors from around 1930 and the appointment of civilian staff to C3 in the mid-1950s. The first men hired as photographers in the department who had not previously served as police officers came with qualifications and experience in professional photography rather than amateur, shaking up existing practice in a variety of ways.[76] However, crime scene photography in this period did not derive its authority or epistemological value from the technology or science of photography, from the facsimile potential of the camera or from claims to authentic depiction. The technologies – in terms of camera types and specifications – are not therefore a focus of this book. Police photographers were required to appear in court to 'introduce' the images they had made, and a stock phrase emerged by the 1930s which articulated that 'the untouched negatives are in my possession'. But this was the extent of claims to lack of interference in the photographs. Though fakes existed in photography throughout the twentieth century, from the Cottingley Fairies to Tyding and Browder via 'spirit photography',[77] I have been unable to find any cases, trial transcripts, Home Office memoranda or newspaper articles which suggest authenticity of crime scene photographs was disputed. In comparison, other sciences and technologies were widely debated in the courtroom and it was widely observed by contemporary police that defence barristers would leap upon any opportunity to have evidence dismissed as less than wholly credible.[78] The English court system and acceptance of evidence were so tightly bound to precedent that any successful challenges by defence counsel to photographs and their admissibility in court would appear again and again throughout the century. The fact that it does not is, I argue, linked to the fact the photographs were not claimed to be facsimile or self-evident documents. Rather, both sides of the adversarial debate called on the same photographs to authenticate the narratives they offered.

This book argues that the events that had the most impact on crime scene photography and its epistemic power were changes that happened in the courtroom at the end of the photographic document's journey. While funding for new equipment, innovations, better training and more consistent practices contributed to what crime scene photography could accomplish, it was legal change and precedent that had the most impact on its applications, on the epistemological meanings of crime scene photographs. Such changes impacted what was captured in the frame but, more significantly, they changed what the photographs were used to say in court. As this book will show, changes to written law and legal precedent altered courtroom narratives and the ways photographs and other evidence were used to support them.

Katherine Biber has articulated just some of the problematic ways photographs have been used to identify individuals, highlighting racial and confirmation biases, police practices and the failure of many judiciaries to consider decades of debate regarding photography's capacity for 'truth' and readings as a direct transcription from life.[79] Like Biber, I offer no conclusive answers to questions regarding the ethical use of criminal evidence 'after the fact(s)', preferring to approach each case and its complexities individually. In so doing, I also draw on Lizzie Seal's reflections on the emotional feelings of allegiance and ambivalence researchers can experience when reading about cases of murder.[80] I have also experienced emotional reactions to recent 'true crime' television and other media that have sought to reinvestigate historical murder cases by reusing depositions and exhibits from the past without a robust critical framework such as those applied by historical criminologists and socio-legal scholars. I find that attempts to re-examine past evidence fail to reflect upon the contemporary evidentiary standards and meanings within which the extant evidence was constructed and interpreted, perpetuating the power inequalities, racial, cultural, social and gendered biases embedded within them.[81] I see this as tantamount to historical victim-blaming and am particularly offended by uncritical perpetuation of evidence that condemns women's sexuality. This view has informed my decision not to reproduce any intimate photographs of murder victims, though images of dead bodies proliferate in social media and 'true crime' documentaries today, numbing their impact. My primary reason is that these images, unlike those of the crime scene, tended to be tightly framed and closed upon the victim's anatomy, telling little or nothing about the context of the crime scene, mainly because they were most frequently taken off-site at a post-mortem examination. Early in the research project from which this book draws, I chose to exclude cases of

child murder because these crime scenes were not analysed for evidence of the identity or culpability of the child in anything like the same way as adult contemporaries; the range of narratives that could be deployed in defence of child murder in the courtroom was exceedingly limited. I also feel that these photographs, like those of sexual murders against women and vulnerable men, fetishize the body and perpetuate the power inequalities within which such crimes were committed. This may seem at odds with the aims of a book about crime when so much literature on the subject capitalizes, even if only a little, on society's endless fascination with violent death. I cannot claim immunity from the kind of curiosity currently drawing millions of viewers to documentaries and podcasts about murder. However, in selecting cases for the book, I have tried to avoid the canon of cases on which histories of crime in London have most frequently drawn. Although the more violent murders by strangers, particularly multiple murderers with protracted investigations, have left more sources (primary, press, literary and visual), more mundane, domestic murders can tell us much about the everyday experiences of ordinary people. Though it is only the fact that there was a murder charge and a trial that means that there is an archival record of the cases I have selected, I take nothing for granted. In presenting narratives that were told by prosecution and defence, though I cannot claim to be uninfluenced by my own allegiances and views, I take no sides and assume no facts. I mean no disrespect to defendants or victims, I take the view that all evidence must be necessarily limited, fallible and corruptible. In most murder cases, only two people ever knew what 'really' happened and one of them died before they could tell anyone about it. The other was required to tell a version of events to try to save their own life during a period in which hanging was punishment for murder.

Viewed through the most famous, violent or prolific killings, the city is characterized as dark and dangerous, London's spaces pathologized, particularly its working-class neighbourhoods. This book shows that murder could, and did, happen anywhere, and most commonly happened in intimate domestic spaces between people who knew each other. Crime scenes can, therefore, tell us a great deal more about the everyday experiences of ordinary people, their consumption of their spaces and their geographies. In this book, 'domestic' murder means murder in everyday, domestic settings, usually, but not always, a dwelling inhabited by one or both of victim and defendant. The parties may not necessarily have been partners, but the domestic setting means that the killing was somehow enabled by the relationship, intimacy or trust between them. The implications of this are brought out in each case.

Selecting cases that seem to perpetuate social, racial and gender inequalities may appear problematic, and I cannot hope to satisfactorily negotiate the many biases and stereotypes embedded in the documents on which this book is based. However, I feel it is vital to confront these stereotypes and assumptions and uncover their impact wherever possible. As Seal has articulated, citing a wealth of criminological literature, legal outcomes are affected by stereotypes and 'it is crucial that feminist research [for example] does not confine itself to "ideologically sound" cases' or those with which we can sympathize more easily, as this risks missing opportunities to challenge restrictive and derogatory norms.[82] In her study of historical cases of women who killed, Seal argued that cultural representations of such women, in the form of stock stories, drew upon fictional and media portrayals. 'The various elements of a woman's case and aspects of her identity,' she argued, 'are subsumed into a pre-existing narrative, which follows the conventions of storytelling.'[83] Such narratives are contingent on time and place, and it is therefore essential to explore a range of subjectivities in their historical, cultural and legal contexts. Constructions and representations of normative domesticity, femininity, masculinity, sexuality, race and citizenship, for examples, have played significant roles in informing perceptions of guilt, culpability, entitlement to justice and access to mercy. The narratives in which these constructions were embedded in the past, stories that ended in outcomes which we might now deem unsafe, unequal or unjust, should, therefore, be illuminated rather than avoided. In so doing we can better understand how such tropes and narratives were constructed, perpetuated and what their legacies were. Seal and I found that racist and derogatory stereotypes were called upon to construct narratives about defendants of colour to save their lives. By deploying a narrative of a murder that made a man of colour less culpable because of a pathological inability to control his emotions, for example, petitioners appealed to contemporary understandings of racial difference that they hoped would lead to a commutation of a death sentence.[84] This work calls for the analysis of other stock stories and tropes to examine how historically and legally contingent narratives about social groups were constructed and deployed. As Eamonn Carrabine has argued, calling on a wide range of disciplines and methodologies to turn to the visual as well as the narrative, 'images, and the stories they contain, tell us something meaningful about the individuals or groups who produced them', further, meanings are 'both cultural and historical, and can change over time'.[85] Rather than being static and inevitable consequences, the particular nuances of individual case narratives are brought out to more significant effect by analysing images, I argue, because they demonstrate the unique characteristics of

the home, relationships and identities under scrutiny, and the ways that cultural constructions could be refracted through or superimposed upon evidence of and at the crime scene.

Conclusion and structure of the book

This book contributes to foregoing literature on crime scene photography by illustrating how these images owe their epistemological power not to 'forensics' as we might understand it today but in its most straightforward definition: of the law, of the courtroom. To call crime scene photography forensic photography is misleading because it infers scientific accuracy and facsimile and that it is from this purpose, application and interpretation that the medium gains its importance and effectiveness as a historical document about crime. Rather, my research has shown that photographing crime scenes in twentieth-century London meant fashioning one of many documents that contributed to an imagined narrative of a murder. That narrative invariably featured visual elements or evoked visual cues to reference a specific trope with linked legal outcomes. These narratives therefore altered not only according to historical, social, cultural and political contexts but also according to legal change.

Just as photographs are not self-evident nor are depositions, statements and other documents which, though they purport to represent the voices of ordinary citizens, were created by police and judiciary representing the interests of the state and maintaining the status quo. Rather, case file documents and other exhibits of evidence each speak to a particular element of a familiar narrative told in pursuance of a specific legal outcome. In a judicial system based on precedent and with crimes widely reported in newspapers and consumed by the public in a variety of media, narratives became widely understood and circulated, adapting over time according to legal, social and cultural change.

Each chapter opens with a vignette to set the scene, a method long-established in microhistory writing and recently applied to visual and material histories of crime.[86] Each focusses on an encounter with a crime scene in order to illustrate the different ways spaces could be interpreted and represented according to personal perspective, professional or institutional identity and legal context. By describing people, characterizing individuals insofar as one might better understand their reading of a crime scene and crime narrative, we can better comprehend the complexities of the documents and images that remain for historians and criminologists to view and further interpret. Structuring the

chapters in this way also demonstrates the information and preconceptions those photographing scenes brought with them and, I argue, allowed them to inform the images they made of the scenes. Chapters 2–4 use the vignette device to set the scene from the perspective of those who defined it – police officers and police photographers. In so doing, I communicate some of the perspectives that shaped initial interpretations of the scene and demonstrate the close relationship between those first encounters with the crime space and the establishment of a narrative of the crime in the earliest phases.

Based on personal and prosopographical research, Chapter 2 opens with a vignette describing a PC's first arrival and encounter with a crime scene. Articulating something of his family and social background, the local knowledge and values he likely brought with him to the scene and what he saw there, we set the scene not only for the exploration of the case but the significance of his visual first impressions to his and his colleagues' imagining of the narrative of Lilian Anderson's death in the first instance. Being in many ways a typical domestic murder in a typical Camden home, the Anderson case illustrates the limits of crime scene practice and the ways evidence archived for murders in the past has been shaped by a variety of personal and professional perspectives and practices. The rest of the chapter shows how that initial encounter and other police impressions of the crime established a narrative that shaped the investigation and collection of evidence including interviews, to the exclusion of possible alternatives presented in court by experts. It also begins to explore the importance of the courtroom context for interpreting evidence of crimes past, highlighting what cannot be known about the Anderson case because of the absence of a trial transcript. Thus, the first case study chapter establishes some of the limits of the crime scene, of crime narratives, of crime scene photography and of archives about crime.

Chapter 3 takes a different case as its study but picks up where the opening vignette of Chapter 2 left off by focussing on the perspective of the police photographer himself. Describing in detail the way crime scene photographs were commissioned and made identifies many factors determining their content and character. The vignette sets the scene in Bloomsbury, allowing readers to imagine the house and the process of recording it, but simultaneously highlights the spatial and temporal boundaries of the scene that were set by the extent of the crime narrative known at the time the photographer made his visit. Similarly, it identifies practical and methodological issues that influenced camera placement, position and perspective, and how the limitations of contemporary camera technology and equipment in use by Metropolitan Police at that time determined

what the photographer was able to capture. Most significantly, however, it identifies the crime scene photograph as a human construction, shaped by a multitude of personal and professional perspectives and subjectivities rather than a facsimile of facts or a medium of objective scientific 'proof'. Drawing on writing by the police photographer himself, Inspector James O'Brien, and echoing his own way of speaking about his professional practice, the vignette establishes the empirical limits of crime scene photography in a way no other publication has attempted.

The vignette in Chapter 4 takes the perspective of another police photographer, Alfred Madden. A contemporary of O'Brien, Madden was also a career police officer and a long-term London resident. Though I do not claim to know what Madden thought of the mews house he was sent to photograph any more than we can know what his colleagues thought of any of the crime scenes they were called to, I believe it behoves us to consider the previous residences of police officers and how they might have shaped their views of the mews house. Police described the home of Elvira Barney as 'a different class of mews house' signalling their familiarity with this type of house but showing how far it differed and how grossly ostentatious it was in comparison. These opposite views are echoed in newspaper reporting on the person of Mrs Barney compared to contemporaries. However, the chapter also demonstrates that English crime scene photographs were not published in the press and so informed the public visualization of crime scenes in very limited ways. By directly comparing public images of Mrs Barney and the crime scene with those displayed in the courtroom, Chapter 4 demonstrates the very different demands made of forensic (legal) photography and photography consumed by the public through the popular press.

Chapter 5 opens with a different type of vignette – authored not by me but extracted from a 'murder story' written by Frank Harrison c. 1950. His manuscript, which heavily referenced the universally familiar 'Ripper' trope, was used by his defence to attempt to portray him as mentally ill and diminish his responsibility for the murder of his wife in 1957. However, the chapter shows the difference between rhetorical and imagined references to a Ripper trope, and how visual staging at the crime scene could be used to attempt to manipulate the murder narrative and the culpability of a defendant. Focusing on the case of Patrick Hartney, accused of murdering his wife Lilian in 1945, the chapter explores crime scene photographs that called on common visual tropes associated with the urban landscape and female sexuality. However, the wartime context of the case also affected the narrative of the crime because it allowed a further trope to be deployed: the returning soldier killing his wife, a narrative

that drew on contemporary concerns about the emotional impact of war on serving men and the contrasting expanded opportunities for women's work and leisure. Chapter 5 builds on the scenes set and cases explored in the preceding chapters to demonstrate the powerful connection between crime narrative and visual, imagined or literal.

Chapter 6 opens with a vignette less fictional than that by Frank Harrison in Chapter 5, but featuring more imaginative content in terms of thoughts and conversations than previous chapters. I argue that this method helps us to explore the impact of social and institutional biases against people of colour on readings of the domestic crime scene. When a West African man was murdered in his home, police explored explanations for his death associated with racial stereotypes. Crime scene photographs and evidence were examined for drugs, sex and antisocial activities for examples. This chapter shows that reading crime scene photographs and associated sources against the grain permits alternative readings that instead prioritize comfort, permanence, familial love and positive relationships with neighbours, all factors seemingly ignored by police in their investigations of these spaces because residents were men of colour. The chapter also highlights the extent to which police interpretations and crime narratives could influence courtroom readings of crime scene photographs and eventual trial outcomes.

Building upon Chapter 6, Chapter 7 opens in the courtroom with the jackpot of domestic murder case files in terms of the richly visual evidence it provides of all the foregoing points. At the Burdett trial, micro-narratives of class, gender, domesticity and social change were pieced together to form two compelling, illustrated stories of the defendant's guilt on the one hand and his lesser culpability on the other. By comparing the interiority of the crime scene photographs to exterior images of the same area made at the same time, the complexities and fluidities of social and spatial boundaries are highlighted in this chapter. Taking us indoors into the private lives of ordinary people in the past humanizes the crime scene photograph and the police officers who made them, demonstrating the fragility and fallibility of the 'evidence' they provide for the police, the public and the judicial system that would judge and condemn them. Finally, at the end of the book I use a further vignette to reflect on the Burdett case and the evidence crime scene photographs have bestowed through the archives of the state.

This book shows that photographing crime scenes in twentieth-century London was not an exercise of anonymous, objective and empirical forensic method. Instead, each set of photographs had a human author, a subjective

meaning, a preferred reading and a predetermined purpose. Though readings and purposes varied according to crime circumstances and contemporary contexts across the century, they supported narratives of crime in which were embedded social mores and meanings of place and space that perpetuated rather than transcended the social, cultural and racial biases of the legal system and society in which they were made and deployed.

2

'Isn't Dinner Ready?': Spatializing Working-Class Home and Marriage in Camden

Encountering Prebend Street

Police Constable Alexander Hall rocked gently on his heels as he stood watching traffic at the junction of Great College Street and Camden Road on 23 September 1934. It was that time on a Sunday afternoon when people started heading home for their tea. Women in pairs, baskets over their arms, hats close together, chattered about the price of things they had bought as they walked quickly along. Hall's tea and front room were only a couple of hours and less than a mile away. A tram rattled by in that direction headed towards Mrs Hall who was at this moment straightening the tablecloth in front of the bay window. PC Hall adjusted his helmet and the steady trickle of motors and bicycles crossing in front of him continued. It was getting along all right just now, but he must be ready to step in and direct the traffic if things got much busier. It was the perfect spot, this corner, with the acute angles of the X-shaped junction to his left and right he could keep watch on a wide area. The railway bridge directly overhead shaded him from the strong September sunshine, and the public conveniences were just far enough away so he could observe the comings and goings without being bothered by the smell of them. With the arched station entrance on the opposite side from where he stood, Hall could watch most of the foot-traffic pass by at half-a-dozen yards distance without being disturbed. The only thing he had to look out for was the pigeons that roosted under the bridge. They seemed to use him for target practice if he did not change his position now and then.

There was the familiar tap. Hall brought his arm from behind his back to inspect a spattered sleeve, but it was a child trying to get his attention. She stood very close with her moon face turned up to him. Hall was about to give her a reassuring smile and a chuck under the chin, he had a little girl of his own, though Emily was now only weeks from turning eighteen. Although this child could not have been

much more than nine or ten, her expression formed deep worry lines across her forehead. The ribbon securing her plaited hair was wet and frayed at one end as though she had been chewing on it. She was skinny and short for her age, but her dropped-waist dress belonged to a younger child and had been let down at the hem. One of her bony knees was dirty, the other marked by an old scab.

'Please mister,' she said, 'can you come? The doctor says we need a policeman.' She looked distractedly over her shoulder in the direction of the canal.

'Where?' Hall asked,

'At our house, my brother's,' she pointed, 'Lily won't wake up.' Hall took her hot and dusty right hand and she put the ribbon back in her mouth with her left. They walked south down Great College Street and turned left just before the canal. The terraces were the same dirty yellow brick as most of Camden Town but the houses taller and thinner than Hall's. Meaner looking. Each of the many windows stacked three or four high was differently lit, curtained or opened, revealing only fractions of activities inside. What a view they had. For the left side of Prebend Street was terrace from end to end, the other started halfway along after a strip of wasteland sloping down to towpath and canal. The windows of a wooden shed there were punctured with deliberate, jagged holes. The water was dark and oily, disappearing around the bend to wharves and warehouses. At the farthest end of the street, both terraces terminated in the enormous steel viaduct. It was the same line Hall had just been standing under, but cutting through the houses at the level of the first floor windows made the perspective seem impossible. All dwarfed the tiny women without hats gathered in the road in clutches, arms folded, knowing-looking, signposting the house Hall and the girl headed for; number 12.

PC Hall reached over the little girl's head to push open the heavy door and followed her in and straight up the stairs, avoiding the upturned floorboards. It was light outside, but the hall and landing were dim by hissing gas lamps, watermarks and bulging plaster adding to the shadows. The damp smell was stifling. From below, there was a powerful pull as all the air seemed to be sucked out of the staircase, followed by the front door slamming, resounding through the whole house. Every door on the landings lurched in sympathy, and somewhere a dog barked, silenced by the muffled rebuke of its owner. An older man with a leather bag ascending the stairs behind them removed his hat to speak, but his words disappeared under the tremendous din of a train crossing the viaduct outside. The building trembled, and the roar went on and on while his lips moved meaninglessly. Finally, he pointed to one of the doorways off the first floor landing, and Hall followed his finger. In the opening he stopped short, unsure where to step. The room could not have been much more than seven feet by eleven feet and so

crowded with furniture there was barely any space to stand. Hall placed his feet on the most worn patches of linoleum and stepped gingerly inside. The iron bedstead that took up most of the space on the left of the room was occupied, coverings in various shades of white heaped upon it, a figure in dark clothes covered with a thin sheet laid awkwardly across. Knees, lower legs and one slippered foot hung off the side of the bed. Hall did not need to lift the sheet to know what was underneath.

Hall turned to look for the girl, but the doorway was empty and as the noisy train finally receded and the rattle of crockery slowed to a soft tinkle, a deep murmuring came from the next room. Edging back out towards the doorway, past a small table bearing a bowl filled with water and floating cabbage, Hall tried to take in as much as he could and pick out some item with meaning. The rough old armchair by the table had a blanket and half-covered pillow thrown upon it, a tea towel and discarded dishcloth. Surrounding the fireplace was an ill-fitting fireguard, a child's chair perilously close, another blanket abandoned there. On the mantelpiece a framed print of a painting – a familiar windmill – tea-caddy, empty vase, a little inkpot, ashtray, medicine bottle, a lonely button. A small gas cooker and tiny stone sink squeezed into the corner, crowded with pans, more hanging above, two scraps of lino pinned behind. Above, all manner of linens drying, rough edges curling. Another chair filled with cushions and pillows hid a tin bucket and crowded the corner by the sink. The lace curtains were too long for the window and trailed on the floor in the dust. Between the bedstead and the back of the door, which was covered in coats, two broken chairs stood one in front of the other, neither with a full complement of wooden staves on its back or upholstery on its seat. A single lambswool-lined ladies slipper, upside down showing its shiny worn sole, was discarded on the frontmost chair. There was a bare electric lightbulb overhead, its ancestor gas lamp on the wall, the corresponding meter above the broken chairs, to which another washing line was tied, strung diagonally across the room.

Tiny details overwhelmed the PC: the lace on the curtains stitched several times over, the patterns on the wallpaper, roses interrupted where it peeled away by the sink. The wedding photograph hanging over the bed had slipped down behind the glass, making one or two of the dozen variations of the same face seem to peer over the bottom edge of the frame. The delicate blue and white tea set was placed just so, cups and saucers bright and pristine compared to the chipped heavy bowl they clustered around. As Hall watched, a strand of straw adhering to the up-turned bristles of a well-used floor brush came loose and fell slowly out of sight. The room was finally still, its many accoutrements betraying all manner of hasty tasks packed into the tiny space: cooking, eating, cleaning, sitting, sleeping. It was a wonder there was room for dying.

All time had stopped. Hall took his notebook and pencil from his pocket, but the graphite hovered in the air. There was at once too much to record and nothing at all. No blood, no blades, just the shape of a person under a sheet, clothed, face covered and legs exposed, a vast expanse of near-white in a room otherwise so busy with textures and contrasts competing for attention. Hall followed the murmuring sound instead, leading to another room, no bigger and no less busy, except it had several people in it. The little girl with her hair in her mouth sat cross-legged on a fold-out bed with a big doll, no, a small toddler, sat in her lap. This tiny girl was chewing a wooden horse. The doctor from the stairs was sitting in a threadbare armchair. A sandy-haired young man with his head in his hands sat on the edge of the bed. He was mumbling incoherently, groaning, rending his clothes and pulling at the skin of his face.

'I was called to attend a woman in a fit,' said the doctor, struggling to extract himself from the loose cushions of the chair. 'But it's one for the Coroner,' he said quietly, trying not to look at the moaning man or the two little girls on the bed. He took a card from his waistcoat pocket showing an address on Great College Street and handed it to Hall, sliding quickly out of the room. Hall perched on the hard, worn edge of the chair he had been sitting in. His knees were up to his chest, but at least he was now at eye-level with the man whose head was in his hands. He was weeping now.

Hall tried a weak smile at the children, and then in his best sympathetic voice addressed the sobbing man.

'Can you tell me what happened?' he asked, pencil poised over notebook.

'I can't!' the thin man choked, the slow shake of his head becoming faster and more desperate. He was looking around for some inspiration or explanation, 'I mean, I don't know what happened!' He looked into Hall's face, searching, as though the PC might have the answer himself. 'We were ... I was ...,' he grabbed at his pale hair with both hands, pulling it hard, then slowly brought his fists down in front of his face, looking from one to the other in something like disbelief. 'I gave her a smack. And she fell down dead.'[1]

Constructing narratives

PC Alexander Hall was the first officer to arrive at 12 Prebend Street and it was his encounter with the first floor back room that determined the walls of the room to be the boundaries of the crime scene. It did not extend into the communal hallway and landing, or the other room the family inhabited.

The doctor suggested Lilian Anderson had died from the effects of a fit, but this was uncertain in light of John Anderson's admission that he had hit his wife before she died. PC Hall immediately contacted Somers Town Police Station to request the attendance of more senior colleagues. Divisional Inspector Ernest Andrews came quickly, determined that a serious crime might have been committed, took John Anderson back to the station and contacted Scotland Yard to request a photographer meet him at the house. The two photographs he took show in detail the domestic materiality and economies of space practised by an ordinary working-class family in a dwelling that would otherwise remain in the past behind closed doors. Very few working-class people photographed the interiors of their own homes before the middle of the twentieth century, and images taken by social surveyors or charities attempted to highlight the worst conditions and often appear posed or contrived.[2] Lilian's death cut across an ordinary Sunday afternoon and so the crime scene photographs record her home with little staging or artifice. The cabbage she was preparing for the family's meal was still floating in the water on the little table by the door. The bed still bore the imprint of her body, and the pillows that had propped up her head were flung in a chair. It is Lilian's death in the room that renders pictures of it uncanny; the interrupted routine appears a kind of poignant tableau with the knowledge that these are crime scene photographs. Applying a twenty-first-century logic, a viewer might find themselves looking for hidden clues, murder weapons, wondering which innocuous everyday object in the frame might have ended Lilian's life, transformed her husband into a murder suspect and her home into a crime scene. But the clues are not there for finding.

No secret revelation awaits discovery in the archived folder for the Anderson case. The only detailed records available regarding Lilian Anderson's death are those retained in the Central Criminal Court depositions file for 'R v. John Charles Anderson', including the two photographs and plan of the room in which she died.[3] In addition, a few contemporary newspaper articles described the pre-trial proceedings and court verdict. Reading 'along the grain' we might assume these depositions to be spontaneous prose, continuous narratives offered by witnesses, describing what they knew of the circumstances of Lilian's death. Reading against the grain, however, reveals them to be 'enforced narratives', heavily constructed stories, the details of which arose from closed questions put to witnesses.[4] Statements and depositions made at police interviews and the courts of magistrates and coroners were not the actual words of witnesses or defendants, though they were treated as such at the

higher court of the Old Bailey. Nor do they represent anything like a verbatim transcript of questions and answers asked in court. The documents more closely resemble represent puzzle pieces, arranged to form narratives that remain out of sight until the entire picture is complete. Indeed, contemporary legal counsel applied this same metaphor, as later chapters will show. However, it was only at the trial that a deposition or statement was held up to the light and scrutinized, shaped to fit a different part of the puzzle or deemed insignificant. Courtroom transcripts contextualize abstract details that otherwise seem to bear no relevance to the overall case. Without a transcript, one is working without the box. We do not know what questions were asked to form a deposition or statement, or what picture those asking had in mind. Though the Anderson file is rich in visual detail about the family's home, and depositions taken at Clerkenwell Police Court provide some suggestions about how contemporaries might have interpreted such evidence, no archival record remains of the trial at the Old Bailey. If a transcript were available, as in most of the other cases explored in this book, it would reconstruct how the photographs, depositions, reports and statements were discussed and weighed at the trial, how narratives were tested, investigations conducted, case decisions made and eventual trial outcomes reached. It is not possible to assert with any certainty how evidence was used in court or what it meant to a case without the transcript. It is impossible to make confident claims to accurate reconstruction of a case from such limited evidence, and even less to say what really happened on the day a murder victim died.

'What really happened' when Lilian Anderson died became unrecoverable when her husband's life depended on it. Critically, each iteration of the crime narrative had a potential legal outcome. If the smack was, as PC Hall initially suspected and some of the evidence suggested, symptomatic of domestic violence, then it was murder and John could hang. If she had 'said something nasty' before he hit her, as ten-year-old Rose deposed,[5] it might be provocation and a charge of manslaughter for John instead. The only alternative was an accident. With no transcript surviving for the trial of John Anderson, it is impossible to know how deposition file micro-narratives, including photographs and plans, were mobilized or which evidence was prioritized. Rather, based on contemporary press reporting of this and similar cases, combined with the deposition file micro-narratives, I suggest that there were two likely tales told. Widely understood tropes based on previous crimes and trials would have dovetailed neatly with the specific circumstances of the Anderson's home and perceived identities to form likely narratives of Lilian's death.

PC Hall was allowed home for his tea when DI Andrews took over at the house. John Anderson was booked in at Somers Town Police Station while Professor Bernard Spilsbury, Honorary Pathologist to the Home Office and celebrity courtroom commentator on scientific evidence, also performed a first-person reading of the Andersons' home.[6] He observed the body in situ and looked around the room where Lilian lay, though he did not explore it in any detail. Lilian's body was removed to St Pancras Mortuary where Spilsbury would perform the post-mortem to determine what had caused her death. In contrast to Ian Burney and Neil Pemberton's findings, trial transcripts reveal crime scene observation by pathologists to be a common practice throughout the 1930s to1950s, not reserved only for the most shocking, violent or mysterious deaths.[7] Rather, it was such an ordinary practice for Spilsbury to attend the place a possible murder had been committed that he only mentioned having seen the crime scene when he was asked about it directly. Such questions only usually arose at the trial, but it was relevant in the Anderson case at Clerkenwell Police Court because of the specific conditions of the backroom at 12 Prebend Street. The room was so small and packed with furniture that Spilsbury, the police photographer and plan-maker all commented on the micro-geographies of the Andersons' domestic space as being of potential relevance to the narrative of how Lilian Anderson died.

When Spilsbury left, and Lilian Anderson's body was removed to the mortuary, Inspector James O'Brien of Scotland Yard's Photographic Bureau was able to take photographs at Prebend Street. It was not essential for a victim's body to be in situ when photographs were made. Indeed Amy Bell has also observed that this was rare in the 1930s.[8] Medical circumstances, such as the possibility of successful treatment, often saw victims taken to hospital before they could be pronounced dead. O'Brien likely received little instruction or information before he took his photographs, other than that the back room on the first floor was the crime scene. The photographs he took came at an early stage in the development of something like a standardized practice that would change little until the late 1950s. It was not until the 1920s that the Fingerprint and Photographic Bureau at Scotland Yard acquired the type of camera required for off-site photography. By 1930 the department was sending staff out to crime scenes more routinely, increasing the remit and workload of C3. In part, this was facilitated by new equipment including the increased availability of flash to illuminate interiors, but it likely also owed much to improved communication between stations and central offices enabled by other new technologies adopted by police forces in this period.[9] Detectives and photographers noted in their memoirs that dead

bodies tended to appear at evenings and weekends. Staff whose expertise was required for serious cases like murder were usually summoned from their homes. The most common night for murder was Saturday, making Sunday call-outs synonymous with murder scenes for police photographers.[10] Reading about murder in the newspaper was part of the familiar culture of the English Sunday afternoon, as strongly associated with it as roast dinner and a cup of tea according to George Orwell and popular films.[11] This context is important because, as Lynda Nead has argued and the above narrative suggests, English Sunday afternoons had a particular 'structure of feeling' strongly associated with home and family.[12] John and Lilian Anderson had been about to go out to see John's Aunt at Greenwich on the afternoon Lilian died. Lilian had gone to the markets with her mother, and members of the family had shared a drink at the local pub on their way home.[13] Family context was a significant element in the social identity cultivated by police officers, even codified in the terms of their employment.[14] Respectable working-class backgrounds, families, marriages and homes were central to the perspective from which they policed the lives of other Londoners. This theme will be further brought out in later chapters but for the purposes of the Anderson case, suffice it to say that it seems unlikely that any officer would fail to observe a home they were sent to without comparing it to their own. Police were far more likely to live in single household dwellings, if they were married, than in houses with communal facilities like the Andersons. Though class and respectability were arguably readable from people's homes, murder was not limited to working-class houses or districts. A 'Sunday job' could take a police photographer like James O'Brien to any Metropolitan Police Division, anywhere within a fifteen-mile radius of Charing Cross. This jurisdiction encompassed inner-city urban, rural and suburban; murder could and did happen anywhere. Throughout the twentieth century, murders were most commonly intra-domestic, mainly perpetrated by males known to their victims through an intimate sexual or familial relationship.[15] Thus it was interior scenes that were most often required to be photographed for murder trials, giving a sense of how death had occurred rather than at whose hands.

While O'Brien took the crime scene photographs (Figures 2.1 and 2.2) of the Andersons' kitchen, DI Andrews interviewed John Anderson at Somers Town Police Station. Duty Sergeant MacDonald was taking notes and recorded Anderson's early emotional outbursts; 'I did not intend to hit her, we were only sparring ...!' at which point the detective immediately stopped him and cautioned him.[16] If he had not done so, any confession that followed would be worthless. Anything John said would be inadmissible in court unless he was

Working-Class Home and Marriage in Camden　　　39

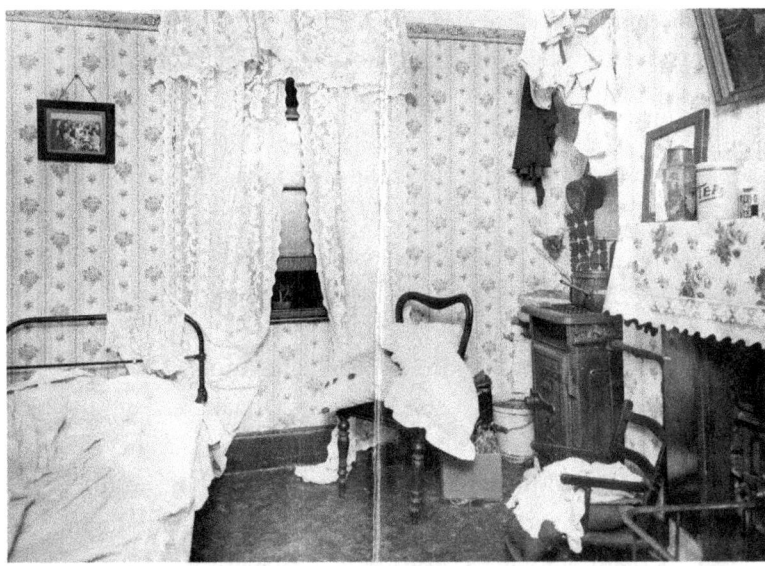

Figure 2.1 First floor back kitchen [photograph 1 of 2] taken by Detective Inspector James O'Brien, New Scotland Yard Photographic Section, at 12 Prebend Street, Camden Town, 23 September 1934. Source: The National Archives (TNA): CRIM 1/742: Anderson, John: Murder: Exhibit 2 (1). © Crown copyright. Metropolitan Police Service. Used with permission.

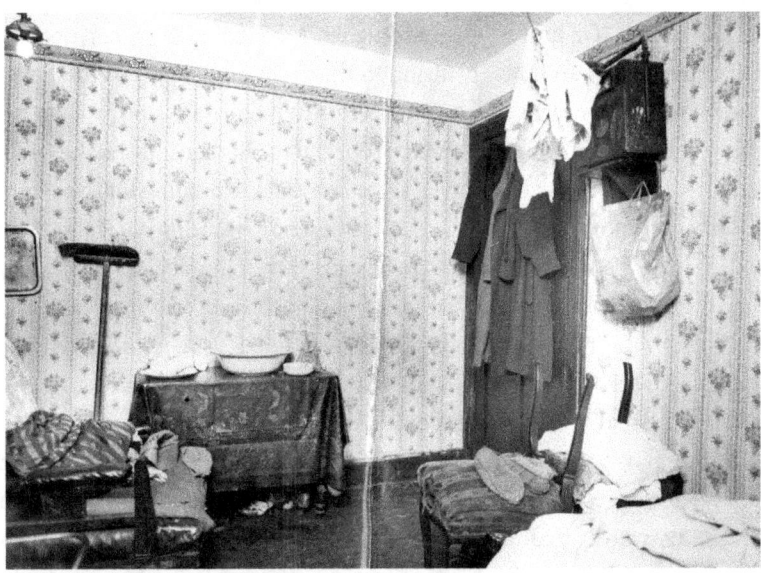

Figure 2.2 First floor back kitchen [photograph 2 of 2] taken by Detective Inspector James O'Brien, New Scotland Yard Photographic Section, at 12 Prebend Street, Camden Town, 23 September 1934. Source: TNA: CRIM 1/742: Anderson, John: Murder: Exhibit 2 (2). © Crown copyright. Metropolitan Police Service. Used with permission.

warned of the implications. Next, Andrews asked John if he would like to write his own statement or have Sergeant MacDonald write it for him and he said he preferred the latter.[17] Andrews proceeded to ask John about his wife, their married life, the years, months, weeks, hours and moments leading up to PC Hall's arrival: How long had John and Lilian been married? How many children did they have? Did they quarrel? Was theirs a happy marriage? With Andrews asking closed questions like these, MacDonald wrote down John's answers in the form of narrative prose, longhand: 'We have been married five years and have one baby age three years. During our married life we have had about six tiffs, nothing serious. She was one of the best wives in the world.'[18] The interview lasted roughly two hours, concluding at 10.15 pm. MacDonald read out the statement and John agreed it was all true and signed it. DI Andrews again cautioned John Anderson and informed him that he was under arrest and would be charged with murdering his wife, to which the prisoner responded 'I did not!'[19]

Professor Bernard Spilsbury's post-mortem established a narrative of events leading to Lilian's death primarily by examining her body, though his reading of her home also influenced him. In his report, he described new and old bruises, including five recent small marks on her arm, as though she had been grasped by a hand in the moments before she died. She was young and slim but had not enjoyed perfect health. There was an appendix operation scar on her abdomen and congestion in her lungs, but these had not contributed to her death which Spilsbury stated was caused by bruising to the brain and spinal cord.[20] Spilsbury's post-mortem report received limited dissection at the magistrate's court that would likely have been far more detailed and thorough at the higher court of the Old Bailey. Without the benefit of a transcript, it is possible only to assume that Spilsbury was asked for his opinion regarding the cause of Lilian's head injury. He said that the injury suggested too heavy an impact to be caused by a simple fall against an object. Anyway, she would have put out her hands or had some other reflex response such as bending or twisting to lessen the blow, he offered. A fall would only cause a fatal injury like this if the deceased were unconscious before hitting the floor. It was possible, he said, that a person could be knocked out by a blow to the jaw, and such a strike may not leave a mark. Spilsbury, who was notoriously unswayable by leading or suggestive cross-examination in the courtroom, was offering or implying a narrative of domestic violence.[21] Significantly, there was no visual evidence presented to support his findings. No photographs of Lilian Anderson's body were presented at the police court, and O'Brien did not mention taking any.

Domestic violence cases rarely received a proportion of column inches reflective of the time they occupied at the capital's courts. It was the more

shocking, salacious or sexually piquant cases that were more likely to sell copy than these common crimes. Like many newspapers of the day, *The Daily Herald* featured a regular 'In the Courts' column detailing various sensational stories from magistrates, coroners and criminal courts.[22] On 25 September 1934, page seven reported various court appearances, the majority taking place in the capital (though two particularly tragic national cases also featured). Among them, the newspaper reported that Mrs Elizabeth Tyler of Stepney was recently brought into the Old Bailey courtroom on a stretcher to give evidence against her husband. He was charged with causing grievous bodily harm to her at their home, following which 'only an operation saved her life'. The conclusion to the story: 'Tyler [the husband] was sentenced to three months' hard labour.' The topmost court report on the same page featured a photographic portrait of a young woman with full dark lips, white skin and a close-fitting hat framing her face: 'MRS LILIAN ANDERSON' the column declared, whose 'HUSBAND [was] IN TEARS AT COURT' when he was 'remanded in custody until to-day week, charged with the murder of his wife'. She died from head injuries, the court heard from DI Andrews, after she and her husband 'were sparring' in the kitchen of their home in Prebend Street, Camden Town.[23] Like Mrs Tyler's stretcher, John's tears at Clerkenwell Police Court provided journalists with a melodramatic reference that could be played upon to raise interest: a device for capturing readers' attention and increasing interest in an otherwise run-of-the-mill case. Tears and stretchers were some of the few things in the courtroom about which newspapers were allowed to report. Press powers to report on courtroom evidence and dialogue were limited from the 1920s. Until a verdict was delivered, reporters instead prioritized courtroom action, including the behaviour, demeanour, even clothing of those present.[24] Writing the narrative of the crime using only the newspaper's limited view of the case would thus risk surmising that it was some element of courtroom behaviour rather than the evidence that led to the eventual outcome of the trial. Material exhibits, including photographs, are underestimated in crime history and historical criminology because press were not permitted to comment upon their content in any detail until the trial had concluded when the outcome was of more interest.

Spatializing narratives

The primary purposes of the police court or magistrates' court hearing were to determine if a jury trial was necessary and which articles of evidence, including depositions, photographs and material exhibits, would be admissible there,

tested against guidelines such as the Judges' Rules. Furthermore, police courts heard only a one-sided view of the evidence as these hearings functioned as an opportunity for defence advocates to hear prosecution evidence and cross-examine witnesses to see if they might relate something helpful to the defence. They would then build their case and reveal it at the jury trial.[25] Only early-stage evidence, filtered by the magistrate, was therefore sent to the Central Criminal Court and preserved in the depositions file. At Clerkenwell Police Court witnesses who were at the house on the day Lilian died were questioned. Anderson, under advice, 'reserved his defence' for the Old Bailey, just as other defendants on murder charges almost invariably did.[26] These matters of process mean a certain amount of reading between the lines to unravel the questions asked of witnesses. Details about the Anderson's marriage and Lilian's housewifery and domestic ability show that questions were explicitly asked about such things. This is not merely because gendered roles were significant in these cases – what husband and wife had been doing that day, in that place, for example – but these factors also had a bearing on the outcome of the case. As later chapters will show, it was not only the stereotypes of gendered identity that affected perceptions of defendants' guilt and victims' culpability, but also their relative performances of gender. It mattered that Lilian was preparing a meal and caring for her family right before she died, the photographs of her homemaking practice demonstrable evidence of her effectiveness as a housewife, which might help to exclude a possible defence of provocation.[27] She was doing what was expected of her, compared to contemporary values, meaning she was innocent in her own murder.

The Judges' Rules articulated the circumstances under which a police interview should be conducted to ensure it was admissible in court. Following accusations of aggressive interviewing and applying pressure in the 1920s, extracting forced or fabricated confessions, the Judges' Rules were intended to regulate the admissibility into evidence of fairly extracted statements.[28] Rather than dictating police practice when conducting interviews, however, they impacted bureaucracy, record-keeping and courtroom testimony.[29] As we will see, this is significant because of the adversarial nature of trials and the processes of questioning and discrediting evidence. Seemingly convincing evidence against a defendant could be undermined or dismissed entirely if their legal representatives could show that proper rules governing collection had not been followed. In turn, this caused police to adopt practices to guard against such accusations arising. When a high-profile trial saw the defence argue that a statement should not be admissible because it was extracted under pressure,

it was not long before police, rather than ensuring they did not apply pressure, wrote out a common wording which every defendant was required to sign at the top of their statement declaring that no pressure had been applied. This is just one example, and it is important because it demonstrates the role of legal practice and precedent in police behaviour, including collection of evidence at a crime scene.

The Judges' Rules and other standards of evidence were, at least in theory, tested at the Police Court or Magistrates Court, rather than at the Old Bailey in front of a jury and legally trained judge. These hearings necessarily took place within days of arrest, placing police under pressure to record a scene, gather evidence and identify witnesses rapidly. In practice, this meant that suspects were rarely arrested unless there was already strong enough evidence to convict, such as a confession or admission of guilt. Despite representations to the contrary in popular culture and contemporary press, murder investigations where the identity of the person responsible for the deceased's death was unknown were relatively infrequent. Though statistics are unreliable, the vast majority of murder cases required police to collect evidence to shore up a theory or narrative they already had and to prove that murder, not manslaughter, was the appropriate charge (e.g. that the victim had been killed deliberately), rather than that it was their man 'whodunnit'. Crucially, this meant that the scene itself was heavily relied upon; material objects and evidence pieced together to support a narrative of intentional slaying. Evidence of pre-planning and motive, for instance, could usually be found in the home in cases of domestic murder. Here was where a couple's relationship played out – where patterns of provocative behaviour could be found on the walls themselves, where malicious planning was conspicuous against regular daily routines. Furthermore, any deviation from expected norms of everyday life would be observed by family, neighbours and strangers alike, perceptible in people's appearances and actions, but also in how their homes looked compared to others.[30] The ideal home and family were increasingly depicted in visual media over the twentieth century and inextricably bound to notions of ideal citizenship.[31] For a jury to decide if this home was the scene of a crime or a terrible accident (for example), they needed to be able to imagine it.

With crime scene photographs showing successful homemaking practices, there was no evidence of Lilian provoking her husband to violence. But John did not likely fit the stereotype of a violent husband either. Certainly his tears in court were incompatible with the brutish figure popularly imagined to be responsible for domestic violence and marital cruelty. But, as Annette Ballinger has described, domestic violence could be concealed by everyday domestic

routines, hidden in the fabric of the home.[32] Other cases bear out the use of household objects as weapons, for example, and the mundane daily occurrences that could turn into violent outbursts. Domestic violence was so frequent that, it seems, murder could be an everyday event.[33] Though there exists some evidence that courts were dealing with violent husbands more harshly in the early twentieth century, and that society was tolerating physical abuse in marriage less and less during the interwar period, police reluctance to become involved in what was seen as a private matter and the cost of obtaining a magistrate's order meant that only the cases with the most serious consequences are part of the historical record.[34] Domestic violence could hide in plain sight when it was assumed to be a regular part of daily life for working-class families.

Edith Murphy, who lived on the ground floor at 12 Prebend Street with her husband, heard John Anderson calling to her from the floor above just after 3 pm on Sunday, 23 September, she told Clerkenwell Police Court. She found Lilian lying unconscious on the bed in the kitchen and assumed the otherwise healthy young woman must have 'had a fit'.[35] John was frantically attempting to revive his wife by shaking her, touching her face and calling 'Lil'! Lil'!' when Jane Francis arrived from next door at number 11. She had heard John shouting from the next building. Standing at the threshold of the kitchen, she asked: 'What ever is the matter?' John was barely coherent but replied that he had smacked his wife's face, and she had fallen on the back of her head. Mrs Francis told Mrs Murphy to fetch some water to bathe Lilian's face, but the wet flannel failed to revive her. John put his ear to Lilian's chest and could not hear her heart beating. 'Fetch a doctor,' Mrs Francis told Mrs Murphy, who duly obeyed.[36] The local general practitioner lived a few hundred metres away on Great College Street and arrived within ten minutes to attend to 'a woman in a fit'. Dr Thom deposed that he found the young woman's husband weeping over her uncontrollably, rocking back and forth and desperately calling her name in a most distressed manner. Thom examined her briefly but confirmed what those assembled doubtless already knew; they should contact the Coroner; she was dead. He made no further examination of Mrs Anderson's body, assuming she had died from the effects of her 'fit'. There was no blood on her face or anything to indicate violence or struggle in the room.[37] John's statement to DI Andrews and Sergeant MacDonald was then read out at the police court, giving an alternative narrative to Spilsbury's suggestion that John's deliberate punch had caused her death. He had come home to find her preparing cabbage and asked '"isn't dinner ready?"' whereupon he immediately sat on the bed and started reading the paper, informing his wife that there were only ten minutes before they had to

go out again to see his Aunt at Greenwich. Lilian made some comment about how much quicker their dinner would be if her husband helped her, rather than just sitting there. Rose had thought it sounded nasty but John interpreted it as her poking fun at him.

> I got up off the bed and swung my left arm at her in fun, not intending to hit her ... As I struck her she either slipped or tripped over the foot of the bed and fell against the gas pipe which runs down the wall almost beside the door. She laid still and I thought she was shamming ... I had no intention of hurting her. I wouldn't hurt her for the world. She often came with me to boxing shows and wrestling shows and we were always sparring about with one another ...[38]

The magistrate deemed Anderson's statement, plan and photographs admissible evidence.[39] In fact, these were the only exhibits of evidence and, accompanied by the depositions taken and Spilsbury's post-mortem report, the only record of Lilian's death and her husband's trial. The photographs show a small room filled with things, the detritus of domestic life performed in a small space. Each family in the building lived the same way, two rooms apiece, a tap and cooker installed this side of the turn of the century but otherwise unmodernized since the house was built in the nineteenth.[40] The Andersons were poor, but not conspicuously so given their circumstances. According to the plan-maker's statement, the room was seven feet nine by eleven feet seven. He, O'Brien and Spilsbury all commented on how small and crowded with furniture it was, supported by the visual representations of the room.[41] Most of their furniture was old or broken, and the room was necessarily very crowded. But the wallpaper was bright and clean, the linens repaired, and decorative as well as functional homemaking was being practised.

That the clearance between furniture was significant to the narrative is demonstrated by the fact that these measurements were recorded on the plan (Figure 2.3), whereas the majority of other floorplans did not feature so many detailed dimensions. The clear message is that it was difficult to move around in this space, let alone when there was also a toddler, an eleven-year-old, and another adult in it. The first floor rooms at number 12 were far from an 'ideal home', a concept rising in significance in the 1930s with important visual referents and imaginative powers.[42] Rather, they represent an ordinary and necessary makeshift domestic economy: homemaking skills, repairs, fixing things. In 1930s London precarious household economies, unemployment and the Means Test made this kind of living a necessity for most working-class people. Few women of Lilian's class lived in homes much different from that depicted in the photographs of the room where she died. The most straightforward, common-sense reading

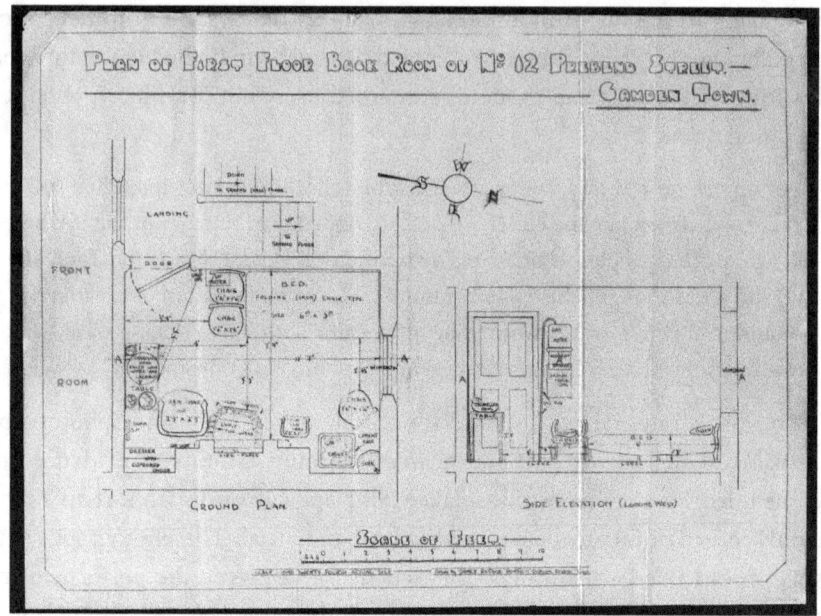

Figure 2.3 Plan of first floor back room of No. 12 Prebend Street, Camden Town by PC Sidney Bostock, 1934. Source: TNA: CRIM 1/742: Anderson, John: Murder: Exhibit 1. © Crown copyright. Metropolitan Police Service. Used with permission.

of the two visual exhibits was therefore one that matched the third exhibit – her husband's statement – that she had accidentally tripped over the plentiful furniture.

Conclusion

The narrative opening of this chapter illustrates how police first encountered crime scenes and how their initial enquiries set the parameters for the investigation and narrative formation that followed, including the questions asked of witnesses and suspected persons, and the spatial boundaries of the crime scene set for photographer and plan-maker to record. Thinking about the scene outside of the photographic frame highlights some of the contemporary surroundings and living standards that may have influenced the content of the photographs police produced. With enquiries still ongoing at the time the photographer attended, a narrative of the crime suggested, but yet to be settled on by police, they could only imagine what might later prove relevant. As the next chapter will describe in more detail, photographers took wide-angle establishing shots of a crime scene,

a space established only by imagined boundaries according to the room where the victim was killed or discovered. The post-mortem did not need to determine an injury, cause of death, weapon or poison before photographs were taken. In some cases, if it was dark, or if events witnessed did not come to light until later, the photographer might have to make a second visit to the premises. Between photographs, any amount of cleaning up or moving of bodies, furniture, exhibits or belongings might take place. As we will see, these issues made little difference to the admissibility or effectiveness of crime scene photographs in the early- and mid-twentieth century because their empirical meaning did not go so far as to require an exact visual copy of the entire scene and its contents.

John Anderson's statement, supported by his neighbours' depositions, formed a narrative in which Lilian's death had been the result of a tragic accident. He had not intended to kill his wife. The couple were play-fighting, she tripped over the abundant furniture in the overcrowded room, hit her head on the gas pipe and died. Other legal framings were possible in the same circumstances; John's defence advocates might have defined Lilian's remarks as provocation, concluding that manslaughter, not murder, was a more appropriate charge.[43] In this case, however, the photographs and plan were likely deployed in support of the former narrative; geography and overcrowding, the housing conditions associated with the Andersons' class, were the cause. The not guilty verdict recorded in the case against John Anderson seems to endorse that supposition. However, with only depositions and newspaper reports – the latter restricted by legal limits, unwritten moral codes and reader interests – only a surface reading of the case, including the photographs, is possible. When sources suggest two potential narratives of the case it is difficult to resist reconstructing them, or to avoid assumptions about which was more likely to be 'true', or at least accepted by the court, given that the trial outcome seems to favour one of them. But it may be that an entirely different narrative was offered. The court may have believed Anderson guilty of murdering his wife but not been able to prove it with the available evidence. As this chapter and others show, without a transcript we do not know which depositions or exhibits were accepted, in whole or in part, or challenged by advocates in the courtroom. Nor can we gain an impression of which were prioritized or ignored by the jury when forming their verdict. It is impossible to recover the precise empirical meaning of crime scene photographs without at least some understanding of the forum in which they were deployed. The next chapter turns to a case for which a transcript is available, demonstrating the negotiations that took place over visual evidence and the formation of narrative, paying particular attention to the themes and tropes that were most contentious to contemporaries.

3

'She Wore No Ring': Picturing Sexual Jealousy and Provocation in Bloomsbury

Encountering Torrington Square

After some fifteen years in the Photographic Section at Scotland Yard, James O'Brien reflected in 1936, he was finally seeing the scenes of crime work conducted by himself and his colleagues appreciated by ordinary police officers. Yet he invariably found that insufficient care had been taken by those officers, between requesting attendance by a police photographer and their arrival, however prompt, to enable a wholly accurate and complete pictorial record of the scene to be made.[1] The Bloomsbury house O'Brien attended on Tuesday, 18 September 1934, at Torrington Square, was a prime example, and one of the many instances in his extensive canon of experience that led him to this conclusion regarding his colleagues' lack of consideration for preserving the scene for the arrival of the photographer. Shortly after 8.50 pm that evening O'Brien received the message from Metropolitan Police Central Office that Divisional Detective Inspector John Edwards of 'C' Division had requested the attendance of a photographer 'at the scene of a case of murder'. Twenty minutes later Edwards placed another call, asking for all ports, police divisions and departments including CID (Criminal Investigation Department) and the Press Bureau to be alerted. They now had a suspect. A man was wanted for the murder of his landlord in Torrington Square, Bloomsbury, and it was feared he 'may endeavour to leave the Country'. The message described him as 'George CALLI [sic], a Cypriot, age 28–30, 5ft. 7 ins., complexion and hair dark, clean shaven. Dress; dark suit, believed brown and probably bloodstained.'[2] With the urgency such a case obviously demanded, James O'Brien proceeded promptly to Bloomsbury, arriving less than an hour after Edwards had placed the first call. As he approached the building every light and lamp appeared to be blazing behind the partially opened sashes and ornamental windows, even those below street

level. A small crowd of nosy parkers was gathered by the front steps, despite the late hour, male and female hats bobbing earnestly. Their straight, neat shadows formed reaching fingers, cast by the many illuminations of the houses and street lamps.[3] The busy metropolitan thoroughfare, police station, underground, omnibuses, shops and cafes of Tottenham Court Road were only a few streets away, but Gordon, Russell, Bedford and Torrington Squares in Bloomsbury all looked inward and upward for their respectable identity. No-nonsense terraces faced neat gardens with tended borders, non-residents deterred by cast-iron fences and gates with sentry-spikes. Deliberately placed trees prevented a direct line of sight from windows on one side to the other, providing privacy and natural inspiration for the libraries, studies and salons inhabited by intellectuals, educational establishments and publishing houses. At the southern end of the square, the University of London was half-way to completing construction of an already impossibly tall building. It even looked down on the great dome of near-neighbour, the British Museum. At this time of night, however, the Senate House site was in darkness, the shadow of a half-finished modernist ghost where a line of partly lit houses ought to close the square.[4]

A half dozen pairs of eyes considered him as O'Brien hefted his gear up the stone steps to the door of number 39. When it opened, a PC peered cautiously through the crack before admitting him. The hallway was even more crowded than the street outside but much less controlled. Officers and detectives in clusters of threes and fours were variously crouched, bent over and peering at bloody marks on the wall and carpet, jostling one another as they changed places, crossing on the staircase, appearing and disappearing from rooms just out of sight. O'Brien exchanged a sympathetic glance with the wide glassy eyes of a tiger skin mounted awkwardly on the wall next to him. The poor beast had flattened itself against the plaster to avoid human traffic. O'Brien recognized DDI John Edwards among the melee and, catching the man's eye, called out to him over the tangle of voices. His own was frustratingly ineffective: 'Might we have a word or two about the affair?' Edwards straightened unhurriedly, replacing the dirty doormat he had been holding up with the point of his pencil. O'Brien cringed under his moustache. The police photographer's maxim was that it was no business of his if things had been moved, he had only to concern himself with what was there **now**. If the inspector in charge allowed evidence to be disturbed it was his look-out, if there was some question about the content of the photographs when they were laid before the court, a photographer need only say that this was what he found **when he arrived** and ...[5] Edwards suddenly barked at the other officers to 'clear out', the sound effortlessly penetrating rooms

above and below, instantly conjuring obedient men from stairs and doorways. As a dozen identical uniforms filed past them, O'Brien and Edwards faced each other at eye-level with the tiger skin.

'I have men out looking for a Cypriot' Edwards said flatly, 'stabbed the householder in the back', he pointed a thumb to the bloody patch behind him at the bottom of the stairs, adding 'dead' as if it needed clarifying when O'Brien only came out after hours for murder. 'Gave the housekeeper a fright, poor girl, she's at University Hospital with a bad cut on the arm. Blood on the wall might be hers or his but could be the Cypriot's, cut in the struggle.' He looked off into the distance and squinted as if trying to conjure some special power to see the man in hiding. 'Let us hope so,' he added.[6]

Edwards' optimism belied the requirements of the judicial process. An injury on a man whose other physical characteristics matched the description given by the surviving victim or other direct witnesses would enable police to make an arrest and conduct an interview. Ditto the grey silk handkerchief found in the dining room at number 39, were it positively identified as the property of the suspect. No sensible defence barrister would attempt to argue an alibi or mistaken identity in the face of that evidence. That is why O'Brien felt his role was so crucial. It would be important for the jury to be sure how witnesses observed identifying features corresponding to the description put out, for example. How close were they standing when they saw him enter or flee? Was their view direct and un-obscured? O'Brien's photographs would position witness statements and other evidence – they would shore up, bolster, support and strengthen police work done by ordinary officers and inspectors in charge like Edwards.[7] If only they really appreciated it.

Photography was not considered policing on a par with bobbies and detectives. Nothing O'Brien did at the scene was going to actually catch a criminal, only help convict him later, after the police legwork was done and the courts took over. His fingerprint boffin colleagues were a sort of last resort, called upon only to defeat the cleverest recidivists who evaded capture. As O'Brien looked over Edwards' shoulder down the hallway he considered the scene. Two people had grappled together at the bottom of the stairs for possession of a blade, Edwards had said. Now one of them was dead, and the other would claim black was white and up was down if he thought it would save him from the gallows. The housekeeper would likely be a more impartial witness. Perhaps she came home to find the deadly attack in progress and the Cypriot, disturbed mid-deed, cut her as he made his escape. Or had she come downstairs to witness the assault, the bloody men blocking her escape? Alternatively, the girl might have happened upon the

Cypriot when she came from the back of the house or the basement beyond, bravely trying to tackle the knife-wielding brute attacking her employer and, in so doing, sustaining an injury herself. Each of these projected paths merged, like curling smoke, at the point where the blood ran over the edge of the carpet at the bottom of the stairs, and the creamy white painted plaster of the wall was interrupted with a brown-red smear. O'Brien's objective was to produce a pictorial record that would enable the court to visualize any one or all of these scenarios just as he was. The jury must be able to imagine, each and collectively, in their mind's eyes, the relationship between the blood on the carpet and the staircase above, or with any other object appertaining to the case, referred to by witnesses. O'Brien's photographs would make it clear if this scenario or that action were likely to have happened, or were even possible, the way it was described from the witness box. With perhaps half a dozen people describing this scene, months after they had seen it for only a moment, they would all be likely to convey a different word-picture. His photograph, on the other hand, would help them to remember, to communicate and to be understood by those who would decide which conception had been satisfactorily made out.[8]

The task before him required O'Brien to draw on all his extensive experience and skill. The room was an awkward shape. A table on the left would prevent setting up a camera in that position, and because the smear of blood disappeared around the curve of the wall, it was not visible from this side of the staircase. He stood in the doorway to the front parlour instead, set up as a dining room, and turned to face the hallway side-on. The huge mirror over the table reflected O'Brien's face at him. He was frowning. It would also reflect the flash and ruin the exposure unless he was far inside the other room from where only some of the bloody carpet would be visible. He looked to his right for an alternative point of view. The staircase was out. Having experimented with setting up a tripod on stairs before, O'Brien had determined never to attempt such an endeavour again. He moved around to the side of the staircase instead, where the corridor narrowed and darkened, leading to further rooms and the basement kitchen. As he did so, he made a point of giving the bloody curve of the wall a wide berth and stepping cautiously over the dark pool on the carpet, disturbing nothing. The eyes of Edwards and the tiger were still following him from the other end of the hallway, but O'Brien took his time, bending slightly to check the perspective, squinting thoughtfully.[9] From the position he selected, the two important elements of the scene would be visible in one exposure: the curve of the wall and its bloody smear and the dark patch on the floor at the bottom of the stairs. The dining room doorway was not visible, but all possible

entry and exit points and routes converging could be indicated on a photograph taken from this position.[10] O'Brien nodded decisively, with Edwards still regarding him, amused. He snapped his tripod open. Ordinary officers would never really understand the great power of police photography unless their case depended upon it. Moreover, few would be likely to give credit to the work of the Photographic Bureau over their own boys in blue as instrumental to a positive conviction.[11]

O'Brien lined up the top of the tripod with the end of the staircase handrail. This viewpoint would ensure no distortion of the vertical lines of walls and furniture in the final image, which might offer a clever defence barrister an opportunity to claim a photograph was misleading. He frowned at Edwards as he checked the tripod with a small spirit level,[12] indicating that the DDI would be in the way where he currently stood like a bored bobby, rocking on his heels with his hands clasped behind his back. It was important to exclude, as far as possible, any suggestion of police presence or interference in interior crime scene photography. O'Brien and his colleagues at C3 attempted always to depict the scene as at the moment of discovery. Exterior crime scenes, most commonly motor vehicle incidents, required a different approach, and occasionally it was necessary to indicate the distance between two points by having an officer, carefully positioned, stand on the edge of the road in a long-perspective photograph. Indoors, however, the jury would be better served to imagine the scene first-hand, as though they had discovered it, and no other person had been there since the victims had departed.[13]

As O'Brien secured camera to tripod, Edwards stepped over the blood, mounted the stairs, and with a half turn and a flourish of his mackintosh sat down on the steps. Just high enough to look down on O'Brien. Edwards took a cigarette from the pocket of his coat and offered it between the balusters, but O'Brien shook his head, no, so the inspector put it in his own mouth and patted himself for a box of matches. Meanwhile, O'Brien checked the camera focusing screen. Though he could make out the blurred white shape of the wall on the left, it was unclear what the extreme right of the resulting image would be. Edwards was noisily retrieving the matches from his pocket. He extracted one with the tips of his fingernails, striking it against the box with a crunch and a rip. Before he could bring it to the end of the cigarette between his lips, O'Brien stopped him: 'Hold it out in front of you, would you? That's it.' Edwards eyed him suspiciously. 'Further' O'Brien pushed impatiently. The inspector looked quite ridiculous sat on the stairs, fag hanging from the corner of his mouth, one arm extended, the tiny flame chasing down the wood toward his fingers.

'Look here, is this some sort of photographer's joke?' he asked irritably through half-closed lips. O'Brien was staring at his focussing screen, making tiny adjustments to the camera.

'No,' he replied levelly, looking up only to blow sharply at the match, extinguishing it before the flame reached Edwards' fingertips. 'It helps position and focus the camera. Where the light disappears off the edge of the screen corresponds to the limit of the frame on the final exposure.'[14]

'Oh. Don't they have some newfangled kit to do that yet?' O'Brien ignored him, twisting together a metal rod with wooden handle and a rectangular tray something like a small dustpan. He gripped the handle between his knees, bending awkwardly, keeping the tray steady with one hand and delicately placing a tiny metal object into the hole near the centre of the tray. Around it, black stains swirled like storm clouds. Edwards peered over the bannister while O'Brien shook a dirty white powder in an even layer along the length of the tray with his other hand. He now had some difficulty replacing the cap of the container of powder since he was holding the pole at the same time and trying not to spill the contents of the tray.

'Should I hold something?' Edwards offered, though his tone belied his reluctance.

'Thank you.' O'Brien smiled, handing him the rod around the end of the staircase handrail. Distinguished DDI Edwards looked something like a chimney sweep with the lamp in his hand. Unburdened, O'Brien darted out from behind the camera and flicked the electric light switch by the front door. He stood for a second while his eyes adjusted to the near-darkness. Gratefully, someone had left the curtains open in the dining room, and a little light from the streetlamps was coming through the doorway into the hall. It reflected a sickly yellow off the slick of blood on the floor. O'Brien found his way back to his position behind the tripod and reached for the plate where he had carefully laid it in the bag. Under the focussing cloth he removed the plate from its case and inserted the glass carefully into the camera, replacing the cloth and taking the cap from the lens. For these brief moments, Edwards was sitting in the dark listening to the tiny sounds, holding steady his sweep.

'Stay very still.' O'Brien instructed him. Edwards felt a little tug on the pole above his hand and loosened his grip, expecting O'Brien to take it from him. Instead, there was a loud crack from the tray, a ripping noise like fabric tearing and a low 'woof' as the pan sprang aflame with a blinding white light. Edwards cursed but mercifully kept hold of the lamp. The burning light receded to glowing embers and ash. O'Brien replaced the cap on the lens and in a few deft movements extracted

the plate from the camera and snapped it in its case under the cloth. Before the embers extinguished, he was up and around by the front door, switching the lights back on, Edwards squinting uncomfortably. O'Brien lifted the tripod, camera and all, and set it down in the dining room, just out of sight of its previous position on the other side of the wall. He returned to the hallway to see Edwards getting to his feet on the stairs. O'Brien took the lamp from him, and the scowling DI set about lighting his now soggy cigarette. In the next room, O'Brien repeated his routine to make a second exposure, taking care to remain out of sight of the hallway mirror, and the miserable DDI. Before he could finish his fag, O'Brien disassembled the camera and tripod and clicked shut the leather case. He emerged from the dining room to see Edwards taking the last draw on his cigarette, grinding out the stub on the edge of the stairs while O'Brien touched his hat goodbye, winked at the tiger and snapped the front door closed behind him.[15] It was a shame, with such a satisfying exit, that O'Brien was recalled to 39 Torrington Square a couple of days later to take another photograph of the dining room.[16]

Police Photographer James O'Brien's second visit was necessary because the first two photographs reflected only what was known on the evening of the crime and the evidential priority, as it was understood in those first few hours, of proving the suspect had been at the scene. Meanwhile, the suspect Georgios Kalli Georgiou was arrested and he and other witnesses were interviewed. Their information opened up a new possible narrative that needed to be reflected in photographs. Crime scene photography was more likely to be required in cases like this one at Torrington Square where the suspect absconded and might deny involvement, than in the Anderson case, explored in the last chapter, for example. From the earliest stage of police involvement in the Anderson case it was clear to them that *how-* rather than *who-dunnit* was key.[17] In contrast, with the killer apparently on the run, police believed the conviction of any defendant they captured would rely on proving his identity and presence. Police deployed photography with a forward-projecting view of the necessity of visual aids in future court proceedings. The benefits of photography were foreseen where the narrative of events might be contentious, as in the Anderson case, or where the suspect's involvement might later need to be proven, as in the Georgiou case explored in the present chapter. However, taking photographs at the scene early on in an investigation, especially before a suspect was apprehended, had potential pitfalls. Before hearing from all witnesses, including other victims and the would-be defendant, police could not compose a narrative of the crime to guide their selection and recording of spaces. Nor would they yet be aware of any counter-narrative proposed by the defendant and his advocates in court.

In many instances, it was necessary to send the photographer back to the scene of the crime days later to take further photographs at the same location. In some instances, police found they had failed to anticipate defence strategy and photograph critical spaces. With the limitations of the medium, lighting and expense, the Metropolitan Police Photographic Department was minded to take fewer photographs of more extensive areas than multiple exposures of greater detail.[18] Unlike the proliferation of images enabled by digital technology and handheld devices everywhere in the twenty-first century, the constant click, click of shutter and blink of flash that accompanies crime scenes in present popular culture, it was rare for more than two photographs of each relevant room to be taken until at least the 1950s.

However, cases seemingly did not suffer for lack of crime scene photographs in the interwar period. Very few case outcomes seem to have explicitly turned upon the pictures of the scene, unlike famous instances of crucial fingerprint evidence, for example.[19] Rather, visual aids contributed to something like the imagination and impression of a place, as well as the playing out of the narrative in three-dimensional space, as shown in the last chapter. In contrast to the Anderson case, however, this chapter refers to trial transcripts to demonstrate exactly how evidence was deployed to support specific legal definitions with particular narrative plots and contingent outcomes. However, the Georgiou case in the present chapter also shows the limits of the empirical potential of crime scene photographs as evidence of these narratives because it was visual evidence other than the photographs of the crime scene that allowed the jury to imagine the people and places that allegedly led to murder. The defence narrative, in this case, was particularly powerful because it spoke to important contemporary concerns regarding the sexuality of young women. Defence advocates also called upon visual evidence to strengthen their narrative. Though the theme of women's sexuality was significant in many murder cases throughout the twentieth century, it was particularly potent when combined with apparent opportunities for reworking of identities, particularly social status, that the 1920s and 1930s permitted.[20]

The above vignette of photographer O'Brien's first encounter with the crime scene at 39 Torrington Square identifies many factors determining the content and character of crime scene photographs. It highlights the spatial and temporal boundaries of the crime scene that were set by the extent of the crime narrative known at the time the photographer made his visit; the anticipated purpose of the photographs was to link the identity of the alleged murderer to the scene of the crime at a later time and place: the courtroom. It has also described many

of the practical and methodological issues that influenced camera placement, position and perspective, and how the limitations of the equipment determined what the photographer was able to capture. It identifies the crime scene photograph as a human construction, shaped by a multitude of personal and professional perspectives and subjectivities rather than a facsimile of facts or a medium of objective scientific 'proof'. The next section will show how evidence collected of and at the crime scene was built up in response to statements by the defendant and key witnesses through multiple visits. Despite this seemingly reflexive approach to crime scene investigation and evidence collection, the chapter will show how what proved to be the most meaningful domestic evidence was not photographed at all. Furthermore, it was defence counsel, rather than prosecution, who mobilized the most powerful visual evidence in the Torrington Square case. Ultimately, it was the legal parameters, definitions and demands of the courtroom that determined the meaning of any exhibit, visual, verbal or material, and its influence on the outcome of the trial.

The defendant's narrative

Shortly after James O'Brien took his first two photographs and left 39 Torrington Square on the night of 18 September 1934, Georgios Kalli Georgiou handed himself in to Metropolitan Police. DDI Edwards conducted the interview. Georgiou's English was fair, but in case he did not understand the implications of the charges Edwards wished to make, an interpreter was engaged to be present at his interview. Georgiou was cautioned and asked for an account of the events preceding and including that evening.[21] Police asked questions, probed his answers and wrote down the responses in the form of narrative prose. Witnesses at the scene had already been briefly interviewed, with PCs noting the details in their notebooks. This process of questioning and the ways in which information was selectively recorded and drove the investigation is important because it demonstrates the shape and texture of police thinking about a case and the formation of stories and images about crime.[22] Each witness or defendant may have slightly modified the developing narrative Edwards was compiling, but police were unlikely to deviate very far from their early readings of a case, preferring to dismiss, ignore or downplay details that did not fit with what they thought they already knew. This was a reflexive but largely unyielding method of compiling a crime narrative, responding to the messy, confusing and fragmentary nature of the information received in the earliest hours after a serious crime

when the pressure to identify, detain and arrest a suspect was intense.[23] The story upon which the DDI or other senior officers in charge settled was written into a police report to form the brief for the Director of Public Prosecutions, thereby informing the prosecuting barrister what kind of case he was expected to construct and predict potential defence grounds. It formed the basis for the criminal indictment, signposting significant evidence and remarking upon any difficult witnesses or potentially contentious details.[24]

According to an interim report prepared by DDI Edwards at the request of the Home Secretary,[25] Georgiou was thirty years old, from Nicosia in Cyprus, and a coppersmith earning three pounds a week. His employers stated that 'he was a willing worker' and gave him 'a good character [reference]'. Though Edwards acknowledged that 'there are no previous convictions recorded against this man' he alleged that 'for some months prior to his arrest, he is known to have habitually associated with undesirable characters who frequent low class cafes in the Tottenham Court Road District'.[26] Soho, Bloomsbury and Holborn seem to have formed an area of preferred settlement for Cypriot emigres in the 1930s.[27] Edwards observation about Georgiou's recent 'habitual association', and the ways the terms 'Greek', 'Greek-Cypriot' and 'Cypriot' were used in apparently derogatory or accusatory ways, lends support to Evan Smith and Andrekos Varnava's finding that Metropolitan Police, in co-operation with Colonial and Home Offices, created and monitored a 'suspect community' of people from Cyprus in the interwar period.[28] The Home Office classified Cypriot people under a special category of 'colonials' in its indexes of capital cases, placing them somewhere between, but not part of, related classifications of 'foreigners' (mainly white Europeans) and 'coloured'.[29] These contemporary contexts had significant impacts on perceptions of Georgiou's identity, behaviour and, eventually, the outcome of his case.[30] Early readings of Georgiou by DDI Edwards and colleagues seem unlikely to have escaped the influence of these prevailing stereotypes and the bloody scene where he was alleged to have killed a middle-aged white business-owner in a respectable Bloomsbury boarding house. Early newspaper reports of murders often highlighted contrasting identities of the victim and the suspect, in this case, christening Georgiou 'the Cypriot murderer'.[31] However, it says something of the strength of contemporary stereotypes about gender over other identities that more time and effort in court were devoted to analysing the sexuality of a central female character.[32]

According to the answers he gave through an interpreter, recorded in his statement, Georgios Kalli Georgiou was unmarried and had been in England for about three years by the time of his arrest. He had been renting a room at

Torrington Square for about three months, he said, and knew the dead man Thomas James as the proprietor of the boarding house. The girl with the cut arm, the housekeeper, Georgiou said he knew as Margaret McKinnon. They had been engaged to be married and living together for nine months before they moved to Torrington Square. At their home together in rooms at Lambs Conduit Street, Holborn, Margaret wore a wedding ring Georgiou had given her, and they rented in the names of Mr and Mrs Kalli. He 'kept' Margaret financially, giving her all his savings and wages to bank for their future wedding and life together. However, Margaret became 'fed up with being by herself and decided to get a job'. Working as a daily help from 6 am to 12 noon at 39 Torrington Square, she left the ring Georgiou gave her at home.[33] In the context of some occupations barred to married women in the 1930s, and the couple not being legally married, this need not be considered evidence of any betrayal on Margaret's part.[34] However, Georgiou's statement highlighted it as meaningful, imbuing the wedding ring with meaning and ensuring it was later designated an exhibit of evidence. Within a few days of commencing her position, Margaret told her fiancée that it would be more convenient for her to sleep where she worked. Her new employer offered twice the salary and more responsibility as the live-in housekeeper, she told him. They need not part, for he could take a room shortly becoming available at the house – a small furnished room on the second floor. They would still see each other every day, though they would sleep in separate rooms, and 'we should both save our money and get married at the end of two or three years'.[35] Georgiou agreed, perhaps not realizing that the arrangement meant the couple would not be sleeping together anymore. He became jealous and suspicious:

> I kept observation to see if she was behaving herself. I suspected that she was sleeping with Mr James and I watched at nights. After watching for fifteen or twenty days I discovered they were sleeping together.[36]

Georgiou's statement established a new narrative of the crime. Jealousy over Margaret McKinnon was a satisfactory motive for the killing of Thomas James. The suspect had just admitted to the how and why of the killing. It did not even matter if she really was sleeping with James (I will refer to Margaret by her first name since her last name differed in the documents, whereas Georgiou's first name was different according to which witness was speaking and Thomas James was commonly referred to by his last name throughout). The fact that a romantic relationship had existed between Georgiou and Margaret altered the direction of the investigation from here on. For example, it made it important to question

Margaret for her perspective on the couple's relationship at Torrington Square, to see if this was a factor in the attack on her or her employer from her point of view. It was also important to check Georgiou's version of events against other witnesses, including Margaret, to see if he could be relied upon to tell the truth. A sexual or romantic relationship was significant in any case of murder because it suggested that the defendant had a motive. Jealousy was a very common narrative deployed in support of prosecutions until it was virtually ruled out of definitions of capital murder by the 1957 Homicide Act.[37] On the other hand, sexual jealousy or romantic disappointment could also be mobilized by defence advocates as a provocative or mitigating factor which altered the degree to which a defendant was culpable. Narratives of jealousy could be used to argue for a lesser charge such as manslaughter or to argue for mercy and reprieve of a capital sentence. In the Anderson case, explored in the last chapter, the adversarial trial processes likely examined both spouses for evidence of transgressing gendered roles. The outcome of the case suggests the jury perceived husband and wife equally innocent of any transgression of their marital or domestic roles.

In the earliest hours following the Torrington Square murder, there did not appear to be any romantic or sexual motive connected to the crime. With the man suspected of killing his landlord having fled the scene, the evidentiary priority of the police was to link their suspect to the death of the victim conclusively. Metropolitan Police officers' immediate objective was to find him, detain him and prove that he had committed the act. These kinds of cases required a different photographic strategy than most domestic murders. In the death of Lilian Anderson in the last chapter, it was clear from the outset that if anyone was responsible for her death, it was the other resident who had been with her when she died. In such cases, where there was no attempt to flee, evidence collection by police, including photography, focussed on proving the (deliberate) circumstances under which the deceased met their death. In most cases, initial interpretations shaped the evidence collected in the first days after a victim's death and, most significantly, the direction of a later trial.

Meanwhile, Georgiou's interview continued. The statement described how Georgiou had confronted both Margaret and James. She denied sleeping with her employer; besides, she said, it was none of Georgiou's business whom she slept with. Next Georgiou tried James, asking him if he was aware that Margaret was engaged to him, Georgiou, and that they had lived together 'as man and wife'. The boarding house proprietor replied that he did not care. Over the following days, the ménage quarrelled nightly. Georgiou did not want to leave Margaret and was afraid to go out of the house to work in case the door was

locked against him with his belongings inside. James swore at him and used threatening language '"You f_____g Greek bastard get out of here!"' quotes the statement. Georgiou suggested that James leave Margaret alone, he already had a wife, so 'give me my girl', but James said it was Margaret he loved and Georgiou was 'no good', he must 'clear out' within the week or James would kill him.[38] Georgiou's narrative describes physical symptoms of his emotional anguish, his romantic disappointment, the betrayal, his fear of what James might do; he had pains in his bones the next day that kept him from work. In the evening he went to the dining room for his dinner, which Margaret fetched for him, and a further confrontation with James ensued. At this point Margaret's behaviour turned from passive observer to co-attacker; she joined in the swearing and Georgiou's fear escalated. He went upstairs to his room, fetched his knife and descended the stairs to find James and Margaret waiting for him. He could not remember whom he stabbed or where he discarded the knife as he ran from the house, but he later realized he had sustained an injury to the third finger of his left hand. He could not be sure how he had come by the cut, he told Edwards, but he thought it was probably a small knife from the dining table, brandished by either Margaret or James.[39] It had been bleeding freely during the interview, and so the Divisional Police Surgeon came to dress the wound.[40] It was 2 am when the interview concluded. Georgiou put his 'X' on the bottom of the statement after a paragraph that described how the entire document had been interpreted to him and was 'true and correct'. DDI Edwards witnessed it and signed his name.[41] It must have occurred to Edwards that Georgiou's narrative of events included some aspects of self-defence: James had threatened him, he was scared, Margaret had turned on him, he was trying to leave when James came at him with a knife and he had the cut on his hand. Whether Edwards accepted this narrative or not would depend on what he found as he continued his investigations.

The witness's narrative

On arriving at University College Hospital with a bleeding wound to her arm, Margaret McKinnon was in shock. She was able only to tell police that the man who had stabbed her and her employer was a boarder at the house named 'Kalli' and that he had 'run away'.[42] The following day, 19 September, DI George Hatherill was permitted to interview her in the hospital. Just as with Georgiou and with witnesses interviewed by police, Hatherill asked questions and wrote her answers into narrative prose. She was asked about her relationship with George,

or Kalli as she also called him, the police having established from him overnight that they had been a couple. Hatherill found that Margaret's family name was not McKinnon but Watt. She was twenty-one, single, born in Kilmarnock, Scotland, and had no family, she told him. Before she took the job with Mr James at Torrington Square, she had worked at a restaurant in Holborn for four months and lived for most of that time with George/Kalli in Lambs Conduit Street. They were engaged to be married, but 'George and I were always having rows, and I got fed-up with it and decided to leave him'. He threatened to kill her if she did and she feared for her life, she said. He was jealous, and he did not want her to work, only to stay at home and look after him. He caused her to lose her job at the restaurant. When the job at Torrington Square offered accommodation, Margaret took it as an opportunity to break with George. However, after about a month he came to the house and threatened to tell her new employer of his seemingly respectable housekeeper's having formerly lived with him 'as man and wife'. The alternative, George told her, was that he, George, also came to live at Torrington Square. As manager of the house and under further threats to her life and job, Margaret rented him a room. However, being near to Margaret did not satisfy him, she said. He followed her about and threatened to kill her if she did not go out with him twice a week. She implied that his interest in her was mainly sexual and it was only his lustfulness that made him want to marry her.[43]

On Monday 17 September 1934, Georgiou told Margaret he was going back to Cyprus and 'you have got to come too'. She refused, 'and he again threatened to tell Mr James' unless she gave him ten pounds (for his fare home). Margaret confessed to her employer that night that she had previously had a relationship with one of their boarders and that he was now threatening her. 'Mr James told me I was a little fool and he knew something had happened between Calli [sic], and I.' Despite her fears, Margaret's employment was unaffected, and the following day she and James went to view another house in Torrington Square with a view to subletting it and renting it out as rooms in the same way as number 39. They were now partners in business, Margaret explained, and had entered an agreement in which she would receive a half share of all profits.[44] This was a considerable improvement in circumstances for the young woman, who had previously only been working at low-paid, often dirty manual jobs. Housekeepers and landladies, by contrast, had responsibilities, and policed their tenants' private lives to maintain the respectability of the house and accordingly high rents.[45] Returning to 39 Torrington Square later that evening, Margaret continued her usual routine and laid the table in the dining room for the guests who took their evening meals. Calli [sic] came in '"You are not coming with me to Cyprus?"' he asked, '"You

don't love me any more?"' Margaret could not meet his eye but carried on with her work, kneeling to pick up her tray from beside the fireplace. "'No," she said. She looked around to see Georgiou coming towards her with a wild look in his eye. 'He aimed a blow at me with the knife and I caught his wrist. We struggled and he then pushed the knife into my arm. I called for Mr James, but he was some time coming as he was in the toilet.' Margaret and her employer managed to gain control of Georgiou for a moment, but then he had James on the floor in the passage. James grabbed Georgiou's wrists and told Margaret to run. She shouted for help in the street and found a policeman nearby, but when they returned to the house Mr James lay dying at the top of the steps by the front door, and his assailant was running away. Her final sentence, presumably in response to a direct question on the matter, was 'Nothing improper ever took place between Mr James and I.'[46]

In this narrative, Kalli/Georgiou had been the cause of the fatal confrontation and had fetched his sheath-knife before coming into the dining room to confront Margaret about their plans to marry and go to Cyprus. It implied that he intended to stab her if she would not agree to come away with him. Bending down to retrieve her serving tray from the fireside kerb, Margaret was attacked by her former lover, an altercation that ended in the hallway with her would-be protector receiving a fatal stab wound. Inspector James O'Brien was now dispatched to Torrington Square to take a further photograph of the dining room which would allow the court to imagine these moments. Officers from Tottenham Court Road Station accompanied him and took another look around the property, including the basement.[47] What they found there raised more questions for Margaret, and so she was called in to be interviewed again. It is important to note, however, that officers did not instruct O'Brien to take photographs in the basement while they were there. This lends further support to my argument that situating objects, proving their location in a room, was of a lesser priority than situating narrative – visualizing the events to which witnesses referred. For further photographs to be taken at the scene, crucial actions on which conviction might depend must be situated there and explicitly identified by witnesses in their statements.

On 20 September Margaret was further interviewed by police, her answers to their questions written into a statement. This time questioning focussed almost exclusively on her relationships with Georgios Kalli Georgiou and Thomas James. She explained how she had first met Kalli casually in Shaftesbury Avenue, where her friend gave him Margaret's address. He wrote to her, suggesting they go out to the pictures, and further dates followed before they lived together 'as man and wife'. She insisted that she had worked rather

than been 'kept' by him during their relationship. Of James, she said he was 'very kind to me and gave me presents … He took me out to the pictures and I looked upon him as a father and he never suggested anything improper to me'. Yet police seem to have been suspicious of some of their living arrangements; otherwise, the information Margaret offered about the house seems strangely spontaneous and direct:

> He [her employer] used to keep his clothes in my bedroom, as there was no where else to keep them. My bedroom was in the basement and Mr James used to sleep on a divan in the dining room on the first floor … When I was in my bedroom I kept the door locked. When Mr James wanted to use the bedroom, I went into the kitchen.[48]

This new line of questioning can only have emerged from the second police visit to the property when O'Brien took his further photograph of the dining room (Figure 3.3). At that point, police searched Margaret's bedroom to see which story was corroborated – Georgiou's or Margaret's. Finding James' clothes mixed up with hers, they asked her to account for it. They also asked more questions about the altercation in the dining room, where drops of blood were found on the carpet when they went back to check Margaret's story. A section of carpet was removed and taken to Scotland Yard to be photographed by one of the static cameras in the Photographic Bureau's studio laboratory. This was the method James O'Brien described as predating on-site crime scene photography in his 1936 series of articles in *The Police Journal*, which followed the tradition of photographing fingerprints and other tiny details on objects which could be transported to Scotland Yard.[49] This image, a piece of patterned carpet folded over a wooden block with small chalk circles highlighting otherwise invisible droplets of blood, shows nothing of the crime scene and is indecipherable without the context provided by the transcript. Even then, it received less attention in the Old Bailey courtroom than the photographs taken at the scene. Of far greater significance to the case was the photograph police found in Margaret's bedroom while O'Brien was taking his third exposure (Figure 3.3) in the dining room. Defence advocates questioned her about it at length:

> On Tuesday 11th September Mr James took me down to Brighton for the day. We went by train and returned home about 9pm. We had our photograph taken together while we were there. I wrote on the back of one of the photos 'With fondest love Margaret, 11th September' and gave it to him. I knew he was a married man and did this for fun. We both treated it as a joke and laughed about it.[50]

Here the interview ended and Margaret signed her statement.

The photograph of Margaret and her employer at Brighton looks more like the portrait of a courting couple than a pair of respectable people who are partners in business. Their arms are linked, hands touching and they are both smiling, suggesting intimacy or at least familiarity beyond that of co-workers. Even with Margaret's innocent interpretation of the photograph 'as a joke' there is additional meaning to be read. 'Going to Brighton' was synonymous with adultery, Claire Langhamer has argued.[51] The photograph may have been a sentimental souvenir of a day out Margaret had enjoyed with a man who was like a father to her. However, there also exists a strong possibility that James planned to give the photograph to his wife to use as evidence of adultery in a divorce case. No-fault divorce was impossible and collusion unlawful, so it is unlikely Margaret or Mrs James would admit to such a plan. Furthermore, this photograph, like that of the carpet fragment, exists only in one iteration of the Georgiou files, the CRIM file, which is not where the trial transcript is archived. Exhibit 12 (Figure 3.6) also exists in only one of the Georgiou files.[52] Police found the little book on their final visit to 39 Torrington Square when they handed the keys to the property back to the lessee, Mrs Lumley. Her voice and the evidence she brought to the Old Bailey trial are only recorded in the trial transcript (retained in the DPP file) and not in the CRIM file because she was a defence witness, not prosecution witness.[53] Georgiou's advocates hoped her evidence would persuade the jury that he had been less than legally culpable of capital murder. To have this impact, exhibits had to be visually powerful and carefully woven into the fabric of a narrative with a specific legal framing. Within limits of legal practice and precedent, prosecution counsel for the Crown and defence advocates for the defendant delivered, shaped and debated different narratives of the death of Thomas James, each with its own life-or-death outcome for Georgios Kalli Georgiou. Trial transcripts are the most important source for examining the contemporary meaning of exhibits of evidence including statements, photographs, material objects and the results of scientific testing, because they demonstrate how such evidence and its empirical potential, limits and meanings were filtered through the requirements of the courtroom, deployed in support of performed narratives shaped by legal definitions. The next section of this chapter explores the significance of visual evidence to these narratives in the courtroom.

Courtroom narratives

The evidence table in the courtroom on the day of Georgios Kalli Georgiou's trial bore a variety of objects, including a handkerchief, table knife, large knife

and sheath, a wedding ring, a post office savings book, a plan of the ground floor and staircase of 39 Torrington Square, a 'found' photograph of two people and an album of photographs taken by James O'Brien.[54] Without context, provided by the trial transcript, this is merely a list of items and an incomplete one. Some of the items the official List of Exhibits refers to were retained in the same file, some have other afterlives.[55] Each iteration of the Georgiou case file relies on the institutional perspective of the interwar British government and the bureaucratic rules and policies in operation over the decades since their creation at the Home Office and National Archives, many of which were kept secret or not recorded at all.[56] These institutional and bureaucratic factors are highly significant, to be sure, shaping the collection and retention of evidence overall, but it is important to note that each document, photograph and object used in the case was created by a different hand, each with their own concerns and priorities. Metropolitan Police were no exception, and historians and criminologists have described a broad spectrum of twentieth-century contexts that affected investigative practices, evidence collection, detection, offence classification, interview techniques and record-keeping.[57] Crime scene photographs and other visual evidence, this chapter argues, uniquely demonstrate the courtroom as the most powerful context shaping forensic practice and the significance of narratives of crime.

The King v. Georgios Kalli Georgiou opened at The Central Criminal Court, Old Bailey, on Monday, 22 October 1934 before Justice Rayner Goddard. Eustace Fulton appeared for the Crown on behalf of the Director of Public Prosecutions, and F.G. Paterson represented the prisoner. From start to finish the trial lasted only a single day, packing in the examination and cross-examination of nearly thirty witnesses, plus opening speeches, closing arguments and summing-up. In addition, the defendant had some of the more contentious evidence, including his questions and answers, translated through an interpreter.[58] Goddard was known for his speedy conduct of proceedings,[59] but eighty-four typed pages of dialogue must have been delivered and responded to with dizzying rapidity to fit between the hours of 9 am to 6 pm.[60] The speed, tone and formality with which barristers, Judges and clerks of the court orated are not recorded in trial transcripts. Staging, timing and other rhetorical techniques were deployed to add to the drama and impact of adversarial questioning, but such features are not effectively communicated by a document that was intended to provide a strictly dispassionate legal record of proceedings in the event of an appeal.[61] In many instances, some features of a trial were omitted from a transcript altogether. Opening speeches by prosecution and defence were not recorded in the Georgiou transcript. In other cases, they tell a long and detailed narrative,

prosecution in particular signposting evidence in their favour, deploying rhetorical devices designed to seem neutral but offering a very particular reading of the crime narrative.[62] Following this verbal scene-setting and story-telling, the first witnesses called at murder trials were usually police plan-makers and photographers whose exhibits acted as a visual reference point – memory-aid and demonstrative tool – for following witnesses to point to when they described locations, objects and finding of further evidence.[63] Prosecution witnesses were called first, with counsel permitted to ask questions requiring yes or no answers. To 'lead' a witness was to include the answer one was hoping for in the question, permitted regarding points agreed upon by both parties.

Thus, in the Georgiou case, the first witness was called and asked if his name was PC George Pannell and if he had made Exhibit 7, the plan. He replied in the affirmative and was despatched with utmost haste for, as Justice Goddard point out: 'Nothing turns on the plan.' Entitled to cross-examine every prosecution witness, Paterson asked him only if his plan of 39 Torrington Square included the basement 'where Miss Watt had been sleeping'. Pannell confirmed that no; it did not (only the ground floor and first floor were represented, including the staircase).[64] Paterson was also eager to highlight to the jury that none of the photographs depicted Margaret's basement bedroom either. Today this seems a significant oversight considering the numerous pages that described objects entered into evidence found in that room, all of which were deployed to support a narrow version of the murder narrative. However, it is important to note that this version of the crime story was in favour of the defendant, and police only turned their attention to Margaret's basement bedroom after they had settled on their narrative of the crime which informed the charge against Georgiou.

When Inspector James O'Brien was examined and cross-examined, his photographs were apparently on display in the courtroom, but copies were also provided for the jury to look at closely. There were the first and second photographs he had taken on the night of the 18 September showing, respectively, the hallway (Figure 3.1) and the dining room facing the door to the hallway (Figure 3.2). In this second photograph, details such as the many bold patterns competing for focus in the room are visible, but the monochrome print and wide-angle do not permit close analysis, even if C3 enlarged the image to the maximum their technology allowed.[65] Later in the trial, the position of articles on the table would become important, but these are very difficult to make out according to the photograph. The third photograph (Figure 3.3), taken on 20 September, showing the fireplace where Margaret claimed Georgiou had attacked her, was also intended to allow the jury to imagine competing narratives playing out in

space, in common with the Anderson case of the last chapter. Neither defence nor prosecution asked O'Brien about the contents of his photographs, only the circumstances in which he had made them.⁶⁶ Other witnesses would be called to 'prove' (i.e. introduce or verbally verify) additional exhibits and place them, temporally, within the space O'Brien's photographs depicted.

Despite the close-up photograph of the carpet fragment, its purpose at the trial was, like the photographs at the crime scene, limited to situating the narrative in

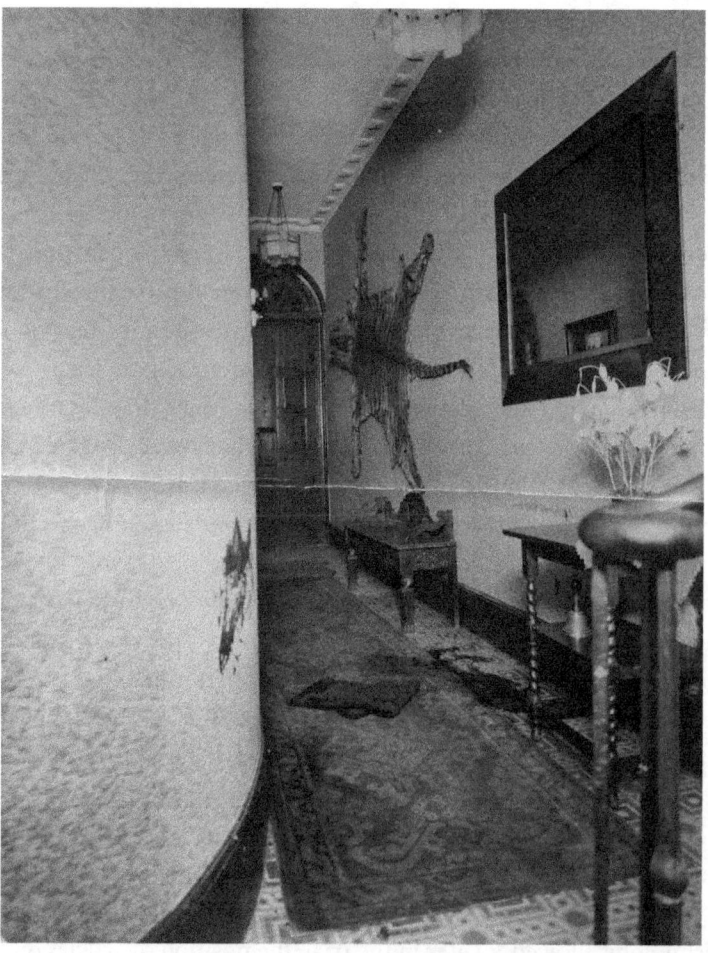

Figure 3.1 Ground floor hallway [crime scene photograph 1 of 3] taken by Detective Inspector James O'Brien, New Scotland Yard Photographic Section, at 39 Torrington Square, Bloomsbury, 18 September 1934. Source: TNA: CRIM 1/743: Georgiou, Georgios Kalli: Murder: Exhibit 9 (1). © Crown copyright. Metropolitan Police Service. Used with permission.

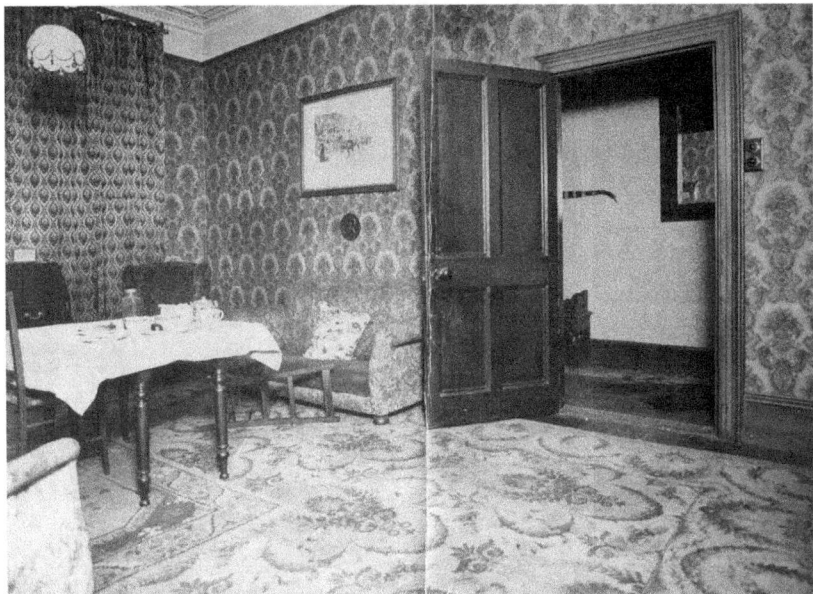

Figure 3.2 Dining room [crime scene photograph 2 of 3] taken by Detective Inspector James O'Brien, New Scotland Yard Photographic Section, at 39 Torrington Square, Bloomsbury, 18 September 1934. Source: TNA: CRIM 1/743: Georgiou, Georgios Kalli: Murder: Exhibit 9 (2). © Crown copyright. Metropolitan Police Service. Used with permission.

space. The Divisional Surgeon, asked to comment on the meaning of the blood spots, said he would need to see the carpet itself, not a photograph of it, but the carpet was not brought into court.[67] According to the competing narratives told by Georgiou and Margaret (see above), it mattered whose blood it was. Police took the carpet fragment from the dining room where Margaret claimed Georgiou had attacked her with a knife before James came to her aid. If this was her blood, it supported that narrative. If it was Georgiou's blood, it supported his narrative that Margaret or James had attacked him with a knife from the table first, causing him to defend himself. DNA testing was not available at this time, but blood groups could be identified in certain circumstances. Deputy Assistant Commissioner of the Metropolitan Police, R. M. Howe, noted that the tests were expensive, that their utility depended on Georgiou's blood being of a different group to the victim(s) and that a positive result would only go so far as to 'make even more certain the probability that some of the blood belonged to the injured man'. The decision whether to order the tests or not was to be made by the Director of Public Prosecutions, but Howe commented, 'Personally I think it unlikely that any scientific evidence at all will be required.'[68] This information

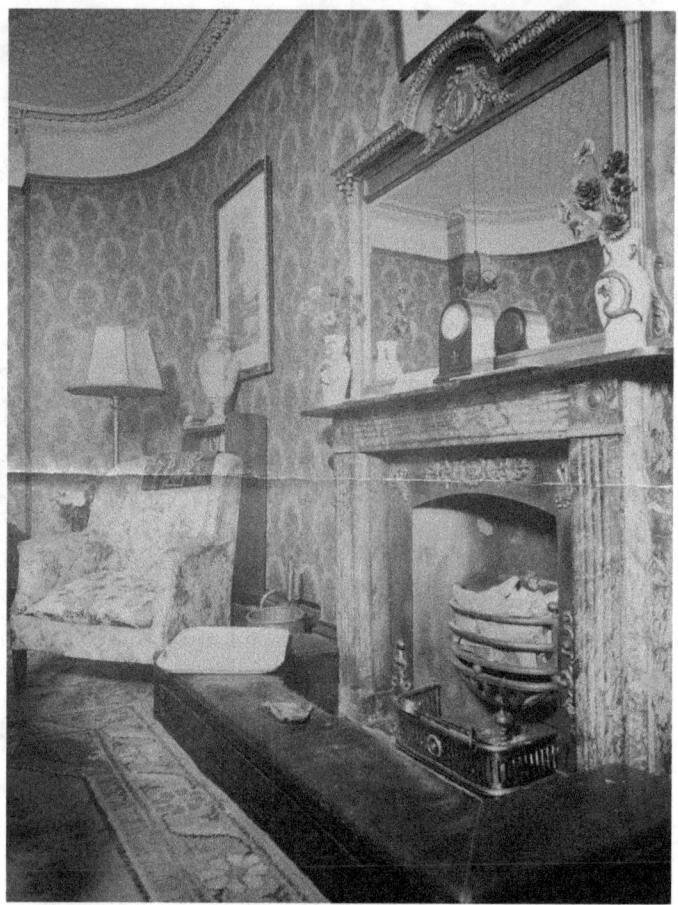

Figure 3.3 Dining room [crime scene photograph 3 of 3] taken by Detective Inspector James O'Brien, New Scotland Yard Photographic Section, at 39 Torrington Square, Bloomsbury, 20 September 1934. Source: TNA: CRIM 1/743: Georgiou, Georgios Kalli: Murder: Exhibit 9 (3). © Crown copyright. Metropolitan Police Service. Used with permission.

again contextualizes the photograph of the carpet to demonstrate the limited forensic methods applied to even life-or-death cases. Howe would go on to adapt an early twentieth-century text of Hans Gross for post-war Metropolitan Police and serve on the Detective Committee advising on Scientific Aids in investigation. Thus his lack of unbridled enthusiasm for scientific tests in the Georgiou case supports Alison Adam's argument regarding the long bedding-in processes or adoption time of scientific techniques and the implications of funding for legal outcomes.[69]

Questions and answers exchanged between Fulton for the prosecution and Margaret McKinnon Watt ran to a little over three pages.[70] Paterson's cross-examination, on the other hand, was three times that, and from the beginning he made it clear upon whom he was placing culpability in the crime, establishing a patronizing and moralistic tone from his very first question:

Now, Miss Watt, I have to ask you some very unpleasant questions.
A. Yes.
Q You will understand it is just as unpleasant for me as it is for you, will you not. You realize that, do you?
A. Certainly.
Q I want to see how far we can rely on your evidence.[71]

Through careful ordering and phrasing of his questions, Paterson highlighted the time that had elapsed between Margaret's meeting Georgiou and sleeping with him, her familiarity with her employer whom she called 'Tom'. He explicitly asked if she slept with the latter when he took her to Brighton. She said no. Next, Paterson introduced another man's name, suggesting a third sexual relationship with a man she had met at her hotel job. She said she did not know any person with that name. 'Do you mind writing down on a piece of paper with a pencil, "I will show you my bedroom,"' Paterson asked, and she did so. Paterson then handed Margaret a small book, Exhibit 12, open in the middle: 'Is that your writing? A. Yes it is ... I remember now.'[72]

Exhibit 12 (Figure 3.4) stands out from the rest of the evidence in the Georgiou file, in part because the cover is in colour, unlike the monochrome photographs and documents. The cover of Girls' Friend Library No. 434 announces the title of that issue's main story in garish red capitals: 'SHE WORE NO RING'. Two illustrations in muted hues of dark blue and grey suggest moments in time featuring the same young woman. In the upper-left image, she stands before a gothic leaded window wearing white, with a frilled headdress and long veil, her hand raised and fingers splayed. The serious-faced man next to her has sharp features, small eyes, low eyebrows, a thin moustache and slicked-back hair: the baddie. He is placing a ring on her wedding finger. In the main illustration, the woman's face is made up, upturned to a different man with softer features. Her hooded eyes look into his, and he returns a gentle expression, his mouth almost touching hers. The table, chair and mantelpiece behind them suggest a more domestic or otherwise intimate setting. The man holds her close, and she clutches his arm, her left hand stark white and naked against his dark blue suit.

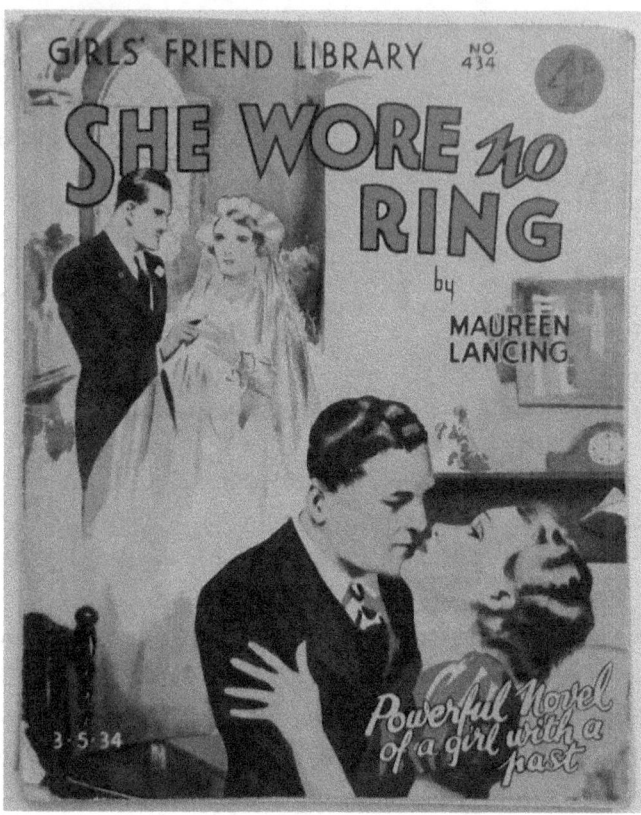

Figure 3.4 Book cover: Lancing, Maureen, *Girls' Friend Library 434: She Wore No Ring* (London: Amalgamated Press, 3 May 1934). Source: TNA: CRIM 1/743: Georgiou, Georgios Kalli: Murder: Exhibit 12: Copy of book. Copyright © Rebellion Publishing IP Ltd. Used with permission.

At her shoulder, a caption informs readers of the kind of story inside: 'Powerful novel of a girl with a past.'[73]

The woman depicted on the cover is the central character of the romance novelette, a young woman named Miss Susan James. In common with Margaret McKinnon Watt, the fictional Susan James 'was a girl without a relation in the world, earning her own living [in London] and wondering what life held for her in the way of love and romance'. The story begins with Susan leaving her job to get married to Sam, 'a Colonial, on a visit to the Old Country' where he knew nobody. She had not known him for many months, but they had fallen in love and were marrying right away so she could accompany him as he returned to his native New Zealand. As the wedding reception begins, police officers appear and arrest Sam, unmasking him as a gun-carrying,

womanizing criminal wanted on blackmail charges. Shocked, humiliated and heartbroken, Susan throws away her wedding ring promising never to love or trust another man again and escapes into the anonymous London crowds to start a new life where nobody knows her. She takes a lodging in Chelsea and a job in the City as private secretary to Basil, a handsome and kind man with whom she quickly falls secretly in love. She feels she does not deserve him, this titled business owner with a mansion in Finchley and a smart flat in Knightsbridge. She is just an ordinary secretary, unwittingly married to an international criminal. As he lay dying after falling down a lift shaft, Basil confesses to Susan that he has fallen in love with her while they were working side by side. Only the hope of having a future with Susan will give him a reason to fight for life, he says.[74]

By not wearing a ring at work, Susan had left herself open to Basil's feelings, the book moralizes, even invited them; 'she had been at fault. She should have told Basil King that she was a married woman.' Her 'secret history' as an already-married woman threatened her respectability, the job she enjoyed and even the life of the man she loved.[75] Worst of all, she had pretended to be better than she was. Basil's mother objects to Susan, preferring prettier, wealthier Lady Vera, and further obstacles threaten their union. Basil nearly dies from his lift-shaft-fall injuries, then it seems he will be forever confined to a wheelchair and 'not a proper man', unless he gets an operation. Susan's husband Sam escapes prison and confronts her, threatening everything, but is fortuitously run over and killed by a bus. Basil, meanwhile, has a successful operation and walks again, but dead crook Sam's real wife appears at Basil's mother's house, exposing Susan's secret to her worst enemy. Susan now realizes that Sam's marriage to her was bigamous; she was never actually his wife. However, she can no longer bear the weight of her deceit and confesses everything to Basil. Furious with her for wearing no ring and concealing her past from him, Basil ditches Susan for Vera. With a broken heart and no hope of her own, Susan falls deathly ill. On the brink, Basil comes back to her, Vera finds someone else, and everyone lives happily ever after – 'the story of love triumphant'.[76]

The story in the novel bears many similarities with Margaret's own and might suggest that Margaret was similarly morally culpable by not wearing her ring at work or telling her employer that she was engaged to Georgiou when she started work at Torrington Square. The book and its powerful imagery certainly support Matt Houlbrook's arguments regarding the salience of contemporary concerns for self-reinvention and social improvement through interwar movements, opportunities and deception.[77] However, the courtroom paid no

attention to the contents of the novel according to the trial transcript. It is only the visual evidence of the cover that creates a strong, imagined impression. Justice Goddard objected that he could not see the relevance of the Exhibit or Paterson's questioning of Margaret about the love notes written inside. Paterson claimed he was trying to test Margaret, to see how far her story could be trusted, but Goddard saw that it was an effort to moralize against her, to communicate to the jury a condemnation of Margaret's sexuality. *She Wore No Ring* was a story of concealed commitment, a young woman attempting to take advantage of men and cross social boundaries, 'a girl with a past' who inspired jealousy, provoking Georgiou to kill a rival for Margaret's affection. As Goddard later pointed out, this was technically at odds with the self-defence narrative Paterson presented. It was one thing to portray Margaret as 'untruthful', quite another for 'this case to be made into a general attack on Margaret Watt's character', he said. 'We are not trying Margaret Watt we are trying the prisoner for murder …'[78] The 'powerful novel of a girl with a past' implied, through the love notes written in its margins and the bold illustrations on the cover, that Margaret's version of the crime was not to be trusted because she was sexually active, deceitful and provocative. The defence's aims in this regard are brought out in Paterson's examination of the defendant, Georgiou, where questioning focused on his feelings about Margaret and her relationship with James,[79] and in the testimony of Mrs Lumley, finder of the novel, who let slip that she had been motivated to come to the Old Bailey 'to save him [Georgiou]' because Margaret's claims at the police court that 'He was like a father to me' were, in her opinion, at odds with the 'state I found the bed linen in' and the impression she had gained from her bedroom. This further highlights the perceived connection between Margaret Watt's sexuality and Georgiou's lesser culpability. Ultimately, however, it demonstrates that Georgiou's defence advocates would use any evidence at their disposal that might inspire sympathy for their client on the part of the jury and affect the outcome of the trial.

Judge Goddard, in his summing-up, summarized the evidence for the jury and explicitly described the three possible narratives they were being asked to select from and the evidence that supported each:

1. Self-defence. The defendant was attacked by James (with a table knife) and then defended himself trying to get away. Such a narrative would entitle the jury to reduce the charge to manslaughter, the judge told them. Inconsistent with this narrative was the evidence that showed James was stabbed in the back and Georgiou's statement in which he said he had

gone upstairs to fetch his knife after he was attacked by James, rather than running out of the house.
2. Georgiou had intended to kill Margaret. The testimony of a publican supported this narrative; he described a conversation in which Georgiou showed him a photograph of his erstwhile fiancé and announced his plan to kill her. Another witness deposed that this was the day Georgiou bought a knife, implying it was for the express purpose of murdering Margaret. If Georgiou attacked Margaret and in so doing injured James when he came between them, that amounted to murder, the judge informed the jury, because though James was not the intended victim, Georgiou had intended to kill.
3. The third possibility, he said, and 'I merely put it out for your consideration' that there was a fight or 'sudden fracas' between Georgiou and James at which point Georgiou drew a knife. From here the judge's summing up has been underlined in pencil to show the most significant passages, corresponding to page numbers referenced upon the Appeal papers:

> The difficulty is that he said he went upstairs and fetched it. If there was a sudden fracas and in the heat of passion he picked up a knife and struck a man, that act reduces the crime to manslaughter, but I am bound to point out to you that that is not the defence that he has put forward, nor am I able to see where that class of defence would come in here, because as I say, it is not the picking up of a weapon [the sheath knife did not come from the table], or, if you have a weapon about you, the drawing of it on the sudden passion of the moment and inflicting a fatal blow. The prisoner says he went to his room and got it and the prisoner says on coming down[stairs] he was attacked again and that was why he drew the knife.[80]

Here, Goddard highlighted the direct relationship between narratives and legal definitions. If it happened this way, it is murder; that way, it is manslaughter. He also invited the jury to imagine the visual playing out of these narratives, aided by the crime scene photographs and floorplan.

Conclusion

The jury returned a verdict of guilty of murder 'with a strong recommendation to mercy, owing to the great provocation he received by the remarks from James'.[81] An appeal against the conviction was unsuccessful but the Home Secretary recorded that the Justices who dismissed the appeal all felt Georgiou's was a case for clemency. Paterson, who represented Georgiou, went to Whitehall to meet

with the Home Secretary to advocate for reprieve of the death sentence. Notes on this meeting, a report from Goddard and dozens of newspaper clippings collected on the case all prioritize the sexual or romantic jealousy provoking Georgiou and normalize the racist comments James made. This interpretation is echoed in Home Office reports recommending a conditional pardon for Georgiou,[82] and the Home Office index of capital cases which summarizes the case among other cases of 'Murder by Commonwealth, Colonial, Citizens' (the majority of whom were described as Cypriot or French Canadian) in these few lines:

> GEORGIOU, G. (1934) Stabbed man who associated with woman he was attached to. Jury strong mercy recommn [recommendation]. CCA thought it a clemency case. Respited.[83]

As the vignette opening this chapter, describing how O'Brien created the first two images, demonstrates, the photographs were intended as a record that would allow the jury to imagine the action that had led to the death of Mr James. At that time, the crime scene evidence was required to link the identity of the suspect to the scene. When Georgios Kalli Georgiou handed himself in and admitted to delivering the blow that killed James, and he and Margaret Watt were questioned, the area of the altercation was extended to include the dining room. O'Brien returned to Torrington Square and photographed the dining room fireplace in order to allow the jury to imagine this new version of events. However, in court, as the transcript shows, these images were relatively ineffective and referred to far less frequently than other visual evidence. If O'Brien had photographed Margaret's bedroom, prosecution or defence would have used that image to show Margaret and James were sleeping together. But police failed to instruct O'Brien to photograph that room, and defence advocates very rarely, if ever, caused their own photographs to be taken or produced evidence that was not provided to them by police. What they did do, however, was introduce into evidence in court two very powerful images referencing Margaret's sexuality, thus painting her as a provocative instrument in the events leading to James' death: the first was the photograph of Margaret and Tom at Brighton, the second was the cover of the novelette found in her room.

However, it is important to note that the official outcome of the trial does not reflect the obvious significance of Margaret Watt's sexuality and deception, or the visual evidence that was used to evoke these themes. Rather, the words that framed his pardon appear to suggest that Thomas James provoked Georgiou to murder. As the next chapter shows, the processes of criminal trial and justice were rarely straightforward or transparent. The comparative identities of the defendant, victim and, in the Georgiou case, witness did not directly translate

to the recorded outcome of the trial. In many case files, whether collected and preserved in the interests of an appeal, to inform the prosecution of a case, or to record Home Office decisions for future reference, there seems very little relationship between the evidence recorded and the outcome of the trial. This has serious implications for popular culture and representations of crimes in the past, which have 'reviewed' cases based on very partial notions of how a jury made their decision based upon what evidence or information. It also has implications for the meaning of justice in twentieth-century England and Wales, raising questions regarding the application of judicial discretion and the methods by which the Home Office determined which prisoners or cases were deserving of reprieve. Did the Home Secretary, as civil servants claimed, make mercy decisions based solely on the evidence (including photographs) in each case where a defendant was found guilty and sentenced to death? Did the number of mercy petitions received influence the likelihood of stopping an execution? Were contemporary political priorities, including prevailing views on capital punishment and abolition, allowed to influence individual case decisions? How important was it to the Home Office, who administered justice in twentieth-century England and Wales, that justice 'be seen to be done' more than to *be* done? In some cases, the evidence seems so heavily stacked against a defendant, public opinion so decisive, that nothing but a guilty outcome seems possible. However, no public outcry follows a not guilty verdict or reprieve. Nowhere is this better illustrated than in the case of Elvira Barney, explored in the next chapter.

Postscript

Petitions to the Home Office for mercy on behalf of Georgiou were numerous and came from a variety of quarters. As was common, some of them highlighted the circumstances of the case that had particularly resonated with them, that they felt mitigated the crime, based on what they had read in the papers.[84] Significantly, these letters remarked on Margaret's sexuality more than James calling Georgiou a 'Greek b ...' Besides concerned members of the press-reading public, petitioners included barristers and legal men, clergymen and groups of Cypriot emigres based in London, including the Tottenham Court Road area. Many took the opportunity to point out that, as a Cypriot, Georgiou was a British citizen.[85] The family, Greek Orthodox Church and public all alluded to contemporary politics they felt should contribute to the prisoner's case for mercy, namely the recent engagement and imminent marriage between King George V's fourth son, Prince George, Duke of Kent, and Princess Marina of

Greece and Denmark. Stylish, modern and occupying a perceived identity that was somewhere between familiar and cosmopolitan rather than negatively 'foreign', Marina was very popular. She had been born in Greece (not Cyprus, but most English people arguably failed to understand the difference) but was exiled with her family as a child. She was of the Greek Orthodox faith like Georgiou, but would marry as tradition demanded in an Anglican ceremony at Westminster Abbey. As a 'foreign princess' she was exotic and interesting, a descendant of Queen Victoria but not German. She was already embedded in the British branch of the royal family as god-daughter of her future mother-in-law, and second cousin of her future husband. One of the bridesmaids at the highly publicized wedding was the groom's niece, Elizabeth, who would later marry the bride's first cousin, Philip.[86] Although the monarch granted mercy to those sentenced to death only in name, 'royal' pardons decided purely at the discretion of the Home Office, it was widely believed that the occasion of his son's marriage made the King predisposed to grant a reprieve to one of the bride's [perceived] countrymen and co-religionists. As described above, this was not the stated reason for Georgiou's commuted sentence and likely played no part in the Home Office's decision. However, the context of the royal wedding is not irrelevant in the case of Georgiou because it highlights the multiplicity of unrecorded factors that may have influenced decisions to reprieve. Identification between Georgiou the romantically disappointed 'Colonial' and the contemporaneous royal wedding that played a significant role in the domestication of the monarchy in the 1930s speaks to the emotional regimes and cultural resonance of romance in the press highlighted by Claire Langhamer.[87]

In 1942 the Governor and Anglican chaplain at Camp Hill Prison, Isle of Wight, reported to the Home Office that Georgiou was of low intelligence, illiterate, his English was poor and he was very sensitive – he became upset when speaking about his crime. But he was extremely hard-working, well-behaved and respectful. To other prisoners, he was friendly and kind, and responsive to positive influences, but due to his poor English, he was lonely. On 9 April 1943 Georgios Kalli Georgiou was released on licence. Five years later he applied for a passport to allow him to travel to Cyprus, which the Home Office believed to be a one-way trip. The address on his application showed that since his release he had been living back in Bloomsbury, less than half a mile from the site of the house on Torrington Square.[88] The last archival trace of Margaret McKinnon Watt sees her working as a Bookkeeper in 1939, just off Tottenham Court Road.[89]

4

'The Love Hut': Perverting Public/Private Boundaries in Knightsbridge

Encountering 'The Love Hut', William Mews

On 31 May 1932, Detective Sergeant Alfred Madden arrived at work early to look at the prints he had left hanging to dry the previous day, the many fruits of weekend crimes. Tuesday was usually when the Fingerprint and Photographic departments caught their breath; murders rarely happened on Monday nights. Yet the weary figure of former Flying Squad Detective Inspector Walter Hambrook waiting in the otherwise empty office told Madden a photographer was required for an important job. Moments later shops were passing by in a blur as the detective's car swung off Knightsbridge. Through the greasy front windscreen, Madden caught a glimpse of a row of facsimiled houses. Arched windows and framed porches lined up in a repeating pattern, shrinking and fading into the misty distance. The stucco was whitewashed, but this miserable weather made everything paper-grey. Even the neat shrubs and spring flowerbeds in the centre of Lowndes Square seemed colourless. On the four sides facing into it, the tall, identical terraces threatened to fold in. Madden tried to make out the tops of the buildings but had to bring his face so close to the glass that his breath soon obscured the view. He abandoned his attempt to count the windows and guess at the number of floors and rooms. No matter, it was not one of these he had come to photograph, that much he knew. Hambrook took another sharp left into a narrow gap and the car jumped and juddered over the uneven cobbles before swinging one way then another to steer between motors parked haphazardly on both sides of the tiny back street. In contrast to the tidy square at the front with no signs of life, the backs of the houses revealed their secret workings. Here and there were an open window, a maid beating a carpet, a steaming chimney. Concrete and brick was criss-crossed with pipes and guttering. There were no ionic columns, grand porticoes or arch-topped windows on this side.[1]

Well below the backs of the big houses and under the long shadows they cast, yellow brick mews houses sat low and wide. These buildings were far more familiar, like those where unmarried PCs used to bunk, sharing rooms above police vans and stables. Madden could imagine the warm, straw-scented, low-ceilinged rooms behind the small windows that almost touched the roofline on the upper level. He pictured a liveried horse being led out of the folding wooden doors below, now variously ajar, folded open or shuttered. But it was hatless human heads atop neatly pressed overalls that appeared, curiously examining Madden and Hambrook's arrival. Wiping his hands on a rag, one came as far as the door of the shiny black Morris parked across his garage entrance and, finding their vehicle uninteresting, turned back to his work. As they finally slowed, a young, uniformed chauffeur dashed out in front to hop into a pristine Lanchester, flicking a half-smoked cigarette in the general direction of a dustbin on his way. Hardly waiting for Hambrook's vehicle to clear the gleaming chromium bumper of his own car, he began manoeuvring the thing out of the tangle towards the square.[2]

Overhead, a woman with neatly pinned hair slammed shut a sash window. Further down the mews, between a parked Morris taxi and an oversized Delage, another in her house dress pretended not to watch them as she shook out a duster. While Madden wrestled his camera and tripod out of the car, she took up her brush and concentratedly swept her already clean doorstep. Even with the residents busy at their work, Madden felt like he was being surreptitiously observed. The uniformed police constable standing to attention in one of the doorways was more obvious, watching with interest as Madden picked his way over the uneven cobbles. Had the conspicuous PC not been on guard, and this building not been different from all its neighbours, the lettering on the stone lintel over the door would have told Madden he had reached the right house: 21 Williams Mews.[3]

Unlike the other buildings, 21 had no garage but the ghost of one. The bricks were cleaner, the mortar between them lighter where there were once wooden doors and now a smaller entrance and windows. One could imagine walking into a bricked-in car. The reality was almost as cramped. The tiny hallway was little more than a dark box. To the left, the scullery was blank and empty besides a stone sink and tiny table crowded with dozens of discarded drinking glasses and soda syphons. All colour and life were concentrated only in the room directly facing the front door. As he stepped up to the doorway, Madden's eyes could not take in all the furnishings and objects. Chairs, rug, sofa, paintings, curtains, their many patterns and hues all competed for his attention. Coloured bottles

were clustered on a sort of bar in one corner, over which a large picture hung. As Madden squinted to try to make out the poses of the figures in the image, Hambrook stepped in behind him and an identically coated and hatted detective descended the staircase to crowd the tiny hallway. The three of them shuffled uncomfortably to allow Madden to get to the stairs.[4]

Where they turned to form a small landing, the top steps were filled with the crumpled body of a slim young man. His hair and face were clean and smooth, his clothes new and neatly pressed, save for his crumpled undone tie. He was leaning uncomfortably like a passed out drunk against the landing wall. Two pillows were placed by his head like the sympathetic afterthought of a wife who could not carry her husband to bed. The only thing out of place was the towel stuffed down the unbuttoned neck of his fine white shirt, forming a sort of clumsy cravat. Madden sought out footholds, spaces he could place his feet to climb over the body and reach the upstairs of the house. Where was he going to set up to get a photograph? He noticed the index finger of the young man's left hand was extended, the others curled under: he might have been pointing to the bathroom doorway, indicating the one possible position for the camera and tripod. On the other hand, his digits might have been imperfectly aligned with the trigger of the revolver lying inches away.[5]

Police narratives

> Even the police, when they saw the place, were as shocked as it's possible for policemen to be … The place was equipped with the impediments of fetishism and perversion.[6]

The case explored in this chapter is in many ways exceptional. The status of the individuals involved and the attention the case received contemporaneously have ensured a depth and range of archival and newspaper sources are extant, despite an outcome to the case which would usually ensure only few documents preserved. The result is that the crime scene photographs can be supported by detailed material that frames their making and meaning as well as their interpretation in court. Despite the wealth of historical sources available and the interesting characters associated with it, the trial of Elvira Barney seems to have been largely forgotten in the twenty-first century.[7] Though it was in many ways a very singular trial, this chapter illustrates the ways crime scene photographs were imbricated with a variety of evidence to create a narrative of crime that spoke directly to contemporary class conflict in the capital. Images

of Elvira Barney's home, concealed in a service street but thrown open to public scrutiny by the crime of murder, laid bare the stark social differences that separated the wealthy and working residents who lived so close to one another yet so differently in twentieth-century London. Previous chapters have explored the limits of photographing crime scenes; the way they were shaped by police perspectives in the first instance, the impossibility of knowing exactly what they, and other evidence, were used to show without the benefit of a trial transcript; the overwhelming priority given to narrative above image and how the latter played a significant but supporting role, illustrative rather than self-evident. The Barney case explored in the present chapter demonstrates the overwhelming significance of the crime scene for police forming opinions about defendant, narrative and culpability, yet it also shows how such views could be completely overwhelmed in the context of the courtroom performance. Furthermore, though contemporary newspapers were endlessly fascinated by the person and home of Elvira Barney, they too were limited in what they were able to tell about her and what they were able to show about the crime scene. As we will see, this modifies understandings of police powers and press perspectives and nuances notions of overwhelming forensic values at the crime scene in favour of prioritizing the courtroom as a space of evidentiary importance.

By the time Detective Sergeant Alfred Madden of Scotland Yard's Photographic Bureau positioned his tripod to make his first photograph at William Mews, as many as a dozen police, doctors and other interested parties had seen, and stepped over, the body at the top of the stairs. As if Thomas William Scott Stephen were not enough names, the 26-year-old was known to most of his friends as 'Michael' and to his girlfriend as 'Mickeh' in the mock accent they affected for each other.[8] Madden's first photograph (detail of which shown in Figure 4.1) was not recognizable as its subject. Michael was slim, with smooth, delicate features. But the doorframe and pillows obscured the upper half of his face and the lower half of his legs. With his arm extended and the flash of the camera highlighting white skin and metal, the subject of the image is Michael's hand and the gun it almost mirrors.[9] It was unusual for a body to remain in situ long enough for it to be captured by a police photographer's camera at this time.[10] But nothing about this case was ordinary, few aspects of it would reflect common practice. Whereas in the majority of cases busy police photographers were called to the scene and simply directed to relevant rooms, with little supervision or direction, it seems unlikely that Madden would not have heard at least a little about the house and its residents on his way to this scene, or while he set up his camera. The house and its inhabitants were truly

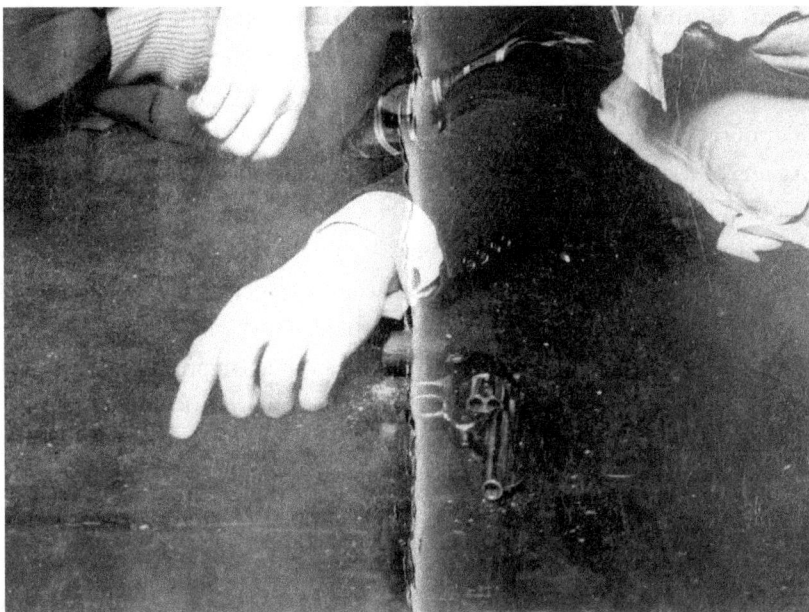

Figure 4.1 Detail from photograph of landing [photograph 1 of 5], taken by Sergeant Alfred Madden, New Scotland Yard, at 21 Williams [sic] Mews, Knightsbridge, 31 May 1932. Source: TNA: CRIM 1/610: Barney, Elvira Dolores: Murder: Exhibit 3: (1). © Crown copyright. Metropolitan Police Service. Used with permission.

shocking, perverting and disrupting the respectable working-class domesticity that surrounded them.

To Metropolitan Police officers, William Mews was a familiar street. Many divisional PCs lived, or had lived, in cobbled cul-de-sacs like this one, among other working-class people of the 'respectable' type.[11] Chauffeurs and their families were set apart from indoor servants by their living over the garage in the mews, but also by their skills as mechanics, caring for the status symbols of the wealthy who dwelled in the big houses for which the mews acted as service roads. Knightsbridge and Belgravia mansions and villas had been built with stables for horses and lock-ups for carriages, with liveried coachmen, footmen and grooms living above. Exchanging horse and coach for a motorcar required fewer men, affording more space for a man and his family, but also demanded more specialized skills and a respectability even further above that of the live-in servants in the main house. In the 1920s some 'bohemian types' had started moving into mews all over London but particularly the affluent

parts of Kensington, Chelsea and Belgravia, imposing their parties on the previously private spaces enjoyed by chauffeurs and their families. Transgression of subtle social and geographical boundaries was observed and negotiated by contemporaries living within and without tiny mews streets.

Agatha Christie's *Murder in the Mews*, published in 1937, described wealthy interlopers in a fictional, but familiar mews who relied on working neighbours to keep their secrets.[12] Christie, the best-selling author of all time, has been described as a chronicler of twentieth-century social change through her detective fiction, though perhaps more particularly of rural communities than urban ones. However, Christie accurately captured important details about politics of space and time in London mews in the 1930s in her short story, attuned as she was to declining community and changing meanings of place.[13] Christie's fictional Bardsley Gardens Mews, like real-life William Mews, came alive during daylight hours when garage doors were thrown open and cobbles hummed with the sounds of engines running, vehicle maintenance and slow-moving vans making deliveries. Some taxi firms and service garages had their workshops and headquarters in these types of streets, seeing various comings and goings at ground level and communication between people and premises, observed and overlooked by one another. After dark, or after working hours, however, noise was taboo and people went indoors. Workshops were shuttered, garage doors closed and the business of family life was conducted upstairs in relative quiet with minimal intrusion from the rest of the street.[14] The real-life murder in the mews of Michael Stephen in 1932 revealed a lifestyle incompatible with the respectable working-class residents and one that was already receiving criticism in the press for its lawlessness, laziness and wasteful existence. With these crimes against respectability so close to home, Metropolitan Police had very visceral feelings towards this particular mews-invader who was the alleged murderer. Her behaviour towards police did nothing to further endear her to them.

Elvira Barney, née Mullens, was the daughter of a knight. Sir John was in banking, stockbroker to the king, with a country seat in Sussex and the largest house on Belgrave Square. Larger even than later neighbours Prince George and Princess Marina, Duke and Duchess of Kent. Avril, the younger of Sir John's daughters, was no less than a Princess herself, having married Russian exile Prince George Imeritinsky. Their mother, Evelyn née Adamson, belonged to a landed gentry family and enjoyed all the status and influence such privilege conferred. She was frequently referenced in the society pages for her charity dinners, her fine clothing and jewellery and her good taste in interior design.[15] However, interwar England had a deeply ambivalent relationship with its aristocracy. Even

before the abdication scandal it was the younger generation of the titled and wealthy, who simply enjoyed their parents' money and wasted their lives, that received poor press and attention. The words 'cocktails' and 'costume parties' became synonymous with sex and debauchery. With hundreds of thousands of working-class young men sacrificed in the Great War and still more struggling with unemployment and the Means Test, these young people represented a stark contrast.[16] Works of literature by people who moved in her circles created characters closely resembling Elvira Barney. Even if they were not directly inspired by the real Elvira herself, Noel Coward's character named Elvira and Evelyn Waugh's Agatha Runcible apparently bore many characteristics in common: overt sexuality, fatalistic attitudes, fondness for drugs, intensely emotional relationships spilling over into violent melodrama, hedonism, alcoholism and very dangerous driving.[17] She was not alone in any of these pursuits, and these interests were not confined to the rich in 1932. However, there was a social expectation that such behaviour would remain hidden behind closed doors. Even the press were complicit in the censoring of certain behaviours among the elite.[18] Elvira had plenty of money to hide behind. She could afford to sleep in until the afternoon; make the occasional appearance on stage; share her bed with any person of any sex; host lavish parties with cocktails and caviar sandwiches; mix with artists, actresses, authors and aristocrats; drive sports cars; acquire a gun without a licence; buy banned books; consume plenty of cocaine; and hide all evidence of these activities in a backstreet building converted to her own specifications, located conveniently for her car, her parents' house and the expensive shops and hotels on nearby Knightsbridge. But what she did not have, and could not buy, was discretion. Furthermore, her dealings with the police made it clear that though she thought they worked for her, she was above their control. As a figure on the fringes of the 'smart set', whose portrait (Figure 4.2) headed society gossip in fashionable newspapers, it seems unlikely that Metropolitan Police would be able to resist chatter about her among their own ranks, particularly when she defied their authority.

On at least three occasions in as many months Elvira had called police to help her. She had two telephones in her house, one downstairs and one upstairs by her bed. The latter had the police phone number noted next to it for easy reference and Elvira used it often. On 3 March 1934 at 2 am and 15 April at midnight, for examples, Mrs Barney had called police to her home to eject a guest who would not leave. On the first occasion a window had been smashed, she alleged, in her struggle with the man. At 4 am on 17 February a taxi driver fetched a police officer to assist Mrs Barney at her home because she could not make her guests leave.

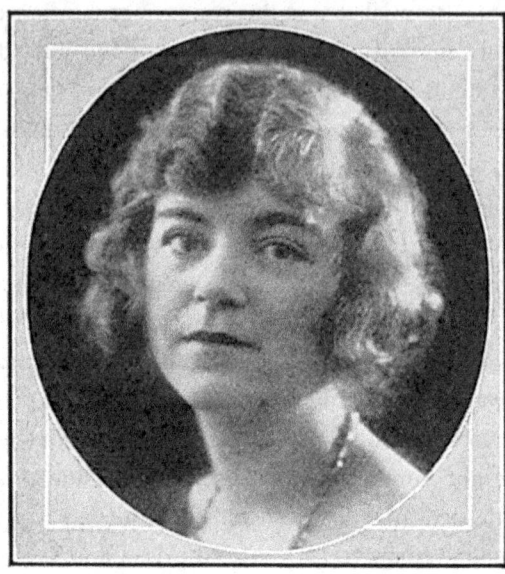

Figure 4.2 Portrait of Elvira Mullens on the announcement of her engagement to John Sterling Barney. Source: *The Tatler*, 15 August 1928. © Illustrated London News Ltd., Mary Evans Picture Library. Used with permission.

They were drunk and shouting in the mews, threatening to go around the corner to wake her mother if she did not let them in. The next morning a neighbour at No 11 approached a duty PC and complained about the resident of No 21 and her guests. 'It was impossible for anyone living near to sleep,' he said. This was just one of 'numerous complaints received [by police] with reference to the conduct of the person living there, and of the people who visited'.[19] When police arrived at her home hours after the death of Michael Scott Stephen, Elvira's behaviour did little to endear her to them. Her rage was uncontrollable, police described her 'paroxysms' and how she called them names, refusing to comply with their requests or answer their questions. She threatened to have their jobs, telling them she knew the former Commissioner for Police of the Metropolis. When her mother called on the telephone, she attempted to wrestle the receiver from an officer, and when another kindly suggested she wear a warm coat because it would be cold at the police station she hit him in the face. These demonstrations of entitlement and non-compliance were noted in communications between police, DPP and Home Office, circulated so widely it seems likely that word-of-mouth regarding the incidents was even higher.[20] It would take a great deal of personal and

professional restraint to restrict the impact of such disrespectful behaviour against an institution so proud of its powers over anyone regardless of class. This theme would emerge later in proceedings, as we will see.

A few hours before police came to 21 William Mews – Monday evening, 31 May, Elvira held one of her noisy cocktail parties. As usual, the living room furniture was pushed back against the walls to allow maximum space for dancing to the gramophone. Suitably inconspicuous staff served caviar sandwiches to about thirty guests who were variously standing, sitting, talking and dancing, spilling out of the door into the mews while Elvira mingled among them all. Everyone 'seemed happy and voted the party a success'.[21] The neighbours, including those who had complained to police in the past, were happy when the party was wound up about 10 pm and Elvira and Michael went off to dine at Café de Paris, followed by cocktails at another nightclub. The chauffeur's families' respite was short. As usual, the couple came home noisily in the early hours, taking their argument to bed, and after a while there were the not uncommon sounds of shouting and shooting from Elvira Barney's bedroom.[22] It was in this room that Madden took his second and third photographs hours later. At the Old Bailey he explained that this room had been indicated to him by colleagues because of the bullet marks on the wall and wardrobe, where, according to the police report:

> There was a mark on the wall where a bullet had struck and at the side of the wardrobe itself there was a hole caused by the ricochet of the bullet. Plaster from the wall had fallen and a very small quantity was resting on the top newspaper, which was a copy of the *Daily Sketch* of the 30th May, 1932.[23]

The date of the newspaper on which dust from the bullet hole rested was highly significant and directly contradicted Elvira's narrative of Michael's death on 31 May and her version of how the marks in the bedroom had been caused weeks before. Though bullet marks are an example of what we might think of in the twenty-first century as 'trace' evidence, to be analysed in minute detail, the corresponding crime scene photograph merely situates the bullet marks in a wider view of the bedroom, showing their rough relative position compared to the window and the rest of the furniture in the room. One does not notice them unless they are pointed out. The date of the newspaper dated the bullet hole and created a narrative of multiple shots on the night Michael died. As we will see, a contrasting narrative was told by Elvira and defence counsel. But the newspaper date is not visible in the photograph; therefore, this could not be called anything like the sort of 'proof' of the date of the shot that a jury would expect in the twenty-first century.

Apart from the *Daily Sketch* on which plaster dust rested, the room was full of reading material, including more than fifty magazines and newspapers, such as *The Daily Express*, *The Stage*, *National Graphic*, *Cosmopolitan*, *London Life*, *Tatler*, *The Picture Budget*, *Vanity Fair*, theatre programmes, and a book called *This Delicate Creature*, published in 1928. The central character, Boda, in a loveless marriage, having affairs and interested in drugs, bears a remarkable resemblance to Elvira herself.[24] Magazine covers suggest Elvira's possible self-identity, or certainly her aspirations. They pictured attractive, active young women in bright colours and modern style, driving cars or playing sports. There were no house or home magazines; Elvira's understanding of herself does not seem to have been related to domesticity or family life. It is impossible to know to what extent Elvira's lifestyle resembled the magazines she consumed and, as Matt Houlbrook has argued in the case of Edith Thompson in the 1920s, it is dangerous to claim strong links between reading and a sense of self identification, although Edith's extensive written commentaries on what she read help Houlbrook draw conclusions about the way her reading influenced her and allowed her a degree of escapism.[25] What can be said about Elvira is that she read magazines that featured young, mobile, glamorous, active, affluent and cultured party-goers enjoying driving, sports, dancing, films and theatre, and the case files and contemporary newspaper reports, including comments from her friends, describe these as among Elvira's interests. Her hobbies and her lifestyle were facilitated by her money and the privacy it purchased her in her mews home.

Whether or not Elvira did identify with the media she consumed, the narrative formed about her bedroom was that she spent a great deal of time in it. She also read letters in bed, including two from Michael found in her room and read out in court.[26] One letter indicates that he wanted her to find it in her bedroom and read it when he was not there. Handwritten on her pale blue headed notepaper, the pre-printed address ('21 Williams [sic] Mews//Lowndes Square, S.W.1.//Sloane 6869') is crossed out and 'Love Hut' handwritten in its place. He wrote the letter downstairs in the living room, perhaps at the small writing desk, when she was in the house. At one point he smudges the ink because she came downstairs and he had to hide it under his coat, according to the letter. 'Baby, little Fatable,' he writes, 'This little note is to be awaiting your arrival in the place in which I've been happiest of all my life.'[27] That he meant the bedroom is clear from her reply. It seems that she found the letter before he had intended, but she reassures him in her response: 'I will read your letter dozens [underlined] of times when I'm in bed tonight.'[28] Elvira's bedroom was the part of the house where she spent the most time and enjoyed the most privacy, and

the letters and witness statements intimate that Elvira also enjoyed an active sex life there. Such evidence contributed to the case for the prosecution, who needed to draw the attention of the jury to what contemporary society deemed her indecent behaviour, particularly as a married woman and the daughter of a knight with links to royalty. If the jury could be convinced that Michael Stephen's death had been caused by sexual jealousy rather than being an accident, as her defence counsel argued, Elvira could be convicted of murder.[29] This underscores the significant potential power of the photographs of Elvira's bedroom and the narrative they told about her.

The bedroom furniture is exquisite. Even with no colour in the image (Figure 4.3) the flash reflects the fine polished wood and highly patterned silk curtains, the latter woven with a contemporary cloud design. The curtains dominate the image. Descriptions in the police report, compared with the scale plans and the two photographs of the bedroom, show that there was a section of the room omitted from the images Madden made:

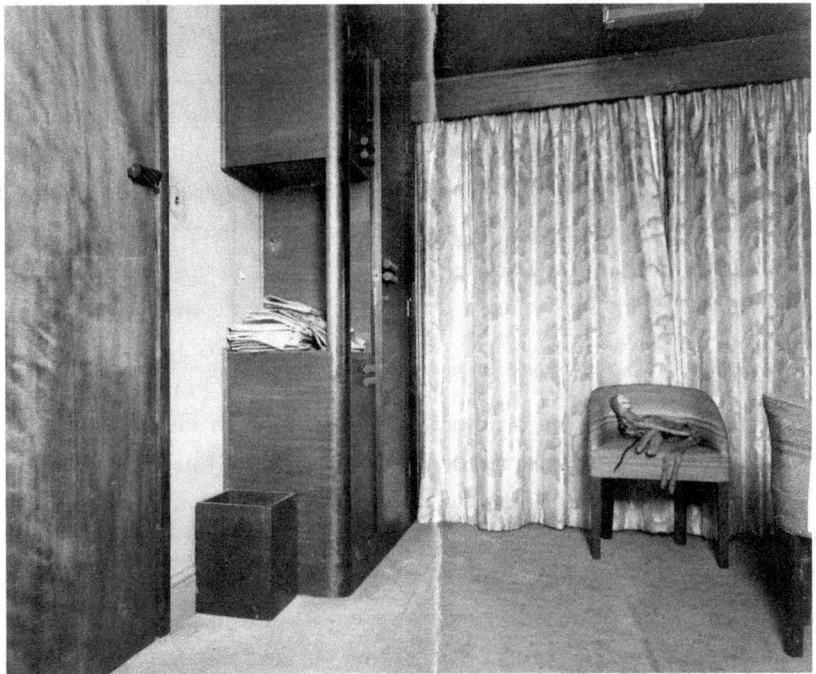

Figure 4.3 Mrs Barney's bedroom [photograph 2 of 5], taken by Sergeant Alfred Madden, New Scotland Yard, at 21 Williams [sic] Mews, Knightsbridge, 31 May 1932. Source: TNA: CRIM 1/610: Barney, Elvira Dolores: Murder: Exhibit 3: (2). © Crown copyright. Metropolitan Police Service. Used with permission.

> At the foot of the bed was a dressing table on which was some spilled face powder and an empty wine glass. Under the dressing table, on the carpet, there was a large quantity of face powder. Opposite the dressing table there was a chair and in the seat of the chair there was also face powder. A fixed wardrobe extended from the dressing table to the window [matching the fixed wardrobes on the opposite side].[30]

More 'face powder' was found in the bathroom cabinet. Metropolitan Police later recorded more overt references to Elvira's alleged habitual cocaine use, and several individuals in her close and wider social milieu were known or strongly suspected users, adding meaning to the seemingly benign reference to cosmetics.[31] Like contemporary press, police were assiduously avoiding overt reference to less-than-legal activities of powerful people and their rich children.[32] Madden's failure to photograph the part of the bedroom that showed 'snow' sprinkled over surfaces might be similarly explained. Alternatively, he may simply have been avoiding the glare of reflecting flash in the dressing table mirror.

The second photograph (Figure 4.4) shows the wallpaper on the opposite wall bears the exact same pattern as the curtains. The upholstered chairs are matching, two seats in this photograph and the armchair in the second image of the room upholstered in the same fabric, from which a matching coverlet is laid on the bed – a pattern of stripes and waves in threads of contrasting luminosity. The room is not very large, perhaps just less than twice the width of a double bed, which is against the side wall so as not to block the fireplace. Over the head of the bed is built-in wooden shelving, again in a contemporary style. Here there are books, a telephone, a tumbler or drinking glass. A modernist motif, which also complements the handles of the wardrobe, is echoed on the fire surround/mantel. The double mantelpiece bears a few small ornaments and trinkets, including what appear to be the kind of straw camel or donkey souvenirs found at seaside resorts. There is a small clock and a framed photograph which might be of Michael himself or it could be Elvira's mother. The bed is not neatly made and there seem to be some pyjamas or nightclothes on top of the eiderdown. There is a coat slung on the arm of the armchair and the seat cushion is half hanging out. It is a pretty, contemporary room, but the furnishings belong in a much larger, finer house. Elvira's home must have seemed a stark contrast to the upstairs of other houses in the mews and this comparison is important. As the Police Report commented:

> The address, 21 Williams Mews, is a different class of house to the majority of premises in the Mews ... [It] is a converted stable consisting of two floors. On the ground floor, on the left upon entering, is a small scullery, and opposite the

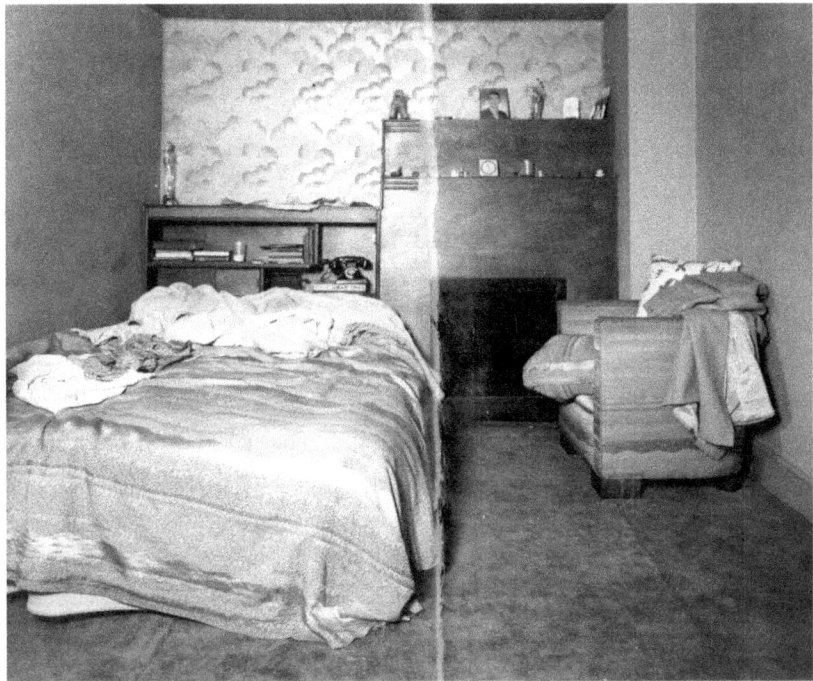

Figure 4.4 Mrs Barney's bedroom, opposite view [photograph 3 of 5], taken by Sergeant Alfred Madden, New Scotland Yard, at 21 Williams [*sic*] Mews, Knightsbridge, 31 May 1932. Source: TNA: CRIM 1/610: Barney, Elvira Dolores: Murder: Exhibit 3: (3). © Crown copyright. Metropolitan Police Service. Used with permission.

entry door is a door leading to a room fixed up as a lounge, and fitted with a bijou cocktail bar in the left corner … the place is prodigally furnished.[33]

Neighbouring dwellings consisted of two or at most three rooms: a single living space for cooking, eating and relaxing and two rooms for sleeping, with the garage and workshop or stables forming the ground floor. They could be quite dark, usually mews houses had windows only on the side that looked onto the cobbled street and the other mews houses. Though there might be an entrance through the garage to the back of the big house, there were rarely windows overlooking it. Bright colours must therefore have been an arresting sight and it seems likely that the other dwellings in the mews contained far more modest and functional furniture than that Elvira enjoyed.[34] Descriptions of the crime scene by police make it clear that the message they wished to communicate was about Elvira's decadent wealth and the amount of time she spent in her bedroom. Contrast this space, for example, with the scullery on the ground floor. No photographs were taken here but descriptions are conspicuous. There was nothing in the room but

the detritus of the party: empty bottles, soda syphons and dirty drinking glasses. Elvira had no interest in kitting out the kitchen with cooking implements and dining accoutrements because she ate out every night. The luxuriously furnished bedroom with large and comfortable bed, soft furnishings, telephone, and plentiful reading material were supportive of Metropolitan Police's view and the crown's contention that here was a lazy, wastrel of a woman who spent more time in her bedroom than her kitchen and demanded people do what she told them or face her violent temper.

It was not until neighbours deposed at the police court that it was clear that, when it came to violent outbursts, Elvira had form. Her relationship with Michael, mainly conducted in her bedroom, also came to the window where it was observed by the entire neighbourhood. The 'wicked' woman regularly appeared there naked or nearly nude, shouting at Michael or taking shots at him in the street below. When her aim, or her resolve, failed, she would threaten to turn the gun on herself and fall down in a faint until he pounded on the door to be let in again. Her relative social position to Michael Stephen and Elvira Barney did not prevent Mrs Hall the chauffeur's wife from telling him to 'clear off' as he was 'a perfect nuisance'.[35]

When these episodes came to light at the police court in the testimony of neighbours living opposite, Madden returned to the mews with his camera and captured an image of the exterior of the house (Figure 4.5) and another showing its situation in the mews – specifically, this photograph (Figure 4.6) would show the upstairs window of Elvira's house and the bedroom window of Mrs Hall directly opposite. Jurors would thus be able to imagine what the chauffeur's wife saw when Elvira was allegedly firing a gun into the mews at her boyfriend a few weeks before his death. It is similar relative comparisons which did so much to damage Elvira's image, illustrated to great effect by the crime scene photographs of her mews home. Compared to her neighbours, respectable working married women, she was guilty of the worst sins against her gender. Compared to theirs, her home was excessively extravagant and shocking. Given that she had alienated them by her home and behaviour, evidence collected and constructed by Metropolitan Police against her was unlikely to paint her in anything but a starkly negative light.

The two exterior photographs are complementary in their framing. The first, Figure 4.5, sets the scene by locating the 'Love Hut' at the centre of the image. Placing the corner of the building at the centre of the frame results in the small mews house appearing to be looming out towards the viewer. By facing the two perpendicular walls, rather than placing the camera parallel with only one, the

Perverting Public/Private Boundaries

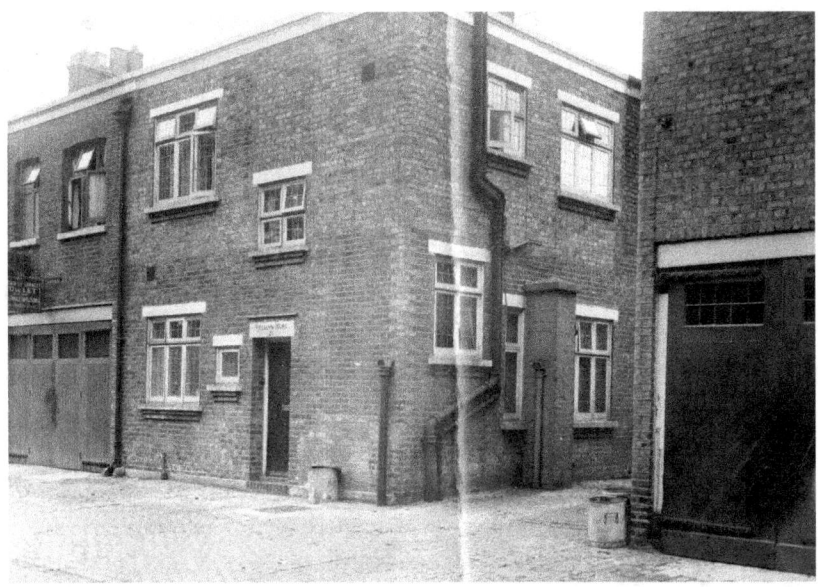

Figure 4.5 21 William Mews, exterior [photograph 4 of 5], taken by Sergeant Alfred Madden, New Scotland Yard, 8 June 1932. Source: TNA: CRIM 1/610: Barney, Elvira Dolores: Murder: Exhibit 3: (4). © Crown copyright. Metropolitan Police Service. Used with permission.

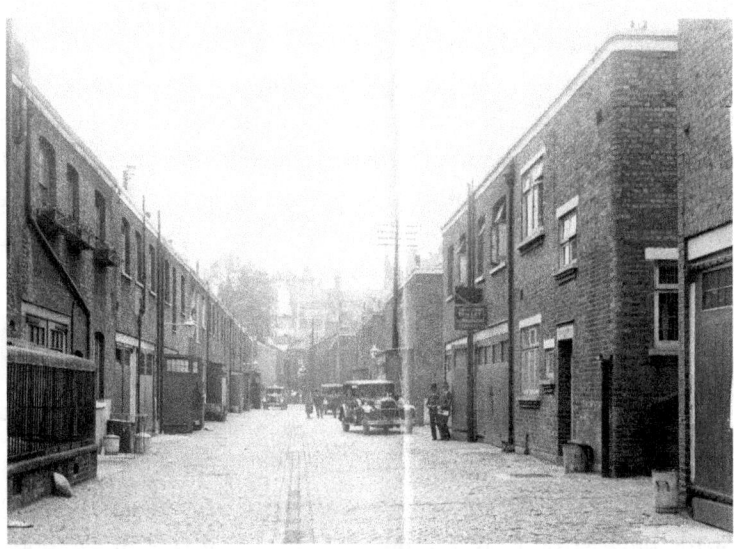

Figure 4.6 William Mews looking north [photograph 5 of 5], taken by Sergeant Alfred Madden, New Scotland Yard, 8 June 1932. Source: TNA: CRIM 1/610: Barney, Elvira Dolores: Murder: Exhibit 3: (5). © Crown copyright. Metropolitan Police Service. Used with permission.

photographer captures as much of the building as possible. Though the point of view of Figure 4.6 is only a few feet away from Figure 4.5, it inverts the first exterior photograph, playing with perspective and pleasing symmetry. The sky, cobbled road surface and two lines of houses converge at a distant and invisible vanishing point. The second exterior photograph is unusual in the sense that there are tiny figures visible in the distance. Metropolitan police photographs rarely included people if they could help it, but the people are at some distance so it is possible that the photographer did not see them when he was setting up his shot. The courtroom transcripts show that these two images were not merely taken for the purpose of showing what the house looked like, but in order to situate the witness testimony of the neighbours. The large window overlooking the mews was Juliet's balcony. Elvira had leaned out of it nearly nude, screamed at her boyfriend in the mews below from it and been seen there with the gun in her hand.

Among the respectable working-class chauffeurs and their families who were her neighbours and the usual inhabitants of these types of streets, Elvira's late-night party lifestyle was noisy, vulgar and out of place. Police were particularly appalled by the expensive furnishings and sexually suggestive paintings which made Elvira a conspicuous character at a time of economic depression and widespread unemployment. The camera's focus on the luxuriously furnished bedroom suggested laziness and sex, supported by the descriptions of objects found there and the descriptions by police. By honing in on items in the house that suggested Elvira was living a sexually and morally deviant lifestyle, police attempted to show that she had motive to shoot the man she claimed was just a friend: sexual jealousy. The evidence seemed stacked against her. A firearms expert showed how Elvira's gun required considerable effort to pull the trigger, hardly compatible with a narrative of accidental firing during a struggle – the narrative Elvira offered in her defence. But Elvira's family wealth and status paid for the best advocate available and she was acquitted of all charges.[36]

Courtroom narratives

The trial of Elvira Barney at the Old Bailey in 1932 demonstrates perfectly how, though evidence was collected and constructed by Metropolitan Police, theirs was not the only narrative of a crime. Though they were the authors of the evidence, police created their narratives, visual and rhetorical, specifically for deployment in the courtroom where other actors assumed the role of storytellers with their own agendas. Judges, barristers and solicitors, at Police Courts and

Old Bailey, were able to use the complex precedents and proscriptions of the law and legal traditions to shape and modify the story for the prosecution. As we saw in the last chapter, images and narratives could be shaped to speak to legal definitions or call on contemporary tropes that defendants and their advocates hoped would lead to acquittal, lesser charges or more lenient sentences. Though it was ultimately the jury who would decide guilty or not guilty, legal actors had at their disposal a variety of legal rulings, technicalities and precedents that could help direct the decisions available to them. Most significantly, it was the space of the courtroom where competing meanings, precedents and traditions vied for the attention and priority of the jury.

In the Georgiou case (Chapter 3), the prosecution focussed on the planning they argued characterized Thomas James' death as murder and not self-defence, accident or manslaughter. Georgiou had bought a knife and gone upstairs to his room to fetch it, they argued. Cutting across this, defending counsel focussed their examination of Margaret McKinnon Watt, as a key witness for the prosecution, as a woman who lied, deceived and practised immorality. Her affair with the victim had caused Georgiou to react, they argued. In the case of Elvira Barney, however, a similar approach would require blackening the name of a young man who appeared, on the face of it, to have been relatively weak. He was not a masculine brute beating Mrs Barney or taking advantage of her. She had invited him into her home and she clearly had money and influence; she could have gotten rid of him had she wished to. The only possible way for Elvira to avoid a murder conviction was to say that the gun that killed Michael had been used to threaten her own life, not his, that he was courageously trying to stop her from hurting herself and the gun had gone off accidentally. It has been suggested that Patrick Hastings, defending, felt more confident about his ability to convince the jury of the latter point – accidental firing, than the former – that Mrs Barney was suicidal.[37] It was a risky strategy to call upon negative aspects of her image as someone having an extramarital sexual affair and a wanton party lifestyle to the extent that she had committed the crime out of jealousy. Even in cases where the jury were convinced that this was a 'crime of passion' did not automatically find the defendant guilty of a lesser charge (manslaughter) or acquit. As in the Georgiou case, such a narrative might mitigate a crime only to the point of mercy in the face of a guilty verdict and death sentence, not necessarily pardon them freely. Hastings could not risk such an outcome where the defendant was a member of the wealthy well-connected elite.

Perhaps her comment about knowing the Commissioner of Police meant that Elvira was surprised to find herself in front of an Old Bailey jury. It is possible, though only conjecture, that she knew the name because of a car accident in central

London a few years previously. Elvira had been badly injured and perhaps there was a danger she might be convicted on a dangerous driving charge until her father stepped in. It was certainly the kind of thing he would be able to use his influence for. Being so closely associated with the finances of the King, Sir John Ashley Mullens might be able to argue that it was best his daughter's name was kept out of the press for the sake of His Majesty. That Mullens and his family had the kinds of connections that would have given him influence with the press is illustrated by the fact that, in years to come, Michael's brother and two of Elvira's sister's husbands would all enjoy careers in newspapers. Elvira might be on trial because she had exhausted her one free pass already. Police were certainly unlikely to let this one go considering how she had behaved towards them and, unfortunately for Elvira, the name she dropped was useless as her connection had retired. The then Commissioner of Police apparently urged pursuance of a conviction, and the press were also pushing for a trial. Concerned letters from interested parties were worried about how it might look if a trial were not forthcoming – that the daughters of knights were getting away with murder was a headline they could not risk.[38] What is clear from the case files is that police were heavily influenced in their interpretation of the crime by the luxurious surroundings and neighbourly misconduct at 21 William Mews. This can be seen in the Police Report, Brief for the Prosecution and Opening Speech for the Crown.[39]

Referred to throughout as Mrs Barney, highlighting her marriage to another man, Elvira's home and lifestyle there were the focus of the opening speech by Sir Percival Clarke.

> She has been living for the past eighteen months in premises known as Williams [sic] Mews, Lowndes Square – an extravagantly furnished converted flat on two floors. On the ground floor there was a lounge and a sitting-room, at one end of which was a cocktail bar [with all the connotations of that piece of furniture]. On the first floor there was a bedroom and another room, in which was a chair and a bath.[40]

Describing the ground floor as a lounge and a sitting room made it sound like two rooms when it in fact was one, besides the small scullery-kitchen. Opening speeches were intended to introduce the prosecution's case, signposting exhibits of evidence and appealing to the jury's rational and logical understanding of what would be fair to the person in the dock. The person in the dock apparently did not correspond, aesthetically, to the photographs of her home. Perhaps this was intentional. The composition of juries was not such that Elvira would be judged by her genuine peers, rather she was more likely the recipient of paternalistic

pity from a male majority jury.⁴¹ The poor little rich girl wore black, no makeup, her face looked puffy and more than once she had to be helped to her feet by the wardresses that flanked her in the dock. Her own defence counsel made such observations and highlighted the ways her image and her home could be manipulated to suit the interests of the press: '[Elvira] would inevitably have been described as beautiful had she been the reverse, just as everything about her little two-floored dwelling was called luxurious.'⁴²

Press narratives

Though press did not fully report all of the proceedings in the trial of Elvira Barney, the commentary that did feature provides an interesting and useful comparison to the official records of the case and trial. With references to the extravagance and perversion of domesticity her home represented, it is particularly revealing to examine differences between visual interpretations of the crime scene used in the case, and those depicted in the press. There existed a long tradition of *Illustrated Police News* and similar publications depicting murder crime scenes, almost invariably at either the moment of discovery of a body or crime scene, or the moment a deadly attack was made (immediately before someone died). Cases from the 1930s are uniquely able to provide such comparisons because it is only during this decade that the use of crime scene photography overlapped with the final years of illustrated press. Drawings were increasingly giving way to photography in newspapers and press were not permitted access to photograph interiors at crime scenes. The *Illustrated Police News*' full page of illustrations for the Barney case (Figure 4.7) compared to the actual crime scene photographs support Alice Smalley's findings that *IPN* based their depictions on stock interpretations in order to appeal to imagined ideas of the crime setting.⁴³ Press were clearly aware that the body was found at the top of the stairs but the landing they imagined does not resemble that depicted in the crime scene photographs, in geography or decoration. Carpet, bannister and diamond pattern on door or wall have no equal in Elvira's house according to any contemporary photographs. 'The cocktail party' in the top left of the *IPN* page does not compare to descriptions of Elvira's lounge, though it is possible that the paper was referencing one of the nightclubs Elvira and her friends attended rather than her home. It is arguably the words 'cocktail party' that bear the most meaning, however, though they are some cues here to wealth and status including the monocle, pearls and clothing of the party-goers, the

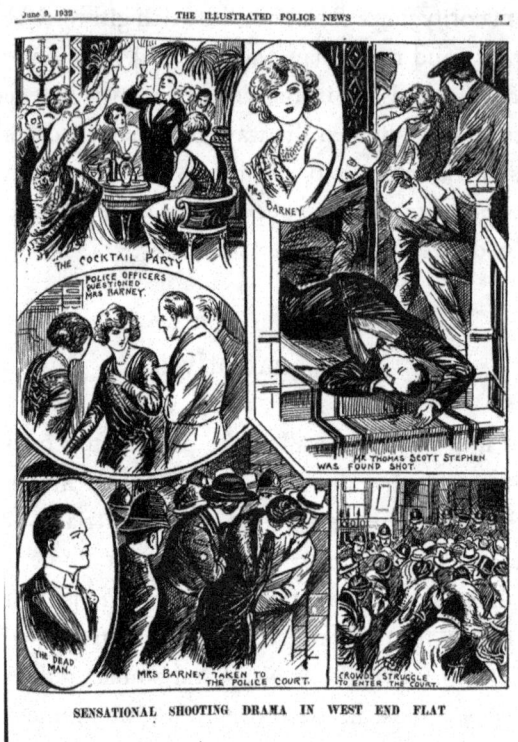

Figure 4.7 'SENSATIONAL SHOOTING DRAMA IN WEST END FLAT', *The Illustrated Police News,* 9 June 1932, p. 5. Newspaper image © Successor rightsholder unknown. With thanks to *The British Newspaper Archive* (www.britishnewspaperarchive.co.uk).

candlestick, curtains, leafy palm and cocktail shakers in the room depicted, real or imaginary. The inset portrait of her, on the other hand, bears some resemblance to an identifiable photograph of Elvira.[44] The bottom right drawing is also recognizable as the exterior of Westminster Police Court. The angled pillars with inset square carvings are directly comparable to the real-life architecture of the entrance to the building in contemporary photographs and the railings also seem to have been copied from life.[45] The imagined scenes *IPN* have included in their composition are engineered to show the luxurious surroundings and cocktail culture Elvira was understood to be part of, but they also illustrate that the artist had seen neither the interior of 21 William Mews nor the crime scene photographs at the time the sketch was made.[46]

Elvira's trial was enthusiastically reported in a variety of press; the majority of whom, in these early stages before the Old Bailey trial, commented on Elvira's home and lifestyle in similar ways. Despite press reporting restrictions which required newspapers to deploy euphemistic language about sex and drugs and

avoid discussing the merits of the case or the framing of the evidence until after the trial, there were concerns regarding public opinion about the case. The Director of Public Prosecutions received an anonymous postcard claiming to have knowledge of the special home comforts Elvira was allowed while on remand at Holloway Prison, including 'telephone, powder-puffs and grand tea-gown etc'.[47] He also communicated with other members of the judiciary who had genuine concerns about the impact of the case on public opinion about the impartiality of the courts. Wilfred Dell, Registrar of the Mayor's and City of London Court, for example, wrote at the conclusion of the trial: 'nasty comparisons are made as to what would have happened had the prisoner been a man or woman without any influence' suggesting that the outcome of the trial might have been different were it not for the wealth and status of the defendant.[48]

With such concerns so high it must have seemed to some observers that Elvira's conviction was inevitable. But as in the Georgiou case, the official outcome of the trial was not necessarily synonymous with the view of justice being done. The judge's summing-up in the case was widely reported, particularly his condemnation of wealthy young people and their 'wasted lives'. As one commentator pronounced: 'He [the judge] could see, with his wise eyes, further than the dock ... the whole social order being undermined by a gang of pin-heads.'[49] In the *Daily Herald*, journalist Hannen Swaffer moralized about the entire generation, describing the cult of cocktails as a specifically classed and sexualized movement characterized by 'modern life in a mews, the invasion of stable yards ... lived in, until recently, only the by the families of those in charge of horses'. These respectable working people, he claimed, had recently had their nights 'made hideous' by 'the Bright Young Things who have gone there to live- silly young people to whom jazz is the music of the heavens'.[50]

Despite Elvira's acquittal, the journalist claimed, 'what was found most guilty of all yesterday was a phase of modern life which, adulated, flattered and advertised, is spreading its poison right across the West End of London-yes, right across the world.' Swaffer was less euphemistic than some newspapers about the sex lives of Elvira's set: 'Effeminate young men take part in these parties ... young men go dressed as women, and women as young men. All three sexes are on parade!' There were further political implications too: 'They are Bolshies in dress clothes, for they hate Law and Order. They despise it. They are a danger, not only to their own class, but to all the other classes in the land ... Oh, the books they read! Oh, the plays they bleat at! Oh, the wasted lives!'[51] Swaffer's enthusiastic editorial highlights the specific geographical framing of the mews and its respectable working-class identity that Elvira so spectacularly transgressed. With such condemnatory language by the judge celebrated by the author, one might expect

that the conclusion to the trial was a conviction – a verdict of guilty of murder and sentence of death, or at least guilty of manslaughter. But Elvira Barney was acquitted. Most press seemed to celebrate rather than commiserate. Whether because of her connections, wealth or influence, or simply because she made for interesting reading, the public's appetite for justice appears, from press reports, to have been satiated simply by the rhetorical rather than legal condemnation of her social circle and their lifestyle and habits. Elvira herself did not need to be found guilty for justice to be seen to be done. Moral lessons were highlighted in the weeks after the trial:

> For three days the court held a microcosm of the world. Life with all its pain and passion, its sin and suffering and splendid courage was epitomised within its walls ... I heard the voice of eternal justice as clearly in the judgments of Mr Justice Humphreys as ever Moses heard it on Mount Sinai. The judge condemned that cocktail philosophy of selfish pleasure in which thousands of people to-day – many of them in high society – are spending their useless lives.[52]

Elvira provided further fodder for those who would point to her lifestyle and pity her rather than envy her. A few weeks after her acquittal she was before the courts again, this time in France, having gone back to her fast lifestyle and caused a serious car accident.[53] She was not out of the headlines for very long, *IPN* published very different drawings of Elvira Barney in 1936 when she died in a Paris hotel room, only a few years after her acquittal.[54]

Conclusion

The case against Elvira Barney for the murder of her boyfriend 'Michael' William Scott Stephen provides a snapshot of the private life of a wealthy socialite who enjoyed all that money could buy, including privacy, art, fitted furniture and coordinating curtains and wallpaper. Though she could have lived in much more luxurious surroundings a few hundred metres away with her parents and sister, her converted mews house gave her the independence from them that she craved. She could drive her own car, keep late hours, host noisy parties, go out, drink and take drugs, and sleep with whomever she liked. She faced neither her parents' shame nor a public scandal so long as the people she surrounded herself with would keep her secrets. Elvira's home and lifestyle differed little from her contemporaries; her behaviour did not deviate from the norms of her 'set'. But the face

powder, matching curtains and gun had different meanings in the context of the mews, where Elvira did not belong. The crime scene photographs, by contrasting the interior with the exterior of the house, demonstrated Elvira's indiscretions – her failure to fit in with the respectable hours and even maintain the appropriate boundaries between upstairs and downstairs, inside and outside. By bringing her neighbours into her home through her expansive converted house and its huge windows she was corrupting them. But that these messages needed only be communicated subtly is clear from the fact that this supposed highly corrupting painting in the downstairs living room was not photographed. That room was not part of the crime scene and so a description of it would do.

'The impediments of fetishism and perversion' might sound like references to sex but they refer to the fetishism of material items, the obsession with 'things' evidenced by Elvira's expensive furniture and art packed into the tiny house. Her library may have featured 'books that would not make it through her majesty's customs' – perhaps she owned the kind of queer literature some of her friends were interested in.[55] Elvira may have been bisexual. But what she was guilty of perverting was the boundaries of class and rules of behaviour. Elvira Barney's case shows that, even in a home that was modest in size compared to what she could afford to live in, improved amenities, more modern design, newer furnishings and more fashionable decorations could be purchased, but these were not the most influential factors on everyday life and experience at home. By pushing the boundaries of her home outside the walls of her house Elvira could take advantage of the additional space, attempt to wrestle control over who was allowed inside and when, and enjoy freedoms not normally associated with her class. It was her economic and social capital that allowed her to do this. The case of Michael Stephen's death illustrates that the boundaries between public and private and between the social worlds inside and outside the home space (in itself not restricted to the walls and doors of the building) are not distinct, or fixed; rather, they are constantly being negotiated.

However, the trial of Elvira Barney demonstrates, like the Georgiou case, that very little about a crime can be determined by the outcome of the trial. Official outcomes were not necessarily equivalent to the prevailing view of the circumstances of the crime. The evidence against Elvira Barney for the deliberate killing of Michael Scott Stephen was powerful, but she was not found guilty of murder. She was not even punished for her illegal possession of the unlicensed firearm that killed him, despite the evidence for that crime being incontrovertibly proven.[56] For justice to be seen to be done did not necessarily

mean following the evidence to the most obvious conclusion. Furthermore, the trial of Elvira Barney shows that the perspectives and priorities of police and judiciary, public and press, were not necessarily the same. The next chapter turns to the two-way communication of narratives about murder and justice, including the visual, and suggests how common narratives could be drawn upon to attempt to divert an investigation.

5

'Murder Story': Telling 'Ripper' Tales in Limehouse and Beyond

COPY: Exhibit 'H'

… There was the usual crowd at "The Brown Cow", the town's local. They were all in little groups, standing at the bar with their glasses of their favourite beverage on the counter not far away from them.

"What do you think of the 'Vermin Alley' murder?", asked one, a certain Steve Carter, who was engaged to a lovely girl, Pauline Brown.

"A dirty piece of work, if you ask me", replied Bob Elliot, who was very busy with his old and mild. "Why should anyone want to murder a pleasant young girl as Maria Townsend. It makes my blood run cold to even think of it".

"They made a horrible mess of her, whoever it was", spoke out Carter again. "Did you see the body, Bob?".

"I'll say I did", said Elliot slowly. "It was covered with blood and mutilated beyond recognition. It looked as if a great bird's sharp talons had ripped at it. The flesh had been torn off in large lumps, and the victim's insides could be plainly seen. It was ghastly, ghastly".

… Steve shut the door behind him and began his walk through the poorly lighted streets. The lighting was supplied by gas lamps, which were just bright enough to show the way. How different the town was by night than it was by day. It was Saturday night, not that it was any different from other nights except for the one thing that filled the quite [sic] houses with dread. The hidden horror that lurked in the dark. Behind the walls of the houses, peace; in the streets, a creature, heaven knows what!

… Elliot began walking more slowly as he faintly saw the entrance to the passage. Perhaps the monster was in there waiting for him! They say a murderer always returns to the scene of his crime, but maybe that might not apply to a monster. It was probably miles away from here, possibly hundreds of miles.!

The alley was nearer now, much nearer! In a few moments he would know! The entrance looked black and menacing as if horrible death lurked inside! It was ten feet away now, nine feet, eight, seven six!. The name was just audible [*sic*] on the iron plate nailed to the brick wall of one of the houses next to it, 'Vermin Alley'. He wanted to turn and run but the silent opening hypnotised him! He had to know if anything was down there, and he trembled at the suspense. He was opposite the passage now, and he shook like a leaf in a high wind! Then his eyes popped out of his head, and the perspiration poured down his face! Something had moved in there; something had actually moved! What was it? It must be the monster! It was going to kill him! He was finished! It moved again! Horrible visions of his body being torn to pieces flashed vividly into his mind! It was terrible, awful, shattering![1]

So went extracts of the 'Murder Story' manuscript found in Frank Harrison's desk drawer after he was arrested on suspicion of the murder of his wife in 1957. After multiple killings and terrifying night-time encounters, the men of Harrison's fictional town eventually cornered the 'madman with hooks for hands' in the local haunted house and he was killed in a face-off with one of the story's tragic male heroes. Though the story borrows from a variety of genres, the dominant theme was the violent 'Ripper'-type killings of young women. The Ripper trope has proved a pervasive cultural trope repeated in literature, film and still image throughout the twentieth century and beyond. Criminologist Louise Wattis and historian Judith Walkowitz have argued that the Ripper has become a cultural cipher through which social and moral priorities and concerns of any age can be articulated by variations on the narrative, a view supported by the cases explored in this chapter. Furthermore, Megha Anwer and Lynda Nead have highlighted strong visual, spatial, imagined and affective representations of the Ripper narrative.[2] My contribution to this literature is to demonstrate how the narrative could be deployed forensically; that is, how accused murderers and their defence counsel called upon these familiar Ripper references in pursuit of specific outcomes which were historically and legally contingent.

Frank Harrison's 'Murder Story' employed repeated references to established Ripper visual imagery, including tenement housing, a faceless stalker, labyrinthine alleyways, Victorian gas lamps and evisceration of female bodies.[3] Despite sensational newspaper reports to the contrary, the story did not anticipate the type of violence Harrison was accused of using against his wife. Doris Harrison's decomposing body was found in a cupboard under the stairs of their suburban home many weeks after she had been reported missing

by friends and family in 1957. She had suffered multiple skull-fractures which police believed had been delivered in the couple's bedroom. The narrative established by police and prosecution was that Frank wished to rid himself of Doris and sell their house so he could start a new life with his girlfriend.[4] However, the powerful references to violence in the story he imagined were deployed by his defence counsel as evidence of his 'morbid or unwell mind'.[5] Furthermore, attempts were made in cross-examination of witnesses to portray Doris Harrison as a nagging wife whose decision not to have children caused arguments with her husband. These strategies were employed with the aim of evoking sympathy for defendant over victim because, under the new rules recently codified in the 1957 Murder Act, acceptance of these alternative narratives would diminish Harrison's responsibility for the killing and entitle him to a conviction for manslaughter rather than murder and potentially a significantly shorter sentence. As the judge took great pains to explain to the jury, if Harrison had been brought to trial only a year earlier, he would have faced the possibility of capital punishment as it was then the mandatory sentence for a murder conviction.[6] This is an important context because, as Lizzie Seal has argued, the possibility of hanging affected jury's verdicts.[7] In Harrison's case, the jury were released from the grave possibility of sending a man to be hanged and had no difficulty finding him guilty of murder. Despite several evocative murder stories offered to the courtroom, the jury's verdict seemed to endorse the view that the prosecution's narrative was the more compelling; that Frank Harrison had transgressed the boundaries of his marriage by sneaking off on holiday with his mistress and conducting his affair in full sight and understanding of his colleagues at work.[8] Harrison's Ripper story did not figure in this accepted forensic (i.e. courtroom) narrative.

As argued in previous chapters, evidence for a murder, including powerful visual material, was compiled in order to construct a narrative that spoke directly to contemporary social and moral priorities and concerns. Murder of romantic partners, spouses or potential spouses, wives, girlfriends or mistresses and accompanying narratives, categories of murder and cultural tropes were most familiar to press, public and judiciary alike. Their intensely emotional narratives of disappointment, betrayal and jealousy had the potential to evoke the strongest feelings of sympathy and mitigate crimes. It is important to understand the powerful incentives that existed for men accused of partner-murder to describe their wives as unfaithful, nagging or transgressing other contemporary moral boundaries: whether such portrayals were accurate or not, they could evoke sympathy from the jury, judge and Home Office; mitigate crimes; lessen

sentences; aid appeals for mercy; and in some cases help men literally get away with murder. Nowhere is this more apparent than during the years of the Second World War and the period of demobilization of British and allied forces in the years immediately following. Returning soldiers who killed wives alleged to have been unfaithful while they were away fighting for their country were treated sympathetically on such a frequent basis that a familiar narrative was created and circulated widely by press and judiciary themselves, referred to here as 'the returning soldier narrative'. Gendered discourses surrounding defending one's home, family and nation at all costs, maintaining morale and the comforts of home, visible in contemporary social concerns and commentary as much as in the physical landscape of the capital, contributed to the power of this narrative in the courtroom.[9]

As Lynda Nead has argued, the war had an associated visual vocabulary – common affective tropes and structures of feeling that cut across a variety of media, cultural representations and public fora.[10] Crime and justice were also imbued with visual, literal and imagined structures of feeling associated with wartime and reconstruction in the 1940s. In London in particular, a visual culture of murder called upon visceral imagined landscapes that included hiding crimes in ruined buildings, concealing bodies under rubble, air-raid sounds masking screams and dangerous men lurking in the lonely darkened streets of the blackout or disappearing in the anonymous crowds of peripatetic servicemen.[11] These are just a few examples of familiar imagined and visual referents, read in depictions of crime scenes that signified a particular type of murder and could be called upon to pursue a murder conviction or defend against one. Police, photographers and legal counsel were not the only agents capable of influencing the visual record or shaping the narrative at or of a crime scene, however. The killer himself could stage certain aspects of a scene in order to manipulate readings of the murder. To do so he could draw on imagined references to crime scenes widely available in popular culture. Though the returning soldier killing his wife was statistically far more common than stranger-murder, the latter, including Ripper narratives, loomed larger in popular culture both contemporaneously and in the years since the Second World War. This chapter explores both tropes, referencing several wartime cases but particularly focussing on that of Patrick Hartney who came to trial in 1946 for the murder of his wife Lilian. I use the case to demonstrate how the defendant attempted, through visual staging that was enhanced by crime scene photographs, to spin a killing as a sexually motivated stranger-murder, placing the culpability for the crime with his wife's urban mobility. For his defence counsel, however, the confines of the law and judicial discretionary

powers meant it was necessary to place Hartney in something closer to the returning soldier trope. The Hartney case demonstrates to a distinctive degree the highly significant role visual aesthetics played in understanding and deploying narratives of crime, and the way they were represented through the medium of crime scene photography.

The returning soldier narrative

Wartime popular culture highlighted the imagined visual characteristics of common wartime themes and their rootedness in domestic continuity and gendered roles. In the film *Since You Went Away*, for example, Tim Hilton's comfortable empty armchair waits his return from war in the opening credits.[12] His wife, Anne Hilton, experiences changes and deprivations associated with national and global wartime conditions, as well as the more personal impacts of war at home, including Tim's absence.[13] Though the film was made in the United States, this domestic wartime scenario was recognizable to women on both sides of the Atlantic. In a letter to her husband who was serving in Burma in 1945, Kathleen Patmore wrote that she had seen the film at the pictures and described the Hiltons' half empty home as like that of servicemen and their families all over England.[14] Her letters, and others that became exhibits of evidence in murder cases, support a view of the Home Front as a complex gendered space in which women faced daily domestic challenges that seemed incompatible with an uncomplicated family reunion when the war was over. Irretrievable changes were wrought on all aspects of life, including altering the traditional divisions between genders and social classes, home and work. Combined with the physical and emotional impacts of war on men, women, relationships and families, other wartime conditions lingered after fighting ceased: demobbing was slow, rationing continued, resettlement, rebuilding and reconstruction affected everyday domestic life well after 1945.[15] The war also lingered visually, Lynda Nead argues, referencing colourless ruins, fog and clothes rationing. These images, particularly associated with the changed exterior landscapes of urban streets, sharpened the significance of interior domestic familiarity, consistency and comfort.[16]

The highly charged meanings of home are particularly evident in cases of murder in the years between the start of the war and the end of demobilization. Any non-domestic activity by married women during the war could be portrayed as evidence of betrayal of husband, home, family and country even years later.

Lingering impatience associated with waiting for the war to end, long periods of separation caused by serving or being billeted, suspicion of associating with other men, jealous feelings about 'going out', could all be mapped directly onto commonly understood features of manslaughter: long-term, slow-boiling factors eroding a relationship, with a sudden trigger like coming home causing the defendant to 'snap' and kill his wife suddenly. Though constructed in a way that clearly biases the account against the deceased wife, returning soldier wife-murder cases and their evidence therefore describe marriage and family life over the long-term: how a couple met, how long they had lived together, where each had been working or living more recently, the specific circumstances of the war. Files include letters between couples and depositions from friends and neighbours regarding their marriage and home life together and separately. Case files for returning-soldier murders provide historians with a variety of opportunities, including exploring the impact of global events on individuals, marriages, families and homes, the personal experiences of demobilization and reconstruction often obscured by nostalgia and national sentiment. However, they also invite us to be deeply sceptical about sources that assign personal blame because such narratives minimize the impact of historical events on family breakdown, divorce and spouse murder. Social and political agendas were not well served by tropes that perpetuated the idea that murder was the extreme outcome of common problems, of everyday domestic conflict.

Home and domestic life were consistently evoked in cases of murder where returning soldiers killed their wives, domestic failures of women contrasted directly with men's wartime service. Evidence archived for the murder of Ivy Booth by her husband Fred in 1945, for example, highlighted her lack of letter writing to her husband and how this allowed him to imagine she 'was taking advantage of my being abroad and having a good time'.[17] His status as a soldier was highlighted by press in sympathetic pen-portraits of Fred and damning ones of Ivy. She was at the pub when he came home unannounced, rather than at home, newspapers commented.[18] Similarly, Cyril Patmore wrote to his wife Kathleen when he was abroad in Burma, she had 'a funny way of showing [her love]' for him, he said, asking where were the regular newspapers, cigarettes and letters he expected from her.[19] Reg Keymer sent his Army Chaplain to check on his wife Peggy when her letters became irregular. He suspected she was going out and having a good time with her girl friends in the Land Army when she should have waiting at home for him. After her death, letters in Peggy's handbag became evidence at her husband's trial, showing that she had been writing to other men. They were explicitly referenced in press reports as influencing the

jury to treat Reg sympathetically when he was tried for her murder.[20] These are only a few examples of what seemed, even to the judiciary, to have become such a common phenomenon that there were concerns that servicemen would begin to believe they could kill their wives with impunity.

This fear is well illustrated by the comments of a judge summing up a case of wife-murder by a returning soldier who was struck by the frequency of such cases:

> It remains the law, subject to certain aspects of provocation, that no man or woman is allowed to take the law into his or her own hands and kill an unfaithful wife or an unfaithful husband. That should be known by everybody. If Parliament thinks fit to pass an Act that returning soldiers, finding their wives unfaithful, may kill them, and, if they do, it will be manslaughter [rather than murder], it will be the law. Until that is done it is not the law.[21]

The judge was informing the jury that a narrative of sexual betrayal did not legally mitigate the murder charge and entitle the defendant to a verdict of guilty of manslaughter instead. However, the outcome of the case and newspaper reporting on it demonstrate that the jury found the narrative more powerful than the judge's instruction on the law and pronounced the defendant guilty of manslaughter.[22]

On 16 February 1946 the main headline on the front page of the *Daily Mirror* announced '2 HUSBANDS ARE CLEARED OF WIFE MURDER'. The two cases were 'soldier Frederick Marshall Booth, 33, who had told of constant rows with his wife after his return from the Far East. Acquitted … ' and 'Patrick Hartney, 51, ex-naval stoker, who had told the Old Bailey No. 1 Court: "I loved my wife. I did not murder her."' The back page of the same paper continued the stories of the two cases. Under the headline 'His "mind went blank" in row in bedroom', it was reported that Judge Mr Justice Staple had 'told the jury that "guilty" or "not guilty" was the only verdict they could give' in the Booth case 'they must rule out manslaughter'.[23] The Booth case file fragments suggest a contrasting narrative in which the suspicious husband tried to trick his wife by coming home on leave unannounced, resurrecting an ongoing argument about his distrust and the kind of life he expected her to lead. He did not want her to go out, even to work, but the loneliness was unbearable. The argument ended when Ivy resisted Fred's attempted rape and he strangled her.[24] It is not possible to be certain about this narrative of events any more than it is possible to assert that Fred might not have walked free had the Jury been able to convict him of manslaughter. Booth's temporary loss of control did not align with popular notions of murderous aforethought. There

is also some evidence to suggest that juries and mercy decision-makers thought differently about the death sentence against the background of wartime loss of life.[25] This further supports the argument that definitions of murder and interpretations of criminal evidence were historically contingent.

As for the other husband cleared of wife murder in the headline, Patrick Hartney, 'He was [the] "perfect husband"' and his dead wife's parents said they knew he 'could never do such a thing'. He 'wouldn't hurt a fly', said her mother. His status as an ex-Navy stoker who had recently been discharged on medical grounds was highlighted. Contrasting the spouses, the report pointed out that Lilian Hartney was younger than her husband and described her as 'very passionate'. Most significantly, she 'used to say he was no good to her and taunted him because he was deteriorating physically. That might have preyed on his mind.'[26] Again, this somewhat euphemistic reference to provocative sexual behaviour by a wife seems at odds with the not guilty verdict and the statement of innocence from the victim's mother. It may be explained by an instruction from the judge that the jury rule out manslaughter, as in the Booth case reported under the same headline. Consideration for Hartney's health may also have played a role in sympathies for him. Medical reports identified that it was not tuberculosis Hartney was suffering from, as press reported, but advanced lung cancer – information that was not shared with the patient. He had not long left to live, they said.[27] The Home Office would have been reluctant to hang him in such circumstances. Hartney's acquittal did not lead to further investigation in order to identify other suspects; the conclusion to the trial was not that Hartney had not been responsible for his wife's death but that he would not be hanged for it. His defence advocates' strategy – provocation – the narrative that Hartney temporarily lost control following his wife's taunts rather than welcoming him home, staying in at night and giving up her job to take care of him when he was discharged from the services, was not the same as that offered in the hours after Lilian's death was discovered and photographs made of the scene. Later, Metropolitan Police became confident that Hartney had manipulated the crime scene. Drawing on visual culture and popular contemporary notions of stranger-murder, he had attempted to make it appear that Lilian had been killed somewhere else by someone else.

Ripper narratives

On Tuesday, 7 August 1945, *The Daily Mirror*'s Crime Reporter drew on a variety of visual references to fashion a narrative of discovery:

> In the narrow by-ways of Limehouse, London, hundreds of detectives were searching yesterday for a strangler ... Mrs. Hartney's body, only half-dressed, was found at dawn. A look of horror was on her face ... Only a few hours before, she had left her home in East India Dock-road, Limehouse, after reading a crime thriller, "The Lodger," based on Jack the Ripper, notorious killer ... a mysterious stranger had been following her from district to district in the past few months.[28]

In the hours immediately after Lilian Hartney's body was discovered, Metropolitan Police pursued this narrative of stranger murder and allowed it to shape their early recording of the scene. As this section of the chapter will show, Lilian's body was situated in a way that strongly referenced 'Ripper'-type killings, drawing on an established visual language of murder with an associated narrative that did not implicate her husband.[29] As with preceding chapters, my impressions of the case are based on the files preserved at the National Archives and assume no 'facts' from the incomplete and partial documents relating to the investigation and trial, or from press reports and trial outcome.

The murders in Whitechapel in the 1880s have a well-rehearsed and widely known visual language. The Jack the Ripper streets were, indeed are, imagined as night-time alleyways, narrow cobbled 'warrens' with dangerous dark corners, fog and flickering gas lamps, close to, but hidden from, busy main thoroughfares (see Figure 5.1).[30] The middle-class male gaze of the Victorian press constructed an image of Whitechapel as visibly poor, alien, with transient 'foreign' populations and cosmopolitan cultures characterized by a variety of social ills including sex, prostitution, drink, disease and crime. These fantasies pre-existed the sexual murders of 1888 attributed to 'Jack the Ripper' but were sharpened by the violent killings of women whose identities were imbricated with the image of the spaces in which their bodies were found – public but secret equating to unknowable danger just below the surface. The doorways, courtyards and dosshouses appearing in illustrated press imbued the Whitechapel horrors with a geographical and environmental character that was visually recognizable but simultaneously unknowable and ungovernable. For example, *The Penny Illustrated Paper*'s full page of illustrations subtitled 'The Miller-Court Murder, Whitechapel: Site of Mary Kelly's Lodgings' (Figure 5.1)[31] echoed earlier coverage such as 'Scene of the Terrible Murder in Hanbury-Street, Whitechapel'.[32] These illustrations located the sites of the murders in multiple scales, depicting the broken window through which 'the murdered woman was first seen' in the Kelly case and indicating with a cross the precise location on the drawing, in the yard by the fence, 'where body was found [Hanbury Street]'. Mary Kelly's lodging was additionally shown in the context of the narrow gas-lamp-lit court in an inset

illustration, where half-hidden women peeped out of doorways and windows, another standing in the street with her hands on her hips. Both the thoroughfare facing 'No. 29 Hanbury Street' and 'Entrance to Millers Court in Dorset Street' were illustrated on the covers of the respective editions, including crowds of people and helmeted police. One might be a slightly reduced inverse print of the other, the drawings are so alike. As Judith Walkowitz has argued, the illustrated press created a common imagined iconography of the Ripper murders, a visual vocabulary representing outdoor danger in confined but public spaces. The inevitability of the crimes was linked to the perceived identities of the women and the environmental, social, material and economic deprivations that led to their vulnerability.[33]

The Ripper aesthetic of shadowy alleys was central to the contemporary popular culture of the murders and has been a common feature of their cultural memory. However, it is not based on crime scene photographs. As Megha Anwer has pointed out, the Mary Kelly bedroom photograph, widely considered to be the first 'crime scene photograph' in England and Wales, is the only photographic image authorized by police that depicts the body in situ. All other police photography related to the Whitechapel victims shows their bodies in the mortuary.[34] This has the effect of making the person of 'the prostitute' (as the victims were identified) the cause or provocation rather than the victim of the crime. Furthermore, the Mary Kelly photograph was taken indoors, and does not depict the situation of her bedroom within the wider geography of building, court or street depicted in press illustrations (e.g. Figure 5.1). Yet the Ripper murders have been associated with a visual rhetoric that places women in public space in sexual danger, at risk of bloody violence and mutilation, and associates the material deprivations of crowded, working-class urban housing with feelings of fear. The same contradictions are observable in the less-remembered crimes of the 'Blackout Ripper'. Gordon Cummins, whose crimes were discovered in 1942, was given the soubriquet 'Ripper' as a relatively inoffensive code for the sexual mutilations he inflicted on his victims. As with the 'Yorkshire Ripper' later in the twentieth century, it also had the effect of pathologizing those victims as prostitutes, or at least women walking the streets after dark. Though the Blackout Ripper crimes were mobilized to make women fearful of being in public spaces at night, five of Cummins' own 'canonical six' victims (four murders, two attempted murders) were attacked in their own beds.[35] Cummins was more likely motivated by material gain than sexual pleasure to commit his crimes, stealing money and items of value from the women he killed. The sexual injuries and post-mortem mutilations he performed were mobilized in his defence as

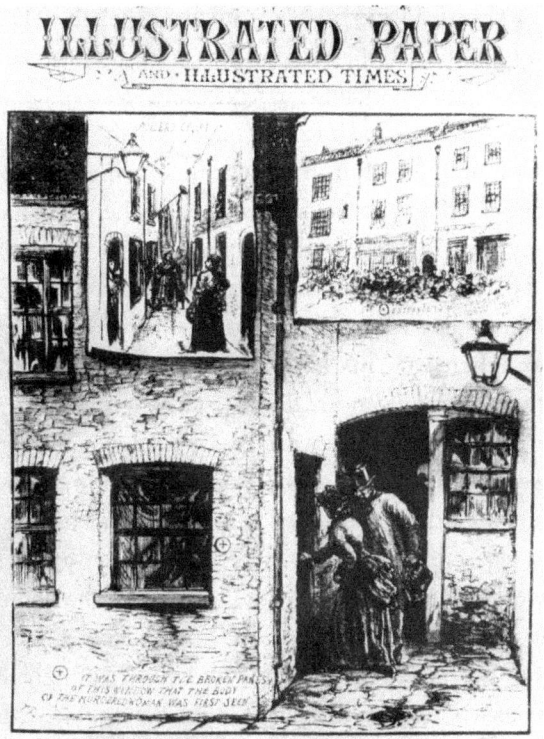

Figure 5.1 'The Miller-Court Murder, Whitechapel: Site of Mary Kelly's Lodgings', *The Penny Illustrated Paper*, 9 November 1888, p. 1. © Interfoto / Sammlung Rauch / Mary Evans Picture Library. Used with permission.

symptoms of mental disturbance and mitigation, a strategy not unknown in twentieth-century English courtrooms. (Janet Weston's detailed and thorough analysis of the medico-legal implications of diagnosing sexual crimes is highly instructive here.)[36] This represents a potential manipulation of the crime scene visuals in itself: based on an understanding (though limited and inaccurate) of criminalistics, Gordon Cummins tried to create a crime scene at odds with the upper-class identity he cultivated. However, for the purposes of this chapter it is sufficient to say that the 'Blackout Ripper' was contemporary confirmation of sexual murder associated with urban danger, his hunting grounds imagined to be the kind of lonely dark alleyways and semi-ruined Victorian streets his namesake had frequented.[37]

Lilian Hartney's murder was initially investigated by police as a 'Ripper' killing because the scene and situation in which her body was discovered so closely resembled the imagined setting associated with these crimes. Though Gordon

Cummins was by now dead and the Blackout was officially over, the crime scene referenced many familiar Ripper tropes that were reinforced, I argue, by the framing of the photographs. Lilian Hartney's body was laid out at the foot of the large wide wooden doors that led into the precincts of the Labour Exchange. It was a Victorian brick building with iron railings that formed a square entranceway in front of the doors. Lilian was laid across this area, her right hand touching the doors where they met. Her feet were hip-width apart, toes pointing outwards, legs straight and bare of stockings. Her dress was lifted up and folded back at the front to expose her pubic region, apart from which she was fully clothed. Her coat was open and there were marks visible on her neck and left wrist. Her head was turned outward, away from the doors, facing her handbag which lay a few inches from her left shoulder. Her wedding ring, earrings, a brooch or posy on her coat lapel were all visible; she was dressed too well to be going out to work, one might observe. Curled tendrils of hair lay around her head, once styled, now messy, and cigarette ends, leaves, tickets and other paper litter seemed to have been blown around her by an eddying wind.[38] The camera angle places Lilian's pubis at the centre of the frame, not taken from directly overhead but likely as downward facing as the tripod would allow without showing more of the doors, or the legs of the tripod itself. (Unlike Paris crime scene photography which positioned the tripod and camera directly over the body and in doing so ensured the equipment was captured in the photographic frame, Metropolitan Police sought to exclude any suggestion of their own equipment.)[39] Rotating the image 90 degrees, portrait, rather than landscape, Lilian could be standing in a defiant pose with her right hand on her hip.

The second crime scene photograph was taken from a few yards away and depicted Lilian's body in the wider space of the yard entrance blocked by the doors. Framed in order that her body was viewed side-on, about one third from the bottom of the image, the photograph depicted her facing the camera. The perspective is lower than the standing eye-level police photographers were guided to use.[40] The street in front of her is cobbled and she is boxed into a small space at the entrance off the street itself, the railing on the right of the doors, the brick wall on the left. This is a space of night-time assignations – a closed-in area, the doors are virtually invisible from an angle up or down the street – Lilian Hartney's body could only be seen when the doors were practically face-on. Though the balconies of nearby flats overlooked the spot, it is unlikely that residents would be able to see the body because of the doors and wall blocking the view. Only the yard doors of the public building were possible witnesses. With her dress lifted to show no knickers, her coat still on and her handbag nearby, the scene says Lilian

was either engaged in prostitution or was out seeking sex. The photographs of Lilian Hartney's body are confrontational. She returns the photographer's gaze just as Mary Kelly did in the photograph of her murder scene.[41]

The third crime scene photograph betrays some (living) human presence and suggests a narrative for Lilian Hartney's murder as the third in the sequence of photographs. Here, it is Figure 5.2, and the first shown here from the Hartney case, but it should be remembered that it is the third photograph George Salter took on 6 August 1945. Lilian Hartney's body is concealed from the camera lens by the square section of wall in the lower left-hand quadrant of the image. The tops of the wooden doors are just visible over the wall. Directly opposite her body, on the extreme right of the photograph, a uniformed police officer is standing backed against the wall, trying to hide himself from the camera's view. At his feet is the tarpaulin used to conceal Lilian Hartney's body from public gaze. In the distance, it is clear why such a precaution was necessary. With Salter positioned

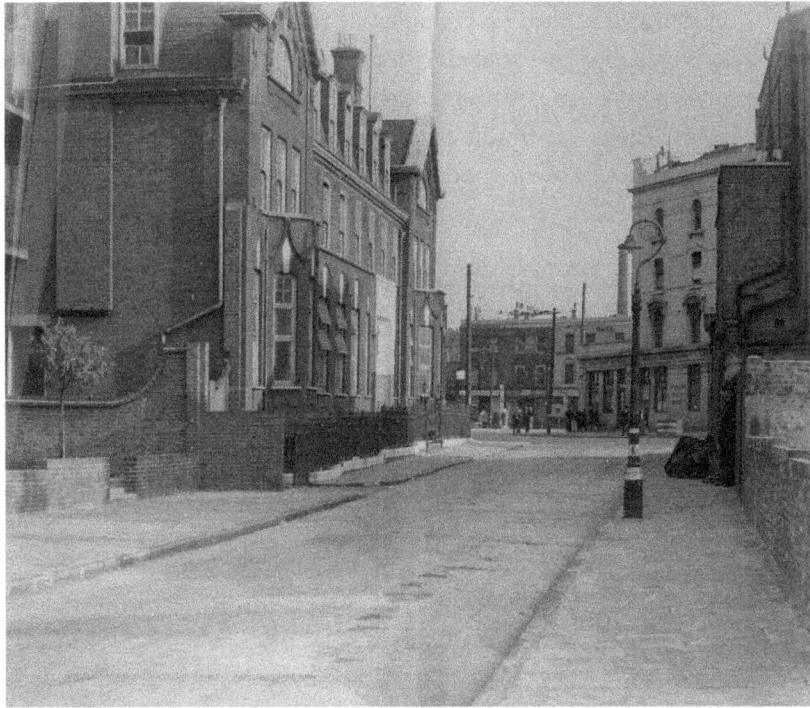

Figure 5.2 Rich Street, Limehouse, photograph 3 of 3 taken 6 August 1945 by Detective Sergeant George Salter, New Scotland Yard. Source: TNA: CRIM 1/1754: Hartney, Patrick: Murder: Exhibit 10: (3). © Crown copyright. Metropolitan Police Service. Used with permission.

on the pavement but looking towards the point at which this side street meets a public thoroughfare, people on the opposite corner of the street can be seen. This small section of road is a busy public thoroughfare – a complex junction of multiple roads and tramways. As described in previous chapters, police could not very well move on every person in the area when they were photographing public spaces. But in this instance capturing people in the frame likely served a useful purpose. The building in front of which most of the individuals are congregated is a pub. As this was a Bank Holiday, there were likely a lot of people in it, and some of them have come outside to see what is going on. There are three groups of people – one partly obscured by the lamppost but consisting of two or three men and a woman, perhaps more. The group in the centre, right outside the pub entrance are six or seven strong, one or two of them are women, and some are leaning casually against the wall of the public house. Two men on the very corner of the street may not have anything to do with the pub, but the others seem to have been in it, or about to enter it. Almost everyone is looking directly at the camera. This image is intended to show the relationship between the location of the body (established in the two photographs that I have not reproduced here) and the drinking culture associated with the pub. The intimation is that Lilian Hartney came out of the pub with someone and looked for a place nearby to have sex out of sight. The police-produced plans that situated the crime scene in the wider context of the neighbourhood reinforced this link.[42]

Competing narratives

Limehouse streets were usually busy with early-morning traffic at 5 am on a Monday, but 6 August 1945 was a Bank Holiday. Streets were quiet, with very few people and vehicles around, except the dairyman who found Lilian Hartney lying in the entrance to the Labour Exchange.[43] Police were quick to arrive; Limehouse Police Station was barely 200 yards away. The statements police officers made of their discovery of the body were recorded in August 1945, but they did not depose at Thames Police Court until December 1945 or January 1946.[44] The latter documents were far shorter and excluded detail not directly supportive of Hartney as murderer. Hindsight, it seems, had been of significant benefit. Initial readings of the crime scene followed the logical signs; with her legs apart and pubic region on show police suspected rape was the motive for Lilian Hartney's murder. It was noted, however, that there were no signs of struggle in the gateway. One of the officers recognized Mrs Hartney as

a local woman who had recently attended the station to report a theft from her lodgings. Once her address was established, again, less than 200 yards away, an officer went to see Mr Hartney with a view to having him identify the body. His behaviour was strange. Police found him in bed, with the bed clothes wrapped around his shoulders. When he was asked where his wife was he said he did not know, 'she's been out all night' but he was not worried, he said, because she often got bad-tempered and 'went off', sometimes she slept in air-raid shelters, he said. Whilst this explanation was not incompatible with the narrative police already suspected, Hartney's next interaction with them was strange. They asked him to accompany them, whereupon he threw back the covers to reveal he was already fully dressed apart from his shirt collar. 'Did he always go to bed with all his clothes on?' police asked. Hartney told them it helped him to sleep. He was sick with tuberculosis of the lungs, which also accounted, he said, for why he was sweating so profusely.[45]

The police officer who led Hartney to the Labour Exchange entrance told him, before they reached the spot, that they suspected his wife might have met with an accident and would he be willing to identify the body. He expressed no concern and showed no appropriate emotion. The gateway entrance had been covered with a tarpaulin to obscure the public gaze but as they approached, Hartney simply looked through the railings, which provided him with a partially obscured and oblique view of the top of his wife's head only. 'That's her,' he said, very lightly. He was asked to look again, more directly; he must be sure, they said. He went around to the other side, looked over the wall and said 'yes, definitely' and was allowed to go home.[46] The rape narrative was proceeded with, the scene recorded, and the three photographs described above were taken by C3 photographer George Salter. It was noted that there was little sign of a struggle in the gateway, however. Perhaps the sex had been consensual, up to a point, and then Mrs Hartney had been killed. At the post-mortem, however, it was noted that her wrists and throat had been tied with string which had not been found at the scene, and that there were teeth marks around her nipples, though she had been found with her clothes on (with the exception of knickers). There were no signs of sexual violence on or around her pubic region, and her coat was not very dirty either. Officers went to the Hartney's home and asked Patrick if his wife had been in the habit of going out with no knickers on, to which he replied that she had not had any clean ones to wear that day. Looking around his room, they noticed that there was a stained sheet shoved in a corner, with a damp patch of urine on it. 'My wife was dirty, she wet the bed' was his explanation. There were detective fiction books on the table, police noted, that Hartney said he and

his wife both liked to read. Police took some of them away to look at. Perhaps inspired by the books, Hartney also offered some observations of his own. It was funny, he said, that she had been found near the Chinese restaurant she used to go to. Perhaps she had been in there with a man last night. Or perhaps she had been attacked in an air raid shelter, an idea that fitted with the observation that there were no signs of struggle at the site where her body was discovered (and also coincidentally fitted with the Blackout Ripper's first victim, who had been found in an air raid shelter).[47] Hartney also offered the following:

> I hate to tell you but she was over-sexed. I am ill and too old now ... and she used to throw it up in my face that I was no good to her [sexually]. You can see by the state of this room how she has behaved, and not looked after me.[48]

As previous chapters have explored, these kinds of transgressions of expected women's domestic roles established a significant motive. Furthermore, the war having only recently concluded and Hartney discharged, coming home to his wife (who was living in London and not where he had put her in Chatham), one or other of them may be looking for a way out of the marriage. It was noted that Hartney was Irish and his wife was also from Irish Catholic stock. This made divorce an unlikely solution to an unwanted marriage. This seemed like motive. Hartney was asked to accompany police to Limehouse Station to answer further questions about his wife. In the process of being interviewed it became clear that Hartney was so ill he would require hospital treatment, and the entire case had to be suspended. Now strongly suspected of murdering his wife and placing her body in the gateway near their home in order to fabricate a narrative of sex crime in which she was at least partly culpable, supported by post-mortem findings that suggested she had not been raped, after all. She may not even have had sex recently, the only seminal staining found upon her clothing was old. Burned string was found in the Hartney's fireplace. The teeth marks on Lilian's breasts showed imperfect dentition on either the upper or lower jaw and it was noted that Patrick Hartney wore dentures due to missing front teeth. Police Sergeant James Stenhouse was dispatched to examine all air raid shelters within a three-quarter-mile radius for signs of a struggle, or the missing string that had tied Lilian's wrists. None were discovered. When neighbours were interviewed they claimed to have heard scuffling in the corridor and sounds in the garden overnight.[49] So on 8 August 1945, George Salter was dispatched to Limehouse to take further photographs.[50] This time, he took photographs that firmly reinforced the prevailing police perspective that Hartney was their man. He was giving the impression that he was very ill but it was noted that his condition varied. He had

managed to go shopping and to the pub, and to walk between the police station, his home and the gateway where he identified his wife's body. He had only recently been on 'Heavy Work' rations, having been a Naval Stoker during the war. Prior to that he had worked for some time as a Royal Mail porter, preceding which he had a 26-year career in the Navy. He was strong, especially for his age and infirmity, and Lilian only weighed seven stones (105 pounds or 47 kilos).[51]

The photographs traced a journey police believed Hartney had made and in so doing allowed the jury to imagine him in Limehouse, moving through the streets and alleys. The images began at the back doorstep of the Hartney's home with a view of the door police believed, based on what the neighbours had heard, that Patrick had removed his wife's body through.[52]

The semi-basement door is low and dark with patches of damp and dripping Victorian plumbing adding to the impression of dirt and neglect. The paving slabs are cracked and uneven and the washhouse is directly opposite the back door, low and dingy. The images of the back of the house Mr and Mrs Hartney lodged in were not photographed in a flattering light. Figure 5.3 (unlike Figure 5.2 with the distant people) shows a lonely and neglected yard. The leaves of the

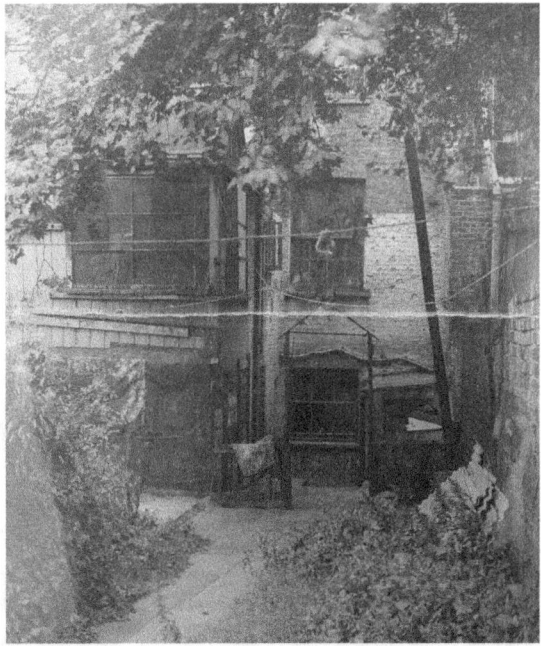

Figure 5.3 Yard, Limehouse, photograph 2 of 9 taken 8 August 1945 by Detective Sergeant George Salter, New Scotland Yard. Source: TNA: DPP 2/1452: Hartney: Murder. © Crown copyright. Metropolitan Police Service. Used with permission.

tree directly in front of the camera have moved during the exposure creating a dynamism rarely seen in crime scene photography. There are all the markers of poverty here – broken window glass, uneven bricks, a building in disrepair, peeling paint, overgrown or untended plants, some scraps of corrugated iron leaned against the wall and some other building materials about to fall away from it. The line across the middle of the photograph is the fold of the print, the one above it is the washing line, still with the metal part of a broken peg dangling from it. The back of the house looks ramshackle, abandoned. There are some textiles in the yard, perhaps someone's washing put out to dry, but they are more likely discarded or abandoned given that police described cobwebs on most of the surfaces apart from the doorway and the path leading away from the house.[53]

For the next image in the sequence, Figure 5.4, Salter simply turned his tripod around and moved back towards the house a few feet. This second exposure shows the opposite view of the yard to Figure 5.3, with stinging nettles and weeds growing in the garden and half-broken dustbins and other rubbish in the yard. The back gate, which leads out onto an alleyway, is set into a dirty brick wall with shards of glass concreted into the top to prevent anyone climbing over. The lamp

Figure 5.4 Yard, opposite view, photograph 3 of 9 taken 8 August 1945 by Detective Sergeant George Salter, New Scotland Yard. Source: TNA: DPP 2/1452: Hartney: Murder. © Crown copyright. Metropolitan Police Service. Used with permission.

above, police later noted, had a smashed bulb, and the wall in the centre top of the frame is part of a ruin. Figure 5.5 sees the police photographer on the other side of the gate from the preceding photograph (Figure 5.4). The same tree is visible as in Figure 5.3, but here it is revealed to be growing in a gated yard next to the garden of the house that the Hartneys inhabited. These photographs are taken with the outdoor type of camera rather than the indoor wide-angle lens O'Brien recommended for interior crime scene photography. This image demonstrates why a different lens type was necessary because it demonstrates the extremely long perspective enabled by the outdoor type of camera used for road traffic accidents and similar external crime scenes. Salter has deliberately positioned the camera in line with the tops of the railings on both sides of the alleyway, creating a vanishing point at which all lines seem to converge, virtually at the centre of the frame. The three pairs of bollards set at equal distances beyond the edge of the next building, the tree and its shadows, the tall buildings on either side, all contribute to a feeling of closed-in and tight spaces. Though this is public, it is concealed from the main thoroughfares. There are no people in the photograph,

Figure 5.5 From back gate looking left, photograph 4 of 9 taken 8 August 1945 by Detective Sergeant George Salter, New Scotland Yard. Source: TNA: DPP 2/1452: Hartney: Murder. © Crown copyright. Metropolitan Police Service. Used with permission.

not even in the very distance. This type of environment, the pavement and the buildings speak directly to a Ripper aesthetic of alleys and closed spaces, doorways, side streets and corners behind which danger might lurk.

Combined with the next photograph (Figure 5.6), Figure 5.5 asks us to imagine Hartney coming out of the gate that is invisible to us (Salter is standing next to it, which is partly why he is not in the dead centre of the street), and surreptitiously looking left and right down the alleyway before coming out into the street with the dead body of his wife. Figure 5.6 is taken from the other side of the alleyway, by the railings visible on the right-hand side of the frame of Figure 5.5, this time looking North up the alleyway, the back gate to Hartney's home on the right. Again (as with Figure 5.5), Figure 5.6 gives the impression of walls closing in, or perhaps folding in, with the walls on the sides of the frame leading to an invisible vanishing point in the centre of the image. The lamppost (with its broken bulb) adds a dramatic touch, and also a reference to Victorianism and prostitution. The looming building in the very distance is the Chinese restaurant that Hartney mentioned as a favourite haunt of his wife, though the proprietor there remembered Lilian as a weekly customer at most. She occasionally went

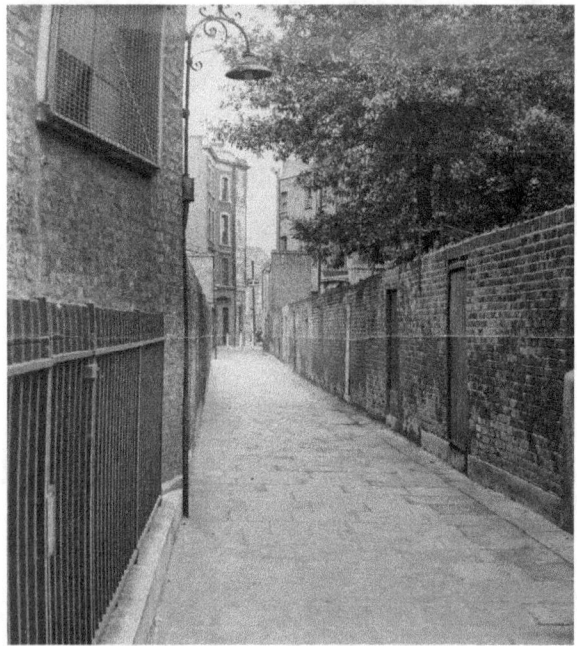

Figure 5.6 Showing back gate looking north, photograph 5 of 9 taken 8 August 1945 by Detective Sergeant George Salter, New Scotland Yard. Source: TNA: DPP 2/1452: Hartney: Murder. © Crown copyright. Metropolitan Police Service. Used with permission.

in, alone, for Chop Suey, and was remembered by other women in the area who formed most of the clientele. Despite Hartney's attempts to make it sound as though Lilian had been stalked or followed, or his suggestion that it was 'funny' that she had been 'found near there', the restaurant is closer to their home and in direct view of their back gate, whereas the site where Lilian's body was found is the same distance again from the Chinese restaurant. Suggesting the Chinese restaurant as a site of surveillance or a meeting place for a tryst that ended in her death had further imagined implications in Limehouse alleyways. There was an established visual trope here too that drew on the environmental deprivations and depravations of the residents to imply sexual danger for white women from the Chinese menace or Yellow Peril. As Sascha Auerbach has argued, Limehouse also became a site of poverty tourism and cosmopolitan curiosity, cultural tropes embedded in geography and environment emerging from fictional portrayals that pathologized residents and imbued 'Limehouse' with imagined visual connotations of crime, drugs, sex and poverty.[54] As Seal and Neale have identified, the danger white women faced from Chinese sailors was highlighted in narratives about their murders, implying their own culpability when they engaged in sexual relationships with them.[55] This was the narrative Hartney was implying by placing his wife in the gateway of a Labour Exchange in a Limehouse alleyway, and by suggesting that she had been out on the tiles or met someone who killed her in a Chinese restaurant – she was culpable in her own death by being out in these dangerous spaces at night – a narrative in common with the Blackout Ripper and Jack the Ripper, though these too were constructions rather than realities.

It seems unlikely that Hartney, or whoever moved Lilian's body from her bedroom where it was established she died to the gateway where her body was found, would have chosen a route that took them right across the path of any vehicles entering or leaving the precincts of the Limehouse Police Station. However, this is the route that Salter traced with his next photograph (Figure 5.7). In this image, Salter has moved further down the alleyway, away from the Chinese restaurant and the Hartney's back gate. He is standing at the junction of that alleyway (made inaccessible to vehicular traffic by bollards), with a tiny side-road that today serves the rear of Limehouse Police Station. Again, broken panes of glass, graffiti and damaged brickwork, abandoned or semi-derelict buildings add to the structure of feeling associated with the damage done by the war, and the backstreet feel of these photographs. The gateway on the right bears a strong resemblance to the one in which Lilian's body was found only a street or two away. The doorway on the left might be the place for a night-time assignation or a dark figure in a cloak to hide in the shadows, ready to follow or attack.

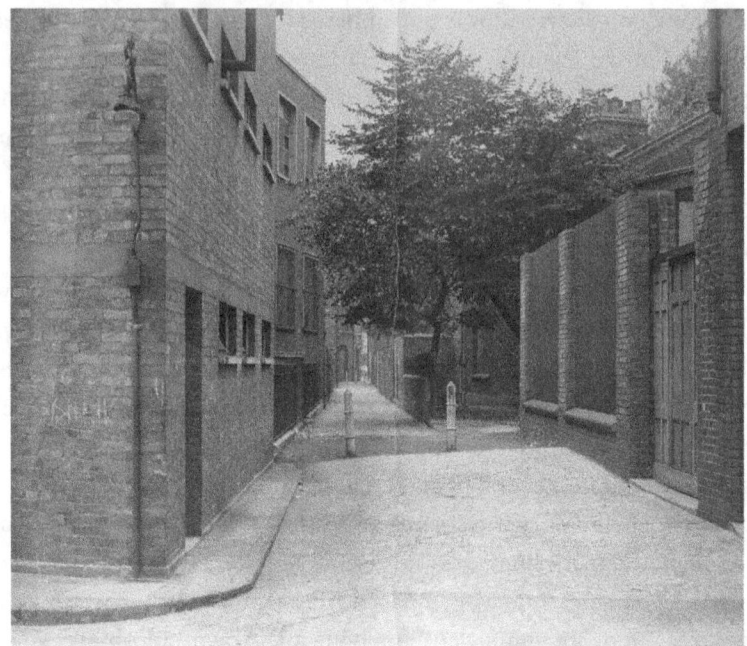

Figure 5.7 From rear of Limehouse Police Station looking north, photograph 6 of 9 taken 8 August 1945 by Detective Sergeant George Salter, New Scotland Yard. Source: TNA: DPP 2/1452: Hartney: Murder. © Crown copyright. Metropolitan Police Service. Used with permission.

The way the archived files for the investigation and trial of Patrick Hartney are constructed suggests that only the two images of Lilian's body in the gateway and that showing the relationship between the gateway and the end of the street, including the public house and the people on the corner, were displayed in the courtroom. We might speculate that the reason for this is that the Director of Public Prosecutions, confronted with the knowledge that Hartney was not going to live much longer, decided not to pursue a prosecution too heartily. Or it might have been that, given such a long time to review the evidence, it was decided that the images of the Limehouse alleyways simply did not support a notion of Hartney as the killer of his wife. They made it look like a stranger had followed her from her home and killed her, which was also incompatible with the narrative defence counsel presented to the jury to obtain sympathetic treatment for their client.[56] At the trial, as the newspaper report highlighted, a narrative of provocation was pursued. Lilian's behaviour including her cruel taunting of her husband's inability to satisfy her sexually was cited as reasons for her death.[57] The defence could not have it both ways; they could not argue that Hartney had not killed his wife

at all, but that if he did it was provocation. Hartney was found not guilty and discharged.⁵⁸ Lilian's mother took him back to Chatham, to the home where Lilian had lived before she married, where he died within six months of his acquittal.⁵⁹

Conclusion

As Louise Wattis has identified, the 'Ripper' appellation means less for the killer than for perceptions of his victims, for sex workers and for women generally, including fear, restricted spatial mobility, condemnatory discourses on women's sexuality (and conversely a lack of condemnatory discourse on men's violence), victim blaming and unequal policing.⁶⁰ The same can be said of the imagined visual trope of the Ripper, so culturally prolific that it could be referenced by killers in their efforts to conceal their crimes and shape the narrative into one that favoured their innocence or lesser culpability. Furthermore, photography associated with crimes attributed to 'Jack the Ripper' and the 'Blackout Ripper' plays little part in the formation of the visual Ripper trope, which emerged instead from an urban gothic imagination and illustrated press. Yorkshire Ripper, Blackout Ripper and Jack the Ripper tropes all drew on evocative visual referents that rehearsed already established notions of shadowy Victorian streets where women selling sex walked and were murdered. Gordon Cummins has not been so well remembered as Jack the Ripper or the Yorkshire Ripper, arguably because he was apprehended so soon after his spree and swiftly brought to justice during a time when press had other reporting priorities. Furthermore, direct comparisons are not possible because the Whitechapel murderer was never brought to justice. Were he captured and tried for his crimes, a body of evidence resembling that of the Blackout Ripper files might include the mortuary photographs of the victims and the photograph of Mary Kelly's body and bedroom. In 2019 Hallie Rubenhold's bestselling book about the five canonical victims of Jack the Ripper focussed on the lives of the women who were killed in Whitechapel rather than the shadowy figure of folklore. Rubenhold suggests that the women may have been sleeping when they were attacked rather than in the act of sex with the Ripper. In so doing she diverts attention from the victims as prostitutes and considers them as whole beings with complex and nuanced lives characterized not only by poverty and their experiences of living in London but also by their likes and dislikes, loves, disappointments and use of geographical spaces.⁶¹ Were a similar book written about the victims of Blackout Ripper Gordon Cummins the author would be able to draw on a rich seam of evidence from the murder case files for the trial, including depositions and trial

transcripts that would highlight the biases of police against women they saw primarily as sexualized beings (that is though, like the victims of his namesake, it is not certain that they were all selling sex). Furthermore, the crime scene photographs, though highly personal and disturbing, depicting in graphic detail the sexual injuries inflicted upon the victims, would also have much to tell about the women themselves. Though the photographs in the Blackout Ripper case were mobilized by prosecution to condemn and by his defence advocates to argue that he was insane and deserving of sympathy, the parts of the photographs around the edges of the women's bodies show their lives and homes – the strategies they had for washing and drying their stockings, the personal items they liked to keep around them, the little ornaments and objects they treasured, the framed photographs they kept, the ways they coordinated their soft furnishings, the books they liked to read and the strategies they had for keeping themselves safe.[62] Images of home have the potential to humanize. Crime scene photographs do not have the ability to retrieve 'what really happened' but, through application of careful and critical analysis 'a kind of magical realism' can be practised which has the potential to 'make the dead come to life'.[63]

Lilian Hartney's killer deprived us of a view into her home by moving her body from the place she died to public space. In so doing, whoever he was, he attempted to craft a narrative by his staging of the scene, which made Lilian at least partially responsible for her own murder. She was going out on the tiles and enjoying herself when, like other soldiers' wives, she should have been waiting for her husband to come home. When he was discharged, she should have dropped everything, even visits with her own family, to be with him and take care of him. But she went out instead. Patrick Hartney was unable to effectively argue that his wife had been killed by a stranger; the police compiled compelling evidence that he had killed his wife in her bed and moved her body. Hartney's defence counsel therefore had to argue that he had been provoked, that Lilian's comments had preyed on his mind and he had lost his temper with her. With this narrative settled upon by the court, alternatives could be discarded – Salter's turn-by-turn account of how Hartney had moved her body without being seen was not required. It was agreed that he must have done this; it did not require proof or clarification or a point of contention over which advocates could argue. Lilian became culpable in her own murder in other ways. This chapter has explored how contemporary tropes about gender were mobilized in pursuance of a particular crime narrative through images. The next chapter sees tropes about race mobilized in the same way, with consequences for the archival record of the home-crime-scene.

6

'Joseph Aaku's Cat': Imagining Home and Race in St Pancras

Encountering Oakley Square

One foggy Friday evening in November 1951, Theresa Maher stepped from the busy pavement of Eversholt Street into Oakley Square Gardens where the gravel crunched under her court shoes. She glanced around to be sure no one was watching and stopped at a spot lit by the overhead lamp post but protected from sight of her destination by the boundary hedge. She retrieved an enamelled compact from her handbag, pressed the powderpuff to her nose and rubbed an invisible smudge of lipstick from her teeth before emerging from the gardens opposite number 10. The light in the ground floor windows was turned out just as she mounted the steps to the porticoed front door. Theresa hesitated. Alf, the Nigerian musician who lived downstairs, opened it, juggling a shiny black instrument case. He looked up, smiling when he saw Theresa, and stepped back against the door to hold it open for her, spreading his arms as he did so to show the full length of his fine new suit – cut slightly loose and very flattering, the dark brown colour set off by the spotless black wool overcoat folded over one arm. He winked and Theresa blushed as she passed, looking back to see him touching his felt hat to her as the door swung shut between them.

As she climbed the stairs to Joe's flat on the first floor, Theresa saw that his door was open just a crack – a sliver of light and the sound of Joe whistling to himself leaking onto the landing. She realized she had been holding her breath when Joe's muscular frame slowly filled the doorway. Where Alf was slim, sharp-featured and meticulously groomed, his friend and neighbour was broader, darker-skinned and effortlessly good-looking. He was still wearing his blue work coat which smelled faintly of axle grease but there was also a pleasing scent of hair oil and toast about him. 'You're late,' he teased, tapping his rolled-gold watch. He

leaned over slowly and kissed her cheek while she blushed again, the half-day's stubble on his high, round cheekbone grazing her forehead as he moved away. He looked down at her, smiling his broad contagious smile. 'You look nice,' he said, and she felt the burning in her cheeks spread to her toes. Finally, he stepped aside to let her into the room and took her coat from her shoulders, hanging it on the hook inside the door which he closed firmly and decisively.

Theresa put down her handbag by the dining table on which was spread a clean tablecloth and the latest *Racing Review*. Plates, knives and cups were placed there two-by-two and a pot of tea was steaming on the sideboard. Theresa remembered suddenly how long the day had been and how tired she was. What a relief to be here where the tea was already made, and off the ration now too this last month. The feeling must have shown on her face. 'Sit down,' he said, indicating the leather settee, and set about pouring. Before she did so, Theresa made a show of warming her hands before the gas fire so she could get close to the mantel. She noticed with some pleasure the neat little stack of shillings ready on top of the meter. It was a week since she had been here and Theresa always wondered if Joe had other girls around. But there on the mantelpiece was the tumbler she had left, half hidden behind an ornamental wooden cigarette box, and the only lipstick on the rim was hers. Other things had moved: the bottle of hair tonic, clothes brush, cough mixture and ashtray. She smoothed her own hair in the mirror while Joe was busy applying a thick layer of butter to some toast at the table. She had sent him a postcard when she went away with her sister a couple of months before. She had yet to stay over here, then. It was perched on a shelf in the mirrored over-mantel, but she noticed he had turned it around to show the handwritten message, with her name and three kisses, now facing outward into the room. She smiled at this. She often wondered how serious he was about her. They had never made plans beyond the next date, but it seemed to Theresa a pretty good sign that Joe had kept her postcard and displayed it next to a treasured photograph brought with him from Nigeria. Of whom, she was not sure – a tall black man holding the hand of a child, but they were too far from the camera for Theresa to tell if they shared any features in common with Joe. Another picture – a studio portrait of five young men grinning brightly, a band he liked – was less carefully wedged in the mirror frame.

The mantelpiece surface was the one exception to Joe's general tidiness, Theresa observed. The cooker in the corner was always clean and neat, the pans on top of it kept one inside the other. There was always something wrapped in paper in the meat-safe, at least a scrape of butter in a covered dish and a few slices of bread. He got a little milk from Alf when Theresa was coming round,

did not take it in his tea himself, just two large sugars from a patterned bowl kept permanently filled. On top of the chest of drawers was a little tray with a few sherry glasses and a fluted bottle of Joe's favourite drink. The level of liquid inside had halved since she was here last, a sure sign that Alf or one of the other half-dozen residents of the house had been by to play cards or listen to the news on the wireless while the men smoked endless cigarettes and knocked back glass after glass of Clayton's Orange Squash.

Theresa took off her shoes and nudged them under the settee. Her feet were sore but the carpet was soft, even through her stockings. Joe handed her a tea, smiling with some secret.

'What are you up to?' she asked, suspicious.

'You haven't noticed.' He grinned wider. Theresa followed his gaze to the double bed against the wall. It looked so inviting, thick blankets and coverlets neatly arranged, deep pillows at the head, a cushion and …

'Oh!' Theresa exclaimed, trying not to spill her steaming cup. Partly camouflaged against the dark bedclothes, a little black-and-white cat looked up at Theresa with big yellow eyes. It turned its ears back and then forward, looking from Joe to Theresa, narrowing its eyes to a squint. It was somewhere between a kitten and a full-grown cat, on the skinny side perhaps, but its fur was sleek and shiny. Theresa was rooted to the spot in surprise but Joe tiptoed across the carpet and tickled the top of the cat's head as it began to purr loudly and push against his hand.

'He likes you,' Theresa said approvingly. She put her teacup gently on the mantelpiece and slowly approached the cat, letting him sniff her hand and give his approval. The rumbling grew louder and more insistent. The cat stretched out on the bed to expose his soft white belly which Theresa gave a tentative stroke. His fur was warm and he vibrated contentedly while Theresa sat on the edge of the bed and rubbed the little cat's chin with her finger, causing his eyes to close in ecstasy and his whiskers to curl towards his nose. Joe watched the two of them and enjoyed Theresa's un-self-conscious giggle when the rapturous chin-tickle was interrupted by the cat's sudden urge to lick a delicate paw and smooth it over and around one ear.

'I thought he could keep you company when I'm on nights,' said Joe, catching Theresa's eye to make sure she understood; he wanted her to live here with them.

Shortly after 11 pm on Friday, 4 January 1952, Alf Payne's sleep was disturbed by voices coming from the room above his. It was not unusual to hear talking – Theresa had been visiting family and staying with friends over Christmas, planning a reunion with Joe early in the New Year – but Joe was

not usually so noisy. A curious sound like a chair scraping on carpet brought Alf fully out of his sleep. He rose from his bed and reached for his dressing gown. A loud bump came from the ceiling. He fumbled – worried – with his robe, while rapid footsteps descended the stairs. As Alf unlocked the door of his ground-floor room the front door slammed shut. He opened it, looking out across the dark square, to see a man, almost running, illuminated briefly as he passed under the yellow spotlight of the streetlamp opposite and disappearing into the dark. Upstairs, two other housemates roused from their sleep found Joe on the floor of his room between the settee and mantelpiece, bleeding freely from a deep, jagged stab wound in the back of his neck.[1]

Just over a week later, Backary Manneh, 25 years old and born in The Gambia, was arrested and charged with Joe's murder. This was a newsworthy case because of the police work involved in the detection and capture of the suspect, which had the public on the look out for a black man with a cut hand. Most midcentury murders were domestic cases in that the victim and defendant were usually in a romantic or familial relationship, and not much investigation was involved in seeing them through to conclusion.[2] Newspapers reporting on Joe's murder and appealing for sightings of the killer painted a dark and dangerous picture, drawing links between immigration and other contemporary concerns such as miscegenation and drugs.[3] This was not a case of domestic murder in the same sense as the deaths of Lilian Anderson or Michael Scott Stephen, explored in earlier chapters as murders between romantic partners. Nor was it domestic meaning the people involved were linked by address or jealousy over a mutual romantic partner, like the death of Thomas James in Chapter 3. Rather, this was a domestic murder in the sense that it occurred in the domestic setting of the victim's home, and access to that space likely relied on a friendship or at least an acquaintance between victim and defendant.

Like the vignettes opening Chapters 2, 3 and 4 of this book, the above story of how Theresa Maher encountered her boyfriend's flat at Oakley Square and, on this visit, came to live there, is based on information provided by witness depositions and materialities observed in photographs and evidence lists, supported where possible by additional research regarding people and place. The conversations and perspectives of the individuals are imagined; we do not know if Theresa stopped to fix her makeup on her way to Joe's house, or whether his adopting a kitten was the catalyst for their decision to cohabit; her responses to questions were not so detailed as this. What is important here is that this narrative represents an interpretation of the space denied it by contemporaries. Seeing Joe Aaku's flat at 10 Oakley Square as a comfortable, homely, domesticated space

reflects most of the available evidence, from a variety of sources, particularly the crime scene photograph. It should be stressed that this interpretation in no way alters the crime narrative. Yet with the same information, albeit without the historical distance of many decades, police and contemporary press told very different stories about the identities of the men of colour whose homes they investigated as part of this case, their relationships with white women, friends, neighbours and the London landscape.

Lizzie Seal and I explored legal narratives at play in cases of intimate partner murder between men of colour and white women which identified racialized emotional norms deciding which relationships and affections were legitimate and what counted as acceptable mitigation.[4] This chapter builds on this literature by examining a case of murder between two men who were not romantically involved, identifying narratives at play regarding the homes of men of colour when case outcomes were not directly contingent upon such perceptions. This context is important because it brings into sharper relief the meanings of domesticity in crime narratives in other chapters, showing how home-making and appropriate/inappropriate domestic behaviours could be mobilized for and against defendant and victim. As each chapter of the book shows, such interpretations were specifically gendered according to contemporary social mores. More than that, however, Joseph Aaku's murder highlights the significance of race and image in crime narratives and the denial of homely, domesticated interpretations of crime scenes that were homes to men of colour, even where such an interpretation had no bearing on the crime narrative itself.

Picturing race and racializing place

The extant sources regarding the murder of Joe Aaku open a window on the domestic spaces and experiences of men of colour in London at this time. Reading sources 'against the grain' in the way demonstrated by the above vignette is particularly instructive in these types of cases because, as Paul Gilroy and Kennetta Hammond Perry have articulated, housing and miscegenation – and therefore home, family and domesticity – were the primary sites around which racial anxiety coalesced in the 1950s: 'Race was thus fixed in a matrix between the imagery of squalor and that of sordid sexuality.'[5] Black Londoners were depicted either in public space or as a problematic presence for white neighbours, in photography and sociological studies.[6] As Stuart Hall has described, images of arrival and movement through space in the capital have

tended to highlight tensions, to make black Britons at once a part of and separate from the culture or society in which they live.[7] Joe Aaku's murder takes us indoors, opening up the look and feel of a black Londoner's home in the mid-twentieth century, highlighting the ways in which this space was interpreted and was specifically racialized. It asks in what ways evidence was influenced by the blackness of defendant and victim, and how readings of the home crime scene became imbued with the racialized tropes and institutional racisms practised by Metropolitan Police and contemporary press. Crime, Paul Gilroy argued, was a primary prism for understanding the presence of people of colour in twentieth-century Britain (though not uppermost in public consciousness until the 1970s), despite comprising a statistically negligible proportion of indicted or convicted persons.[8] Though numbers are far from straightforward, Lizzie Seal and I have similarly identified disproportionate numbers of men of colour hanged in twentieth-century England and Wales.[9]

Those who have investigated the influence of race on readings of police photographs in the past have focused on portraiture or surveillance images. Katherine Biber, for example, has discussed the various complexities associated with reading race in images of an alleged bank robber in Australia, identifying psycho-social implications.[10] As Kate West has highlighted, race and 'the criminal' have been interwoven in criminal portraiture since the earliest applications of photography to crime.[11] Creating a problem from single Black men crafted narratives of miscegenation, casting migrants to Britain in the role of temporary workers or else a threat to the white status quo, particularly white women. As Kennetta Hammond Perry and others have recently highlighted, discourses about the arrival of Windrush as the defining moment of Black British History are beginning to be challenged in prominent popular discourses as well as academic publishing. Counter-narratives to the stereotypical trope of single Jamaican men arriving in 1948 as workers in London, particularly Brixton or Notting Hill, are emerging. This adds further importance to Perry's work and also that of Tina Campt, suggesting ways of viewing photographs of people of colour in their private and homely spaces as means of communicating their success, social achievements and familial culture in Britain to relatives and friends 'back home' and for a shared memory of community, permanence and legitimacy.[12] Exploring cases of men sentenced to death in the twentieth century who were categorized by Home Office officials as 'coloured', Lizzie Seal and I have identified individual families and extensive communities embedded in the societies they inhabited. A recognizably 'top-down' discourse of racial difference in government bureaucracy, policing and criminal justice comes to the fore

in cases defined as 'murder by coloured persons' throughout the twentieth century, echoed in sensational newspaper reports. However, reading murder case files 'against the grain' this research also identified families of colour and their cultures firmly woven into the texture of a variety of local cultures, outside London and before Windrush.[13]

The case file for the murder of Joseph Aaku identifies two main individuals and extensive and connected networks of neighbours, friends and colleagues of various backgrounds who were making a home in Britain. Many lived outside the main areas more traditionally identified as neighbourhoods of black settlement, and a variety of black backgrounds are identified, the majority West African rather than West Indian or Afro-Caribbean. Those who were asked about the length of their residence in England placed it at between two and five years, suggesting migration narratives which challenge the dominant Windrush stories of Caribbean migration beginning in 1948. White publicans who were asked about black regulars said that they often served repeat customers they recognized as well as one-off or infrequent visitors. Black men were a visible presence in the shops, public houses and on the streets in the St Pancras, Euston and Tottenham Court Road areas. The ways the identities of the defendant and victim were shaped and treated by police, prosecution and defence lend significant support to Wendy Webster's argument that men of colour were denied an interpretation of their homes and behaviours that was compatible with settled comfortable domesticity, preferring instead to place them as a transient population incapable of constructing a family life or unwilling to do so.[14] Indeed, this idea of transient, single male living in London was promoted by press and courtroom narratives of Joe Aaku's murder.

When Christmas Humphreys KC addressed the Old Bailey jury on 24 March 1952, he informed them that they would have little trouble determining that Joseph Aaku had been murdered. He had received a stab wound to the back of the neck that had severed his spinal cord between his second and third vertebrae. 'The issue,' he told them 'is one of proof of identity.' They must decide whether it had been proved that it was the man in the dock who had committed the murder:

> Gentlemen of the jury ... you will be asked to consider a great mass of detailed evidence, all of which, when fitted neatly together like a jigsaw puzzle, forms a picture (which must add up to guilt). The evidence is not any the worse for being circumstantial evidence as opposed to direct evidence, because any one witness may be mistaken in what he thinks he sees or hears, but if you get a great mass of evidence which all builds up to the same conclusion, then you may be satisfied indeed that the charge laid is proved. You are going to hear many

> witnesses from the underworld of London. Many of them will be West African negroes, … some of the girls called will be no better than they ought to be, and some of the witnesses living together are not husband and wife, and it may well be that some of the witnesses called before you have been in trouble with the police before. You will bear all that in mind, and you will consider whether each witness is telling you the truth and whether the evidence of all those witnesses put together satisfies you of the guilt of the accused.[15]

This rhetoric was designed to sound like a fair and balanced introduction, the warning about the kind of people the jury would hear from was delivered with all the patriarchal condescension of a middle-aged white man in a courtroom of the colonial centre. He is appealing here to 'colonial common sense', drawing direct links between the race of the witnesses and defendant and whether their words could be trusted or their morality questioned.[16] The miscegenation issue Stuart Hall identified as prominent in understandings of black men's lives and their relationships with women is also sharply underscored.[17] Humphreys went on to use the jigsaw puzzle metaphor that he and colleagues regularly deployed in this period, highlighting the significant role of imagined and visual in jurisprudence and delivering justice:

> You will appreciate that whereas I have tried to give you the whole picture of the jigsaw puzzle now, you must necessarily hear the little pieces of it proved, and it may not be easy at times to keep the main picture in mind. I have, I am afraid at some length, put that picture before you in the hope that it will enable you to understand the evidence as it is put before you.[18]

As the opening speech might suggest, racial bias was a prominent feature of the questioning in the courtroom at Backary Manneh's trial, and in others of black and minority ethnic men throughout the twentieth century. They were far from the only migrants, however. Some kind of migration history is a common feature of case files for murder trials: Margaret McKinnon Watt and Georgios Kalli Georgiou (Chapter 3) had both migrated to London from Scotland and Cyprus, respectively; Patrick Hartney was born in Ireland and Lilian Hartney née Riley was also of Irish descent (Chapter 5). Wherever an individual (defendant or victim) could be identified as a 'foreigner', their behaviour condemned or somehow pathologized because of their origins (even if only within England and Wales), they would be. However, as Laura Tabili, Wendy Webster and others have argued, at various points in twentieth-century Britain a racial other has been specifically designated by the colour of the skin as a visible means of identification.[19] Police reports and other documents that described defendants,

witnesses and victims to other police officials or to the DPP who could not see them explicitly described people by the colour of their skin if they were not white. Using words like 'coloured', 'half-caste' and 'negro' and also pathologizing their language as childlike and simple, un-English even when this was their first language, colour could be read in black-and-white documents, even those without pictures.

It is against this contemporary backdrop, and the caption of the opening speech about how to read the image of a black man that the trial of Backary Manneh opened at the Central Criminal Court on Monday, 24 March 1952. Photographs and descriptions of Manneh had already been racialized in the press; one newspaper described how he appeared in court wearing a cape, making him a figure as threatening and strange as possible.[20] The 'cape' is better explained as his long coat, worn around his shoulders because he could not fit his swollen and heavily bandaged hand through the sleeve. These kinds of interpretations, as highlighted by Gilroy and Hall and other scholars of black Britain who have challenged the visual history of black presence in post-war Britain, are also present in crime scene photography. There was only a single crime scene photograph of Joe Aaku's home in the Manneh case, all other images were close-ups of Joe's body showing his injuries on the post-mortem table. Descriptions of the defendants' and victims' homes racialized the photograph of the crime scene, setting up for the jury a context for everything they saw in the image, negative explanations that framed this flat as racially specific and defined by the colour of the man who lived there.

The jury were informed that the crime scene photograph showed packets of 'hemp' on the floor but they were not shown in close-up. They are about as clearly perceptible as the cat on the bed (to whom this chapter will later return); they might be socks or some other innocuous item. Joe's home was described as a 'den', connecting it with animals as well as with drugs. In comparison to Elvira Barney's euphemistic 'face powder' (see Chapter 4) any evidence in Joseph Aaku's home was immediately and explicitly interrogated for evidence of drug-taking and drug-dealing; however, it is clear that this is an emerging rather than commonly recognized trope associated with black men in London because it required explanation. The 'expert' witness called upon to speak about the 'Indian Menace' of hemp, a man later a Conservative MP and described as 'eccentric' at best, posited the entire British drug problem as an effect of Caribbean and African migration to Britain, adding to interpretations of Joe's home as both a place from which drugs were dealt and a place where they were consumed.[21] Donald McIntosh Johnson's book was used by defence counsel to describe the

role marijuana played in the death of Joseph Aaku but it had the impact of describing the role the race of the defendant and victim played on the crime. The passage highlighted and bookmarked by defence advocates indicates their intention to suggest that Joe Aaku might be violent because of his use of drugs, framing his killing by Backary Manneh as self-defence. 'Marihuana', it said, was a drug that could help Mexicans 'fight without fear of death', assist assassins and make them more biddable, and influence Malays to 'run amok'.[22]

Johnson described special premises set up by men of colour for smoking 'Indian hemp' in which 'uninhibited couples' indulged in sex with multiple partners. (Theresa denied smoking cannabis, though she had seen Joe smoking it, and she made attempts to challenge implications of a less than committed relationship between her and her partner embedded in questioning.) These themes show clear parallels with the alleged dangers of Chinese men and opium dens in Limehouse earlier in the century – racialized spaces that directly threatened white women's sexuality.[23] Johnson concluded that cannabis indica was dangerous because it stimulated the imagination, minimizing inhibitions and parts of the brain responsible for 'restraining influences'. It intensified emotional responses which were already present in the personality of an individual – not quite releasing those under the influence from all responsibility for their actions. Rising imports of the drug, Johnson claimed, came hidden under chocolate and other innocent goods for domestic consumption, smuggled onto ships by West Indian seafarers. They placed British people at risk of becoming victims of acts of sexual perversion and violence. Worse, white people might be tricked into taking the drug themselves, as Johnson describes in a fictional and fantastical story of 'the perfect crime'. This hypothetical narrative he describes as a plausible scenario to which 'who-knows-how-many of our fellow countrymen' are at risk of falling victim 'unless heed is taken of the information in this book'.[24] Johnson summarizes in another section underlined and bookmarked by the defence: 'It seems certain that the removal of inhibitions applies also to the emotions of violence and aggressiveness when these are present in the drug-taker ... aggressiveness + imagination = violent crime.'[25]

Seal and Neale have identified the potential for racist stereotypes to be mobilized in support of mercy appeals.[26] Manneh's defence advocates' attempt to pathologize Joe Aaku as violent and addicted to drugs must therefore be seen in the context of trying to save their client from the gallows. However, it must also be seen in the context of racialized interpretations of homes in this period. Social scientists and commentators explicitly linked housing conditions, miscegenation and race. For example, Elspeth Huxley described 'the Blacks Next

Door' 'living in revolting slums' or 'substantial Victorian houses' for which she narrated a profoundly visual, middle class and white history:

> the sort of houses that would once have had a maid-of-all-work in the attic, a mistress in her decent bombazine mending pinafores in the parlour, and the master in his striped trousers, black coat and wing collar going off to his city office every morning on the dot.[27]

Huxley described this takeover of housing by black immigrants as a pattern which subverted the social and racial boundaries of English houses but also the geographical ones:

> Into these middle-class, nineteenth-century houses, maybe with a little front garden and a yard at the back, go the immigrants ... To live hugger-mugger with one room for each family, and plenty of communal life within the larger inter-related group – the extended family – is just what they were used to back home and what many of them like.[28]

Interpretations such as this one place the 'blame' for what is interpreted as poor living standards firmly with the cultural characteristics of the inhabitants and demonstrate the white middle-class values and meanings that came to define the ideal home. But this is a post-war myth. The good home was visualized as entirely private, inconspicuous, quiet, clean and tidy on the outside. It should preferably be self-contained, or only attached to one other dwelling, but should enjoy separate entrances, front gardens and back gardens. It should have net curtains to keep what went on inside private, and so that other neighbours did not feel overlooked. This ideal of home became associated with race and national identity, as this second quote from Elspeth Huxley shows:

> Caribbean domestic habits and customs collide with our own. Most West Indians ... like loud music, noise in general, conviviality, visiting each other, keeping late hours at week-ends, dancing and jiving ... Most English prefer to keep themselves to themselves and guard their privacy. Ours is a land of the wall, the high fence, the privet hedge – all descendants of the moated grange.[29]

The reference to the moated grange further promotes the idea that the English home is middle class, private and white. However, as the subdivided terraces in Prebend Street and Limehouse in Chapters 2 and 5 of this book show, white working-class people had lived in multiple occupancy houses for decades, if not centuries. As the respectable lodging house at Torrington Square and the little mews house in Knightsbridge demonstrate, large spaces and remoteness from neighbours were not necessarily characteristic of the homes of white-collar

workers or those of wealthy independent means. Rather, as Claire Langhamer has identified, these notions of an ideal home were imagined, their origins in interwar Britain intensified after the Second World War.[30]

This deepened divide between public and private, which Wendy Webster argues is raced, is borne out in murder case files where men and women of colour, and to a lesser extent, white male European migrants, were subjected to a higher degree of scrutiny in their public behaviour and movement around the city and neighbourhood than men attributed a white, English or other 'local' identity.[31] Similarly, their homes were more thoroughly investigated, for examples, of illegal acts, indicators of violence or what modern policing might refer to as 'antisocial behaviour'. Victims, defendants and witnesses who were described as being from African or Caribbean countries were more likely to be questioned about the public aspects of their private behaviour, demonstrating the impact of the increasing significance of privacy in post-war housing. Joseph Aaku and Backary Manneh were both scrutinized in their public and private behaviour, accused of being involved in drug dealing or taking or both, and the evidence of their domestic lives, relationships and experiences of comfort in their homes significantly diminished. This lends further support to the body of literature on black lives in post-war Britain described above that highlights the absence of comfortable homely domesticity from cultural tropes about black people.

As the vignette opening this chapter describes, the crime scene photograph of Joseph Aaku's flat clearly shows a comfortable and cared-for home: soft bedding, clean linens, a deep settee, modern furniture, decorative and personal touches indicative of domesticity and homeliness. But these articles were not highlighted as significant to the narrative of the murder of Joe Aaku. His home did not require interpretation in this way to make his murderer more guilty. Rather, the stereotypical tropes of racialized domesticity like those referred to by Huxley were invoked in evidence, witness questioning and opening and closing speeches. Neighbours like Alf were not surprised to hear talking coming from Joe's room late at night, they said. Court questioning implied this could be interpreted as constant visitors to deal drugs, not the normal conversations between Joe and Theresa, who had been living together for several months by this time. This illustrates the racialized framing of Joseph's home identity as one that was less private and quiet. Other cases in which the behaviours and homes of people of colour were scrutinized as part of a murder or manslaughter case bear this out.

Both Backary Manneh and Joseph Aaku were in relationships with white women, whose capacity for domesticity and entitlement to comfort were also diminished by their perceived relationships with black men. This fits with

Webster's findings that white women who had relationships with black men were perceived as the victims of their 'incapacity for family and domestic life'. Men of colour in the case files and in media coverage were portrayed as 'rootless and adrift'.[32] Mica Nava has countered this by looking at white women's relationships with black men as *anti*racism, and challenges the notion that such relationships were almost universally condemned.[33] Indeed, earlier research using murder case files has identified many instances in which marriages between men of colour and white women were widely accepted in their communities. They were certainly condemned by the judiciary, however, who took a dim view of white women in relationships with black men, characterizing them as particularly immoral, and subjecting them to closer questioning about private aspects of their lives and relationships that were less likely to be applied to white couples.[34] For his part, Backary was deemed incapable of having a platonic or benevolent relationship with a homeless white woman whom he allowed to stay overnight in his room while his girlfriend was away. He insisted that he took pity on her and gave her some clothes to wear because she was cold and poor,[35] and she was accused of paying for the stay with sex.[36] As James Whitfield has pointed out, white women who slept with black men were invariably cast as prostitutes by Metropolitan Police.[37] An alternative narrative given by Backary and partially validated by the woman describes how he gave her some of his girlfriend's cast-off clothes in order to get rid of her. He had given her a bed for the night because she had nowhere else to go and he felt sorry for her, but he was worried she would be found by his girlfriend who would think they had slept together. The court resisted this interpretation, finding it impossible to imagine that this man would be willing to give a white woman a place to stay and some clothes to wear out of pity or concern.[38]

The transcript for the trial of Backary Manneh for Joe Aaku's murder, and particularly the opening statement at the Old Bailey, illustrates racism operating against domestic interpretations in this period, particularly that white women in relationships with black men were somehow victims of abnormal sexual desire. Backary's home was characterized as a disreputable dwelling, not the home of a couple, but as a drug den where women came and went in pursuit of sex from black men. That this was the court's view and not one shared by neighbours and fellow residents is illustrated in the testimony of Manneh's landlord. He was asked about the comings and goings of Backary's girlfriend, in a way that attempted to suggest a transitory and uncommitted relationship. The landlord, himself a European migrant, refused to engage in such a characterization: 'Q Do you remember when she [Margaret – Manneh's girlfriend] left? A No, because I do not control her.'[39] The extended exchange indicates a more committed bias

on the part of court officials to gendered roles and restrictions compared to people who witnessed in these cases. The landlord did not care whether Backary and his partner were married or not, but questioning seemed to invite white Europeans to share biases concerning 'race' and the condemnation of 'immoral' sexual behaviour. Closed and leading questions gave witnesses little opportunity to challenge the views embedded in their questioning, though some did so.

Witness questioning in court promoted a racialized interpretation of Joe's flat which denied the dead man a domestic identity. The two narratives of Joe's murder fought over in court both relied on seeing his home as particularly black, with all the contemporary connotations such a view had for the potentiality of violence. As Seal and Neale have argued with regard to cases of intimate partner murder by men of colour, these 'fiction effects' can to some extent be countered, or at least challenged, by reading depositions 'against the grain'. In the courtroom, opening narratives positioned a lens through which the jury would view Joe Aaku's flat, his identity and that of the man accused of murdering him there. By opening this chapter with a counter to that narrative, I have promoted a reading of the same photograph that takes account of the obvious materialities of the scene – the domestic accoutrements, the clean and tidy surfaces, the comfortable furnishings and the ultimate symbol of domestic comfort and putting down roots: a cat.

Joseph Aaku's cat

The black-and-white shape on the bed at the right of the crime scene photograph of Joe Aaku's room (Figure 6.1), partly hidden behind the towel and the footboard, is a form so familiar, it must surely be a cat. The white fluff inside its ears highlights their shape against the dark bedding. His head is in profile, little face pointed towards the right-hand side of the frame, his tail curled up towards his body. Movement of his tail accounts for the slight blurring of the outlines of the cat. Or perhaps this can be accounted for by the texture of feline fur. However, I must acknowledge that the shape I am interpreting as a cat could also be Joe Aaku's railway cap and badge catching the light in a strange way. Or it may be some other less familiar object. None of the case files for the murder of Joseph Aaku in January 1952 refer to him owning a cat.[40] However, through the process of writing the narrative that describes Joe's room from the crime scene photograph and other sources in the case file, I have come to understand that it matters little whether there really is a cat on the bed in the photograph, or whether he really owned a cat or not. The cat is more clearly visible, to me, than

Imagining Home and Race in St. Pancras 141

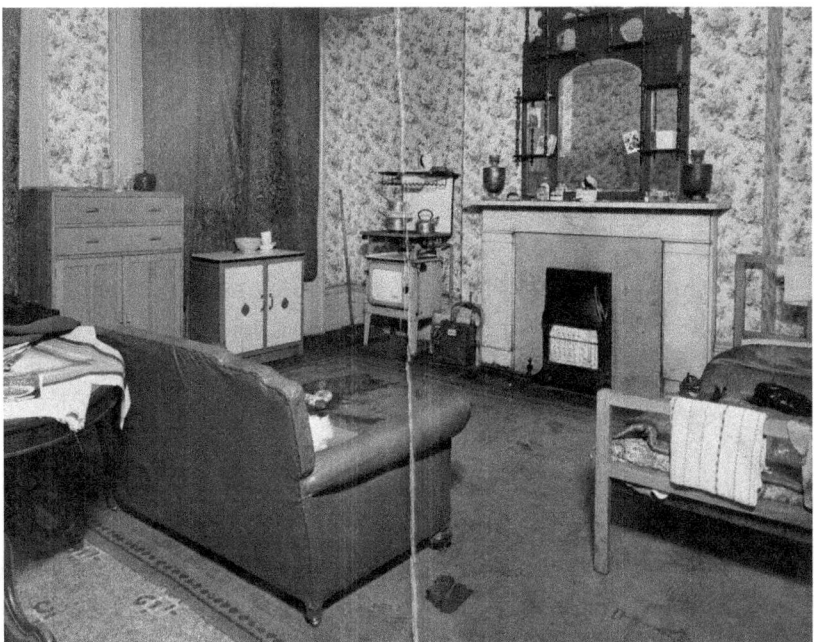

Figure 6.1 Joe Aaku's flat, first floor front room, 10 Oakley Square, taken 5 January 1952 by Sergeant John Merry, New Scotland Yard. Source: TNA: CRIM 1/2206: Manneh, Backary: Murder: Exhibit 2 (1). © Crown copyright. Metropolitan Police Service. Used with permission.

the shapes on the floor described to the courtroom as hemp packets. Described as such, these shapes supported a narrative of drugs, crime and violence which explained Joe's death and linked directly to a positive conviction and capital punishment of his killer. However, drugs did not need to feature in the narrative at all. Manneh may have just as well killed Aaku for his watch, a case exhibit, which the court heard he took from Aaku's body and attempted to sell in various quarters. A cat is suggestive of putting down roots, symbolic of comfort, warmth, care and time spent at home. Narrative microhistories have very frequently referred to cats as cultural icons, referents of domesticity and homely comforts, familial love in animal form.[41]

Little evidence exists regarding the views of jurors; however, it seems possible to assert that when they were told there were hemp packets on the floor in the crime scene photograph they saw them there. If they were told there was a cat on the bed, they would likely have seen it too. Thus, even when an image infers a narrative, captions are significant; we see what we are told is there or what we expect to find. Another example of these effects illuminated by the practice of

writing narratives of encounter involves the bottle on the chest of drawers in the photograph. Sat atop a tiny tray next to three sherry glasses, I imagined this was a bottle of liquor or spirits, perhaps brandy? I used various search terms and sources to attempt to identify the liquid by the shape of the bottle or the name of the manufacturer. Eventually I asked social media followers and the suggestion came: Clayton's Orange Squash. Photographs of aged bottles were searched, compared and confirmed. What I had supposed to be alcohol was actually a soft drink. Be it a bottle or a cat, we seek out and interpret things that are familiar to us, bringing a variety of connotations, often unconscious. Earlier chapters of this book have also articulated notions of supposition and confirmation in their descriptions of police arrival and photography at crime scenes. The figure of Joseph Aaku's cat demonstrates that the visual micro-narrative represented by the crime scene photograph was one of many versions of a crime story embedded in murder trial exhibits and transcripts, each of which relied on mediation by prosecution and defence but also more subtle contemporary contexts – social and cultural familiarity with objects and meanings, stereotypical tropes regarding race, sexuality, class and domesticity. The multiplicity and problematic nature of crime narratives and their dependent contexts must be borne in mind in order to fully appreciate that, rather than communicating objective facts, crime scene photographs were one of many documents that told stories about people, places and events that seem, in the present, to matter to the narrative but crucially may have been overlooked or dismissed by contemporaries. The crime archive does not remember the cat.

Conclusion and outcomes

This chapter has offered a counter-narrative constructed through the description of a space depicted in a crime scene photograph, demonstrating a method by which the historically contingent biases and tropes embedded in criminal justice discourses might be challenged. As earlier chapters have indicated, murder case files do not allow the dead to speak unmediated; 'the past was never really there in the first place'.[42] However, it does not follow that because the cat is not preserved in the archive box it was never really there. Though the chapter invites independent analysis of the photograph of Joe Aaku's flat, asking if that shape *is* a cat on the bed, it should be borne in mind that the details of crime scenes are no more readable now than they were in 1952. DS John Merry, who took the crime scene photograph, was asked if he had noticed the blood

on the carpet in Joe's room. 'No, I did not look at it in any detail,' he said, 'I had no cause to.' Yet when questioned he offered an interpretation of the ambiguous shapes on the floor as packets of hemp, based only on what he remembered from his survey visit.[43]

Trial outcomes, like crime scene photographs, are full of contradictions and competing interpretations. The narrative of Joseph Aaku's murder endorsed by the guilty verdict and sentence of death framed the crime as motivated by money and drugs. Backary Manneh was, it says, desperate to meet his rent or satisfy his drug-cravings. But appeal documents and communications between police and Home Office highlighted the lack of evidence for either man being addicted to drugs or involved in their sale. As far as they were concerned, the 'national drug ring' was entirely fabricated by the press – 'a great deal of nonsense' – Aaku was far from a 'King of Dope', they advised, and the amounts of hemp found on either man very small indeed.[44] However, Manneh's defence advocates relied on the narrative of Aaku's drug-induced violence and their client's self-defence to attempt to save his life. Their grounds for appeal were that the judge had misdirected the jury (a common ground) by saying firstly that there was no evidence from Theresa that Joe was addicted to drugs or violent. Secondly, that the judge misdirected the jury by telling them 'that the photograph exhibited of Joseph Aku's room depicted the scene as at the time of the fight between Aku and his Assailant', though this is not borne out by the trial transcript. Manneh's counsel contended that the crime scene photograph was not taken immediately after the murder and so it could not be interpreted as depicting an undisturbed scene, or a room exactly as it was at the moment the fatal stab was delivered. Though this issue potentially called into question the empirical or evidentiary limits of crime scene photography, the appeal court justices did not enter into a debate or acknowledge the finer details of the appeal but dismissed the grounds as irrelevant to the jury's decision.[45]

Backary Manneh's prison file at the National Archives records that he was hanged at Pentonville Prison on 27 May 1952 for the murder of Joe Aaku. In one of the rare and intriguing instances in which material objects or items other than documents find their way into case files for murder, one of the folders contains a small brown envelope, sealed, and a fragment of bandage, further enclosed by an acetate sleeve like those used to protect photographs in the files. Bold black letters on the folder cover and typed correspondence contained within describe the envelope as containing white crystals found hidden in Manneh's bandage when he was searched on his admittance to the condemned cell. Prison officers interpreted these crystals as cocaine, suggesting

the prisoner smuggled the drug into the prison with the intention of selling it. Officers handed the crystals to the Prison Governor who sought further advice, ensuring the crystals and a record of them would be preserved in the archive of Manneh's last days with prominent references to drugs. The eventual outcome of the governor's enquiries, weeks after Manneh's death, is recorded in thin ballpoint scribble on the inside cover of the folder: Metropolitan Police Drugs Branch pronounced it ordinary table salt.[46]

7

'We've Really Hit the Jackpot Now, Doll': Changing Lives in North Kensington

Prosecution narratives

Monday, 11 February 1957, The Central Criminal Court, Old Bailey, London.

The Clerk's voice came back to him in a flat echo as he opened proceedings in Court Number One. He pulled his gown a little closer against the bitter chill. The scuffling on stone and creaking of wood gradually faded as dozens of impatient public resigned themselves to discomfort. The pressmen in the seats nearest to the exit were more practised, wedged shoulder to shoulder and the warmer for it. A shiver struck the Clerk as he turned to the jury and spoke his next words, making his voice project with exaggerated force. Perhaps the key change underlined to these ten men and two women that proceedings were entering a new stage. It almost seemed appropriate to shout when a man's life was at stake.

> Members of the jury, the prisoner at the bar, Brian Edward Burdett, is charged on indictment with the murder of Moira Burdett. To that indictment he has pleaded Not guilty, and it is your charge to say, having heard the evidence, whether he be guilty or not.[1]

He spoke similar words so often it was difficult to deliver them with sufficient gravity without sounding contrived or rehearsed. The Clerk took his seat in front of the judge while the Shorthand Writer, in the adjacent seat, poised to record the words of the next speaker, whose wig was so crusty with age and dust that one could almost hear it creaking. Solicitor-General Sir Harry Hylton-Foster, QC, MP, made a gesture with his head something like a compromise between a nod and a bow to Mr Justice Pearson – 'May it please you, my Lord ["m'lud"]' – on his throne-like dais before turning to the jury. 'Members of the jury, in this case I appear to present to you the case for the Crown with my learned friends Mr Christmas Humphreys and Mr Mervyn Griffith-Jones.' The

two men he indicated returned an imperious look, virtually indistinguishable from those seated behind in near-identical wigs and gowns 'and the accused is represented by my learned friends Mr Ryder Richardson and Mr David Walder'. Hylton-Foster barely glanced at the skinny bespectacled young man in the dock as he described the charge against him: 'that he murdered his wife by poisoning her in November of last year, the date being the 27th November. Your duty' – these last two words he delivered sforzando, every consonant and syllable slowly and deliberately enunciated – 'is to listen to the evidence and then decide on that evidence whether or no [sic] you are satisfied that the charge is well laid'. He paused, partly for effect, looking down at the voluminous documents in front of him, neat piles of uniform papers tied with white ribbon, among them a brown paper folder, stitched at the spine. Gesturing to the evidence table with a billowing sleeve, he grandly atoned: '[First,] I must tell you a little of the story, so that you may follow the evidence when it is called before you.'[2]

Hylton-Foster and other prosecuting counsel regularly employed this device at trial, referring to the evidence like pieces of a jigsaw or in some other way piecemeal, fragmented or non-chronological, requiring mediation: a narrative outline to make sense of material, verbal and visual evidence (see also Introduction and Chapter 6). Set apart from the rest of the trial proceedings, opening speeches often made claims to neutrality, in tone if not explicitly. Rhetorically and performatively, however, they described the Crown's very particular version of events and framed the prosecution case, signposting the evidence the jury would hear. These opening narratives did more than serve to set the scene; they established a story that followed the strictures of legal definitions of crimes and evidence whose logical outcome was a positive conviction.

At the Burdett trial, Sir Harry Hylton-Foster delivered the opening speech in the straightforward and matter-of-fact style of oration which would later see him unanimously nominated as Speaker of the House of Commons. He avoided bombast, emotion and extraneous or superlative words.[3] It must seem as though he were dispassionately relating only indisputable facts. The story went like this: Moira Richardson was born in October 1935 in South Shields, illegitimate daughter of Alice. Alice's mother brought Moira up as her daughter. Moira never knew that her sister was her mother and the woman she called mother was in fact her grandmother. This information established that the deceased woman and her family were among the lower-working class. At age sixteen, in July 1953, Moira married her boyfriend, Brian. 'Six months after the marriage a boy was born in January 1954', he said, pausing to ensure this fact and its implications were properly understood by the jury; Moira had been pregnant at the time of

their marriage 'she being then under 17 years of age'. They moved to London, living first with his parents and then in rooms, a young family struggling to make ends meet. Within a couple of years, there was 'some mutual unhappiness' and in March 1956 'a separation agreement was entered into, under which he was to pay her £3 a week, and she went off with the baby boy and lived, as formerly, with her grandmother [whom she believed was her mother] at South Shields'. With one eye on the evidence table, Hylton-Foster described how the couple wrote to each other. Moira also sent letters about their little boy to Brian's father, which was a comfort to him when he was ill. The letters, Hylton-Foster said, 'reveal a very touching affection between this young couple' who decided to reconcile, to give their marriage another go. Moira explained in a letter that she wanted to come back but she had some conditions; she wanted a 'decent home to come home to'. She also confessed she was in debt. 'She had not managed the money very well', said Hylton-Foster, 'but she was aware of it and invited [her husband's] help with it when she came back', he generously conceded. Asking the jury to be sympathetic to Moira and Brian, Hylton-Foster told them, 'You will not have the slightest doubt that this was a pathetic touching affection which existed [between the couple].' The family was reunited on 22 June 1956. He explained:

> They went to live in a first floor flat in North Kensington, the address being 28 Appleford Road; there was just a bedroom and a kitchen – two rooms. You may think it must have been rather poor accommodation, but there they were.[4]

Ending the first part of his opening speech by situating the Burdett's home in this way created an imagined setting for the rest of the story, and evidence, that followed. Hylton-Foster explained that the defendant, Brian, worked as a statistical clerk for a washing machine manufacturer, that he had a good reputation as a consistent, punctual hard worker. He rode to work on his motorcycle combination leaving by 8.45 every morning. But on Tuesday 27 November 1956, he did not leave for work on time. At 9.15 he went downstairs to their neighbour Betty and told her that he could not rouse his wife, she had just passed out on the floor. Betty found her cold, could not wake her or find a pulse and sent Brian to get help. When ambulance crew arrived, 'they thought she was dead, and they tried oxygen and artificial respiration, but it had no effect'. She had collapsed on the floor while washing up after breakfast, Brian told them, while he was shaving. Perhaps it was the porridge? Brian rode along to the hospital where the casualty doctor declared Moira dead, 'whereupon he [Brian] burst into tears … He was then asked if he would like a cup of tea, and was given a cup of tea and [drank] it. The importance of that fact I will reveal to you later.'

Hylton-Foster continued the narrative by quoting Brian's words to the Coroner's Officer when he was called on to formally identify his wife's body before post-mortem, highlighting inconsistencies compared to what he had told ambulance crew about Moira's final moments. The following day, Hylton-Foster said, the pathologist found no food in her stomach but a strong smell of cyanide when he opened Moira's body. He also found that she had been six weeks pregnant.

> It being apparent that this woman had died of sodium cyanide poisoning, the police were notified, and at 5 o'clock that afternoon [the day after she died, the day of the post-mortem] the police went round to the flat. The accused was not there, [but] they searched the two rooms [anyway].[5]

Sir Harry Hylton-Foster QC's opening address to the Old Bailey courtroom continued, setting out the basis for the prosecution's case against Brian. By placing key witnesses and exhibits of evidence in the chronology of the narrative, and signposting but side-stepping points at which prosecution and defence disagreed, including depositions by the defendant, Hylton-Foster attempted to present this to the jury as a neutral account. It was anything but neutral. By framing the Burdett's marriage as a young, hasty one, with a child conceived before they were wed, a history of marital problems, money issues and another pregnancy, the prosecution set up a motive for the defendant in the minds of the jury. By implicitly framing Brian's murder of his wife as to do with a pregnancy they could neither afford nor legally terminate, and Moira's perceived failures as a housewife and mother, as not his intellectual equal, the prosecution were fitting the crime into an established narrative with which the jury would be familiar, one that had been successfully deployed against Timothy Evans in a famous case seven years earlier in 1950.

The Evans' home, 10 Rillington Place, had become a notorious 'House of Murder' in 1953 when John Christie was tried for the murders of several women there. Though Christie's conviction threw Evans' alleged murder of his wife and baby into doubt, the entire affair was connected by common threads of poverty and unwanted pregnancy – the life-risking lengths men and women would go in order to (illegally) terminate pregnancies they could not afford. In the press and popular imagination the moral and physical decay of this Victorian terrace had become synonymous, and the 'shabby street' in 'Rotting Hill' was only half a mile from Appleford Road.[6] Kensal Town and Notting Hill were divided only by the railway lane, traversed by Golborne Road bridge, which ran alongside Southam Street. Positing the Burdett's two-room flat as 'rather poor accommodation' therefore benefitted the prosecution's case. The crime scene photographs

contributed to this understanding, showing what was interpreted for the jury as the 'small room', 'makeshift furniture' and 'unfinished chair'. Compared to rising living standards for other social groups at this time, the affluence portrayed by advertising and the availability of innovations in domestic technologies and design, this was far from the 'ideal home' of the late 1950s.[7] However, it is likely that this was the common interior reality for inhabitants of Kensal Town (such as those portrayed in street photography by Roger Mayne explored later in this chapter): each house inhabited by between two and four families, little space or privacy, shared toilets and kitchens comprising only a small cooker and stone sink. Numerous other mid-century murder cases bear this out. For example, it is striking how closely the Burdett's living arrangements echo those of the Anderson family and their neighbours in Camden Town almost a quarter of a century before (see Chapter 2).

Furthermore, Brian's efforts at DIY, his vitriolic reporting to his wife by letter that they could expect a better place to live soon, that their fortunes were about to change, suggest that Brian was aspiring to something more like the contemporary ideal home. He showed an awareness that Britain was on the brink of social change for people like him.[8] He was educated, his parents were of what might be referred to as skilled working-class or lower-middle, and young Brian was benefitting from post-war education improvements and raised age of school-leaving, he had likely been to college or undertaken some training to become a clerk rather than a labourer. By getting into debt, separating, proving herself an unskilled housewife and mother, less than his intellectual equal and getting pregnant again, Moira was preventing Brian from reaching the standard of living to which he aspired. She had to go so he could start again. I am not asserting that this was the reality of the circumstances, that these were the motivations and emotions that led to Moira Burdett's death. Rather, this was the crime narrative prosecution counsel were telling in order to pursue a conviction of murder for Brian Burdett. The photographs and other visual evidence in the file were perfect illustrations.

The Burdett case file represents the archival jackpot when it comes to crime scene photographs in twentieth-century London. It is impossible to ignore the materiality of such a document, suggested in the vignette of archival encounter in the introduction to this book. Within its acid-free grey cardboard coverings are concealed colourful insights into the lives of a family in many ways typical of their time. There are no secrets or revelations to be revealed, and the documents are highly skewed in that they have been collected for the prosecution and defence of murder, but this chapter attempts to unlock the meanings of the

Burdett family's private, interior domestic spaces and the extent to which they had agency to alter them. It illuminates the ways crime scene photographs and ordinary domestic items took on new significance in the context of a murder trial and allows us to situate these meanings in a historical moment seeing a reworking of public and private space, social identities and legal boundaries. Furthermore, it plays with historical scale, highlighting the personal challenges and aspirations of individuals and families in the context of a room, in a flat, in a house, in a street, in a neighbourhood, in a district, in a city, in a nation, all witnessing and experiencing change of which they are aware and are hopeful for, but also anxious about. By focussing on the courtroom context, this chapter explores the Burdett case to demonstrate how crucial visual cues were to comprehending crime narratives and directing a trial towards conviction for a legally defined and socially contingent offence. In the next section I will compare an important visual source for understanding social change in London at precisely the moment of the murder of Moira Burdett, comparing the meanings of these visual representations of North Kensington, of London and of British social life with those represented by the crime scene photographs of her kitchen.

Photographing North Kensington

Photographs of working-class people and their environments in the nineteenth and twentieth centuries typically placed them in public space: on the street, in the workplace or in other problematized spaces subject to surveillance. From nineteenth-century slum photography and early photojournalism, to the surrealists of the 1930s and the social commentary of the 1950s and 1960s, a long-established tradition existed of depicting working-class life for the middle-class gaze through the medium of photography.[9] These images contributed to an imagined social mapping or zoning of class conditions and distinctions in English cities. Bill Brandt, for example, explicitly contrasted working-class children and their outdoor play on public streets with the private, indoor, more ordered lives of middle-class children in *The English at Home*.[10] Interior domestic photography of working-class people has tended to associate housing conditions visible in photographs – peeling paint, damp, crowded rooms – with pathologies of poverty and class laying the responsibility for moral and environmental degradation with residents. In the same ways, photographs of Black Londoners published post-war rarely positioned them in comfortable domesticity, as explained in the last chapter with reference to the case of Backary Manneh

and Joseph Aaku.[11] Rather they drew on visual cues to allude to problems of miscegenation and racialized homes and domestic behaviours. In common with these traditions, photographer Roger Mayne depicted working-class and black people in the late 1950s on streets in North Kensington, London, focussing on Notting Hill and, just over the Golborne Road rail bridge, Kensal Town. Between 1956 and 1961, Mayne made 1,400 photographs of Southam Street in twenty-seven visits to Kensal Town. In his important 2014 article about class and social change in post-war urban England, historian Stephen Brooke argued that Mayne's images consciously depicted working-class culture at a moment of change, as post-war planning and increased consumption were drawing into sharper focus the material differences and dilapidated urban landscape of Southam Street and its neighbours.[12]

The Southam Street of Roger Mayne was an artistic exercise, emerging from a mid-century oeuvre that simultaneously decried the dilapidated conditions of Victorian 'slum' housing and celebrated the vibrancy and immediacy of community life there. Brooke has argued that Mayne was conscious of the imminent disappearance of the social and cultural life Southam Street represented and that his photographs were an exercise in preservation. He may even have anticipated the nostalgic feelings they would come to evoke in the 1980s. The letters in the Burdett file between a young couple of a burgeoning new consumer generation lend support to such a notion – the local papers were 'full of this slump [sic] clearance drive', Brian told his wife in 1956, the same year that Mayne started taking his pictures of Southam Street.[13] The house the Burdetts lived in was just yards from Southam Street on Appleford Road which ran parallel, connected by Golborne Road to the East and two other streets at the West and middle; it may even feature in some of Mayne's photographs. The letters between Brian and Moira in the case file suggest something of the experience of thousands of residents in these streets. Although it would be years before many were rehomed and the old buildings demolished, 1956 was when each house 'had it's [sic] marching orders'.[14]

The 'slums' depicted in Roger Mayne's photographs are a backdrop to the residents who are the focus, but the images make sense only in the context of the crumbling urban landscape. Mayne is well known for his images of working-class children at play in Southam Street but others show a vivid but dramatic and shadowy landscape before which adults and teen-aged people move roughly from left to right or right to left across the frame. They are busy, they are going somewhere – to work, to the shops, to the pub, to home from these places – the journey and the destination part of the classed narrative implied in the

images. In this way, many of Mayne's photographs of working-class Southam Street resemble L. S. Lowry's paintings.[15] If terraces and factory chimneys in the background, with dark figures moving through the landscape in the foreground, are the recognizable ciphers of the working-class North depicted by Lowry, the North Kensington icons are the cracked pillars barely holding up scarred porticoes and rusty balconies on the front of long, tall terraces. Sash windows with rotted wood frames and net curtains keep out the neighbours and the gaze of the camera, while shops, corners and bare walls are marked by broken railings, smog-stained sandstone and graffiti: clumsy misspelled insults and games of noughts and crosses in chalk or scratched into worn paint. See for example, Mayne's 1961 photograph titled 'A corner of Southam Street, North Kensington, London, with children playing in front of a blackened wall' is reproduced here as Figure 7.1. There is an enormous catalogue of Mayne images from which one could choose to represent his work but this one has been selected because it does not feature in Stephen Brooke's article and shows a junction with Golborne Road. Some of the photograph's subjects are in sight of the Burdett house. The hunched woman in the foreground is reminiscent of a Lowry figure. The children behind her are either reading or adding to the graffiti or perhaps bouncing a ball (out of frame) high against the wall. The man of colour coming around the corner

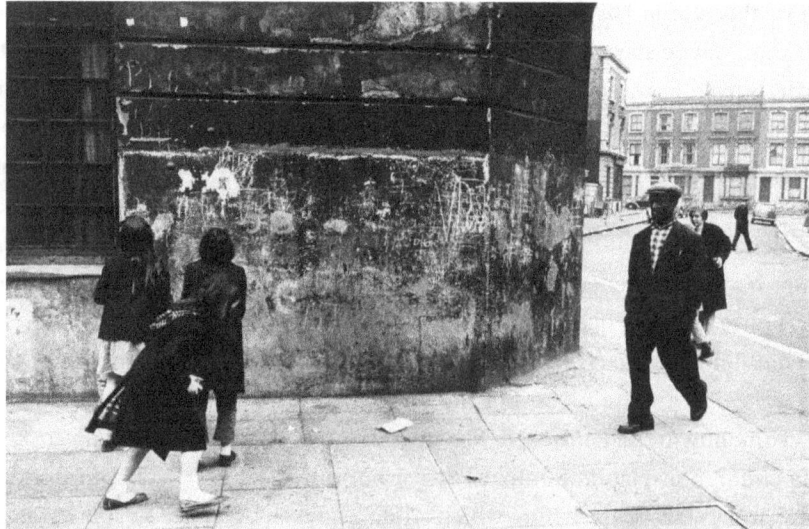

Figure 7.1 Roger Mayne (1961) 'A corner of Southam Street, North Kensington, London, with children playing in front of a blackened wall', Roger Mayne, 1961. © Roger Mayne Archive/Mary Evans Picture Library. Used with permission.

is consistent with many of Mayne's images usually captioned or titled as 'West Indian'. Mayne's corpus did not, apparently, feature any of the Southam Street or North Kensington residents inside their homes, although he later photographed artists and literary types in theirs.[16] Colour photography was available at this time but Mayne worked mainly in monochrome, possibly because of its associations with serious documentary photography. The Burdett file not only takes us indoors at Mayne's Southam Street area but also adds colour there.

North Kensington in image, narrative and courtroom

Within months of the trial of Brian Burdett for the murder of his wife, Moira, significant legal changes would take effect that would impact police practice and courtroom considerations.[17] It was also a moment of significant social and cultural change in the capital, recorded by photographers within metres of the crime scene.[18] The Burdett crime scene photographs themselves are in black and white, like decades of crime scene photography before them, but, in more ways than one, the wealth of additional material in the depositions file adds colour and vibrancy to the space they depict. The narrative this file helps to colourize is one of post-war poverty and deprivation despite every effort taken to eke out a living for a family on what must have been a better-than-average clerical wage. It is a narrative of everyday lives and relationships that was extraordinary only because the marriage ended in murder, apparently motivated by regret, wanting to start again, to wipe the slate clean. The evidence presented by prosecution in support of this narrative, read against the grain, tells much more than one individual family's struggles, illustrating rather the perceived powerful pull of the desire to reinvent oneself in the light of increased post-war opportunities. Poverty and personal debt as factors that could drive people to commit desperate acts in pursuit of improved surroundings and social advancement were offered as motives to kill as part of a story that was particular to the promises of the post-war period. This narrative did not mitigate Moira's death but defined it as capital murder.

For the defence, on the other hand, the richly illustrative and visual enclosures that accompanied Brian's letters served to support their own narrative that he was a good husband and invested in his life with Moira. When they separated and discussed getting back together, Moira disclosed her financial difficulties but she had conditions before she would consider coming back. At the top of her list was 'a decent home to come home to'.[19] The letters and photographs between the

Burdetts are highly instructive because they demonstrate how Brian interpreted this notion: they reveal what his idea of a 'decent home' was, or what he thought Moira's might be. A 'decent home' for the Burdetts in 1956 was a mainly aesthetic concept. For Moira it may have been understood in comparison to the homes they had shared before – they had previously lived in rooms near Brian's parents, and before that they had lived with Brian's mother and father. Brian's mother did not like Moira. She held a dim view of her daughter-in-law's housekeeping and domestic organizational skills commenting 'she was not my sort of housewife'.[20] This was a damning statement indeed in the 1950s. Furthermore, neither Brian nor his mother apparently liked the way Moira cared for their son. Prosecuting counsel later suspected that Mrs Burdett realized the implications of her comments in this regard: that her son was not happy with the way Moira looked after their son and their home could imply something like a motive to kill her. Blanche Burdett seemed to have forgotten saying these things at the police court when questioned about them at the Old Bailey. Brian himself also attempted to challenge some of the implications embedded in prosecution counsel's questioning at his trial. He reworded questions and corrected suggestions in a way that belied his reportedly higher-than-average IQ. It should be remembered that many working-class people, including those who were not familiar with the language of the court or able to make themselves understood there, were not so capable as Brian Burdett.[21]

In his letter that became a defence exhibit at his trial for his wife's murder, Brian responded to his wife's condition that she wanted 'a decent home to come home to' by explaining how he had 'decorated the kitchen'. He had performed a great deal of physical labour including removing wood and ripping out cupboards and damp, removing wallpaper and plastering. 'I have bought one of those spray guns and sprayed the ceiling BLACK! and everybody likes it!' he told his wife. I have used 'a yellow paper on the complete fireplace wall and a greyish paper on t'[sic] other three. Enough paint dripped on the floor to encourage me to spray that as well.' He encloses samples of these wallpapers in the envelope with the letter, including hand-drawn sketches to demonstrate how he had boxed in the pipes and Victorian fireplace surround. He described this as 'a rough old drawing, but perhaps you can understand it xxx'.[22] The yellow paper is printed with a diamond-shaped trellis design in white paint and each diamond shape it forms has a black atomic star printed inside. The pattern is very 'modern', the colour and shapes precisely match the present cultural trope of the 1950s. That such papers were affordable to ordinary working-class people is perhaps surprising. It demonstrates the vernacular of 1956 – with the

Burdetts in debt, though Brian earned a decent wage – it seems there is little reason not to imagine any room in any house in North Kensington as colourful and modern as this one.

It is fortunate that Brian enclosed wallpaper samples in his letter to Moira and that she preserved the letter when they got back together. The pattern is not clearly visible in the crime scene photographs, it actually looks more prosaic than modern, and the monochrome medium deprives the kitchen of all its colour. The other paper is shown in the opposite view of the same room, though it should be noted that the perspective is inaccurate in the images. The impression I had when first encountering this photograph is that the room is quite large, but it is a trick of the camera or of the furniture. The makeshift tabletop (formica or laminated wood – contemporary design on a budget) in the foreground left of Figure 7.2 is the same as that just right of centre, under the curtains, in Figure 7.3. This indicates that the photographer, DS John Merry (one of the last crime scene photographers to have been recruited to C3 from the ranks of ordinary police officers as opposed to civilians with professional photography experience or qualifications), had to wedge himself into the corner by the gas cooker and sink in order to make one of his exposures. He must have been practically sitting on the chest of drawers

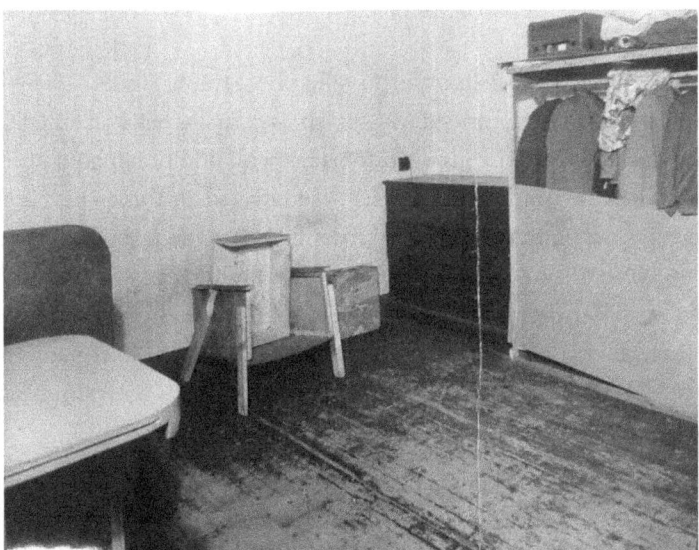

Figure 7.2 First floor kitchen at 28 Appleford Road, North Kensington, taken by Detective Sergeant John Merry, Photographic Department, New Scotland Yard, 8 December 1956. Source: TNA: CRIM 1/2783: Burdett, Brian Edward: Murder: Exhibit 4 (1). © Crown copyright. Metropolitan Police Service. Used with permission.

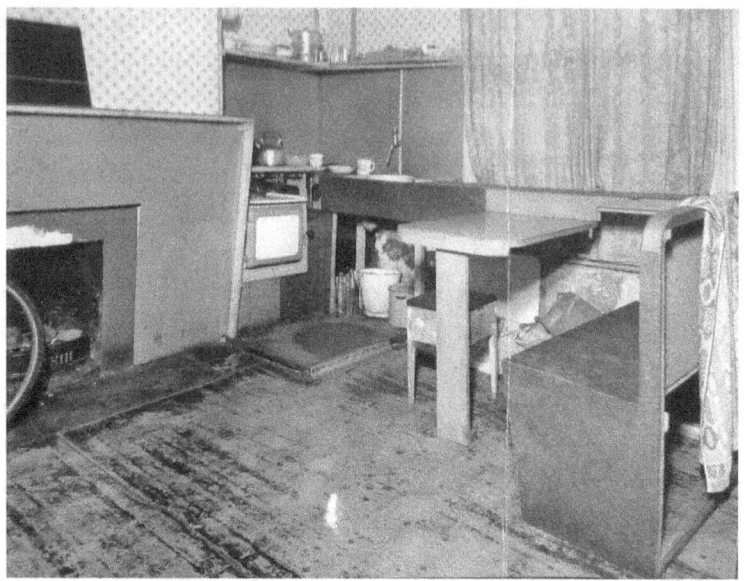

Figure 7.3 First floor kitchen (reverse view), 28 Appleford Road, North Kensington, taken by Detective Sergeant John Merry, Photographic Department, New Scotland Yard, 8 December 1956. Source: TNA: CRIM 1/2783: Burdett, Brian Edward: Murder: Exhibit 4 (2). © Crown copyright. Metropolitan Police Service. Used with permission.

in the corner of Figure 7.2 in order to take photograph Figure 7.3. The second wallpaper which Brian described as 'greyish' is actually black abstract stripes in a cross-hatched design on rough white paper with additional gold accents. The unfinished chair in front of the largest wall covered in this paper seems to be following a vaguely modernist shape to complement the rest of the décor. Brian is going great lengths to fashion a modern if makeshift 'decent home' for himself and his family based on his far-from-professional DIY skills. He even accessorized in complementary colours; 'I've bought a small (4' 3" × 2' 3") contemporary rug sort of green, black, white and yellow geometric pattern – an Axminster,' he tells her proudly. He has plans for their other room too:

> ... a bit of plastering and the walls sizing. I fancy a sprayed ceiling – a rich plum red or my old bottle green with two snazzy contemporary wallpapers. I'll spray that high skirting and the lino and have smallish rugs instead of the fitted carpet which I'll postpone until the new flat.[23]

Later in the letter Brian makes clear that 'the new flat' refers to a long-hoped for council flat. They are on the housing list but there has been no news yet.

That Brian draws a line between the physical labour, effort and expense of painting and rugs, and the cost and investment of fitted carpet is interesting. He envisages that they will not be living at Appleford Road long enough to justify the outlay for fitted carpets, which they may not be able to take with them, but the wallpaper and painting, equally immoveable, are worth doing to improve their living conditions in the short term. The rugs, of course, they can take when they move. These details reveal the extent, limitations and implications of domestic home-making strategies, thus demonstrating the complex reworking of class identities within domestic space. For the defence counsel, Brian Burdett's behaviours in private, including his efforts at DIY, supported their interpretation of him as a good husband and father who provided for his family. They used the letters Hylton-Foster referred to in his opening statement in support of their competing narrative.[24] The letters and their enclosures possess immense value for historians, describing Appleford Road, Kensal Town, in exactly the period of transition Brooke argues is captured in Mayne's photographs of the neighbourhood.[25] They describe the improvements Brian made to the flat that are shown in the photos, and the Burdett's relationships: with each other, with other residents of the building and with their extended families. They show how credit schemes had landed the couple in financial difficulty, how they depended on a local nursery and Moira's additional income to support Brian's, and how the promise of a council flat would mean an improvement in their circumstances in the long-term, but that it would considerably stretch their finances and add to their debts. Brian's letters include local gossip, including the goings-on in the rest of the building. Neighbours and extended family are experiencing similar financial restrictions and concerns for the future. Some are emigrating to Canada and Australia respectively as a means of coping with the same challenges. Brian tries to be happy for them. But when their own fortunes seem to be changing such that they will get out of Appleford Road, he is ecstatic.[26] The Burdett's home and social milieu paint a picture of the 1950s as a privately as well as publicly contradictory decade.[27]

Brian's retelling of how he discovered that their tenancy at Appleford Road was the key to a new home is instructive. Roger Mayne's Southam Street subjects make no comment on the conditions of their surroundings but Brian certainly noticed them:

> The whole story started one Monday morning some weeks ago ... I found the whole of the front of the building covered in scaffolding. Tuesday night when I returned I found they had started a bit of cementing-up patches and Wednesday night it had all gone again! I thought what a waste of time – all that scaffolding

just for a few badly done patches. Anyway over the weekend when I saw Betty [their downstairs neighbour] she told me that a Council bloke had seen the men at work and told them they might as well pack it in because the Council were taking over in a year's time. Then I had a letter from the Landlord explaining the sudden discontinuation of the exterior decorating and he assumed that we would be one of the first to be re-housed in the buildings shortly to be erected! When I paid the rent the lady told me the Council reckoned taking over in between six and twelve months' time but when and where and into what we will move is at present unknown. However, all this is on the level and Pam says her 'Kensington Post' has been full of this new slump [sic] clearance drive lately so I reckon we'll be sitting pretty soon. Our house has had its marching orders and as soon as the new flats go up we move in and our house comes down – for more new flats? We've really hit the jackpot now Doll … I want you both back here pronto. Understand?[28]

Merry's photographs of the Burdett's flat were two wide-angle, establishing shots. They had little purpose before the courtroom where they showed the jury the decoration, the makeshift furniture, the limited space and the few modern conveniences or comfortable furnishings. There were no photographs of the cup from which Moira drank or the teapot that had been scoured. The rug is slung over the back of the homemade furniture rather than photographed close-up to show the stains the cleaners could not remove.[29] Rather than 'proving' items in situ, they gave a 'feel' of the place, communicating subtle messages about the flat and the circumstances of the people who lived in it. In common with other police-created sources, these subtle messages reflect contemporary social mores and values. Further than that, however, the photographs were used to support the narratives told in the courtroom about how and why Moira had died and by whose hand. Every picture told a story that directly informed understandings of the crime and culpability of victim and defendant, their class, gender, race and sexuality. Little used as a source for histories or criminologies of twentieth-century Britain, crime scene photographs and their associated documents therefore offer a unique reading of private, interior domestic spaces and the ways they were interpreted in the courtroom.

As this and other chapters have shown, letters, love notes, books, diaries, cheques, bank statements, rent books, pawn tickets, receipts and all manner of other ephemera police deemed relevant to their investigation into the cause of the victims' death can feature in case files for domestic murders. But it is important to consider these sources in their bureaucratic and legal contexts to analyse the narrative they were being used to support. Going through several stages of

selection and transcription before they were seen by the Old Bailey jury, they can be understood as primarily biased towards the prosecution's narrative. In Brian's case the letters, along with other exhibits of evidence including the album of crime scene photographs, the statements Brian made before and after his arrest, and the cup from which Moira drank the tea that poisoned her, were presented at Marylebone Police Court where the case for the prosecution was laid out. The defence counsel would, by this practice, know what the case against their client consisted of, and select from the available evidence to support their own case. The defence's case would invariably be 'reserved' for the higher court, meaning that they were not obliged to reveal how they would contest the prosecution's narrative until that point in the proceedings. It is important to note that the defence would not be able to produce new exhibits, or conduct investigations of their own, as portrayed in popular US television shows on criminal trials. Rather, their task would be to undermine the prosecution's case against their client, planting doubt in the minds of the jury that their client had committed the crime with which he was charged. They could do this by systematically unpicking each piece of evidence that supported the prosecution's case, but it usually involved offering a narrative of their own, even one which was implied, such as suicide, accidental death, insanity or some mitigating circumstance such as provocation or diminished responsibility (though some of these concepts were not codified or expressly articulated in law until the 1957 Homicide Act, many were applied in discretion long before).

However, judicial practice is based on precedent and experience, and police and prosecution were equally and invariably aware of all the potential tactics or alternative narratives that could be offered to defeat a murder charge. They thus sought to protect against alternative readings of the crime from the outset, in order to secure a successful conviction. This is clear from the notes scribbled on some of the documents, and from the practices of police and the psychiatric reports which followed a standard script. For example: 'I have interviewed the prisoner and read the depositions,' psychiatrists typically wrote, '... I consider him fit to plead to the indictment and do not regard him to be the subject of substantially diminished responsibility,' speaking directly to contemporary legal constructs.[30] Similar standard wording featured in statements by defendants, made at police interviews. Here, the Judges' Rules applied, not to protect defendants against police pressure and harsh interviewing tactics, but to protect police and prosecution from accusations by defence that statements had been extracted under pressure, this being one way that doubt could be cast on the veracity of such evidence, necessitating a not guilty verdict (see Chapter 2).

However, the rules regarding rhetoric in liminal spaces between the strictly regulated police station, courtroom and prison seem to have been unclear or at least less closely scrutinized, as we will see.

Challenging narratives of domesticity

That the new council home would not solve all the Burdett's problems is clear from the letters, particularly the passage quoted above. Brian also ceased work on the interior of their flat at the same time the exterior decorations were suspended. It was not until the following decade that Southam Street and Appleford Road residents were rehoused and Erno Goldfinger's Trellick Tower, erected on Golborne Road, did not open until 1973. High-rise living brought its own challenges and though flats were private they signalled the isolation and loss of community that would inspire Mayne's photographs to be viewed with nostalgic longing for the old 'slums'. Had Brian and Moira been rehoused, there they would have enjoyed a private bathroom, no need to go out into communal areas to go from kitchen to bedroom, and a bedroom for their little boy separate from his parents. They may have enjoyed a fitted kitchen as well as fitted carpets, a rubbish chute instead of a bucket under the sink, heating, storage and views over London. They might also have had less easy access to their neighbours, with whom they might not have had such close relationships as with 'Betty downstairs'. Most significantly, they would have struggled to furnish their new flat, buy the necessary fitted carpets for the bare concrete or tiled floors, and even meet their rent, which Brian estimated to be significantly higher than the Appleford Road flat. These concerns all challenge narratives of the council home as being the straightforward social leveller, the key to upward mobility and higher standards of living promised by contemporaries.[31] Still, Brian was clearly enamoured of the prospect of a council flat and hopeful because the Burdett's Appleford Road tenancy was the ticket to one. The council would have to rehouse them if the present house were deemed unliveable, despite the reality of thousands living like the Burdetts in Southam Street and Appleford Road alone. The narrative that was told in court was such that the desire for the council flat and all the opportunities for improved quality of life it represented was so powerful that it drove Brian to kill Moira.

Last-minute evidence from police had a powerful influence on securing the narrative established by the prosecution in the minds of the jury, or so it seems. Officers entrusted with Brian's custody after he was arrested noted that,

on the way between the police court and Brixton Prison, before his trial went to the Old Bailey, the prisoner was concerned about his case but became chatty when discussing the local area, including which was the best route to take. He started talking about where he lived and casually offered 'I'm worried about the rent on my flat, I mean to keep it on. I don't want to lose the flat, as I may get married again.'[32] Perhaps it was this spontaneous offering, combined with the fact that Brian was alleged to have hidden the poison that killed his wife in such an ordinary, everyday and seemingly innocuous cup of tea, that had the most impact on the jury. Amy Bell has observed the greater emotional impact of crime scene photographs and other case file sources that juxtapose the deadly and mundane.[33] That Brian embedded the means of Moira's murder within such a powerful symbol of ordinary British domestic life also challenges notions of safe and secure indoor domesticity. The North Kensington kitchen could be as dangerous as its streets.

Within two and a half years of Moira's murder in her kitchen, Antiguan carpenter Kelso Cochrane was stabbed with a stiletto knife on the corner of Southam Street and Golborne Road.[34] It is worth highlighting the Cochrane case here because, had his killers been arrested and brought to trial, a Central Criminal Court case file would have existed which might include photographs and depositions from which to reconstruct narratives of street life and public space comparable to Roger Mayne's photographs and Moira Burdett's killing in her kitchen. As it is, the files regarding Kelso Cochrane's death are relatively silent, certainly not as richly detailed as the Burdett files. Of the two Metropolitan Police files on Cochrane's murder held at the National Archives, one is closed until 2041 and the other is concerned with identifying which police officers leaked information to the press about the circumstances of Kelso Cochrane's murder and, critically, his colour, betraying his death as a narrative of racially motivated hate crime.[35] Without a trial, justice for Kelso Cochrane was not forthcoming. Without access to the archival record of police work, we cannot observe the collection and construction of narratives of Cochrane's life and the experiences of his neighbours and friends in North Kensington. Without a transcript, we cannot view the forensic deployment, argument and analysis of evidence, including photographs, narratives, counter-narratives and microhistories of domestic space, indoors or outdoors, safe or unsafe.

Historians who have used trials to illuminate social concerns have relied heavily upon a combination of court depositions and newspaper reporting.[36] However, newspapers highlighted the action in the courtroom over the evidence being deployed there, and so give little context for the documents and photographs.

Court reporting rules ensured newspapers took care not to reveal any detail that might put the paper in contempt of court.[37] In the Burdett case the barest facts of the case were revealed, connections between Brian's actions and Moira's death insinuated but not confirmed until after the case ended and sentence was passed. 'NOW it can be told', the first line of a report in the *Daily Mirror* announced after Brian was found guilty of his wife's murder.[38] Though newspapers were arguably limited in what they were able to report, the article also reveals insights into police interviewing practices. As described above, it was essential to the admissibility of defendant's statements that police were not deemed to be extracting confessions unfairly by offering bribes or threatening their suspects. The Judges' Rules were written to inform police practice on taking evidence to be presented to a judge, but it was not unknown for them to use at least mildly pressurizing tactics to gain information. They could offer or withhold cups of tea, food and cigarettes; they could keep suspects waiting for their interview, thus allowing them time to think, and worry, about what they might say.[39] The newspaper article that follows the conclusion of Brian's trial, for example, describes the significance of the seemingly mundane tea-drinking Hylton-Foster mentioned in his opening speech. Detective Superintendent Webb had 'deliberately left him [Brian] alone … [ellipsis as original] to his thoughts' after their first interview.[40] Even by 1964 after two Royal Commissions on Police Powers investigated allegations of savage questioning and other abuses of power, barrister Ben Whitaker quoted a police officer as saying: "'If we fully observed the [Judges'] Rules, new or old, we would be tying one hand behind our backs, and the public would be the first to howl at us because we never convicted anybody.'" An experienced inspector told him: "'A good policeman remembers the [Judges] Rules – [only] when he is in the witness-box.'"[41] Formulaic repetition of lines such as "I *want* to tell you what happened …" (meaning "I am not under pressure to do so") and "This statement has been read over to me and it is true (signed) …" further highlights concerns for admissibility as shaping defendant statements.[42]

In the same ways that defendant statements and witness depositions appear to be spontaneous prose, but can in fact be considered 'enforced narratives' shaped by invisible questions,[43] I argue that crime scene photographs were similarly shaped by the particular perspectives and demands of the geography, environment and preconceptions of police, as well as the narrative they had established or prioritized at the time the photographs were taken. However, although police court depositions (like Blanche Burdett's) were treated as though they were verbatim at the Old Bailey, crime scene photographs were not considered a detailed or accurate reflection of that which they depicted.

In Chapter 6 we saw how police photographer Merry articulated the lack of necessity for either himself or his camera to look at things at the scene in any detail. In the Burdett case he was not even required to appear in court.[44] Though crime scene photographs can be considered microhistories of domestic murders, the twentieth-century Old Bailey courtroom did not privilege photographs as scientific until after 1957. They do not fit into a narrative of a civilizing, rationalizing or increasingly scientific and objective approach to forensics.

Whatever happened in the first floor kitchen at 28 Appleford Road, Brian was unlikely to admit to intentionally having killed his wife with full 'malice and aforethought' when this would define it as a capital crime. Instead he highlighted the influence of other people, including his victim, in order to make himself appear less culpable. After all, Moira would not be able to contradict his version of events after she died. Avoiding a capital sentence meant successfully arguing manslaughter, rather than murder, which could receive a sentence of anywhere between no prison time and seven years. This could be achieved by arguing self-defence, provocation or diminished responsibility, each depending on the actions of the victim. These tropes were well understood by non-legal professionals at this time, communicated in newspapers and popular fiction, as Chapter 5 highlighted. A wife's domestic failings contributed to the construction of the familiar narrative, including the conditions of the home depicted in crime scene photographs. In Brian's case, passages where his statements described his wife's attitude to their home and its maintenance were highlighted, further delved into by the defence counsel at the Old Bailey. The home and expected roles and behaviour there were constructed as essential to understanding the character of adult women. If she was the victim, the opportunities for discrediting her as a homemaker, housekeeper, mother, cook, wife, lover, etc., were limitless, and the ways those criticisms were woven into narratives of their murders say much about contemporary ideas of morally innocent behaviour and acceptable gendered roles. If she was the defendant, attacks on a woman's character had to be made subtly rather than explicitly, and this would likely be done by drawing attention to the positive aspects of the personality of her victim, thus casting doubt on whether he could have provoked her or required her to defend herself against him. As the majority of murders were committed by husbands against their wives, it follows that narratives of domestically transgressive women victims would be more frequent and more prolific than for men. As domestic violence by men became less tolerated over the mid-century period, women who killed their violent husbands were treated more sympathetically, but they were still open to insinuation from prosecutors that they were less than perfect

when it came to marriage and home, and that their dead husbands had been reasonable, non-violent men who provided for home and family.[45] This kind of image would cast doubt on a narrative of intolerable violence, self-defence or provocation which could sway the jury.

Though the Homicide Act, 1957 would alter legal definitions of provocation, it was frequently reported in the press prior to that date, when judges' summing-up statements told murdering husbands that they were being sentenced to a short period for manslaughter, rather than capitally punished for murder, because they had been provoked by their dead wife's words or actions. The concept of provocation, like 'diminished responsibility', spoke to a sort of temporary state of insanity or loss of control at a point of high emotion. They were thus interpreted by prison medical officers and psychiatrists who prepared reports for submission to the court based on observations and interviews with a defendant and their readings of the statements, depositions, crime scene photographs and other documents in the case file. This is significant because it reveals the degree to which 'medical experts' could be influenced by the narrative of a crime already constructed by police. Narratives that spoke to defendant's reactions to provocative behaviour tended to feature headaches, blackouts or family history of epilepsy or mental illness in the earlier decades of the twentieth century. Later, developments in the field of Psychiatry and the way mental explanations could be applied to murder included extensive interpretation of a victim's behaviour, based on information given by the defendant. In a case from 1969, for example, a psychiatrist employed for the defence of a man who had killed his wife offered a medicalized interpretation of the defendant's violence as being the result of her 'nagging' (his own word). Despite having dinner ready on the table every night when the defendant came home from work, she had driven him to his fatal actions by going out too much.[46] His plea of guilty to manslaughter and not guilty to murder was accepted; he received a suspended sentence and left the Old Bailey a free man. Expert witnesses had considerable power to influence the outcome of a trial with their reports, depending on the quality of their testimony, their performance in court under questioning, and the commitment they showed to their interpretation of the evidence their expertise was called on. However, as Chapters 2 and 5 showed, experts and judges could be ignored by the jury if the crime narrative offered was more compelling. Defendant statements, witness depositions, expert reports and crime scene photographs were all deployed in support of these narratives of a murder, established by police in the first instance and geared towards the most likely positive conviction. Narratives of crime thus spoke directly to legal frameworks and classifications, as well as to contemporary

cultural, social and moral standards, and gendered and raced ideas of what made a working-class individual and a working-class home, respectable.

Police and judicial systems were undergoing radical change in the post-war period as much as life in the home and on the street was, and each inflected the other. Most significantly, the 1957 Homicide Act limited capital murder to killing in the act of theft or robbery or to steal, or killing with a firearm, among other less frequent circumstances, reducing most domestic murders to non-capital offences.[47] Though further research is required to compare the administration and institutional memory of hanging before and after the 1957 Act came into effect, it is inevitable that demands made of evidence in domestic murder cases faced transformation – partly because of changing definitions of murder and their legal applications, but also because domestic murder was no longer a life-or-death matter for the defendant.[48] This further reflects the changing social texture of twentieth-century London, and builds on work by Brooke and others who argue that class remained a powerful, if nuanced, referent of difference in post-war Britain.[49]

Conclusion (jackpot)

Since the archival research for this book commenced, the jackpot of murder files containing the Burdetts' letters and wallpaper, as well as the crime scene photographs, has been closed, first restricted until the 2020s and now subject to review under the Freedom of Information Act.[50] The existence of the trial transcript provides an insight into how the evidence was applied, but any researcher wishing to follow my research steps and test my conclusions will see only the trial transcript and not the evidence it refers to.[51] This represents a reversal compared to most of the cases and files referred to earlier in this book. The transcript shows how the photographs were shaped, how the jury were told what to read in the photograph in terms of the working-class lives of the family and the deprivation as motive for the killing. Buildings have been demolished and landscapes altered beyond recognition, not because they were the scenes of crimes, though this may have made redevelopment a more appealing outcome. Rather, their redevelopment represents the same post-war reworking of home and landscape that the Burdett case illustrates, with all the promise of a future unrealized that it represents.

The particularities of the case against Brian Burdett for the murder of his wife show the private, domestic, homely, interior lives of these working-class

people through both photographic and textual sources, and the ways they were attempting to negotiate material comfort and privacy in their home at a time, and place, undergoing social change. In the same way as Roger Mayne's photographs show a dilapidated urban landscape, framing the working-class residents, so too did crime scene photographs depict homes and the material circumstances of the people who lived in them.[52] By standing in for the space of a crime, I argue, London crime scene photographs situated the narratives of the crime that were deployed in support of prosecution or defence counsel's telling of events at the Old Bailey. The narratives themselves show how the photographs contributed to understandings of a home and implied meanings about the people who lived there, where gender, sexuality, race and class remained powerful ciphers throughout the twentieth century.

8

Conclusion: A Place through Crime

To photograph a crime scene in twentieth-century London was to represent space, place and narrative for the Old Bailey courtroom. Each image represented a microhistory of a murder, as well as telling about the lives and relationships that centred on, and ended in, the domestic space it depicted. As Chapters 2 and 3 illustrated in their explorations of the cases of John Anderson and Georgios Kalli Georgiou, crime scene photography functioned to stand in for spaces in order to geographically situate murder narratives for consumption by the courtroom. Allowing the jury to imagine events playing out in space called on common sense rather than scientific interpretation. Expert police photographers were required to confirm that they had made the images, but not what they showed. Furthermore, detailed examination, investigation from photographs or analysis by the jury, was not part of the function of these images. An effect, but not explicitly stated purpose of representations of crime scenes, was to communicate other information that would assist the jury in testing the narratives they were presented with. As the homes of the Andersons and Elvira Barney show in sharp contrast, social class had visual referents that could contribute to understandings of culpability and guilt: a crime scene photograph could be read for evidence of conformity with or deviation from expected social and gendered roles. As the Georgiou case in Chapter 3 showed, this also becomes clear when spaces went un-photographed. However, other visual referents also had the potential to influence readings of sexuality and secret-keeping, which additionally contributed to understandings of people's homes, identities and crimes.

Interior crime scene photographs, perhaps surprisingly, could tell about the conditions outside of the space they depicted. A 'Bloomsbury Murder' meant something different from 'Murder in Notting Hill', the established cultural understandings of these places bringing something to press reports and readings of photographs.[1] However, the reverse was also true. As Chapter 5 explored through the Hartney case, crime scene photographs could help the courtroom

to understand what sort of a place was outside the frame. By moving his wife's body from their home to the street, as police believed he had done, Hartney could draw on the racialized, sexually dangerous meanings associated with the place of Limehouse and propose a new narrative for her murder in which she was partially culpable – for going out in such an area, alone and at night.

In addition, Hartney and other alleged murderers could draw on the familiar visual referents associated with murder of certain types in order to manipulate crime scenes and crime narratives. In the Harrison case, this meant explicitly deploying a 'murder story' by the defendant in support of a narrative of insanity leading to the murder of his wife. This is significant because it was narratives, more directly than individual exhibits of evidence, that determined the outcome of a case. This is also apparent in the trial of Backary Manneh, explored in Chapter 6, where narratives were suggested for the crime that were heavily rooted in racial stereotypes. Given that housing and home were such powerful themes in the lives of people of colour in Britain in the twentieth century, it behoves us to examine and challenge such narratives, using crime scene photographs to suggest alternative readings, competing narratives of lives and identities, prioritizing the kind of homely interpretations afforded to white people. In so doing, microhistories such as the vignettes with which I have introduced each chapter of this book can be formed from the same visual sources. Similarly, the approach suggested in this book allows us to challenge the accepted view of domesticity in post-war England and Wales as safe, of new homes offering social change and new opportunities. The Burdett case explored in Chapter 7 shows how narratives of domesticity could work for and against defendant and victim, giving colour and nuance to nostalgic views of the domestic past.

The method of reading against the grain applied in this book allows us to peel back the layers of assumptions and tropes regarding class, gender, race and domesticity, as well as analysing how they were employed as the basis for prosecution and defence cases or decisions to grant mercy. Herein lies an interesting tension. Though we may never recover the reasons for criminal justice decisions in the past (as Steedman said, the truth was never there in the first place),[2] examining the various processes through which exhibits of evidence were filtered and shaped and, as QCs and colleagues put it, 'fitted neatly together like a jigsaw puzzle',[3] allows us to explore the impact of pre-existing cultural tropes on interpretations of evidence and their role in determining legal outcomes. Furthermore, this kind of analysis and imagining allows us to explore the cultural circuit formed when narratives of crime were deployed with particular legal aims, filtered from the courts into public knowledge through press and popular culture, re-emerging later as recycled narratives of murder.

That crime scene photographs achieved transportation of place through space and time from someone's living room to the Old Bailey courtroom highlights the careful evocation of imagination, theatrical staging, skills of oration, explanation and argument that took place there. Prosecuting counsel would invariably highlight the most violent, dramatic, calculated or devious acts committed by the person they were seeking to convict. Visual cues such as weapons, bones, blood-stained artefacts and crime scene photographs could assist in this endeavour but they were not the only techniques at their disposal. Telling a coherent and logical narrative, a believable sequence of events that led a clear path through time and space to the deliberate killing of the victim would ensure a positive outcome for prosecution. This was not about scientific proof or direct versus circumstantial evidence. Judges did not anticipate in their summings-up that juries would spend their time deliberating over scientific details or the accuracy of certain types of laboratory testing in order to uncover reasonable doubt. Rather, they were simply asked if the evidence presented added up to the charge. Defendants carefully cultivated their appearances, hired the most practised and talented advocates if they could afford it, and drew on contemporary tropes that were calculated to elicit the most sympathetic responses and generous interpretations. Critically, images of their homes or the homes of victims could make powerful contributions to perceptions of identities of defendant and victim.

This book supports recent urban historiography that argues there was little distinct social zoning separating different classes and urban spaces in the twentieth-century capital, instead offering particularities that define experiences of spaces as more fluid and mobile.[4] It unsettles the boundaries offered by other photographic sources that would suggest that working-class lives were lived in public and middle-class lives in private.[5] It also offers examples of experiences that illustrate a certain continuity over time in terms of people's attempts to negotiate social change for themselves through the spaces in which they lived. Counter-narratives are offered to some of the contemporary discourses deployed by the judiciary. For example, domestic spaces were racialized in order to mark individuals as culturally different from white neighbours and jurors, whereas particular witnesses describe instead common struggles and mutual assistance. This is particularly important as recent historiography has revised 'race relations' narratives of black history prioritizing public, working identities and instead forefronted particularities of experience that show comfort and domesticity as more consequential aspects of the experiences of people of colour.[6] Photographs have a key role to play in this regard, identifying points of contestation between captions or descriptions and images themselves.

Recent uses of imaginative methods, descriptive writing, creative practice and consideration of visual and material evidence by historians and criminologists demand a new way of looking at crime sources, one that takes into account the precise contexts that called a crime story into being and how (and how far) the evidence that remains in the archive was used to authenticate it.[7] Such an approach promises to render the seemingly messy and incoherent case files for twentieth-century crimes more approachable and useful to historians. Particularly numerous and rich for cases of murder than for any other crime, murder case files feature a wide range of documents and ephemera with immeasurable detail and value. Depositions may not be unmediated but, as other historians working with similar texts from far earlier centuries have pointed out, they include rich detail on the everyday lives, activities and experiences of the people deposing. But what happens when we confront the mediation and seek to understand the conditions that made the depositions and other evidence, whether it be documentary, visual or material? The social, economic, cultural and political conditions are telling, to be sure, but so are the investigative, bureaucratic, legal and judicial conditions. The specific circumstances of an instance of crime have something to offer twentieth-century British history that goes beyond derivative generalizations and instead says something particular about the moment at which a crime was committed, investigated and tried. By examining the legal scripts and frameworks through which the sources in case files for murder trials were constituted, we can understand why defendants and witnesses, prosecution and defence counsels told certain narratives. Historically, geographically, politically and legally contingent, the narratives themselves are extremely useful to scholars of twentieth-century British history. By applying recent methods with their focus on storytelling and combining them with attention to the construction of these types of sources, on which very little has previously been written, this book contributes to new movements in historical and criminological writing that are increasingly imaginative, creative and narrative in both the subjects they study and the methods they employ. Its unique contribution to this literature is by its application of such an approach to better understanding the visual, exploring the ways in which evidence, narrative and, crucially, image were deployed to appeal to contemporary ideas of guilty, culpable, innocent or respectable behaviour. The vignettes deployed here to visualize encounters with crime scenes are not simply micro-narratives about individuals, homes or relationships; they are a way of comprehending important and persistent narratives about crime, home and social life: microhistories of a nation itself.

The processes described in this book of investigation, establishing a narrative of events, collection of evidence in support of that narrative and then deployment at the Old Bailey, are important because they identify crime case files as collections of evidence skewed even from the moment a crime was identified. They cannot be considered by historians to be neutral dossiers of photographs, documents, depositions and ephemera, though this is very much what they appear to be on first reading. This book has demonstrated how trial transcripts are critical to this understanding because, unlike depositions, they include something close to a verbatim account of what was said in court, including how each piece of evidence was described, collected, deployed and disputed. This includes the photographs of the scene. Though the technical methods and empirical value of crime scene photography changed little for Metropolitan Police from 1932 to 1957 (the earliest and latest cases explored in this book), Chapters 5, 6 and 7 demonstrate the increasing tendency for photographs to be captioned in the courtroom. Opening speeches by prosecution and summing-up by judges, for examples, subtly suggested to the jury ways of reading the crime scene photographs. However, the outcome of each individual case balanced on a knife-edge of admissible evidence, as well as depending on how convincing prosecution and defence counsels could be in their theatrical displays at the Old Bailey. In criminal trials, I argue, and particularly in trials for murder, narrative was of utmost importance. Prosecution and the police on one side, and defence and the defendant on the other side, offered competing narratives to a judge and jury. Each narrative was constructed to fit a contemporary idea of murder or manslaughter, a legal framework for the story of the crime and a cultural framework of respectability, guilt or culpability for both victim and accused. These narratives were firmly situated in the space of the crime scene. Future research is likely to further support an argument I have touched upon, that 1957 was a significant turning point for photographing crime scenes and creating evidence in twentieth-century London, as well as England and Wales more widely. Not only were photography responsibilities shifting to civilian staff in C3 in 1957, but, more critically, murder and manslaughter were recodified. With the 1957 Homicide Act, the definitions of murder and manslaughter and the boundaries between the narratives that would define them were redrawn. Capital punishment after this date was restricted to types of murder less common in domestic settings. The empirical demands and representative meanings of exhibits of evidence including crime scene photography were thus fundamentally changed when domestic murder ceased to be a matter of life or death.

As representations of a crime narrative, twentieth-century crime scene photographs are themselves microhistories. As such, any examination that takes them as self-evident should be discarded in favour of a more rigorous approach that asks: Whose murder story are they being used to tell and why? Finally, we must not privilege the photograph as a forensic document meaning that its power lies in its association with scientific investigation and facsimile. As this book has shown, 'forensic photography' in the twentieth century, if it can be so called, was deployed forensically – meaning in the courtroom, in relation to the law – rather than made 'forensically' in the sense that every detail was photographed in the most rigorous scientific conditions. In other words, just as we are aware of the high stakes and human feelings behind a defendant's statement, the fallible human perspective behind a witness deposition and the unique interpretative choices made by individual human historians, we must not forget the figure of the human photographer behind the camera.

Postscript: Encountering Appleford Road Part II

When I reached the last leaf in the grey folder with all its stamps and scribbles, I sat back in my swivel chair. The joyful energy that had propelled me through the pile of papers was all but disappeared and I was overcome by an enormous yawn when I thought of the long and overcrowded rush-hour rail journeys between here and home. Closing my notebook, I tried to recall everything I had copied down and what it might mean. How would I start writing about 28 Appleford Road? I turned the folder over, neatened the pages inside and placed the square yellow slip on top. As I handed the file to the friendly man and woman at the returns desk ('thank you,' 'you're welcome') amidst the chorus of barcode beeps, I caught a final glimpse of that message on the cover of CRIM 1/2783: 'Images may cause distress.' I realized I was distressed. Not by blood or bodies, there had been none, and not by photographs of steel drums full of cyanide. I felt as though I had been inside someone's house uninvited. I had looked at Moira Burdett's things: her calorie counting booklet, her teapot, the wallpaper her husband put up for her. I had read her letters and heard what her mother-in-law thought of her housekeeping skills and the way she cared for her son. These things had afterlives as exhibits of evidence that Moira had no power to influence. Five miles east and five months after Moira's

death at Appleford Road, twelve jurors examined these items in the Old Bailey courtroom to decide if her husband should live or die for taking her life. Five miles west and fifty-five years distant here was I, under the glare of the reading room lights, looking at the same images and, like a police photographer choosing where to position his camera, creating meaning and microhistory from the stuff of everyday domestic life and death.

Notes

Chapter 1

1. Scenes of Crime Officer (UK), Crime Scene Investigator (USA). See Michele Byers and Val Marie Johnson, eds., *The CSI Effect: Television, Crime, and Governance* (Lanham: Lexington Books, 2009).
2. *The Porthole Mystery* [TV programme], BBC, 2018; *Murder, Mystery and My Family* [TV series], BBC, 2018.
3. *Making a Murderer* [TV series] Netflix, 2015; *The Confession Tapes* [TV series] Netflix, 2017; See also William J. Turkel, 'The Crime Scene, the Evidential Fetish, and the Usable Past', in *The CSI Effect: Television, Crime and Governance*, ed. by Michele Byers and Val Marie Johnson (Lanham: Lexington Books, 2009), 133–146; Gray Cavender and Nancy Jurik, 'Crime, Criminology and the Crime Genre', in *The Oxford Handbook of the History of Crime and Criminal Justice*, ed. by Paul Knepper and Anja Johansen (Oxford: Oxford University Press, 2016), 320–37.
4. John Tagg, *The Burden of Representation: Essays on Photographies and Histories* (Minneapolis, MN: University of Minnesota Press, 1993), 1.
5. Alison Blunt and Robyn M. Dowling, *Home* (New York: Routledge, 2006).
6. The National Archives: CRIM 1/2783: Central Criminal Court, Depositions, Defendant: Burdett, Brian Edward: Murder, 1957. Exhibit 19: Letter from Brian Burdett to Moira Burdett [1956].
7. Amy Helen Bell, *Murder Capital: Suspicious Deaths in London, 1933–53* (Manchester: Manchester University Press, 2015); Lucy Bland, *Modern Women on Trial: Sexual Transgression in the Age of the Flapper* (Manchester: Manchester University Press, 2013); Robert Darnton, *The Great Cat Massacre and Other Episodes in French Cultural History* (New York: Basic Books, 1999); Carlo Ginzburg, *The Cheese and the Worms: The Cosmos of a Sixteenth-Century Miller* (Baltimore: Johns Hopkins University Press, 1980); Natalie Zemon Davis, *Fiction in the Archives: Pardon Tales and Their Tellers in Sixteenth-Century France* (Stanford, CA: Johns Hopkins University Press, 1987); Matt Houlbrook, *Queer London: Perils and Pleasures in the Sexual Metropolis, 1918–1957* (Chicago: Chicago University Press, 2005); Anne-Marie Kilday and David Nash, eds., *Law, Crime and Deviance since 1700: Micro-Studies in the History of Crime* (London; New York: Bloomsbury, 2017); Frank Mort, *Capital Affairs: London and the Making of the Permissive Society* (New Haven, CT: Yale University Press, 2010);

Eloise Moss, *Night Raiders: Burglary and the Making of Modern Urban Life in London, 1860–1968* (Oxford: Oxford University Press, 2019); Lizzie Seal, *Women, Murder and Femininity: Gender Representations of Women Who Kill* (Basingstoke: Palgrave Macmillan, 2010); Charlotte Wildman, 'Miss Moriarty, the Adventuress and the Crime Queen: The Rise of the Modern Female Criminal in Britain, 1918–1939', *Contemporary British History*, 30/1 (2016), 73–98; J. Carter Wood, *The Most Remarkable Woman in England: Poison, Celebrity and the Trials of Beatrice Pace* (Manchester: Manchester University Press, 2012); Joanne Begiato, 'Beyond the Rule of Thumb: The Materiality of Marital Violence in England c. 1700–1857', *Cultural and Social History*, 15/1 (2018), 39–59.

8 Matt Houlbrook, *Prince of Tricksters: The Incredible True Story of Netley Lucas, Gentleman Crook* (Chicago; London: University of Chicago Press, 2016); Katherine E. Collins, '"A Man of Violent and Ungovernable Temper": Can Fiction Fill Silences in the Archives?', *Life Writing*, 2019, 1–7, DOI: 10.1080/14484528.2018.1564215; Carolyn Steedman, 'Intimacy in Research: Accounting for It', *History of the Human Sciences*, 21/4 (2008), 17–33; Andreas Philippopoulos-Mihalopoulos, 'Writing beyond Distinctions', in *Routledge Handbook of Socio-Legal Theory and Methods*, ed. by Naomi Creutzfeldt, Marc Mason and Kirsten McConnachie (Abingdon: Routledge, 2019), 70–82.

9 Lois Presser, 'Getting on Top through Mass Murder: Narrative, Metaphor, and Violence', *Crime, Media, Culture: An International Journal*, 8/1 (2012), 3–21; J Fleetwood, L Presser, S Sandberg and T Ugelvik, eds, *The Emerald Handbook of Narrative Criminology* (Bingley: Emerald Publishing, 2019).

10 Michelle Brown and Eamonn Carrabine, eds., *Routledge International Handbook of Visual Criminology* (New York: Routledge, 2017); Kate West, 'Visual Criminology and Lombroso: In Memory of Nicole Rafter (1939–2016)', *Theoretical Criminology*, 21/3 (2017), 271–87.

11 L. Seal, 'Emotion and Allegiance in Researching Four Mid-20th-Century Cases of Women Accused of Murder', *Qualitative Research*, 12/6 (2012), 686–701; Lizzie Seal and Maggie O'Neill, *Imaginative Criminology: Of Spaces Past, Present and Future* (Bristol: Bristol University Press, 2019); Lucy Robinson, 'Collaboration in, Collaboration Out: The Eighties in the Age of Digital Reproduction', *Cultural and Social History*, 13/3 (2016), 403–23; William G. Pooley, Matt Houlbrook and Alison Twells, 'Special Issue: Creative Histories', *History Workshop Journal*, forthcoming (2020); Houlbrook, *Prince of Tricksters*, 399.

12 Houlbrook, *Queer London* Moss, *Night Raiders*.

13 Eugenia Parry, *Crime Album Stories: Paris 1886–1902* (Zurich; New York: Scalo, 2000); James Ellroy, *Lapd '53* (New York, NY: Abrams Image, 2015).

14 Eamonn Carrabine, 'Seeing Things: Violence, Voyeurism and the Camera', ed. by Michelle Brown and Eamonn Carrabine, *Theoretical Criminology*, 18/2 (2014), 254; Kate West, 'Feeling Things: From Visual to Material Jurisprudence', *Law & Critique*, 31/1 (2020).

15 Brown and Carrabine, *Routledge International Handbook of Visual Criminology*.
16 Katherine Biber, *In Crime's Archive: The Cultural Afterlife of Evidence* (London; New York: Routledge, 2018); Lizzie Seal, *Capital Punishment in Twentieth-Century Britain: Audience, Justice, Memory* (Abingdon: Routledge, 2014) esp. chapter 5, 99–121; Alison Adam, ed., *Crime and the Construction of Forensic Objectivity from 1850* (Basingstoke: Palgrave Macmillan, 2020) esp. chapter by Angela Sutton-Vane, 279–301.
17 Brown and Carrabine, *Routledge International Handbook of Visual Criminology*; Naomi Creutzfeldt, Marc Mason and Kirsten McConnachie, eds., *Routledge Handbook of Socio-Legal Theory and Methods* (Abingdon: Routledge, 2019); Seal and O'Neill, *Imaginative Criminology*; Paul Knepper and Anja Johansen, eds., *The Oxford Handbook of the History of Crime and Criminal Justice* (Oxford: Oxford University Press, 2016).
18 L. J. Jordanova, *The Look of the Past: Visual and Material Evidence in Historical Practice* (Cambridge: Cambridge University Press, 2012).
19 'Note the Decor. Ignore the Body, Immigration History Research', *Tenement Museum*, https://tenement.org/research.html [accessed 23 November 2015]; Bernard Jacque, 'Blood and Wallpaper' (presented at Crime Scenes and Case Files: Sources for studying Domestic Interiors (Histories of Home Subject Specialist Network Study Day), Geffrye Museum of the Home, London, 2012).
20 Seal, *Women, Murder and Femininity*, 10.
21 Antony M. Brown, *Death of an Actress: A Cold Case Jury True Crime* (London: Mirror Publishing, 2018); *Porthole Mystery*; *Murder, Mystery and My Family*.
22 Turkel, 'The Crime Scene, the Evidential Fetish, and the Usable Past'.
23 Henry Bond, *Lacan at the Scene* (Cambridge, MA; London: MIT Press, 2012).
24 Seal, *Capital Punishment in Twentieth-Century Britain: Audience, Justice, Memory*; Lizzie Seal and Alexa Neale, 'Race, Racialisation and "Colonial Common Sense" in Capital Cases of Men of Colour in England and Wales, 1919–1957', *Open Library of Humanities*, 5/1 (2019), 64.
25 Alexa Neale, 'Murder in Miniature: Reconstructing the Crime Scene in the English Courtroom', in Alison Adam, ed., *Crime and the Construction of Forensic Objectivity from 1850* (Basingstoke: Palgrave Macmillan, 2020), 43–67.
26 Neale, 'Murder in Miniature', 43–67; Biber, *In Crime's Archive*.
27 Biber, *In Crime's Archive*.
28 Rosalind Crone, *Violent Victorians: Popular Entertainment in Nineteenth-Century London* (Manchester; New York: Manchester University Press, 2012), 91–6.
29 Brian Wallis, ed., *Weegee: Murder Is My Business* (New York; Munich: International Center of Photography; DelMonico Books, Prestel, 2013); Anita Lam, 'Decoding the Crime Scene Photograph: Seeing and Narrating the Death of a Gangster', *International Journal for the Semiotics of Law*, 33 (2019).
30 Alice Smalley, 'Representations of Crime, Justice, and Punishment in the Popular Press: A Study of the Illustrated Police News, 1864–1938' (Unpublished PhD thesis: Open University, 2017), 104.

31 Smalley, 'Representations of Crime', 123–36.
32 Lynda Nead, 'Visual Cultures of the Courtroom: Reflections on History, Law and the Image', *Visual Culture in Britain*, 3/2 (2002), 119–41.
33 'Advanced Search', *British Newspaper Archive* <www.britishnewspaperarchive.co.uk/search/advanced> [accessed 5 July 2019]; Smalley, 'Representations of Crime', 123.
34 'Russell Bishop: Murder Trial Jury Retraces Girls' Steps', *BBC News*, 2018 <www.bbc.co.uk/news/uk-england-sussex-45902215> [accessed 1 June 2019].
35 F. Tennyson Jesse, *Trial of Sidney Harry Fox* (Edinburgh: W. Hodge & Co., 1934).
36 'Crime Scene Sub-Reddit', *Reddit* <www.reddit.com/r/CrimeScene>; 'Rotten dot com [Defunct as of 2012]', 1996 <www.rotten.com>.
37 Jan Bondeson, *Murder Houses of London* (Stroud: Amberley Publishing, 2014); David Long, *Murders of London: In the Steps of the Capitals Killers* (London: Random House, 2012); Kris Hollington and Nina Hollington, *Criminal London: A Sightseer's Guide to the Capital of Crime* (London: Aurum, 2013).
38 *Crimewatch* [TV broadcast] BBC, 1984; Deborah Jermyn, *Crime Watching: Investigating Real Crime TV* (London: IB Tauris, 2007).
39 Deborah Cohen, *Family Secrets: The Things We Tried to Hide* (London: IB Tauris, 2014); Houlbrook, *Prince of Tricksters*, 2–10.
40 Seal, *Women, Murder and Femininity*, 10–11.
41 Edward M. Robinson, *Crime Scene Photography*, 2nd ed (Amsterdam; Boston: Elsevier, 2010).
42 Lizzie Seal and Alexa Neale, 'Encountering the Archive: Researching Race, Racialisation and the Death Penalty in England and Wales, 1900–1965', in *Routledge Handbook of Socio-Legal Theory and Methods*, ed. by Naomi Creutzfeldt, Marc Mason and Kirsten McConnachie (Abingdon; New York: Routledge, 2019), 289–300.
43 Amy Bell, 'Crime Scene Photography in England, 1895–1960', *Journal of British Studies*, 57/01 (2018), 53–78; Lela Graybill, 'The Forensic Eye and the Public Mind: The Bertillon System of Crime Scene Photography', *Cultural History*, 8/1 (2019), 94–119.
44 Katherine Biber, *Captive Images: Race, Crime, Photography* (Abingdon; New York: Routledge-Cavendish, 2007).
45 Biber, *In Crime's Archive*, 15.
46 Jennifer Mnookin, 'The Image of Truth: Photographic Evidence and the Power of Analogy', *Yale Journal of Law and Humanities*, 10/1 (1998), 1–74.
47 Alison Adam, *A History of Forensic Science: British Beginnings in the Twentieth Century* (Abingdon: Routledge, 2015), 3–4.
48 Tagg, *The Burden of Representation*; Allan Sekula, 'The Body and the Archive', *October*, 39 (1986), 3–64.
49 Angela Sutton-Vane, 'Murder Cases, Trunks and the Entanglement of Ethics: The Preservation and Display of Crime Records and Scenes of Crime Material', in

Crime and the Construction of Forensic Objectivity from 1850, ed. by Alison Adam (Basingstoke: Palgrave Macmillan, 2020), 279–301.

50 *American Crime Story: The People vs. OJ Simpson* [TV series], FX, 2016, alleged that the Simpson home was redecorated and restaged for the benefit of visiting jurors during his trial, with artworks and objects selected for display that highlighted Simpson's blackness, sporting achievements and commitment to his family, prioritized over any that might suggest he was interested in sexualized images of white women.

51 TNA: J 82/27: Burdett, B.E.: Murder (Central Criminal Court, 1957), Trial transcript [opening speech for the Crown], 2.

52 Lynda Nead, *The Tiger in the Smoke: Art and Culture in Post-War Britain* (New Haven, CT: Yale University Press, 2017); Houlbrook, *Prince of Tricksters*, 399; West, 'Feeling Things: From Visual to Material Jurisprudence'.

53 Shani D'Cruze, 'Intimacy, Professionalism and Domestic Homicide in Interwar Britain: The Case of Buck Ruxton', *Women's History Review*, 16/5 (2007), 701–22; Victoria Stewart, *Crime Writing in Interwar Britain, Fact and Fiction* (Cambridge: Cambridge University Press, 2017).

54 Houlbrook, *Prince of Tricksters*, 2–10.

55 Seal, *Capital Punishment in Twentieth-Century Britain*, 99–121.

56 Bell, 'Crime Scene Photography in England, 1895–1960', 53–78.

57 Bell, *Murder Capital*, 10–12.

58 Ian A. Burney and Neil Pemberton, *Murder and the Making of English CSI* (Baltimore: Johns Hopkins University Press, 2016), 160–2, considers photography a technique embedded within an increasingly choreographed, systematic approach to the crime scene by Metropolitan Police, a tool for recording the process of investigation.

59 Tagg, *The Burden of Representation*.

60 Alan Parker, *Watch the Birdie: A Police Photographer's Story* (Walsall: Cerebus, 2000).

61 Bell, 'Crime Scene Photography in England, 1895–1960', 57.

62 Graybill, 'The Forensic Eye and the Public Mind', 96.

63 Graybill, 'The Forensic Eye and the Public Mind', 97.

64 Graybill, 'The Forensic Eye and the Public Mind', 101.

65 Graybill, 'The Forensic Eye and the Public Mind', 108.

66 Alison Adam, 'Introduction', in Alison Adam, ed., *Crime and the Construction of Forensic Objectivity from 1850* (Basingstoke: Palgrave Macmillan, 2020), 1–13.

67 Adam, *History of Forensics*; Adam, ed., *Crime and the Construction of Forensic Objectivity*.

68 Burney and Pemberton, *Murder and the Making of English CSI*, 162.

69 Kate West, 'Visual Criminology and Lombroso. In Memory of Nicole Rafter', *Theoretical Criminology*, 21/3 (2017), 271–87.

70 Carrabine, 'Punishment in the Frame'. I would respectfully suggest that more attention should be paid to the ways photographic historians have usefully combined Art History approaches and analyses of contemporary 'scientific' discourses regarding the media of photography and the specific knowledge claims of historic photographs within the areas and institutions of science they were deployed; for example, Pichel, Beatriz, 'From Facial Expressions to Bodily Gestures: Passions, Photography and Movement in French 19th century Sciences', *History of the Human Sciences*, 29/1, 27–48.
71 Nicole Rafter, quoted in West, 'Visual Criminology and Lombroso', 276.
72 Bond, *Lacan at the Scene*; Bondeson, *Murder Houses of London*; Ellroy, *Lapd '53*.
73 HO45/10989/X84282/1: Home Office Registered Papers, POLICE: Use of photographic material in Criminal Investigation Department, Edward Bradford, Commissioner of Police, to the Under Secretary of State, Home Office, 25 October 1901.
74 HO45/10989/X84282/1: Bradford to Home Office, 13 May 1902.
75 HO45/10989/X84282.
76 Parker, *Watch the Birdie*.
77 Tagg, *The Burden of Representation*, 2.
78 Fred Cherrill, *Cherrill of the Yard, the Autobiography of Fred Cherrill* (London: Harrap, 1954); MacDonald Hastings, *The Other Mr Churchill: A Lifetime of Shooting and Murder* (London: Four Square Books, 1963); James O'Brien, 'Simple Photography for Policemen: Part I', *Police Journal*, 9/1 (1936), 63–71; Ben Whitaker, *The Police in Society* (London: Methuen, 1979).
79 Biber, *Captive Images*; Biber, *In Crime's Archive*, 15.
80 Seal, 'Emotion and Allegiance in Researching Four Mid-20th-Century Cases of Women Accused of Murder', 686–701.
81 I am particularly uncomfortable with the re-characterization of historic murders as 'cold cases' or 'mysteries' or television shows deeming convictions unsafe based on centuries-old case files, including crime scene photographs and other archived evidence, which can be described as incomplete at best. Brown, *Death of an Actress*; *Porthole Mystery*; *Murder, Mystery and My Family*.
82 Seal, *Women, Murder and Femininity*, 3.
83 Seal, *Women, Murder and Femininity*, 4.
84 Lizzie Seal and Alexa Neale, 'Racializing Mercy: Capital Punishment and Race in Twentieth-Century England and Wales', *Law and History Review*, 2020.
85 Eamonn Carrabine, 'Picture This: Criminology, Image and Narrative', *Crime, Media, Culture: An International Journal*, 12/2 (2016), 258, 265–6.
86 Neale, 'Murder in Miniature', 43–4; West, 'Feeling Things: From Visual to Material Jurisprudence'.

Chapter 2

1. Vignette based on The National Archives: CRIM 1/742: Central Criminal Court, Depositions, Defendant: Anderson, John. Charge: Murder, 1934; London Metropolitan Archives: GLC/MA/SC/03/0948: Greater London Council Slum Clearance and Public Health Files: Baynes Street [Formerly Prebend Street] Area [Camden Town] (London, 1922); 'Map Images', *National Library of Scotland*, https://maps.nls.uk [accessed 10 October 2019]; 'Electoral Registers for London [LMA], Census Returns for England and Wales [TNA], Civil Registration Indexes [GRO]', *Ancestry*, 2002 <www.ancestry.co.uk> [accessed 10 October 2019]; and observations on walking Baynes Street and surrounding area, May 2013.
2. On this issue and its implications for social sciences research see Blunt and Dowling, *Home*; Alison Blunt and Eleanor John, 'Domestic Practice in the Past: Historical Sources and Methods', *Home Cultures*, 11/3 (2014), 269–74; for history Stephen Brooke, 'Revisiting Southam Street: Class, Generation, Gender, and Race in the Photography of Roger Mayne', *Journal of British Studies*, 53/02 (2014), 462–5; for criminology West, 'Visual Criminology and Lombroso', 281.
3. TNA: CRIM 1/742: Anderson, Murder.
4. Lord Devlin, *The Criminal Prosecution in England* (Oxford: Oxford University Press, 1960), 92; Louise A. Jackson, *Child Sexual Abuse in Victorian England* (Abingdon: Routledge, 2000); The National Archives, *Legal Records Information Leaflet 27: Trials in the Old Bailey and the Central Criminal Court*, 2008, 27, http://www.nationalarchives.gov.uk/records/research-guides/old-bailey.htm; Seal and Neale, 'Encountering the Archive', 289–91; Carolyn Steedman, *Dust: The Archive and Cultural History*, Encounters (New Brunswick, NJ: Rutgers University Press, 2002); There is a far greater literature available on the bureaucratic and institutional processes that constructed archives of nineteenth-century crimes, see Clive Emsley, Tim Hitchcock and Robert Shoemaker, 'The Value of the Proceedings as a Historical Source', *Old Bailey Online* <www.oldbaileyonline.org/static/Value.jsp> [accessed 16 January 2019].
5. TNA: CRIM 1/742: Anderson, Murder Statement of Rose Anderson, 2 October 1934.
6. TNA: CRIM 1/742: Anderson, Murder Deposition of Sir Bernard Spilsbury, 25 September 1934.
7. Burney and Pemberton, *Murder and the Making of English CSI*, 63, 101–2.
8. Bell, 'Crime Scene Photography in England, 1895–1960', 61.
9. O'Brien, 'Simple Photography Part 1', 63–4; Joanne Klein, 'Traffic, Telephones and Police Boxes: The Deterioration of Beat Policing in Birmingham, Liverpool and Manchester between the World Wars', in *Policing Interwar Europe: Continuity, Change and Crisis, 1918–1940*, ed. by Gerald Blaney (Basingstoke: Palgrave Macmillan, 2006), 215–36. Klein argues that this was the period when telephones

and police boxes improved communications and stretched fewer personnel over larger geographical areas: pp. 215–16, 225–9.

10 Parker, 96.
11 'Any murders?' asks Rose Sandigate as her husband opens the Sunday morning paper: *It Always Rains on Sunday* [film], UK, 1947; George Orwell, *Decline of the English Murder: And Other Essays* (Harmondsworth: Penguin, 1986), 9.
12 Nead, *Tiger in the Smoke* 'Chapter 8: An English Sunday Afternoon', 277–305.
13 TNA: CRIM 1/742: Anderson, Murder.
14 Mark Clapson and Clive Emsley, 'Street, Beat, and Respectability: The Culture and Self-Image of the Late Victorian and Edwardian Urban Policeman', in *Police and Policing in the Twentieth Century*, ed. by Chris A. Williams, History of Policing (Farnham; Burlington, VT: Ashgate, 2011), 292–317.
15 Shani D'Cruze, Sandra Walklate and Samantha Pegg, *Murder: Social and Historical Approaches to Understanding Murder and Murderers* (Cullompton: Willan, 2006), 14–17.
16 TNA: CRIM 1/742: Anderson, Murder Depositions of DI Ernest Andrews, 24 September and 2 October 1934.
17 Having read TNA files for upwards of 200 murder cases between 1900 and 1971 I have yet to come across a single instance in which a defendant wrote out their own statement.
18 TNA: CRIM 1/742: Anderson, Murder Exhibit 3: Statement of John Charles Anderson, 23 September 1934; Handwritten blue papers at the rear of the case file.
19 TNA: CRIM 1/742: Anderson, Murder DI Ernest Andrews' deposition, 24 September and 2 October 1934..
20 TNA: CRIM 1/742: Anderson, Murder Exhibit C1: Post-Mortem Examination of Lilian Anderson, age 24 years, made at St. Pancras Mortuary on 24 September 1934.
21 TNA: CRIM 1/742: Anderson, Murder Deposition of Sir Bernard Spilsbury, 25 September 1934.
22 Adrian Bingham, *Family Newspapers?: Sex, Private Life, and the British Popular Press 1918–1978* (Oxford; New York: Oxford University Press, 2009), 125–58.
23 *Daily Herald*, 25 September 1934, p. 7.
24 Bingham, *Family Newspapers?*, 126; J. C. Wood, '"The Third Degree": Press Reporting, Crime Fiction and Police Powers in 1920s Britain', *Twentieth Century British History*, 21/4 (2010), 464–85.
25 Devlin, *The Criminal Prosecution in England*; Seal and Neale, 'Encountering the Archive', 289–300.
26 TNA: CRIM 1/742: Anderson, Murder.
27 Terence Morris and Louis Blom-Cooper, *A Calendar of Murder: Criminal Homicide in England since 1957* (London: Michael Joseph, 1964).
28 Wood, '"The Third Degree"', 464–85; Huw Clayton, 'A Bad Case of Police Savidgery: The Interrogation of Irene Savidge at Scotland Yard', *Women's History Magazine*, 61 (2009), 30–8.

29 Devlin, *The Criminal Prosecution in England*; Whitaker, *The Police in Society*, 61–2.
30 B. Taylor and B. Rogaly, '"Mrs Fairly Is a Dirty, Lazy Type": Unsatisfactory Households and the Problem of Problem Families in Norwich 1942–1963', *Twentieth Century British History*, 18/4 (2007), 429–52.
31 Blunt and Dowling, *Home*; C. Langhamer, 'The Meanings of Home in Postwar Britain', *Journal of Contemporary History*, 40/2 (2005), 341–62; Deborah Sugg Ryan, *Ideal Homes, 1918–39: Domestic Design and Suburban Modernism* (Manchester: Manchester University Press, 2018); Alison Ravetz, *The Place of Home: English Domestic Environments, 1914–2000* (London: Spon, 1995); Wendy Webster, *Imagining Home: Gender, 'Race', and National Identity, 1945–64* (London: UCL Press, 1998).
32 A. Ballinger, 'Masculinity in the Dock: Legal Responses to Male Violence and Female Retaliation in England and Wales, 1900–1965', *Social & Legal Studies*, 16/4 (2007), 461.
33 D'Cruze, Walklate and Pegg, *Murder*, 14–17.
34 Ellen Ross, '"Fierce Questions and Taunts": Married Life in Working-Class London', *Feminist Studies*, 8/5 (1982), 575–6.
35 TNA: CRIM 1/742: Anderson, Murder Deposition of Edith Murphy, 9 October 1934.
36 TNA: CRIM 1/742: Anderson, Murder Deposition of Jane Francis, 2 October 1934.
37 TNA: CRIM 1/742: Anderson, Murder Deposition of William Wood Thom, 2 October 1934.
38 TNA: CRIM 1/742: Anderson, Murder Exhibit 3: Statement of Anderson, 23 September 1934.
39 Though John was not required to depose at the police court, the statement made by Sergeant MacDonald and Detective Inspector Andrews was read out, examined for evidence of 'third-degree' interview tactics that would make the document inadmissible at the higher court. See Wood, '"The Third Degree"', 464–85.
40 TNA: CRIM 1/742: Anderson, Murder Depositions of Murphy and Francis; LMA: GLC/MA/SC/03/0948: Prebend Street, Camden Town Within six years of Lilian's death, most of the area was surveyed and designated a slum. LCC noted that number 12 had long suffered from inadequate facilities for storing and preparing food and that the entire building shared a single WC. Mrs Francis from next door had lived in her two rooms in just the same way for more than twenty years, at one time sharing the space with her husband and eight children; The National Archives: RG14/00762/181: Census for England and Wales, 1911: Charles Francis and Household, 11 Prebend Street, Camden Town., 1911.
41 TNA: CRIM 1/742: Anderson, Murder Depositions of PC Sidney Bostock, 2 October 1934, O'Brien and Spilsbury. This equates to roughly 2.3m × 3.5m or, for context, imagine an area the same width and a similar length to an average modern UK car parking space.

42 Ryan, *Ideal Homes, 1918–39*. See also an advertisement on the same page as the report of John's tears, illustrated with a smiling couple and their brand new kitchen furnishings on credit: *Daily Herald*, 25 September 1934, p. 7.
43 Spilsbury's post-mortem findings made more sense in this scenario.

Chapter 3

1 O'Brien, 'Simple Photography Part 1', 63–5.
2 The National Archives: MEPO 3/1695: Metropolitan Police: Office of the Commissioner: Correspondence and Papers, Special Series: Murder of Thomas James by Georgios Kalli Georgiou at Torrington Square, Holborn, 1934: Telephone Messages, 18 September 1934.
3 *Daily Mirror*, 19 September 1934, 3.
4 Historic England, 'Senate House and Institute of Education (University of London) and Attached Railings', *National Heritage List for England*, https://historicengland.org.uk/listing/the-list/list-entry/1113107 [accessed 11 September 2019].
5 O'Brien, 'Simple Photography Part 1', 63–71.
6 O'Brien, 'Simple Photography Part 1', 66.
7 O'Brien, 'Simple Photography Part 1', 63–71; TNA: MEPO 3/1695: Murder of Thomas James Telephone Messages; witness statements.
8 O'Brien, 'Simple Photography Part 1', 63–71; The National Archives: CRIM 1/743: Central Criminal Court, Depositions, Defendant: Georgiou, Georgios Kalli, Charge: Murder., 1934 'Exhibit 9: Book of Photographs [taken by Inspector James O'Brien, 18 and 20 September 1934]'; 'Exhibit 7: Plan [of No. 39 Torrington Square by PC George Pannell, "C" Division'; The National Archives: DPP 2/234: Director of Public Prosecutions Case Papers: GEORGIOU, Georgios K: Murder, 1934 Transcript of shorthand notes of trial at Central Criminal Court, 22 October 1934.
9 TNA: CRIM 1/743: Georgiou, Murder Exhibit 9: Book of Photographs; Exhibit 7: Plan.
10 TNA: CRIM 1/743: Georgiou, Murder Exhibit 9: Book of Photographs; Exhibit 7: Plan.
11 TNA: MEPO 3/1695: Murder of Thomas James Metropolitan Police Report, DDI John Edwards to Acting Superintendent A. Sawyer, 'C', 30 October 1934.
12 O'Brien, 'Simple Photography Part 1', 63–71 p. 67, face p. 70.
13 James O'Brien, 'Simple Photography for Policemen: Part II', *Police Journal*, 9/2 (1936), 173–82; O'Brien, 'Simple Photography Part 1', 66, 71.
14 The conversation is imagined but the principle and method are described in O'Brien, 'Simple Photography Part 1', 63–71.
15 O'Brien, 'Simple Photography Part 1', 67–71.

16. TNA: DPP 2/234: GEORGIOU, Murder Trial transcript [Inspector James O'Brien examined by Mr Byrne for the Prosecution], p. 3.
17. In fact, in many 1930s cases of murder no photographs were taken at all.
18. O'Brien, 'Simple Photography Part 1', 65.
19. Cherrill, *Cherrill of the Yard*.
20. Bland, *Modern Women on Trial* Houlbrook, *Prince of Tricksters*.
21. TNA: MEPO 3/1695: Murder of Thomas James Metropolitan Police Report, DDI John Edwards to Acting Superintendent A. Sawyer, 'C', 21 September 1934.
22. Seal and Neale, 'Encountering the Archive', 289–300.
23. Devlin, *The Criminal Prosecution in England*.
24. TNA: DPP 2/234: GEORGIOU, Murder Copy Police Report, p. 18.
25. TNA: MEPO 3/1695: Murder of Thomas James Request for report, A. Maxwell-Fyfe to the Commissioner of Police of the Metropolis, 20 November 1934.
26. TNA: MEPO 3/1695: Murder of Thomas James To Superintendent from DDI Edwards 'C', 22 November 1934.
27. The National Archives: HO45/22317: Home Office Registered Papers: Criminal: Georgiou, Georgios Kalli: Convicted at Central Criminal Court on 22 October 1934 of Murder and Sentenced to Death (Commuted), 1934 British Christian Cypriot Brotherhood to Under Secretary of State, Home Office, August 1940.
28. Evan Smith and Andrekos Varnava, 'Creating a "Suspect Community": Monitoring and Controlling the Cypriot Community in Inter-War London', *English Historical Review*, 132/558 (2017), 1149–81.
29. The National Archives: HO384/158: Home Office: Noters Section: Precedent Books: Capital Cases, 1901.
30. Lizzie Seal and Alexa Neale, '"In His Passionate Way": Emotion, Race and Gender in Cases of Partner-Murder in England and Wales, 1900–39', *British Journal of Criminology*, 2020; Smith and Varnava, 'Creating a "Suspect Community"', 1149–81.
31. *Daily Mirror*, 20 November 1934, 7.
32. TNA: DPP 2/234: GEORGIOU, Murder Transcript, pp. 5–17.
33. TNA: CRIM 1/743: Georgiou, Murder Statement of Georgiou, 18 September 1934.
34. Ginger Suzanne Frost, *Living in Sin: Cohabiting as Husband and Wife in Nineteenth-Century England*, Gender in History (Manchester; New York: Manchester University Press, 2008); Joanne Klein, 'Irregular Marriages: Unorthodox Working-Class Domestic Life in Liverpool, Birmingham, and Manchester, 1900–1939', *Family History*, 30/2 (2005), 210–229; Claire Langhamer, *The English in Love: The Intimate Story of an Emotional Revolution* (Oxford: Oxford University Press, 2013), 189.
35. TNA: CRIM 1/743: Georgiou, Murder Statement of Georgiou.
36. TNA: CRIM 1/743: Georgiou, Murder Statement of Georgiou.
37. Morris and Blom-Cooper, *A Calendar of Murder*.
38. TNA: CRIM 1/743: Georgiou, Murder Statement of Georgiou.
39. TNA: CRIM 1/743: Georgiou, Murder Statement of Georgiou.

40 TNA: CRIM 1/743: Georgiou, Murder Copy depositions p. 21: William Miller Fairlie, Divisional Surgeon [October 1934].
41 TNA: CRIM 1/743: Georgiou, Murder Exhibit 6: Statement of Georgiou.
42 TNA: MEPO 3/1695: Murder of Thomas James Police Report, p. 2.
43 TNA: MEPO 3/1695: Murder of Thomas James Statement of Margaret McKinnon Watt, 19 September 1934.
44 TNA: MEPO 3/1695: Murder of Thomas James Further statement of Margaret McKinnon Watt, 20 September 1934.
45 Matt Cook, *Queer Domesticities: Homosexuality and Home Life in Twentieth-Century London* (New York: Palgrave Macmillan, 2014), 159–60.
46 TNA: MEPO 3/1695: Murder of Thomas James Further statement of Margaret McKinnon Watt, 20 September 1934.
47 They also instructed O'Brien/his department to photograph a piece of carpet from the dining room which bore spots of blood.
48 TNA: MEPO 3/1695: Murder of Thomas James Further statement of Margaret McKinnon Watt, 20 September 1934.
49 O'Brien, 'Simple Photography Part 1', 63–71; O'Brien, 'Simple Photography Part 2', 173–82; James O'Brien, 'Simple Photography for Policemen: Part III', *Police Journal*, 9/3 (1936), 331–42; James O'Brien, 'Simple Photography for Policemen: Part IV', *Police Journal*, 9/4 (1936), 468–72.
50 TNA: MEPO 3/1695: Murder of Thomas James Additional statement of Margaret McKinnon Watt, 20 September 1934.
51 C. Langhamer, 'Adultery in Post-War England', *History Workshop Journal*, 62/1 (2006), 86–115.
52 TNA: CRIM 1/743: Georgiou, Murder.
53 TNA: DPP 2/234: GEORGIOU, Murder Transcript of shorthand notes, Central Criminal Court, 22 October 1934.
54 Further copies of the same list and Exhibits, though not all, might also feature in other files on the same case; Metropolitan Police Files, Director of Public Prosecutions Case Papers, Home Office Registered Papers and Prison Commission Files.
55 For more on the cultural afterlife of evidence, see Biber, *In Crime's Archive*; Neale, 'Murder in Miniature', 43–67.
56 Seal and Neale, 'Encountering the Archive', 289–300.
57 Chris Williams and Clive Emsley, 'Beware of the Leopard? Police Archives in Great Britain', in *Political Pressure and the Archival Record* ed. by Margaret Procter, Michael Cook and Caroline Williams (Chicago: Society of American Archivists, 2005), 227–35; Sutton-Vane, 'Murder Cases, Trunks and the Entanglement of Ethics', 279–301.
58 TNA: DPP 2/234: GEORGIOU, Murder Transcript.
59 Marcel Berlins, 'A Chief Justice Got Away with Murder', *The Independent* (2 August 1998).

60. TNA: DPP 2/234: GEORGIOU, Murder Transcript, 40.
61. TNA: DPP 2/234: GEORGIOU, Murder; Emsley, Hitchcock and Shoemaker, 'The Value of the Proceedings as a Historical Source'; Shani D'Cruze, '"The Damned Place Was Haunted": The Gothic, Middlebrow Culture and Inter-War "Notable Trials"', *Literature and History*, 15/1 (2006), 37–58 on selective recording of trials.
62. See Chapter 7.
63. For models used in this way before photographs, see Neale, 'Murder in Miniature', 43–67.
64. TNA: DPP 2/234: GEORGIOU, Murder: Transcript, 9.
65. TNA: DPP 2/234: GEORGIOU, Murder: Transcript, 3–4.
66. TNA: DPP 2/234: GEORGIOU, Murder: Transcript, 3–4.
67. TNA: CRIM 1/743: Georgiou, Murder Deposition of William Miller Fairlie, 3 October 1934. TNA: DPP 2/234: GEORGIOU, Murder Transcript, p. 38.
68. TNA: MEPO 3/1695: Murder of Thomas James, Memoranda: Minute 5, 21 September 1934.
69. Adam, *History of Forensics*, 73–4, 126–8.
70. TNA: DPP 2/234: GEORGIOU, Murder, Transcript, 5–8.
71. TNA: DPP 2/234: GEORGIOU, Murder, Transcript (Paterson cross-examines Watt), 9.
72. TNA: DPP 2/234: GEORGIOU, Murder, Transcript, 10–13.
73. TNA: CRIM 1/743: Georgiou, Murder, Exhibit 12: Copy of Maureen Lancing, *She Wore No Ring*, Girls' Friend Library, 434 (London: Amalgamated Press, 1934).
74. Lancing, *She Wore No Ring*.
75. Lancing, *She Wore No Ring*, 16–19.
76. Lancing, *She Wore No Ring* back cover.
77. Houlbrook, *Prince of Tricksters*, 3–6.
78. TNA: DPP 2/234: GEORGIOU, Murder, transcript, 53–9.
79. TNA: DPP 2/234: GEORGIOU, Murder, transcript, 40–52.
80. TNA: DPP 2/234: GEORGIOU, Murder, transcript, 82.
81. TNA: DPP 2/234: GEORGIOU, Murder, transcript, 84.
82. TNA: HO45/22317: Georgiou, Murder, including summary report 'Conditional Pardon' endorsed by John Gilmour [Home Secretary], 30 November 1934.
83. TNA: HO384/158: Home Office 'Black Book' of Capital Cases, 381.
84. Seal, *Capital Punishment in Twentieth-Century Britain*, 101–3.
85. TNA: HO45/22317: Georgiou, Murder.
86. Edward Owens, 'All the World Loves a Lover: Monarchy, Mass Media and the 1934 Royal Wedding of Prince George and Princess Marina', *The English Historical Review*, 133/562 (2018), 597–633.
87. Owens, 'All the World Loves a Lover', 597–633; Seal, *Capital Punishment in Twentieth-Century Britain*; Langhamer, *The English in Love*.

88 TNA: HO45/22317: Georgiou, Murder; The National Archives: PCOM 9/787: Prison Commission Registered Papers: GEORGIOU Georgios Kalli: Convicted of Murder and Sentenced to Death (Commuted), 1943.
89 The National Archives: RG 101/471A: 1939 England and Wales Register [St. Pancras Met B/ASAA/9.1] Schedule No. 260/3 via Ancestry.co.uk, 1939.

Chapter 4

1 The National Archives: CRIM 1/610: Central Criminal Court, Depositions, Defendant: Barney, Elvira Dolores, Charge: Murder, 1932, Exhibits 1–3: Plans and photographs; Depositions; 'Map Images'; and observations on walking William Mews, Knightsbridge and Belgravia, May 2013.
2 TNA: CRIM 1/610: Barney: Murder, Depositions.
3 TNA: CRIM 1/610: Barney: Murder, Exhibit 3: Photographs. William Mews was also called Williams Mews in many contemporary sources.
4 The National Archives: MEPO 3/1673: Metropolitan Police: Office of the Commissioner: Correspondence and Papers: Elvira Dolores Barney Acquitted of the Murder of Thomas William Scott Stephen at Williams [*sic*] Mews, 1932, Police Report: W. Winter to Divisional Detective Inspector, Gerald Road Station, 'B' Division, Metropolitan Police, 6 June 1932, 17.
5 TNA: CRIM 1/610: Barney: Murder, Exhibit 3: Photograph 1 of 5.
6 Hastings, *The Other Mr Churchill*, 199.
7 D. J. Taylor, *Bright Young People: The Rise and Fall of a Generation, 1918–1939* (London: Vintage, 2008); Alexa Neale, 'Murder at the "Love Hut": At Home with Elvira Barney', in *Beyond the Boundaries of Home: Interdisciplinary Approaches*, ed. by Marianela Barrios Aquino and Tom Ottway (Brighton: Vintage, 2017), 10–23.
8 TNA: MEPO 3/1673: Elvira Barney, Police report; Peter Cotes, *Trial of Elvira Barney*, Celebrated Trials Series (Newton Abbot: David & Charles, 1976).
9 Cotes, *Trial of Elvira Barney*; TNA: CRIM 1/610: Barney: Murder Exhibit 3: 1/5.
10 Both Amy Bell and I have observed that bodies did not become a frequent feature of London crime scene photographs until around the middle of the century Bell, 'Crime Scene Photography in England, 1895–1960', 73–4.
11 Clapson and Emsley, 'Street, Beat, and Respectability', 292–317; Klein, 'Irregular Marriages'.
12 Agatha Christie, *Murder in the Mews and Other Stories*, Crime Club (London: Collins, 1937); See also Joe Carstairs and 'X' Garage in Kate Summerscale, *The Queen of Whale Cay* (London: Bloomsbury, 2008).
13 K. D. M. Snell, *Spirits of Community: English Senses of Belonging and Loss, 1750–2000* (London: Bloomsbury, 2016), 129–58 esp. 131.

14 Christie, *Murder in the Mews*, 11–82.
15 *Daily Mirror*, 21 April 1923, 7; 29 October 1925, 11; 7 July 1932, 1; 19 November 1934, 2; TNA: RG14/388/102: 1911 Census [6 Belgrave Square].
16 Houlbrook, *Prince of Tricksters*; Taylor, *Bright Young People*; Bland, *Modern Women on Trial*.
17 Noel Coward, *Blithe Spirit* [play] (London: Bloomsbury Methuen Drama, 2002; originally published by Heinemann, 1941); Evelyn Waugh, *Vile Bodies* (London: Chapman and Hall, 1930); Cotes, *Trial of Elvira Barney*.
18 Bingham, *Family Newspapers?*, 239.
19 TNA: MEPO 3/1673: Elvira Barney Police report; Statements of Police Sergeant James Barnes, and PCs Albert Sewards, Richard Hastings Francis and Robert Campbell, Met Police, 6–8 June 1932.
20 TNA: MEPO 3/1673: Elvira Barney; The National Archives: DPP 2/92: Director of Public Prosecutions Case Papers: BARNEY, Elvira Dolores: Murder, 1932.
21 TNA: CRIM 1/610: Barney: Murder Depositions of Hugh Armigel Wade and Sylvia Coke, 6 June 1932.
22 TNA: MEPO 3/1673: Elvira Barney: Statement of Dorothy Hall, 3 June 1932.
23 TNA: MEPO 3/1673: Elvira Barney, Police report: W. Winter, Met. Police, 6 June 1932.
24 TNA: MEPO 3/1673: Elvira Barney 'List of Papers, Books and Periodicals Taken Possession of by John Sourr, 'B', on 4 June, 1932'; C O'Leary, *This Delicate Creature* (London: Constable, 1928).
25 Matt Houlbrook, 'A Pin to See the Peep Show: Culture, Fiction and Selfhood in the Letters of Edith Thompson', *Past and Present*, 207/1 (2010), 245.
26 Cotes, *Trial of Elvira Barney*; TNA: DPP 2/92: BARNEY: Murder; TNA: CRIM 1/610: Barney: Murder Exhibits 7 and 8: Undated letters between Elvira Barney and Michael Scott Stephen.
27 TNA: CRIM 1/610: Barney: Murder Exhibit 7.
28 TNA: CRIM 1/610: Barney: Murder Exhibit 8.
29 Edgar Lustgarten, The Murder and the Trial (London: Odhams Press, 1960), 247.
30 TNA: MEPO 3/1673: Elvira Barney Police report.
31 TNA: MEPO 3/1673: Elvira Barney 14B: Letter from Barbara Graham to Elvira Barney (undated) with commentary by Met Police, 5 September 1932; Daily Mirror, 31 August 1932, 1.
32 Bingham, *Family Newspapers?*
33 TNA: MEPO 3/1673: Elvira Barney Police report: W. Winter, Met. Police, 6 June 1932, p. 17.
34 I believe Christie borrowed from descriptions of Elvira's home when she imagined the luminous emerald green silks in her fictional *Murder in the Mews*.
35 TNA: MEPO 3/1673: Elvira Barney, Statement of Dorothy Hall.
36 Cotes, *Trial of Elvira Barney*.
37 Cotes, *Trial of Elvira Barney*.

38 TNA: DPP 2/92: BARNEY: Murder, Letter marked 'personal' Wilfred Dell, Registrar of the Mayor's and City of London Court, to E. H. Tindal Atkinson, DPP, 8 July 1932; Anonymous postcard by 'An Observer, Brixton', unaddressed, 10 June 1932.
39 Cotes, *Trial of Elvira Barney*; TNA: DPP 2/92: BARNEY: Murder, Transcript, Opening speech for the Crown.
40 Cotes, *Trial of Elvira Barney*; TNA: DPP 2/92: BARNEY: Murder, Transcript, Opening speech for the Crown.
41 Anne Logan, '"Building a New and Better Order"? Women and Jury Service in England and Wales, c. 1920–70', *Women's History Review*, 22/5 (2013), 701–16.
42 Douglas G. Browne and E. V. Tullett, *Bernard Spilsbury: His Life and Cases* (London: Harrap, 1951), 356.
43 Smalley, 'Representations of Crime'.
44 Popperfoto via Getty Images, 'Circa 1930, Elvira Barney, portrait', *Getty Images* https://www.gettyimages.dk/detail/news-photo/people-crime-murder-pic-circa-1930-elvira-barney-portrait-news-photo/78970197 [accessed 28 September 2019].
45 Popperfoto via Getty Images, 'May 1932, The Scene outside Westminster Court, London, after Elvira Barney's [*sic*] Had Been Charged with the Shooting of Michael Scott Stephen', *Getty Images* www.gettyimages.dk/detail/news-photo/people-crime-murder-pic-may-1932-the-scene-outside-news-photo/78970209 [accessed 28 September 2019].
46 'SENSATIONAL SHOOTING DRAMA IN WEST END FLAT', *Illustrated Police News*, 9 June 1932, 5; TNA: CRIM 1/610: Barney: Murder, Photographs.
47 TNA: DPP 2/92: BARNEY: Murder, 'An Observer' postcard, 10 June 1932.
48 TNA: DPP 2/92: BARNEY: Murder, Dell to Tindal Atkinson, 8 July 1932.
49 Reverend H.S. M'Clelland, 'LESSON OF BARNEY TRIAL/Minister's Impression', *Aberdeen Press and Journal*, 8 July 1932, 6.
50 Hannen Swaffer, 'WASTED LIVES', *Daily Herald*, 7 July 1932, 8.
51 Swaffer, 'WASTED LIVES', 8.
52 M'Clelland, 'LESSON OF BARNEY TRIAL', 6.
53 Cotes, *Trial of Elvira Barney*.
54 'TRAGEDY IN BEDROOM OF LUXURY HOTEL', *Illustrated Police News*, 31 December 1936, 1.
55 Hastings, *The Other Mr Churchill*, 199.
56 Cotes, *Trial of Elvira Barney*; TNA: MEPO 3/1673: Elvira Barney.

Chapter 5

1 The National Archives: CRIM 1/2844: Central Criminal Court, Depositions, Defendant: Harrison, Francis Charles Alfred, Charge: Murder, 1957: Copy Exhibit 'H' [defence] Murder Story found in Harrison's workplace desk drawer.

2 Megha Anwer, 'Murder in Black and White: Victorian Crime Scenes and the Ripper Photographs', *Victorian Studies*, 56/3 (2014), 433; Nead, *Tiger in the Smoke*.
3 TNA: CRIM 1/2844: Harrison: Murder 'Murder story'.
4 The National Archives: DPP 2/2691: Director of Public Prosecutions Case Papers: HARRISON, Francis Charles Alfred: Murder of Doris Alice Ellen HARRISON (Wife), 1957 Advice on evidence [for the Prosecution] from Mervyn Griffith-Jones, 21 August 1957.
5 *Daily Mirror*, 18 September 1957, 7.
6 TNA: DPP 2/2691: HARRISON: Murder Transcript, judge's summing up.
7 Seal, *Capital Punishment in Twentieth-Century Britain*, 24–5.
8 TNA: CRIM 1/2844: Harrison: Murder.
9 Langhamer, 'The Meanings of Home in Postwar Britain', 342–3.
10 Nead, *Tiger in the Smoke*.
11 Bell, *Murder Capital*, 59–61.
12 Julie-Marie Strange, 'Fatherhood, Furniture and the Inter-Personal Dynamics of Working-Class Homes, c. 1870–1914', *Urban History*, 40/02 (2013), 271–86; Megan Doolittle, 'Time, Space, and Memories: The Father's Chair and Grandfather Clocks in Victorian Working-Class Domestic Lives', *Home Cultures*, 8/3 (2011), 245–64 have both described the gendered visual iconography of the armchair.
13 Ivor Novello, *Keep the Home-Fires Burning ('Till the Boys Come Home)* [song] (New York: Chappell, 1915); [Dir.], *Since You Went Away* [Film], (1944).
14 The National Archives: CRIM 1/1698: Central Criminal Court, Depositions, Defendant: PATMORE, Cyril. Charge: Murder, 1945 Exhibit 2: Kathleen to Cyril Patmore, undated.
15 Alan Allport, *Demobbed: Coming Home after the Second World War* (New Haven, CT: Yale University Press, 2009); Barry Turner and Tony Rennell, *When Daddy Came Home: How Family Life Changed Forever in 1945* (London: Hutchinson, 1995); Julie Summers, *Stranger in the House: Women's Stories of Men Returning from the Second World War* (London: Pocket, 2009); Pat Thane, 'Family Life and "Normality" in Postwar British Culture', in *Life after Death: Approaches to a Cultural and Social History of Europe during the 1940s and 1950s*, ed. by R. Bessel and D. Schumann (Cambridge: Cambridge University Press, 2003), 193.
16 Nead, *Tiger in the Smoke*, 132.
17 The National Archives: ASSI 84/33: Assizes: Wales and Chester Circuit: Criminal Depositions and Case Papers: Booth, Frederick Marshall, 1945 Exhibit 1: Statement of defendant, 12 November 1945.
18 *Daily Mirror*, 4 December 1945, p. 8; 16 February 1946, pp. 1, 8.
19 TNA: CRIM 1/1698: PATMORE, Murder Exhibit 3: Copy of letter from Fusilier Patmore to his wife (undated); Men serving in Burma were thought to be particularly susceptible to jealousy, given that they were further from home and

for longer periods than other members of the wartime forces. Turner and Rennell, *When Daddy Came Home*, 167.

20 The National Archives: DPP 2/1354: Director of Public Prosecutions Case Papers: KEYMER: Murder, 1945 Copy of voluntary statement by Reginald Keymer, 6 April 1945; newspaper clipping from Nottingham Evening Post, 3 May 1945; DS Ellington to Chief Constable, Nottingham City Police, 11 April 1945, 3–4.
21 'JURY IGNORE "MURDER" RULING', *Daily Mirror*, 22 September 1945, 3.
22 'JURY IGNORE "MURDER" RULING', 3.
23 '2 HUSBANDS ARE CLEARED OF WIFE MURDER', *Daily Mirror*, 16 February 1946, 1, 8.
24 TNA: ASSI 84/33: Booth.
25 Seal, *Capital Punishment in Twentieth-Century Britain*, 68, 102–4; Bell, *Murder Capital*, 59–60.
26 '2 HUSBANDS ARE CLEARED OF WIFE MURDER', 1, 8.
27 The National Archives: CRIM 1/1754: Central Criminal Court, Depositions, Defendant: HARTNEY, Patrick. Charge: Murder., 1946 Prison Medical Officer's Report: Hugh Grierson to DPP, 1 February 1946.
28 *Daily Mirror*, 7 August 1945, p. 3.
29 I have thought very carefully about which photographs to reproduce in this book on a case-by-case basis and made the decision not to include those of Lilian Hartney's body but to describe them instead. Copying the images would, I feel, risk further exploiting the sexual inequalities that her killer was able to take advantage of.
30 Judith R. Walkowitz, *City of Dreadful Delight: Narratives of Sexual Danger in Late-Victorian London* (Chicago: University of Chicago Press, 1992), 190–244.
31 'The Miller-Court Murder, Whitechapel: Site of Mary Kelly's Lodgings', *Penny Illustrated Paper*, 17 November 1888, 1.
32 'Scene of the Terrible Murder in Hanbury-Street, Whitechapel', *Penny Illustrated Paper*, 15 September 1888, 1.
33 Walkowitz, *City of Dreadful Delight*, 190–244.
34 Anwer, 'Murder in Black and White', 434.
35 The National Archives: CRIM 1/1397: Central Criminal Court, Depositions, Defendant: CUMMINS, Gordon Frederick. Charge: Murder and Attempted Murder, 1942; TNA: DPP 2/952: Director of Public Prosecutions Case Papers: CUMMINS: Murder four Cases. Attempted Murder two Cases, 1942; TNA: DPP 2/989: Director of Public Prosecutions Case Papers: CUMMINS: Appeal – Murder, 1942; TNA: MEPO 3/2206: Metropolitan Police: Office of the Commissioner: Correspondence and Papers: Murder of Four Women and Attempted Murder of Two Others by Gordon Frederick Cummins in the West End of London, 1942; TNA: PCOM 9/919: Prison Commission Registered Papers: CUMMINS Gordon Frederick: Convicted at Central Criminal Court of Murder and Sentenced to Death, 1942; TNA: HO

144/21659: Home Office Registered Papers: CRIMINAL CASES: CUMMINS, Gordon Frederick Convicted at Central Criminal Court for Murder and Sentenced to Death, 1942 incorrectly described as 'a series of murderous attacks in London's air raid shelters' in Peter Adey, David J. Cox and Barry S. Godfrey, *Crime, Regulation and Control during the Blitz: Protecting the Population of Bombed Cities* (London: Bloomsbury, 2016), 81.
36. Janet Weston, *Medicine, the Penal System, and Sexual Crimes in England, 1919–1960s: Diagnosing Deviance* (London: Bloomsbury, 2018).
37. Bell, *Murder Capital*, 103.
38. TNA: CRIM 1/1754: HARTNEY Exhibit 10: Photograph 1.
39. Graybill, 'The Forensic Eye and the Public Mind', 94–119.
40. O'Brien, 'Simple Photography Part 2', 173–82.
41. TNA: CRIM 1/1754: HARTNEY: Exhibit 10, Photograph 2; Anwer, 'Murder in Black and White', 439.
42. TNA: CRIM 1/1754: HARTNEY: Exhibits 8 and 9 (plans).
43. TNA: CRIM 1/1754: HARTNEY: Deposition of Albert Edward Adams, 18 December 1945.
44. TNA: CRIM 1/1754: HARTNEY: Depositions; The National Archives: DPP 2/1452: Director of Public Prosecutions Case Papers: HARTNEY: Murder, 1945: Depositions.
45. TNA: DPP 2/1452: HARTNEY: Murder: Metropolitan Police Report: DDI Freshney to Superintendent Batson, 11 December 1945.
46. TNA: DPP 2/1452: HARTNEY: Murder: Police report.
47. TNA: DPP 2/1452: HARTNEY: Murder: Police report.
48. TNA: DPP 2/1452: HARTNEY: Murder: Deposition of DI Jack Robinson, 9 January 1946.
49. TNA: DPP 2/1452: HARTNEY: Murder: Police report.
50. TNA: DPP 2/1452: HARTNEY: Murder: Statement of DS George Salter, 10 August 1945.
51. TNA: DPP 2/1452: HARTNEY: Murder: Police report including summary of post-mortem report and antecedents of defendant.
52. TNA: DPP 2/1452: HARTNEY: Murder: Police report.
53. TNA: DPP 2/1452: HARTNEY: Murder: Police report; Exhibit 10: Photographs.
54. Sascha Auerbach, *Race, Law, and 'The Chinese Puzzle' in Imperial Britain* (New York: Palgrave Macmillan US, 2009), 85–7, 114–21.
55. Seal and Neale, 'Encountering the Archive', 296–9.
56. TNA: CRIM 1/1754: HARTNEY; TNA: DPP 2/1452: HARTNEY: Murder.
57. '2 HUSBANDS ARE CLEARED OF WIFE MURDER', 8.
58. TNA: DPP 2/1452: HARTNEY: Murder Transcript and notes on Prosecution Brief.
59. '2 HUSBANDS ARE CLEARED OF WIFE MURDER', 8; General Register Office: England and Wales, Civil Registration Death Index, 1916–2007 via Ancestry.com

Deaths registered in July, August and September 1946, p. 273 (Entry for Thomas Patrick Hartney aged 51 at Chatham: Vol. 5b, p. 272); Principal Probate Registry: National Probate Calendar (Index of Wills and Administrations, 1858–1995 via Ancestry.com 1948, p. 179.

60 Louise Wattis, *Revisiting the Yorkshire Ripper Murders: Histories of Gender, Violence and Victimhood* (Basingstoke: Palgrave Macmillan, 2018), 3, 13–14.

61 Hallie Rubenhold, *The Five: The Untold Lives of the Women Killed by Jack the Ripper* (London: Doubleday/Transworld, 2019).

62 TNA: CRIM 1/1397: CUMMINS, Murder; TNA: DPP 2/952: CUMMINS, Murder: Photographs.

63 Seal and Neale, 'Encountering the Archive', 291.

Chapter 6

1 This vignette is based on The National Archives: CRIM 1/2206: Central Criminal Court, Depositions, Defendant: MANNEH, Backary. Charge: Murder, 1952; TNA: DPP 2/2130: Director of Public Prosecutions Case Papers: MANNEH, B: Murder and Appeal, 1952; TNA: PCOM 9/1611: Prison Commission Registered Papers: MANNEH, Backary: Convicted of Murder and Sentenced to Death, 1952; FPG/Hulton Archive/Getty Images, *The Scene of an Accident in Oakley Square, London after Scaffolding and Masonry Collapsed into the Street, Killing One and Injuring Eight, 12th October 1950*, 1950, http://www.gettyimages.co.uk/detail/78660796 [accessed 17 October 2019] I am also grateful to Jessamy Carlson via Twitter (Twitter.com/jessamycarlson) for helping identify the Clayton's Orange Squash bottle.

2 Bell, *Murder Capital*, 34.

3 TNA: PCOM 9/1611: MANNEH, Murder; 'DOPE: Stowaway Sentenced for Murdering Stowaway Who Became a London "reefer King" FOUR CLUES FOUND IN FLAT', *Daily Express*, 28 March 1952.

4 Seal and Neale, 'In His Passionate Way'.

5 Paul Gilroy, 'Blacks and Crime in Postwar Britain (1987)', in *Writing Black Britain, 1948–1998*, ed. by James Procter (Manchester: Manchester University Press, 2000), 72; Kennetta Hammond Perry, *London Is the Place for Me: Black Britons, Citizenship, and the Politics of Race*, Transgressing Boundaries: Studies in Black Politics and Black Communities (New York: Oxford University Press, 2015), 14.

6 Sheila Patterson, *Dark Strangers: A Sociological Study of the Absorption of a Recent West Indian Migrant Group in Brixton, South London*, abridged edition (London: Penguin, 1965); Ruth Glass, *London's Newcomers: The West Indians in London* (London: Centre for Urban Studies, 1960).

7 Stuart Hall, 'Reconstruction Work: Images of Postwar Black Settlement', in *Writing Black Britain, 1948–1998: An Interdisciplinary Anthology*, ed. by James Proctor (Manchester: Manchester University Press, 2000), 82–94.
8 Gilroy, 'Blacks and Crime', 71–8.
9 Seal and Neale, 'Race, Racialisation and "Colonial Common Sense"', 64.
10 Biber, *Captive Images*.
11 West, 'Visual Criminology and Lombroso', 271–87.
12 Perry, *London Is the Place for Me*, 71–4; Tina Campt, *Image Matters: Archive, Photography and the African Diaspora in Europe* (Durham, NC: Duke University Press, 2012), 5–8.
13 Lizzie Seal and Alexa Neale, 'Race, Gender and Bourgeois Respectability: The Execution of Percy Clifford, 1914', *The Irish Jurist*, 60 (2018), 144–53; Seal and Neale, 'Race, Racialisation and "Colonial Common Sense"', 64; Seal and Neale, 'In His Passionate Way'.
14 Webster, *Imagining Home*, 149.
15 TNA: DPP 2/2130: MANNEH, B: Murder and Appeal, 1952: Transcript, 2–3.
16 Seal and Neale, 'Race, Racialisation and "Colonial Common Sense"', 64.
17 Hall, 'Reconstruction Work: Images of Postwar Black Settlement', 82–94.
18 TNA: DPP 2/2130: MANNEH, Murder and Appeal: Transcript, 26.
19 Webster, *Imagining Home*; Laura Tabili, *We Ask for British Justice: Workers and Racial Justice in Late Imperial Britain* (New York: Cornell University Press, 1994).
20 *Daily Mirror*, 15 January 1952, 7.
21 TNA: DPP 2/2130: MANNEH, Murder and Appeal: Examination of Donald McIntosh Johnson by Mr Sarch for defence: Transcript, 170–4.
22 TNA: DPP 2/2130: MANNEH, Murder and Appeal, Exhibit 23: Donald McIntosh Johnson, *Indian Hemp: A Social Menace* (London: Christopher Johnson, 1952), 68.
23 Sascha Auerbach, '"A Holy Panic" Race, Surveillance and the Origins of the War on Drugs in Britain, 1915–1918', in *Transnational Penal Cultures*, ed. by Vivien. Miller and James Campbell (Abingdon: Routledge, 2014), 98–112; See also Bland, *Modern Women on Trial* esp. 'Chapter 2: Butterfly women, "Chinamen" Dope Fiends and Metropolitan Allure', 55–101.
24 Johnson, *Indian Hemp: A Social Menace*: 'Chapter 7: A Hypothetical Case: The Perfect Crime', 76–87.
25 Johnson, *Indian Hemp: A Social Menace*, 68.
26 Seal and Neale, 'Racializing Mercy'.
27 Quoted in Webster, *Imagining Home*, 45.
28 Quoted in Webster, *Imagining Home*, 45.
29 Quoted in Webster, *Imagining Home*, 65.
30 Langhamer, 'The Meanings of Home in Postwar Britain', 341–62.
31 Webster, *Imagining Home*, 149.
32 Webster, *Imagining Home*, 48–9.

33 Mica Nava, *Visceral Cosmopolitanism: Gender, Culture and the Normalisation of Difference* (Oxford; New York: Berg, 2007), 75–8.
34 Seal and Neale, 'In His Passionate Way'.
35 TNA: DPP 2/2130: MANNEH, Murder and Appeal Transcript.
36 TNA: DPP 2/2130: MANNEH, Murder and Appeal: Cross examination of Phyllis Beardsmore by Mr Sarch, transcript, 104–9.
37 James Whitfield, *Unhappy Dialogue: The Metropolitan Police and Black Londoners in Post-War Britain* (Cullompton: Willan, 2004), 149.
38 TNA: DPP 2/2130: MANNEH, Murder and Appeal.
39 TNA: DPP 2/2130: MANNEH, Murder and Appeal Transcript, 62.
40 TNA: CRIM 1/2206: MANNEH, Murder; TNA: DPP 2/2130: MANNEH, Murder and Appeal; TNA: PCOM 9/1611: MANNEH, Murder.
41 Darnton, *The Great Cat Massacre*; David Cressy, *Agnes Bowker's Cat: Travesties and Transgressions in Tudor and Stuart England* (Oxford: Oxford University Press, 2000).
42 Steedman quoted in Seal and Neale, 'Encountering the Archive', 291.
43 TNA: DPP 2/2130: MANNEH, Murder and Appeal: Transcript, 28–9: examination and cross-examination of PS John Merry.
44 TNA: PCOM 9/1611: MANNEH, Murder Metropolitan Police Report: Chief Inspector (CID) to Chief Superintendent 18 June 1952.
45 TNA: DPP 2/2130: MANNEH, Murder and Appeal: Appeal court papers and brief for respondent.
46 TNA: PCOM 9/1611: MANNEH, Murder Handwritten memoranda: Thornton, Drugs Branch, to Mr King, Prison Commission, 26 June 1952.

Chapter 7

1 TNA: J 82/27: Burdett, Murder: Transcript, 1.
2 TNA: J 82/27: Burdett, Murder: Transcript (opening speech for the Prosecution by Sir Harry Hylton-Foster), 2.
3 Marc Brodie, 'Foster, Sir Harry Braustyn Hylton Hylton – (1905–1965), Speaker of the House of Commons', *The Oxford Dictionary of National Biography*, 2004, http://www.oxforddnb.com/view/article/34087 [accessed 10 February 2020].
4 TNA: J 82/27: Burdett, Murder: Transcript, 2.
5 TNA: J 82/27: Burdett, Murder: Transcript, 2.
6 Frank Mort, 'Scandalous Events: Metropolitan Culture and Moral Change in Post-Second World War London', *Representations*, 93/1 (2006), 106–37.
7 Langhamer, 'The Meanings of Home in Postwar Britain', 341–62; Nick Thomas, 'Will the Real 1950s Please Stand Up? Views of a Contradictory Decade', *Cultural and Social History*, 5/2 (2008), 227–35; For more on the 'ideal home' and its interwar origins see Ryan, *Ideal Homes, 1918–39*.

8 Brooke, 'Revisiting Southam Street', 453–96.
9 Bill Brandt, *The English at Home* (London: BT Basford, 1936); Humphrey Spender, *Worktown People* (Bristol: Falling Wall Press, 1982); John Thomson, *Street Life in London* (London: Sampson Low, 1877); Nick Hedges, *Make Life Worth Living: 1968–72*, [Exhibition] 2015, The Science Museum.
10 Brandt, *English at Home*: esp. 29–30 'Circus Boyhood' vs. 'Nursery Girlhood', and 57–8 'East End Playground'/'Kensington Children's Party'
11 Hall, 'Reconstruction Work: Images of Postwar Black Settlement', 82–94; Paul Gilroy and Stuart Hall, eds., *Black Britain: A Photographic History* (London: Saqi, 2007); Campt, *Image Matters*.
12 Brooke, 'Revisiting Southam Street', 453–96.
13 TNA: CRIM 1/2783: Burdett, Murder: Exhibit 18: Undated letter from Brian to Moira Burdett with enclosures. Brooke, 'Revisiting Southam Street', 453.
14 TNA: CRIM 1/2783: Burdett, Murder: Exhibit 18.
15 Chris Waters, 'Representations of Everyday Life: L. S. Lowry and the Landscape of Memory in Postwar Britain', *Representations*, 65 (1999), 121–50.
16 Brooke, 'Revisiting Southam Street', 494: Figure 24, for example.
17 Morris and Blom-Cooper, *A Calendar of Murder*; Seal, *Capital Punishment in Twentieth-Century Britain*, 24–6.
18 Brooke, 'Revisiting Southam Street', 453–96.
19 TNA: CRIM 1/2783: Burdett, Murder: Exhibit 18.
20 TNA: CRIM 1/2783: Burdett, Murder: Deposition of Blanche Burdett, 4 January 1957.
21 TNA: J 82/27: Burdett, Murder: Transcript; Seal and Neale, 'Encountering the Archive', 289–300.
22 TNA: CRIM 1/2783: Burdett, Murder: Exhibit 18 plus enclosures.
23 TNA: CRIM 1/2783: Burdett, Murder: Exhibit 18.
24 TNA: J 82/27: Burdett, Murder: Transcript.
25 Brooke, 'Revisiting Southam Street', 453–96.
26 TNA: CRIM 1/2783: Burdett, Murder: Exhibit 18.
27 Thomas, 'Will the Real 1950s Please Stand Up?', 227–35.
28 TNA: CRIM 1/2783: Burdett, Murder: Exhibit 18.
29 TNA: CRIM 1/2783: Burdett, Murder: Exhibit 4: Photographs.
30 TNA: CRIM 1/2783: Burdett, Murder: Prison Medical Officer's Report.
31 Brooke, 'Revisiting Southam Street', 453–96.
32 TNA: J 82/27: Burdett, Murder Transcript, pp. 16, 111.
33 Bell, *Murder Capital*; Bell, 'Crime Scene Photography in England, 1895–1960', 53–78.
34 Perry, *London Is the Place for Me*, 126–52.
35 The National Archives: MEPO 2/9883: Metropolitan Police: Office of the Commissioner: Correspondence and Papers: Leakage of Information – Receipt of a Cheque from the Sunday Express Newspaper in Response to a Tip Regarding the

Murder of Kelso COCHRANE, 1959; The National Archives, 'Discovery [Online Catalogue]: MEPO 2/9894: Unsolved Murder of Kelso COCHRANE on 17 May 1959', *The National Archives, Discovery*, 2019, https://discovery.nationalarchives.gov.uk/details/r/C10887962 [accessed 17 October 2019].

36 Bland, *Modern Women on Trial*, for example.
37 Bingham, *Family Newspapers?*, 125–7.
38 *Daily Mirror*, 15 February 1957, 3.
39 Wood, '"The Third Degree"', 464–85; Devlin, *The Criminal Prosecution in England*, 43–4.
40 *Daily Mirror*, 15 February 1957, 3.
41 Whitaker, *The Police in Society*, 61–2.
42 TNA: CRIM 1/2783: Burdett, Murder: Burdett Statements.
43 Jackson, *Child Sexual Abuse*; Carolyn Steedman, 'After the Archive', *Comparative Critical Studies*, 8/2 (2011), 333; Seal and Neale, 'Encountering the Archive', 291.
44 TNA: J 82/27: Burdett, Murder: Transcript, 19.
45 Ballinger, 'Masculinity in the Dock', 459–81.
46 The National Archives: CRIM 1/5099: Central Criminal Court, Depositions, Defendant: COWDEROY, Frederick James. Charge: Murder, 1969.
47 Morris and Blom-Cooper, *A Calendar of Murder*.
48 TNA: HO384/158: Home Office 'Black Book' of Capital Cases.
49 Brooke, 'Revisiting Southam Street', 453–96.
50 The National Archives, 'Discovery [Online Catalogue]: CRIM 1/2783: Defendant: BURDETT, Brian Edward. Charge: Murder', *The National Archives, Discovery*, 2019, https://discovery.nationalarchives.gov.uk/details/r/C4202892 [accessed 16 October 2019].
51 TNA: J 82/27: Burdett, Murder.
52 Brooke, 'Revisiting Southam Street', 453–96.

Chapter 8

1 Bell, *Murder Capital*, 41.
2 Seal and Neale, 'Encountering the Archive', 298.
3 TNA: CRIM 1/2206: MANNEH, Murder Trial transcript, 2.
4 Judith R. Walkowitz, *Nights Out: Life in Cosmopolitan London* (New Haven: Yale University Press, 2012); Mort, *Capital Affairs*, 17.
5 Brooke, 'Revisiting Southam Street', 464.
6 Perry, *London Is the Place for Me*; Campt, *Image Matters*.
7 Houlbrook, *Prince of Tricksters*; West, 'Feeling Things: From Visual to Material Jurisprudence'; Seal and O'Neill, *Imaginative Criminology*.

Bibliography

Archives

The National Archives

Assizes: Wales and Chester Circuit: Criminal Depositions and Case Papers:
ASSI 84/33: Booth, Frederick Marshall, 1945.

Central Criminal Court, Depositions:
CRIM 1/610: Barney, Elvira Dolores. Charge: Murder, 1932.
CRIM 1/742: Anderson, John. Charge: Murder, 1934.
CRIM 1/743: Georgiou, Georgios Kalli. Charge: Murder, 1934.
CRIM 1/1397: CUMMINS, Gordon Frederick. Charge: Murder and Attempted Murder, 1942.
CRIM 1/1698: PATMORE, Cyril. Charge: Murder, 1945.
CRIM 1/1754: HARTNEY, Patrick. Charge: Murder, 1946.
CRIM 1/2206: MANNEH, Backary. Charge: Murder, 1952.
CRIM 1/2783: Burdett, Brian Edward. Charge: Murder, 1957.
CRIM 1/2844: Harrison, Francis Charles Alfred. Charge: Murder, 1957.
CRIM 1/5099: COWDEROY, Frederick James. Charge: Murder, 1969.

Director of Public Prosecutions Case Papers:
DPP 2/92: BARNEY, Elvira Dolores: Murder, 1932.
DPP 2/234: GEORGIOU, Georgios K: Murder, 1934.
DPP 2/952: CUMMINS: Murder Four Cases and Attempted Murder Two Cases, 1942.
DPP 2/989: CUMMINS: –Murder and Appeal, 1942.
DPP 2/1354: KEYMER: Murder, 1945.
DPP 2/1452: HARTNEY: Murder, 1945.
DPP 2/2130: MANNEH, B: Murder and Appeal, 1952.
DPP 2/2691: HARRISON: Murder, 1957.

Home Office Registered Papers:
HO 45/10989/X84282/1: Home Office Registered Papers, POLICE: Use of photographic material in Criminal Investigation Department, 1901.
HO 144/21659: CUMMINS, Gordon Frederick: Convicted at Central Criminal Court for Murder and Sentenced to Death, 1942.
HO 45/22317: Georgiou, Georgios Kalli: Convicted at Central Criminal Court on 22 October 1934 of Murder and Sentenced to Death (Commuted), 1934.

Home Office: Noters Section: Precedent Books:
HO 384/158: Capital Cases, 1901.

Court of Criminal Appeal Case Papers:
J 82/27: Burdett, B.E: Murder, 1957.

Metropolitan Police: Office of the Commissioner: Correspondence and Papers:
MEPO 2/9883: Leakage of Information – Receipt of a Cheque from the *Sunday Express* Newspaper in Response to a Tip Regarding the Murder of Kelso COCHRANE, 1959.
MEPO 3/1673: Elvira Dolores Barney Acquitted of the Murder of Thomas William Scott Stephen at Williams [sic] Mews, 1932.
MEPO 3/1695: Murder of Thomas James by Georgios Kalli Georgiou at Torrington Square, Holborn, 1934.
MEPO 3/2206: Murder of Four Women and Attempted Murder of Two Others by Gordon Frederick Cummins in the West End of London, 1942.

Prison Commission Registered Papers:
PCOM 9/787: GEORGIOU Georgios Kalli: Convicted of Murder and Sentenced to Death (Commuted), 1943.
PCOM 9/919: CUMMINS Gordon Frederick: Convicted at Central Criminal Court of Murder and Sentenced to Death, 1942.
PCOM 9/1611: MANNEH, Backary: Convicted of Murder and Sentenced to Death, 1952.

Census Data:
RG 101/471A: 1939 England and Wales Register [St. Pancras Met B/ASAA/9.1] Schedule No. 260/3 via Ancestry.co.uk, 1939.
RG14/00762/181: Census for England and Wales, 1911: Charles Francis and Household, 11 Prebend Street, Camden Town., 1911.

Principal Probate Registry:
National Probate Calendar, Index of Wills and Administrations, 1858–1995 via Ancestry.com

General Register Office

Civil Registration Death Index, England and Wales, 1916–2007 via Ancestry.com

London Metropolitan Archives

GLC/MA/SC/03/0948: Greater London Council Slum Clearance and Public Health Files: Baynes Street [Formerly Prebend Street] Area [Camden Town] (London, 1922).

Publications Books

Adam, Alison, *A History of Forensic Science: British Beginnings in the Twentieth Century* (Abingdon: Routledge, 2015).

Adam, Alison, ed., *Crime and the Construction of Forensic Objectivity from 1850* (Basingstoke: Palgrave Macmillan, 2020).

Adey, Peter, David J. Cox and Barry S. Godfrey, *Crime, Regulation and Control during the Blitz: Protecting the Population of Bombed Cities* (London: Bloomsbury, 2016).

Allport, Alan, *Demobbed: Coming Home after the Second World War* (New Haven, CT; London: Yale University Press, 2009).

Auerbach, Sascha, *Race, Law, and 'The Chinese Puzzle' in Imperial Britain* (New York: Palgrave Macmillan US, 2009).

Barrios Aquino, Marianela, Eduard Campillo-Funollet, Naomi Daw, Khetan Jha, Myles Logan Miller, Alexa Neale and Tom Ottway, *Beyond the Boundaries of Home: Interdisciplinary Approaches* (Brighton: University of Sussex Library, 2017).

Bell, Amy Helen, *Murder Capital: Suspicious Deaths in London, 1933–53* (Manchester: Manchester University Press, 2015).

Bessel, R., and D. Schumann, eds., *Life after Death: Approaches to a Cultural and Social History of Europe during the 1940s and 1950s* (Cambridge: Cambridge University Press, 2003).

Biber, Katherine, *Captive Images: Race, Crime, Photography* (Abingdon; New York: Routledge-Cavendish, 2007).

Biber, Katherine, *In Crime's Archive: The Cultural Afterlife of Evidence* (London; New York: Routledge, 2018).

Bingham, Adrian, *Family Newspapers?: Sex, Private Life, and the British Popular Press 1918–1978* (Oxford; New York: Oxford University Press, 2009).

Bland, Lucy, *Modern Women on Trial: Sexual Transgression in the Age of the Flapper* (Manchester: Manchester University Press, 2013).

Blaney, Gerald, ed., *Policing Interwar Europe: Continuity, Change and Crisis, 1918–1940* (Basingstoke: Palgrave Macmillan, 2006).

Blunt, Alison, and Robyn M. Dowling, *Home* (New York: Routledge, 2006).

Bond, Henry, *Lacan at the Scene* (Cambridge, MA; London: MIT Press, 2012).

Bondeson, Jan, *Murder Houses of London* (Stroud: Amberley, 2014).

Brandt, Bill, *The English at Home* (London: BT Basford, 1936).

Brown, Antony M., *Death of an Actress: A Cold Case Jury True Crime* (London: Mirror Publishing, 2018).

Brown, Michelle, and Eamonn Carrabine, eds., *Routledge International Handbook of Visual Criminology* (New York: Routledge, 2017).

Browne, Douglas G., and E. V. Tullett, *Bernard Spilsbury: His Life and Cases* (London: Harrap, 1951).

Burney, Ian A., and Neil Pemberton, *Murder and the Making of English CSI* (Baltimore: Johns Hopkins University Press, 2016).

Byers, Michele, and Val Marie Johnson, eds., *The CSI Effect: Television, Crime, and Governance* (Lanham: Lexington Books, 2009).
Campt, Tina, *Image Matters: Archive, Photography and the African Diaspora in Europe* (Durham, NC: Duke University Press, 2012).
Cherrill, Fred, *Cherrill of the Yard, the Autobiography of Fred Cherrill* (London: Harrap, 1954).
Christie, Agatha, *Murder in the Mews and Other Stories*, Crime Club (London: Collins, 1937).
Cohen, Deborah, *Family Secrets: The Things We Tried to Hide* (London: Penguin, 2014).
Cook, Matt, *Queer Domesticities: Homosexuality and Home Life in Twentieth-Century London* (New York: Palgrave Macmillan, 2014).
Cotes, Peter, *Trial of Elvira Barney*, Celebrated Trials Series (Newton Abbot: David & Charles, 1976).
Cressy, David, *Agnes Bowker's Cat: Travesties and Transgressions in Tudor and Stuart England* (Oxford: Oxford University Press, 2000).
Creutzfeldt, Naomi, Marc Mason and Kirsten McConnachie, eds., *Routledge Handbook of Socio-Legal Theory and Methods* (Abingdon; New York: Routledge, 2019).
Crone, Rosalind, *Violent Victorians: Popular Entertainment in Nineteenth-Century London* (Manchester; New York: Manchester University Press, 2012).
Darnton, Robert, *The Great Cat Massacre and Other Episodes in French Cultural History* (New York: Basic Books, 1999).
Davis, Natalie Zemon, *Fiction in the Archives: Pardon Tales and Their Tellers in Sixteenth-Century France* (Stanford, CA: Stanford University Press, 1987).
D'Cruze, Shani, Sandra Walklate and Samantha Pegg, *Murder: Social and Historical Approaches to Understanding Murder and Murderers*, Crime and Society Series (Cullompton: Willan, 2006).
Devlin, Lord, *The Criminal Prosecution in England* (Oxford: Oxford University Press, 1960).
Ellroy, James, *Lapd '53* (New York: Abrams Image, 2015).
Fleetwood, Jennifer, Lois Presser, Sveinung Sandberg and Thomas Ugelvik, *The Emerald Handbook of Narrative Criminology* (Bingley: Emerald Publishing, 2019).
Frost, Ginger Suzanne, *Living in Sin: Cohabiting as Husband and Wife in Nineteenth-Century England*, Gender in History (Manchester; New York: Manchester University Press, 2008).
Gilroy, Paul, and Stuart Hall, eds., *Black Britain: A Photographic History* (London: Saqi, 2007).
Ginzburg, Carlo, *The Cheese and the Worms: The Cosmos of a Sixteenth-Century Miller* (Baltimore: Johns Hopkins University Press, 1980).
Glass, Ruth, *London's Newcomers: The West Indians in London* (London: Centre for Urban Studies, 1960).
Hastings, MacDonald, *The Other Mr Churchill: A Lifetime of Shooting and Murder* (London: Four Square Books, 1963).
Hollington, Kris, and Nina Hollington, *Criminal London: A Sightseer's Guide to the Capital of Crime* (London: Aurum, 2013).

Houlbrook, Matt, *Queer London: Perils and Pleasures in the Sexual Metropolis, 1918–1957* (Chicago: University of Chicago Press, 2005).

Houlbrook, Matt, *Prince of Tricksters: The Incredible True Story of Netley Lucas, Gentleman Crook* (Chicago; London: University of Chicago Press, 2016).

Jackson, Louise A., *Child Sexual Abuse in Victorian England* (Abingdon: Routledge, 2000).

Jermyn, Deborah, *Crime Watching: Investigating Real Crime TV* (London: IB Tauris, 2007).

Jesse, F. Tennyson, *Trial of Sidney Harry Fox* (Edinburgh: W. Hodge & Co, 1934).

Johansen, Anja, and Paul Knepper, eds., *The Oxford Handbook of the History of Crime and Criminal Justice* (Oxford: Oxford University Press, 2016).

Johnson, Donald McIntosh, *Indian Hemp: A Social Menace* (London: Christopher Johnson, 1952).

Jordanova, L. J., *The Look of the Past: Visual and Material Evidence in Historical Practice* (Cambridge: Cambridge University Press, 2012).

Kilday, Anne-Marie, and David Nash, eds., *Law, Crime and Deviance since 1700: Micro-Studies in the History of Crime* (London; New York: Bloomsbury, 2017).

Lancing, Maureen, *She Wore No Ring*, Girls' Friend Library, 434, (London: Amalgamated Press, 1934).

Langhamer, Claire, *The English in Love: The Intimate Story of an Emotional Revolution* (Oxford: Oxford University Press, 2013).

Long, David, *Murders of London: In the Steps of the Capitals Killers* (London: Random House, 2012).

Lustgarten, Edgar, *The Murder and the Trial* (London: Odhams Press, 1960).

Miller, Vivien, and James Campbell, eds., *Transnational Penal Cultures* (Abingdon: Routledge, 2014).

Morris, Terence, and Louis Blom-Cooper, *A Calendar of Murder: Criminal Homicide in England since 1957* (London: Michael Joseph, 1964).

Mort, Frank, *Capital Affairs: London and the Making of the Permissive Society* (New Haven CT: Yale University Press, 2010).

Moss, Eloise, *Night Raiders: Burglary and the Making of Modern Urban Life in London, 1860–1968* (Oxford: Oxford University Press, 2019).

Nava, Mica, *Visceral Cosmopolitanism: Gender, Culture and the Normalisation of Difference* (Oxford; New York: Berg, 2007).

Nead, Lynda, *The Tiger in the Smoke: Art and Culture in Post-War Britain* (New Haven, CT: Yale University Press, 2017).

O'Leary, C., *This Delicate Creature* (London: Constable, 1928).

Orwell, George, *Decline of the English Murder: And Other Essays* (Harmondsworth: Penguin, 1986).

Parker, Alan, *Watch the Birdie: A Police Photographer's Story* (Walsall: Cerebus, 2000).

Parry, Eugenia, *Crime Album Stories: Paris 1886–1902* (Zurich; New York: Scalo, 2000).

Patterson, Sheila, *Dark Strangers: A Sociological Study of the Absorption of a Recent West Indian Migrant Group in Brixton, South London*, abridged edition (London: Penguin, 1965).

Perry, Kennetta Hammond, *London Is the Place for Me: Black Britons, Citizenship, and the Politics of Race*, Transgressing Boundaries: Studies in Black Politics and Black Communities (New York, NY: Oxford University Press, 2015).

Procter, James, ed., *Writing Black Britain, 1948–1998* (Manchester: Manchester University Press, 2000).

Procter, Margaret, Michael Cook and Caroline Williams, eds., *Political Pressure and the Archival Record* (Chicago: Society of American Archivists, 2005).

Ravetz, Alison, *The Place of Home: English Domestic Environments, 1914–2000* (London: Spon, 1995).

Robinson, Edward M., *Crime Scene Photography*, 2nd ed (Amsterdam; Boston: Elsevier, 2010).

Rubenhold, Hallie, *The Five: The Untold Lives of the Women Killed by Jack the Ripper* (London: Doubleday/Transworld, 2019).

Ryan, Deborah Sugg, *Ideal Homes, 1918–39: Domestic Design and Suburban Modernism*, Studies in Design and Material Culture (Manchester: Manchester University Press, 2018).

Seal, Lizzie, *Women, Murder and Femininity Gender Representations of Women Who Kill* (Basingstoke: Palgrave Macmillan, 2010).

Seal, Lizzie, *Capital Punishment in Twentieth-Century Britain: Audience, Justice, Memory* (Abingdon: Routledge, 2014).

Seal, Lizzie, and Maggie O'Neill, *Imaginative Criminology: Of Spaces Past, Present and Future* (Bristol: Bristol University Press, 2019).

Snell, K.D.M., *Spirits of Community: English Senses of Belonging and Loss, 1750–2000* (London: Bloomsbury, 2016).

Spender, Humphrey, *Worktown People* (Bristol: Falling Wall Press, 1982).

Steedman, Carolyn, *Dust: The Archive and Cultural History*, Encounters (New Brunswick, NJ: Rutgers University Press, 2002).

Stewart, Victoria, *Crime Writing in Interwar Britain, Fact and Fiction* (Cambridge: Cambridge University Press, 2017).

Summers, Julie, *Stranger in the House: Women's Stories of Men Returning from the Second World War* (London: Pocket, 2009).

Summerscale, Kate, *The Queen of Whale Cay* (London: Bloomsbury, 2008).

Tabili, Laura, *We Ask for British Justice: Workers and Racial Justice in Late Imperial Britain* (New York: Cornell University Press, 1994).

Tagg, John, *The Burden of Representation: Essays on Photographies and Histories* (Minneapolis, MN: University of Minnesota Press 1993).

Taylor, D. J., *Bright Young People: The Rise and Fall of a Generation, 1918–1939* (London: Vintage, 2008).

Thomson, John, *Street Life in London* (London: Sampson Low, 1877).

Turner, Barry, and Tony Rennell, *When Daddy Came Home: How Family Life Changed Forever in 1945* (London: Hutchinson, 1995).

Walkowitz, Judith R., *City of Dreadful Delight: Narratives of Sexual Danger in Late-Victorian London* (Chicago: Chicago University Press, 1992).

Walkowitz, Judith R., *Nights Out: Life in Cosmopolitan London* (New Haven, CT: Yale University Press, 2012).
Wallis, Brian, ed., *Weegee: Murder Is My Business* (New York : Munich, 2013).
Wattis, Louise, *Revisiting the Yorkshire Ripper Murders: Histories of Gender, Violence and Victimhood* (Basingstoke: Palgrave Macmillan, 2018).
Waugh, Evelyn, *Vile Bodies* (London: Chapman and Hall, 1930).
Webster, Wendy, *Imagining Home: Gender, 'Race', and National Identity, 1945–64* (London: UCL Press, 1998).
Weston, Janet, *Medicine, the Penal System, and Sexual Crimes in England, 1919–1960s: Diagnosing Deviance* (London: Bloomsbury, 2018).
Whitaker, Ben, *The Police in Society* (London: Methuen, 1979).
Whitfield, James, *Unhappy Dialogue: The Metropolitan Police and Black Londoners in Post-War Britain* (Cullompton: Willan, 2004).
Williams, Chris A., ed., *Police and Policing in the Twentieth Century* (Farnham; Burlington, VT: Ashgate, 2011).
Wood, J. Carter, *The Most Remarkable Woman in England: Poison, Celebrity and the Trials of Beatrice Pace* (Manchester: Manchester University Press, 2012).

Journal Articles

Anwer, Megha, 'Murder in Black and White: Victorian Crime Scenes and the Ripper Photographs', *Victorian Studies*, 56/3 (2014): 433.
Ballinger, A., 'Masculinity in the Dock: Legal Responses to Male Violence and Female Retaliation in England and Wales, 1900–1965', *Social & Legal Studies*, 16/4 (2007): 459–81.
Begiato, Joanne, 'Beyond the Rule of Thumb: The Materiality of Marital Violence in England c. 1700–1857', *Cultural and Social History*, 15/1 (2018): 39–59.
Bell, Amy, 'Crime Scene Photography in England, 1895–1960', *Journal of British Studies*, 57/01 (2018): 53–78.
Blunt, Alison, and Eleanor John, 'Domestic Practice in the Past: Historical Sources and Methods', *Home Cultures*, 11/3 (2014): 269–74.
Brooke, Stephen, 'Revisiting Southam Street: Class, Generation, Gender, and Race in the Photography of Roger Mayne', *Journal of British Studies*, 53/02 (2014): 453–96.
Burney, Ian, and Neil Pemberton, 'Bruised Witness: Bernard Spilsbury and the Performance of Early Twentieth-Century English Forensic Pathology', *Medical History*, 55 (2011): 41–60.
Carrabine, Eamonn, 'Seeing Things: Violence, Voyeurism and the Camera', *Theoretical Criminology*, 18/2 (2014): 134–58.
Carrabine, Eamonn, 'Picture This: Criminology, Image and Narrative', *Crime, Media, Culture: An International Journal*, 12/2 (2016): 253–70.

Carrabine, Eamonn, 'Punishment in the Frame: Rethinking the History and Sociology of Art', *Sociological Review*, 66/3 (2018): 559–76.

Clayton, Huw, 'A Bad Case of Police Savidgery: The Interrogation of Irene Savidge at Scotland Yard', *Women's History Magazine*, 61 (2009): 30–8.

Collins, Katherine E., '"A Man of Violent and Ungovernable Temper": Can Fiction Fill Silences in the Archives?', *Life Writing* (2019): 1–7.

D'Cruze, Shani, '"The Damned Place Was Haunted": The Gothic, Middlebrow Culture and Inter-War "Notable Trials"', *Literature and History*, 15/1 (2006): 37–58.

D'Cruze, Shani, 'Intimacy, Professionalism and Domestic Homicide in Interwar Britain: The Case of Buck Ruxton', *Women's History Review*, 16/5 (2007): 701–22.

Doolittle, Megan, 'Time, Space, and Memories: The Father's Chair and Grandfather Clocks in Victorian Working-Class Domestic Lives', *Home Cultures*, 8/3 (2011): 245–64.

Graybill, Lela, 'The Forensic Eye and the Public Mind: The Bertillon System of Crime Scene Photography', *Cultural History*, 8/1 (2019): 94–119.

Houlbrook, Matt, 'A Pin to See the Peep Show: Culture, Fiction and Selfhood in the Letters of Edith Thompson', *Past and Present*, 207/1 (2010): 215–49.

Houlbrook, Matt, William G. Pooley and Alison Twells, 'Special Issue: Creative Histories', *History Workshop Journal*, (2020).

Klein, Joanne, 'Irregular Marriages: Unorthodox Working-Class Domestic Life in Liverpool, Birmingham, and Manchester, 1900–1939', *Family History*, 30/2 (2005): 210–229.

Lam, Anita, 'Decoding the Crime Scene Photograph: Seeing and Narrating the Death of a Gangster', *International Journal for the Semiotics of Law*, 33 (2019).

Langhamer, C., 'The Meanings of Home in Postwar Britain', *Journal of Contemporary History*, 40/2 (2005): 341–62.

Langhamer, C., 'Adultery in Post-War England', *History Workshop Journal*, 62/1 (2006): 86–115.

Logan, Anne, '"Building a New and Better Order"? Women and Jury Service in England and Wales, c. 1920–70', *Women's History Review*, 22/5 (2013): 701–16.

Mnookin, Jennifer, 'The Image of Truth: Photographic Evidence and the Power of Analogy', *Yale Journal of Law and Humanities*, 10/1 (1998): 1–74.

Mort, Frank, 'Scandalous Events: Metropolitan Culture and Moral Change in Post-Second World War London', *Representations*, 93/1 (2006): 106–37.

Nead, Lynda, 'Visual Cultures of the Courtroom: Reflections on History, Law and the Image', *Visual Culture in Britain*, 3/2 (2002): 119–41.

O'Brien, James, 'Simple Photography for Policemen: Part I', *Police Journal*, 9/1 (1936): 63–71.

O'Brien, James, 'Simple Photography for Policemen: Part II', *Police Journal*, 9/2 (1936): 173–82.

O'Brien, James, 'Simple Photography for Policemen: Part III', *Police Journal*, 9/3 (1936): 331–42.

O'Brien, James, 'Simple Photography for Policemen: Part IV', *Police Journal*, 9/4 (1936): 468–72.

Owens, Edward, 'All the World Loves a Lover: Monarchy, Mass Media and the 1934 Royal Wedding of Prince George and Princess Marina', *The English Historical Review*, 133/562 (2018): 597–633.

Presser, Lois, 'Getting on Top through Mass Murder: Narrative, Metaphor, and Violence', *Crime, Media, Culture: An International Journal*, 8/1 (2012): 3–21.

Robinson, Lucy, 'Collaboration in, Collaboration out: The Eighties in the Age of Digital Reproduction', *Cultural and Social History*, 13/3 (2016): 403–23.

Ross, Ellen, '"Fierce Questions and Taunts": Married Life in Working-Class London', *Feminist Studies*, 8/5 (1982): 575–602.

Seal, L., 'Emotion and Allegiance in Researching Four Mid-20th-Century Cases of Women Accused of Murder', *Qualitative Research*, 12/6 (2012): 686–701.

Seal, Lizzie, and Alexa Neale, 'Race, Gender and Bourgeois Respectability: The Execution of Percy Clifford, 1914', *The Irish Jurist*, 60 (2018): 144–53.

Seal, Lizzie and Alexa Neale, 'Race, Racialisation and "Colonial Common Sense" in Capital Cases of Men of Colour in England and Wales, 1919–1957', *Open Library of Humanities*, 5/1 (2019).

Seal, Lizzie and Alexa Neale, '"In His Passionate Way": Emotion, Race and Gender in Cases of Partner-Murder in England and Wales, 1900–39', *British Journal of Criminology* 60 (2020).

Seal, Lizzie and Alexa Neale, 'Racializing Mercy: Capital Punishment and Race in Twentieth-Century England and Wales', *Law and History Review*, forthcoming (2020).

Sekula, Allan, 'The Body and the Archive', *October*, 39 (1986): 3–64.

Smith, Evan, and Andrekos Varnava, 'Creating a "Suspect Community": Monitoring and Controlling the Cypriot Community in Inter-War London', *English Historical Review*, 132/558 (2017): 1149–81.

Steedman, Carolyn, 'Intimacy in Research: Accounting for It', *History of the Human Sciences*, 21/4 (2008): 17–33.

Steedman, Carolyn, 'After the Archive', *Comparative Critical Studies*, 8/2 (2011): 321–40.

Strange, Julie-Marie, 'Fatherhood, Furniture and the Inter-Personal Dynamics of Working-Class Homes, c. 1870–1914', *Urban History*, 40/02 (2013): 271–86.

Taylor, B., and B. Rogaly, '"Mrs Fairly Is a Dirty, Lazy Type": Unsatisfactory Households and the Problem of Problem Families in Norwich 1942–1963', *Twentieth Century British History*, 18/4 (2007): 429–52.

Thomas, Nick, 'Will the Real 1950s Please Stand Up? Views of a Contradictory Decade', *Cultural and Social History*, 5/2 (2008): 227–35.

Waters, Chris, 'Representations of Everyday Life: L. S. Lowry and the Landscape of Memory in Postwar Britain', *Representations*, 65 (1999): 121–50.

West, Kate, 'Visual Criminology and Lombroso: In Memory of Nicole Rafter (1939–2016)', *Theoretical Criminology*, 21/3 (2017): 271–87.

West, Kate, 'Feeling Things: From Visual to Material Jurisprudence', *Law & Critique*, 31/1 (2020).

Wildman, Charlotte, 'Miss Moriarty, the Adventuress and the Crime Queen: The Rise of the Modern Female Criminal in Britain, 1918–1939', *Contemporary British History*, 30/1: 73–98 (2016).

Wood, J. C., '"The Third Degree": Press Reporting, Crime Fiction and Police Powers in 1920s Britain', *Twentieth Century British History*, 21/4 (2010): 464–85.

Book Chapters

Auerbach, Sascha, '"A Holy Panic" Race, Surveillance and the Origins of the War on Drugs in Britain, 1915–1918', in *Transnational Penal Cultures*, ed. by Vivien. Miller and James Campbell (Abingdon: Routledge, 2014), 98–112.

Cavender, Gray, and Nancy Jurik, 'Crime, Criminology and the Crime Genre', in *The Oxford Handbook of the History of Crime and Criminal Justice*, ed. by Paul Knepper and Anja Johansen (Oxford: Oxford University Press, 2016), 320–37.

Clapson, Mark, and Clive Emsley, 'Street, Beat, and Respectability: The Culture and Self-Image of the Late Victorian and Edwardian Urban Policeman', in *Police and Policing in the Twentieth Century*, ed. by Chris A. Williams, History of Policing (Farnham; Burlington, VT: Ashgate, 2011), 292–317.

Gilroy, Paul, 'Blacks and Crime in Postwar Britain (1987)', in *Writing Black Britain, 1948–1998*, ed. by James Procter (Manchester: Manchester University Press, 2000), 71–8.

Hall, Stuart, 'Reconstruction Work: Images of Postwar Black Settlement', in *Writing Black Britain, 1948–1998: An Interdisciplinary Anthology*, ed. by James Procter (Manchester: Manchester University Press, 2000), 82–94.

Klein, Joanne, 'Traffic, Telephones and Police Boxes: The Deterioration of Beat Policing in Birmingham, Liverpool and Manchester between the World Wars', in *Policing Interwar Europe: Continuity, Change and Crisis, 1918–1940*, ed. by Gerald Blaney (Basingstoke: Palgrave Macmillan, 2006), 215–36.

Neale, Alexa, 'Murder at the "Love Hut": At Home with Elvira Barney', in *Beyond the Boundaries of Home: Interdisciplinary Approaches*, ed. by Marianela Barrios Aquino, Eduard Campillo-Funollet, Naomi Daw, Khetan Jha, Myles Logan Miller, Alexa Neale and Tom Ottway (Brighton: University of Sussex Library, 2017), 10–23.

Neale, Alexa, 'Murder in Miniature: Reconstructing the Crime Scene in the English Courtroom', in *Crime and the Construction of Forensic Objectivity from 1850* ed. by Alison Adam (Basingstoke: Palgrave Macmillan, 2020).

Philippopoulos-Mihalopoulos, Andreas, 'Writing beyond Distinctions', in *Routledge Handbook of Socio-Legal Theory and Methods*, ed. by Naomi Creutzfeldt, Marc Mason and Kirsten McConnachie (Abingdon; New York: Routledge, 2019), 70–82.

Seal, Lizzie, and Alexa Neale, 'Encountering the Archive: Researching Race, Racialisation and the Death Penalty in England and Wales, 1900–1965', in *Routledge Handbook of Socio-Legal Theory and Methods*, ed. by Naomi Creutzfeldt, Marc Mason and Kirsten McConnachie (Abingdon; New York: Routledge, 2019), 289–300.

Sutton-Vane, Angela, 'Murder Cases, Trunks and the Entanglement of Ethics: The Preservation and Display of Crime Records and Scenes of Crime Material', in *Crime and the Construction of Forensic Objectivity from 1850*, ed. by Alison Adam (Basingstoke: Palgrave Macmillan, 2020), 279–301.
Thane, Pat, 'Family Life and "Normality" in Postwar British Culture', in *Life after Death: Approaches to a Cultural and Social History of Europe during the 1940s and 1950s*, ed. by R. Bessel and D. Schumann (Cambridge: Cambridge University Press, 2003), 193–210.
Turkel, William J., 'The Crime Scene, the Evidential Fetish, and the Usable Past', in *The CSI Effect: Television, Crime and Governance*, ed. by Michele Byers and Val Marie Johnson (Lanham: Lexington Books, 2009), 133–146.
Williams, Chris, and Clive Emsley, 'Beware of the Leopard? Police Archives in Great Britain', in *Political Pressure and the Archival Record* (Chicago: Society of American Archivists, 2005), 227–35.

Newspapers

Aberdeen Press and Journal.
Daily Express.
Daily Herald.
Daily Mirror.
Illustrated Police News.
The Independent.
Penny Illustrated Paper.

Other media

Plays

Coward, Noel, *Blithe Spirit*, 1941.

Songs

Novello, Ivor, *Keep the Home-Fires Burning ('Till the Boys Come Home)* (New York, 1915).

Websites

Ancestry.com, 2019 www.ancestry.co.uk [accessed 10 October 2019].
BBC, 'Russell Bishop: Murder Trial Jury Retraces Girls' Steps', *BBC News*, 2018, www.bbc.co.uk/news/uk-england-sussex-45902215 [accessed 1 June 2019].

Brodie, Marc, 'Foster, Sir Harry Braustyn Hylton Hylton – (1905–1965), Speaker of the House of Commons', *The Oxford Dictionary of National Biography*, 2004, http://www.oxforddnb.com/view/article/34087 [accessed 10 February 2020].

British Newspaper Archive <www.britishnewspaperarchive.co.uk> [accessed 5 July 2019].

'Crime Scene Sub-Reddit', *Reddit* <www.reddit.com/r/CrimeScene>.

Emsley, Clive, Tim Hitchcock and Robert Shoemaker, 'The Value of the Proceedings as a Historical Source', *Old Bailey Online*, www.oldbaileyonline.org/static/Value.jsp [accessed 16 January 2019].

FPG/Hulton Archive/Getty Images, *The Scene of an Accident in Oakley Square, London after Scaffolding and Masonry Collapsed into the Street, Killing One and Injuring Eight, 12th October 1950*, 1950, http://www.gettyimages.co.uk/detail/78660796 [accessed 17 October 2019].

Historic England, 'Senate House and Institute of Education (University of London) and Attached Railings', *National Heritage List for England*, https://historicengland.org.uk/listing/the-list/list-entry/1113107 [accessed 11 September 2019].

'Map Images', *National Library of Scotland*, https://maps.nls.uk [accessed 10 October 2019].

The National Archives, 'Discovery [Online Catalogue]: CRIM 1/2783: Defendant: BURDETT, Brian Edward. Charge: Murder', *The National Archives, Discovery*, 2019, https://discovery.nationalarchives.gov.uk/details/r/C4202892 [accessed 16 October 2019].

The National Archives, 'Discovery [Online Catalogue]: MEPO 2/9894: Unsolved Murder of Kelso COCHRANE on 17 May 1959', *The National Archives, Discovery*, 2019, https://discovery.nationalarchives.gov.uk/details/r/C10887962 [accessed 17 October 2019].

The National Archives, *Legal Records Information Leaflet 27: Trials in the Old Bailey and the Central Criminal Court*, 2008, http://www.nationalarchives.gov.uk/records/research-guides/old-bailey.htm.

'Note the Decor. Ignore the Body, Immigration History Research', *Tenement Museum*, https://tenement.org/research.html [accessed 23 November 2015].

'Rotten dot com [Defunct as of 2012]', 1996, www.rotten.com.

Television

Crimewatch (UK, BBC1; 1984).
Making a Murderer (USA, Netflix; 2015).
American Crime Story: The People vs. OJ Simpson (USA, FX; 2016).
The Confession Tapes (USA, Netflix; 2017).
Murder, Mystery and My Family (UK, BBC1; 2018).
The Porthole Mystery (UK, BBC News; 2018).

Films

It Always Rains on Sunday (UK: Ealing Studios, 1947) Dir. Robert Hamer.
Since You Went Away (US: Selznick International Pictures, 1944) Dir. John Cromwell.

Exhibitions/Presentations

Hedges, Nick, *Make Life Worth Living: 1968–72*, 2015–2014, The Science Museum.
Jacque, Bernard, 'Blood and Wallpaper' (unpublished paper presented at Crime Scenes and Case Files: Sources for studying Domestic Interiors, Histories of Home Subject Specialist Network Study Day) 2012, Geffrye Museum, London.

Unpublished PhD Theses

Smalley, Alice, 'Representations of Crime, Justice, and Punishment in the Popular Press: A Study of the Illustrated Police News, 1864–1938' (Open University, 2017).

Index

Cases are indexed by defendant name and, where relevant, crime scene street address.

Aaku, Joseph (aka Joe Aku, victim) *see* Oakley Square
Adam, Alison 14, 70
alleys and alleyways 103–4, 111–13, 119–24
Anderson, John Charles (defendant) and Lilian née Odd (victim) *see* Prebend Street
Anwer, Megha 104, 112
appeals, criminal 66, 75–7, 143
Appleford Road, Kensal Town, North Kensington (home of Moira née Richardson, victim, and Brian Edward Burdett, defendant) 145–66, *155*, *156*
Auerbach, Sascha 123
authenticity 3, 13–14, 18–23, 26

Ballinger, Annette 43–4
Barney, Elvira Dolores née Mullens (defendant) 86 *see* William Mews
Bell, Amy 13–14, 18–19, 37, 161
Bertillon, Alphonse 19–20
Biber, Katherine 13–14, 23, 132
Blackout Ripper *see* 'Ripper' *under* forensic narratives
blood
 imagined meanings of 1–4, 8–9, 12, 17–18, 103, 112
 readings of at the crime scene 44, 50–4, 64, 69–70, 142–3, 169
Bloomsbury, London *see* Torrington Square
bodies 8–11, 23–4, 104–6, 111–12, 126, 187 n.10
Booth, Frederick Marshall (defendant) and Ivy (victim) 108–10
Brandt, Bill 150
Brighton 11, 64–5, 71, 76
Brooke, Stephen 151–2, 157, 165

Burdett, Brian Edward (defendant) and Moira née Richardson (victim) *see* Appleford Road
Burney, Ian 37, 178 n.58

Camden, London *see* Prebend Street
cameras and equipment 20–3, 27–8, 172–3
 in particular cases 37, 50–7, 64, 81–2, 90, 92–4, 114–16, 120–1, 155
Campt, Tina 132
cannabis *see under* drugs
capital punishment *see also* mercy
 of Backary Manneh 143, 145
 instances of impact on forensic narratives 51, 60, 65, 69–70, 105, 109–10, 136, 141, 153, 163–5
 significance of, esp. to sources 6–7, 11, 15–17, 24–5, 58, 78, 132, 171
Carlson, Jessamy 193 n.1
Carrabine, Eamonn 25
Carstairs, Joe 187 n.12
cats 129, 135, 140–2
Christie, Agatha 84–5, 188 n.34
Christie, John Reginald Halliday (defendant) *see* Rillington Place
class, social
 conflict between/disruption of boundaries 81–5, 96, 99–101
 and post-war identity 146, 148–52, 157, 164–6
 and power above the law 90, 96, 101–2
 'respectable working-class' including police 31, 38, 80–4, 90–2, 94, 99
 working class 35, 44–5, 47, 112, 137, 167–9
Clayton's Orange Squash 129, 142, 193 n.1
cocaine *see under* drugs
Cochrane, Kelso (victim) 161 *see also* Golborne Road
cocktail culture 85–7, 90–1, 96–100

Index

'cold cases' 7, 12, 24, 179 n.81
Coroners 11, 34–5, 44
courtroom performance 15, 65–78, 94–7,
 133–43, 145–50, 159–66, 171
Coward, Noel 85
crime archives, case files 3–7, 13–30, 75–8,
 165–6, 170–3
 problems/opportunities 35–6, 65–6,
 124–6, 142–4, 149–53, 158–66, 170–3
crime scene investigation practice
 according to popular culture 1–30,
 167–73
 according to practitioners 31–41,
 49–57, 79–94, 115, 143, 158–9
 significance of 2, 12–15, 17–21, 25–6,
 168, 171
crime scene photographs
 compared to crime scenes in illustrated
 press 97–102
 compared to other crime photography
 19, 21–3, 51, 98, 112, 132
 foregoing literature on 7, 13–14, 18–20,
 23, 26
 as realism 3, 13–14, 18–23, 26
 as sources for domestic interiors 3, 35,
 172–3
 and theories of photography 6, 13–14,
 19, 21, 23
 as visualizing narrative 2, 9–11, 15–18,
 25–7, 29–30, 167–72
crime scene photography practice
 history of in context 7–26
 in the bureau 21–2, 64, 79
 in the courtroom 22–4, 29–30, 63,
 66–70, 76, 142–3, 167–72
 at the crime scene 26–8, 37–8, 46–7,
 49–57, 79–94, 116–26, 141–3, 167–72
Criminal Investigation Department (CID)
 see under Metropolitan Police
criminal portraits (aka 'mugshots') 19–23,
 51, 132
Crone, Rosalind 9
'CSI effect' 7–9 see also crime scene
 investigation practice according to
 popular culture
Cummins, Gordon Frederick (defendant,
 aka Blackout Ripper) see Ripper
 under forensic narratives
Cyprus and 'Cypriots' 49–52, 58, 62–3,
 76–8, 134

Daily Herald 41, 99
Daily Mirror 109–11, 162
Dark Tourism 11, 21, 24
death penalty see capital punishment
depositions see magistrates court
 and interview practices under
 Metropolitan Police
Director of Public Prosecutions (DPP) 58,
 66, 69, 86, 99, 124, 135
distressing images 4, 19, 23–4, 126, 172
DIY 149, 154–7
domestic murder (defining) 24, 38, 43, 47,
 105–10, 130, 158–9, 163–5, 171
domestic violence 34–8, 40–5, 92, 163
domesticity 3–4, 12, 24–30, 97, 130–44,
 148–66, 167–73
 performed domestic skill (gendered)
 homemaking 42–5, 88, 107–8, 118,
 148
 the state of homeliness 43–5, 82–3,
 107–8, 130–44, 148–66
DPP see Director of Public Prosecutions
drugs 29, 100, 123, 130, 135–44
 cannabis (aka hemp) 135–6, 141–3
 cocaine 85, 88, 90, 143–4

ethical considerations: reproducing crime
 scene photographs 23–5, 191 n.29
Evans, Timothy (defendant) see Rillington
 Place
exhibits of evidence
 'cultural afterlife' of 9, 12, 23–5
 empirical/scientific values 1–30, 46–7,
 65–77, 125–6, 142–4, 167–72, 179
 n.70
 material objects 63–72, 88, 140–4,
 147–9, 154–9, 171–3
 retro-perspectives on 3, 6–9, 11–14,
 18–21, 23–5, 172
expert or 'scientific' witnesses 27, 40,
 135–6, 144, 164

faked photographs 22
Fellig, Arthur see 'Weegee'
forensic narratives 11–30, 94–5, 105–8,
 142, 159, 163–6, 167–72
 accident 36, 43–6, 89, 94–5
 domestic violence 40–5
 drug-induced frenzy 135–6, 138–44
 hate crime 161

insanity 105, 112–13, 126, 168
jealousy 59–78, 89, 94–5, 105–9
murder for robbery 112–13, 141, 143, 165
murder for sex 106, 111–18, 125–6
nagging 164
provocation 60–1, 74–5, 110, 112, 124, 126, 163–4
returning soldier 107–10, 126
'Ripper' (inc. Jack the, Blackout and Yorkshire Rippers) 103–7, 110–26, 168
self-defence 61, 74–5, 136, 143
spouse disposal, starting over 104–7, 149, 153, 160–1
stranger murder *see also* 'Ripper' 106, 111
forensic privilege/supposed objectivity 7, 13–15, 18, 20–1, 23, 28–9, 82, 163
forensics 1–2 *see also* crime scene practices
forgery, fraud 20–2
furnishings and furniture 33–4, 45–7, 80–1, 87–96, 100–1, 126, 154–60

gender, esp. impact on culpability 16–17, 21–5, 42
femininity *see* performed domestic skill *under* domesticity *and* sexuality of women
masculinity 94, 106, 190 n.12
geographies 2–24, 136–7, 167–70 *see also* alleys *and* mews
Georgiou, Georgios Kalli (defendant, aka George Kalli) *see* Torrington Square
Gilroy, Paul 131–2, 135
Golborne Road, Kensal Town, North Kensington 148, 151–2, 160–1
Graybill, Lela 13–14, 19–20
Greece and 'Greeks' 58, 61, 77–8
Gross, Hans, 70
guns, firearms, bullet holes 87, 92, *83*, 94–5, 101

Harrison, Francis Charles Alfred (defendant) and Doris Alice Ellen (victim) *see* 'Murder Story'
Hartney, Patrick (defendant) and Lilian née Riley (victim) *see* Limehouse
Home Office 21–2, 37, 58, 66, 75–8, 86, 105–6, 110, 132, 143

Homicide Act (1957, aka Murder Act) 18, 60, 105, 159, 163–5, 171
Houlbrook, Matt 16, 73, 88
housing conditions as indicators of social identity 38, 43–5, 150–1, 164–6, 167–73
boarding houses/lodging houses 50, 58, 62, 137
decadence/conspicuous wealth 83, 90–1, 97
overcrowding 45, 47, 137, 149
poverty 45, 47, 111–12, 120, 137, 147–53
race 131–2, 136–9, 142, 151, 169, 178 n.50
'respectable working class' 80, 83, 92, 94, 96, 99, 137, 149
'slums' 136–7, 150–3, 158–60, 165, 182 n.40
Huxley, Elspeth 136–7

'ideal home' 43, 45, 137–8, 149, 195 n.7
Illustrated Police News see illustrated press
illustrated press 10, 97, *98*, 100, 111–12, *113*, 125

Jack the Ripper *see* Ripper *under* forensic narratives
James, Thomas (victim) *see* Torrington Square
jigsaw puzzle as metaphor for evidence 36, 133–4, 146
Judges' Rules 41–3, 159–62

Kelly, Mary (victim) 111–12, 115, 125 *see also* Ripper *under* forensic narratives
Keymer, Reg (defendant) and Peggy (victim) 108–9
Knightsbridge, London 73, 79–102, 137 *see also* William Mews

Langhamer, Claire 65, 78, 138
Lee, Frances Glessner 9
legal contexts 9–30, 42–3, 56–7, 65, 113, 136, 146–8 *see also* forensic narratives
Limehouse (home of Lilian née Riley, victim, and Patrick Hartney, defendant) 103–26, *115, 119, 120, 121, 122, 124*

The Lodger (fiction based on Jack the Ripper) 111
Lowry, L. S. 152

McKinnon or Watt, Margaret (witness) *see* Torrington Square
Magistrates Courts/Police Courts 14, 35–7, 40–5, 92–5, 116, 154, 159, 161
Manneh, Backary (defendant) *see* Oakley Square
maps 8–9, 11, 116
Marina, Princess of Greece and Denmark 77–8, 84
marriage 31–47, 59–65, 77–78, 104–10, 118, 134–9, 146–8
material culture 9, 29, 32–4, 126, 130, 140, 154–8
 material fetishism 101
 materiality of photographs/images 21
Mayne, Roger 149, 151–3, 157, 160–1, 166
media *see* press
mental illness/health 28–9, 113, 164
 see also insanity *under* forensic narratives
mercy 16, 25, 58, 74–8, 109–10, 136 *see also* capital punishment
methodology 1–30, 56, 172–3, 191 n.29
Metropolitan Police 14, 21–3, 27, 31–4, 38
 beat policing 31–4, 53, 63, 85
 'C3' Fingerprint and Photographic Department/Section/Bureau, Scotland Yard 20–2, 37, 51–3, 64, 67, 79, 82, 117, 171 *see also* photographers
 Commissioner of Police of the Metropolis 21–2, 86, 95–6
 Criminal Investigation Department (CID) 22, 49
 interview practices, statements 34–35, 38–43, 51, 55–66, 117–118, 159–62
 racism 131–2, 134–5, 138–142, 161
 relationships between staff 49–55
 relationships with public 58, 83–4, 86, 90, 116, 126
 reports, bureaucracy 14–18, 58, 66, 86–7, 90, 96, 143, 161
 values influencing investigation 56–8, 83–4, 90–4, 100–2, 139, 158, 161–4
mews (generally) 80, 83–4, 91 *see also* William Mews

microhistory 5, 13–16, 26, 100, 141, 161–3, 167–73
miscarriages of justice 7, 12, 25–6
miscegenation 130–9, 151
Mnookin, Jennifer 13
models, miniature crime scenes 8–9, 11
mugshots *see* criminal portraits
Mullens family (Sir John Ashley, Evelyn née Adamson, Avril aka Princess Imeritinsky and Elvira *see* Barney, Elvira) 84, 86, 89–90, 96, 100, 110 *see also* Barney, Elvira
Murder Act *see* Homicide Act
Murder in the Mews 84–5
'Murder Story' (unpublished manuscript) 28–9, 103–5, 168

narratives *see also* forensic narratives
 and crime 6–17, 24–8, 67, 81–2, 94, 131, 168, 172
 of crime in a pseudo-scientific text 135–6
 of crime in fiction 84, 88, 103–5, 117–18, 163
 of crime in the press 6–7, 25–8, 40–2, 97–102, 105–13, 131–5, 143, 162–6
 formation of by police at crime scene *see* crime scene investigation practice
 as historical practice 4–5, 12–13, 15–16, 26–7, 170 *see also* vignettes
 images as visual narratives 7–12, 17, 25–8, 41–7, 51–6, 67–8, 75–6, 165–6
National Archives (UK) 4–5, 66, 111, 143, 161, 165, 172
national identity, citizenship 38, 43, 77, 135–8, 150, 161
 'Chinese' 123, 136
 'colonials' and 'foreigners' 58, 76–8, 111, 123, 134
Nava, Mica 139
Nead, Lynda 38, 104, 106–7
neighbours 29, 43, 86–7, 92–6, 118–19, 137–9, 157–61, 169
North Kensington, London 148–50, 151–2, 155 *see also* Appleford Road
Notting Hill, London 132, 148, 151, 167 *see also* Rillington Place
Nutshell Studies 9

Oakley Square, St Pancras, (home of Joseph Aaku, victim, and Theresa Maher, his partner) 127–44, *141*
Old Bailey Proceedings 8
Orwell, George 38

Patmore, Cyril (defendant) and Kathleen (victim) 107–8
Pemberton, Neil 37
Perry, Kennetta Hammond 131, 132
photographers, police 13–14, 18–22, 27, 35–8, 46–7, 49–50, 56, 172
 civilian recruits 18, 22, 155, 171
 Detective Inspector James Reuben O'Brien 28, 37–40, 45, 49–57, 63–76, 121
 Detective Sergeant Alfred Madden 28, 79–83, 87, 89–93
 Detective Sergeant George Salter 115–26
 Detective Sergeant John Merry 141–2, 155–8, 163
Pichel, Beatriz 179 n.70
poison 146–8, 159, 161
police *see* Metropolitan Police
police investigation *see* crime scene practice
Police Journal 64
post-mortem examinations/reports 37, 40, 45, 47, 117, 135, 148
Prebend Street, Camden (home of Lilian née Odd, victim, and John Charles Anderson, defendant) 31–47, *39*, *46*
pregnancy 146, 148, 149
press/newspapers 3–11, 16, 19, 24–8, 35–6, 77–8, 88, 139 *see also* narratives of crime in press
 crime reporting limitations 3, 40–2, 47, 82–5, 90, 96–8, 125, 161–2
 crime scenes in *see under* visual representations of crime scenes
 as material exhibits 87–8, 108, 128 *see also She Wore No Ring*
Princess Imeritinsky *see* Mullens, Avril
Princess Marina *see* Marina, Princess of Greece and Denmark
prisons 78, 143–4, 161
privacy 87–9, 100–1, 137–9, 149, 166
'prostitutes' appellation 111–12, 115, 125–6, 139

provocation *see under* forensic narratives
public houses, pubs 38, 116, 119, 133
public opinion about justice 77, 96, 99–102
public/private dichotomy 137–8, 150–7, 161, 169

race 12–17, 21, 23–5, 29, 58, 61, 76, 127–44
 see also racism *under* Metropolitan Police *and* race *under* housing conditions
Rafter, Nicole 21
Red Barn Murder 9
reflexive interpretation 3, 23–5, 140–2, 172–3
reinvestigation of historic cases 7, 12, 14, 21, 24, 77, 179 n.81
respectability 38, 58, 62, 65, 73, 84, 92, 94
Rillington Place, Notting Hill (home of Timothy Evans, defendant, and John Reginald Halliday Christie, defendant) *cover*, 20, 148
Rubenhold, Hallie 125

scale plans, floorplans 7–11, 35–7, 45–7, *46*, 66–7, 75, 89, 116
Seal, Lizzie 23, 25, 105, 123, 126, 131–2, 136, 140
sexual murder *see under* forensic narratives
sexuality of women 40–1, 56, 58–78, 85–101, 107–18, 123–6, 131–40
Shaftesbury Avenue, London 63–4
She Wore No Ring (novelette) 65–6, *72*, 71–4
Simpson, OJ (defendant) 178 n.50
Smalley, Alice 10, 97
Smith, Evan 58
social change 56, 73–4, 84, 137–8, 149–53, 164–6, 168–9
social housing as supposed key to improving living standards 156–8, 160, 168
Southam Street, Kensal Town, North Kensington 148, 151–3, *152*, 157
Spilsbury, Sir Bernard (Pathologist) 37, 40, 44–5
Stanfield Hall Murder, Norfolk 9
Stephen, 'Michael' Thomas William Scott (victim) *see* William Mews
stories *see* narratives
street photography 149–53, 157, 160–1, 165–6

Tabili, Laura 134
Tagg, John 14
Thompson, Edith (defendant) 88
Torrington Square, Bloomsbury (home of Georgios Kalli Georgiou, defendant, Thomas James, victim, and Margaret McKinnon Watt, witness) 49–78, *68, 69, 70*
Tottenham Court Road, Soho, London 50, 58, 63, 77, 78, 133
trial transcripts, significance of 19, 27, 35–47, 64–76, 82, 139–43, 161–5, 171
trial outcomes, problematic readings of 47, 60, 76–8, 81, 99, 101, 109, 111
trials *see* courtroom performance
'True Crime' 11, 16, 21, 23–4

Varnava, Andrekos 58
vignettes (research-based opening narratives) 12–13, 15–16, 27–9, 56–7, 76, 130–1, 138, 140–2, 149, 168–73 *see also* 'Murder Story'
 Encountering Appleford Road, Part I: 4–5
 Encountering Appleford Road, Part II: 172–3
 Encountering Oakley Square 127–30
 Encountering Prebend Street, 31–4
 Encountering Torrington Square 49–55
 Encountering William Mews 79–81
 Prosecution narratives 145–6
visual representations of crime and crime scenes 7–17, 21, 26, 56, 168–9

courtroom portraits 10
lack of 40, 56, 167
miniatures *see* models
photographs *see* crime scene photographs
plans *see* scale plans
in press 10–11, 19, *98*, 99–102, 105–12, *113*
reconstructions 11
staging 106, 110, 113, 117–18, 125–6, 167–8
waxworks 9

walking, observations 180 n.1, 187 n.1
Walkowitz, Judith 104, 112
war 28, 85, 106–8, 123
Watt, Margaret McKinnon (witness) *see* Torrington Square
Wattis, Louise 104, 125
Waugh, Evelyn 85
Webster, Wendy 133–4, 138–9
'Weegee' (aka Arthur Fellig) 10
West, Kate 21, 132
Weston, Janet 113
Whitaker, Ben 162
Whitfield, James 139
William Mews, Knightsbridge, London (home of Elvira Barney née Mullens, defendant) 79–102, *83, 89, 91, 93, 98*
Windrush 132–3

Yorkshire Ripper *see* Ripper *under* forensic narratives

www.ingramcontent.com/pod-product-compliance
Lightning Source LLC
Chambersburg PA
CBHW072232290426
44111CB00012B/2063